Art of Colonial Latin America Gauvin Alexander Bailey

Φ

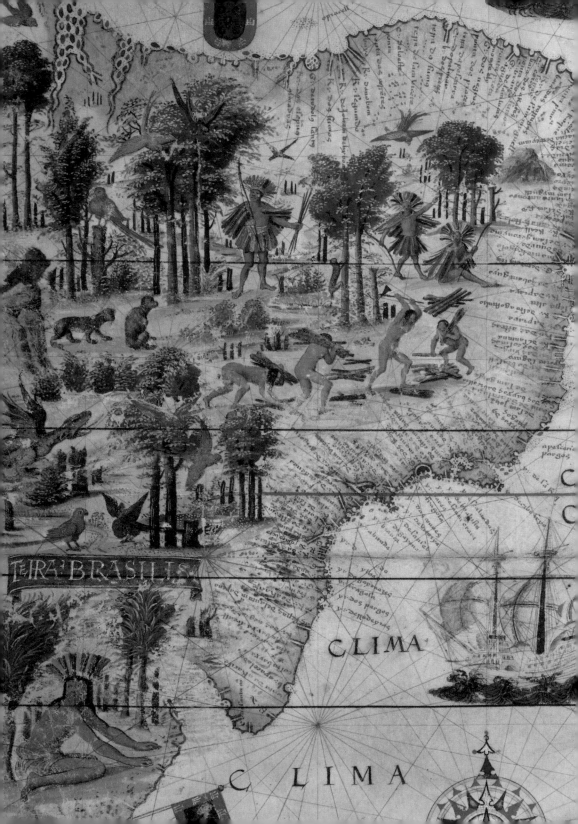

Art of Colonial Latin America

Introduction 4

Opposite
Lopo
Homem-
Reineis,
map of Brazil
from the *Atlas
Miller*
(detail of 17),
1519.
Pigments on
parchment;
42 × 59 cm,
16½ in
× 23¼ in.
Bibliothèque
Nationale,
Paris

Latin American art is more relevant to the world today than at any time in its history. A new public awareness of the subject has fuelled countless exhibitions, studies and television documentaries, making Latin America's rich and varied cultural legacies more accessible than ever before. In the United States and Canada, which are becoming increasingly Hispanic themselves through immigration and the media, there is a growing acknowledgement that Latin American art is part of the national culture. Museums are rushing to create curatorships and mount exhibitions in the field, such as the first retrospective of the Latin American art collection of the Museum of Modern Art, New York, which opened in March 2004 at El Museo del Barrio, Manhattan. In Spain, Portugal, Belgium, France, the Netherlands and Italy, books and exhibitions are reflecting new interest in artistic connections that existed between their countries and the Americas, both past and present. The subject has also aroused enthusiasm in Britain, where Tate Modern appointed its first associate curator of Latin American art in 2002, and in Japan, where the legacy of immigration to Peru and Brazil has led to a curiosity about the arts of those regions. But almost all of this new attention is being focused on pre-Hispanic art and the arts of modern and contemporary Latin America. Scholars and the art-loving public are only slowly coming to terms with the more neglected period that lies in between: the 330-year colonial era, from 1492 to around 1820. This reluctance to consider the colonial period is partly due to what is admittedly a sensitive subject. The arts of the period between the arrival of Christopher Columbus (1492) and the struggles for independence carry with them the baggage of empire and tyranny and the stigma of occupation, displacement and forced conversions. Today some Latin American countries still view the colonial era as an embarrassment, an oppressive and autocratic foil for their pre-Hispanic past and modern nationhood alike, and people around the world are reluctant to embrace an era associated with western Europe's collective guilt.

If we overlooked the arts of colonial Latin America we would lose sight of an arts tradition at least as rich and diverse as western Europe's in the same period, we would avert our eyes from the creative output of an entire hemisphere – with tens of millions of inhabitants – over the course of three centuries. The people and societies who produced and used this art and architecture came from the widest spectrum of backgrounds. They included Africans, Asians and *mestizos* (people of mixed blood), as well as Europeans from places as varied as Spain, Italy and Bohemia. They also included the original Amerindian inhabitants of the continents – not only the descendants of the Aztecs, Inca and Maya, but tribes as diverse as the Puebloans, Aymara, Guaraní and Huilliche. They were farmers and viceroys, priests and soldiers, nuns and marquises. Colonial Latin America was the most cosmopolitan society on earth and it makes a striking parallel to today's global community.

More importantly, if we disregard colonial Latin American culture we also pass over a period in which the foundations of modern Latin America were laid. Just as twentieth-century composers such as Alberto Ginastera or Manuel Ponce drew upon colonial-era folk melodies to create a musical voice for modern Argentina and Mexico, artists from Frida Kahlo (1907–54) to Fernando Botero (b.1932) plumbed the same period in their search for a modern Latin American visual identity. Perhaps the best illustration of colonial art's continuing relevance is the sixteenth-century Mexican painting *The Virgin of Guadalupe* (1), a delicate late Renaissance image of the Virgin of the Apocalypse, whose enigmatic grey-lavender skin colour has inspired generations of Mexicans to accept her as a member of their own ethnic group, whether Amerindian, *mestizo* or *criollo* (people born in America of European parentage). Deriving from a medieval interpretation of a passage in the Apocalypse of John the Apostle, Mary is a protagonist in the eternal war between Jerusalem and Babylon, and appears surrounded by sunbeams, standing on a half-moon and crowned by stars. The single most famous work of Latin American colonial art today, it has been embraced by groups as diverse as Chicano labour activists, feminist artists, paranormal enthusiasts and conservative Catholic sodalities. It is painted on murals in Los Angeles (see 242), embedded in resin keychains in Lima and Bogotá, and is the focus of legions of internet sites around the world.

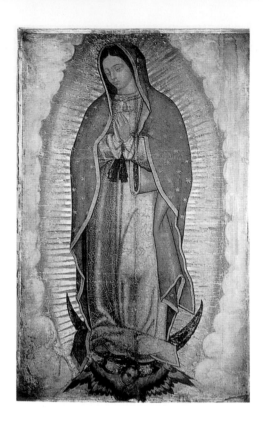

1
Anonymous
Nahua
painter (?),
*The Virgin of
Guadalupe*,
c.1531.
Oil and
tempera on
maguey fibre
cloth;
170 × 105 cm,
67 × 41⅛ in.
Shrine of the
Virgin of
Guadalupe,
Mexico City

This painting has enjoyed a resurgence through the canonization in 2002 by Pope John Paul II (r.1978–) of Juan Diego Cuauhtlatoatzin, who is said to have discovered it in his cloak in 1531. Juan Diego, the bearer of the Virgin's image, thus became the Catholic Church's first Amerindian saint – even though many argue that he never existed. The Virgin of Guadalupe remains at the core of Latin American identity precisely because she embodies the heterogeneous but conflicted legacy of the colonial era. This legacy remains at the centre of Latin American politics, religion, culture and nationalism today. To ignore the colonial past is to lose critical insight into the present.

There has never been a better time to reassess the arts of colonial Latin America. Until quite recently any discussion of the Spanish and Portuguese 'discoveries', conquests and colonies was coloured by a strong bias towards their European protagonists, who were celebrated for 'civilizing' the indigenous people through customs, religion and architecture. Traditional histories emphasized the cult of the personality,

depicted the explorers and conquistadors as superheroes – if flawed by greed and vanity – and saw their exploits as Europe's manifest destiny. The most famous such hero was Christopher Columbus, revered for over a century by North and South Americans, Italians and Spanish alike as a nationalist champion, and honoured by place names, statues and holidays. Hernán Cortés, the conqueror of Mexico (in 1521; see 86), was similarly revered by those who applauded the worldwide spread of European culture. This 'big hero' concept of discovery and conquest has an ancient lineage. During the 'Age of Discovery' itself, European imaginations were steeped in the adventures of fictional knights and kings – it is fitting that Miguel de Cervantes, author of the chivalric parody *Don Quixote*, sought a posting in Bolivia – and the reports from swashbuckling Spanish and Portuguese conquistadors make such compelling reading that they have blinded us to the viewpoint of the Americas' other inhabitants. By silencing Amerindian voices, they turned a substantial part of the population – the majority for much of the colonial era – into passive recipients of European culture. The result has been that we tend to think of the colonial era as a complete break with the pre-Hispanic past, with European culture wiping the slate clean. Such an approach to history has created a tendency to oversimplify the encounter, as if the Europeans and Amerindians represented two unified, homogeneous blocks – more like medieval allegories than historical realities. This traditional focus on the European contribution to the Americas has had a detrimental impact on Latin American colonial art history as well. Up until now, most people believed that colonial culture was purely Iberian in origin, concluding that the arts could be no more than provincial and debased forms of Spanish and Portuguese models.

The 1992 Columbus quincentennial gave people a chance to reassess the Columbian legacy and, while not denying its importance, they have now been able to speak of an encounter rather than a discovery, putting the non-European contribution to colonial Latin American culture on a more equal footing with that of the European colonizers. Although the event highlighted the appalling hardships and changes that this historic moment initiated for the original inhabitants of the American continents, it also revealed the existence of flourishing indigenous

cultures throughout the post-Conquest period, with their own arts traditions, and demonstrated the significant contributions they made to colonial culture – a powerful challenge to the 'clean slate' perception. The 2000 quincentennial of the Portuguese arrival in Brazil and the 2001–2 Brazil exhibitions at the New York and Bilbao Guggenheim Museums and the Ashmolean Museum, Oxford, have given the world a similar opportunity to reflect on the European encounter with Latin America's largest country. One particular contribution of the Brazilian commemoration is a reawakened interest in the plight of the millions of African slaves who were brought to Brazil during the colonial era and to recognize their substantial cultural legacy in the region and in Latin America as a whole. Thanks to this new awareness of Brazil's black culture, scholars and the public alike are now seeing Latin American colonial culture in general as more of a three-way street (Amerindian, African, European). The approaches inspired by these commemorations give us the opportunity to look at the arts of colonial Latin America in a new light. By acknowledging the contributions of the Amerindians, Africans and other non-Europeans to colonial Latin American art – whether symbols and decorative details, styles or techniques, or their associations with non-European faiths and world-views – we gain much greater insight into its riches.

Cultural diversity was not the only thing that made colonial Latin American art unique: it was also crucially conditioned by landscape and geography. Few regions in the world offer as much geographical variety as Latin America. This continent-and-a-half, extending from Tierra del Fuego to California, embraces desolate mountain highlands and thick lowland rainforest, barren, sun-scorched coastal deserts and fertile rolling prairie, glacial fjords and churning tropical rivers. Such climatic extremes resulted in an endless number of stylistic and structural variants. The earthquake-resistant churches of Guatemala and coastal Peru use thick walls and vaults made of lightweight material to protect against earth tremors (see 167). In the rainforests of Paraguay and lowland Bolivia, mission residences have wide verandas to protect their inhabitants from tropical downpours (see 122). In the southern reaches of Chile, on the archipelago of Chiloé, austere wooden churches with tiny windows compensate for the chilly weather, their

resemblance to New England meeting houses matched by their Nordic setting (see 143). The availability of materials, so different in tropical regions such as northern Brazil from desert zones like New Mexico, also dictated whether churches or statues would be made from stone, adobe or wood, and what colours painters would use on their canvas – if they could use canvas at all. In Mexico architects capitalized upon the rich bronzes and pinks of a porous volcanic stone called *tezontle* to give their church façades subtle textures and rich colours that were unique in the world (see 158). In Brazil, native hardwoods such as jacaranda gave colonial sculpture a deep patina and resilience and are much more sensuous and luxurious than the pine or cedar used in Portugal (see 181). In Peru, indigenous weavers exploited the resonant natural dyes native to the region to produce tapestries and shawls of stunning brilliance (see 49). The arts of colonial Latin America also reflect their natural landscapes more directly by incorporating native landscapes or flora and fauna into their ornamentation, so that sculptural decoration around doorways and windows in the buildings of Highland Bolivia includes heads of maize or papayas, retablos (altarpieces) in Paraguay incorporate passionflowers into their decorative scrolls and paintings of biblical scenes from Cuzco in Peru or Quito in Equador feature landscapes dotted with pumas and guinea pigs (see 48).

Most importantly, colonial Latin American art is a testament to human creativity, irrespective of race, ethnicity or birthplace. While there is no denying that certain motifs, symbols or techniques in colonial Latin American art can be traced to Amerindian, African or European forms, too much attention has been paid to linking these traits with the specific ethnic or racial background of the artist, with the result that the artist's work is reduced to the level of an anthropological artefact. This idea of a racially or culturally defined artistic culture comes from nineteenth-century beliefs that an entire people shared an artistic 'will' and that different races had different inherent capacities, theories that were to have dire consequences with the rise of twentieth-century nationalism. The history of colonial Latin American art contradicts such beliefs. It is full of paintings incorporating indigenous motifs that were executed by *criollo* artists, statues of black saints in Brazilian churches by sculptors from Lisbon or perfectly

rendered Italian late Renaissance church façades designed and built by Amerindian masons. We also see many works with Amerindian, African and European features that we know to be the work of *mestizos*. This blending of styles, techniques and iconographies (figures that represent ideas important to a culture or a religion) is precisely what makes Latin American art unique and fascinating, and it should serve as a warning against trying too hard to categorize on the basis of race or ancestry.

The Americas produced artists and architects of extraordinary genius who created unique variants of Renaissance and Baroque forms that were of unprecedented originality and astonishing beauty. Such was the eighteenth-century African-Brazilian sculptor and architect Aleijadinho (Antônio Francisco Lisboa; *c.*1738–1814), the last great sculptor of the international Rococo, whose works' rough anguish express a visceral yet human kind of pathos (see 182, 183). In early seventeenth-century Peru, the Andean Indian painter Diego Quispe Tito (1611–81) created ethereal landscapes, combining shimmering colours redolent of the supernatural with occasional glimpses of a world of Inca symbolism (see 176). Feather paintings of the Purépecha Indian Juan Baptista Cuiris (fl.1550–80) brilliantly fused an Aztec technique with European subject matter to create intricate and luminous portraits of the saints that were the toast of the Renaissance princely courts. None of these artists happen to be of European extraction, but that does not mean that their genius derived from their 'Otherness'. One could cite just as many talented artists with European roots, such as the sixteenth-century Italian-Peruvian painter Matteo da Leccio (1547–1616; see 174) who was the last artist to fresco Michelangelo's (1475–1564) Sistine Chapel. Leccio sought his fortune in Lima and founded a flourishing local school of mural painting. The same goes for the *criollo* late Baroque painter Cristóbal de Villalpando (*c.*1649–1714), one of the leading lights in the luxurious world of eighteenth-century New Spain (now Mexico). Villalpando's giant canvases and murals in the cathedrals of Puebla (see 178) and Mexico City introduce a flickering light technique inspired by Venetian painting that anticipated the technical revolutions of Goya (1746–1828) and Turner (1775–1851), who are celebrated for experimenting with loose and spontaneous techniques.

In most cases we do not even have the luxury of knowing an artist's race or ethnicity. The great majority of colonial Latin America artists, whether European, Amerindian or African, will remain forever anonymous. Most of the carvers, painters and builders who worked in the lands between Patagonia and California saw their task as a communal one and were content never to sign their name.

Images and architecture have been at the core of colonial Latin America since the earliest years of the Conquest. Even the most rudimentary churches needed religious pictures. They were so important to the business of conversion that the Spanish Laws of Burgos of 1512–13 decreed that colonial landowners had to provide the indigenous communities on their property not only with a church and a bell, but also with 'pictures of Our Lady'. Missionaries and colonists alike believed that images could work miracles, whether by converting Amerindians or protecting settlers. This enthusiasm for pictures has little to do with 'art' in the Renaissance and modern sense, but relates instead to the medieval European belief that holy images possessed the presence of their subject. A venerated holy image of the Virgin Mary was not just a portrait of the saint but also an extension of her being. When copies were made of that image, this replication extended her presence infinitely. In fact, the Madonna became something of a victory symbol for Spanish conquest. Hernán Cortés sailed to Mexico with a trunkful of images of the Madonna. He entered fallen Aztec cities bearing a banner of the Virgin Mary nicknamed *La Conquistadora* ('the conqueror'), a tradition that would be taken up by conquistadors and missionaries from Argentina to New Mexico. Their Amerindian adversaries were only too aware of the power the conquistadors invested in holy images and they often attacked or profaned them as a way of routing the missionaries or casting spells on the settlers. Some approaches were even more elaborate. In the Paraguayan back country, the seventeenth-century religious leader Guyraverá even set up mock chapels and anti-missions, where he performed mock masses with altars and manioc-cake Eucharist wafers (made from the pulp of a tropical plant), capitalizing on the Guaraní religious ability to outmanoeuvre an enemy by taking on his attributes.

On the other hand, Amerindians and African-Americans gained solace, power and a sense of identity from the carved and painted saints they made for their churches and houses, drawing on their own traditions of the power of imagery, even if the images they used derived from a European religion. The Guaraní sculptors of Paraguay called themselves 'saint-makers' because they believed that only someone gifted with religious visions could make sculptures of saints and that the image became an extension of the presence of a deity, both Christian and indigenous (see 113). Frequently non-Europeans carved the facial features or coloured the skin of a saint to resemble their own, as with the saints of Chiloé, with high cheekbones and muscular upper bodies, carved by Huilliche sculptors. Scholars have long believed that many Amerindians focused on the imagery of Christ's Passion as a metaphor for their own suffering under the colonial yoke. Elsewhere indigenous people added motifs or symbols from their own pre-Christian faiths, providing the works with a visual shorthand that related to their own spirituality (see Chapter 2). Some of these 'indigenous' features, however, were introduced by European missionaries concerned with making Christian imagery accessible to their congregations.

It is important that we acknowledge how deeply works of art were woven into the fabric of people's daily lives. As we usually see these sculptures, paintings and other objects in the sanitized setting of a museum or as pictures in a book, we tend to overlook their social and religious context. They originally formed part of a larger whole, whether the decoration of a church or house, or the personal adornment of a man or woman; they were lodged in altarpieces, attached to walls, or carried about in processions or on travels. People worshipped or meditated in front of statues or paintings of the saints, touching and anointing them, dressing them in clothing and adorning them with golden crowns or silver frames. People wore embroidered fabrics or used them to decorate their homes or altars; they ate from ceramic vessels and they used silver objects to adorn the Sacred Host, impress a dinner guest or light their way in a mine. An image of a saint was often as powerful a symbol of community identity as any modern flag or coat of arms, a fundamental association with place that is irredeemably lost

when the statue or painting is taken out of context. We can never fully understand a work of Latin American colonial art without keeping these original associations in mind.

The earliest buildings and art works in the Iberian empires reflected the artistic styles of Spain and Portugal at the time. These were remarkably varied, as no single national style had yet emerged in either country. They included the Gothic, an international medieval style whose architecture was typified by rib vaults, pointed arches and delicate tracery windows, and whose sculpture and painting were tinged with startling realism and bright polychrome colouring. Flanders was one of the late-Gothic cultural capitals and it had a particularly powerful influence over Spain and Portugal. Another architectural style seen in the earliest buildings in colonial Latin America is known as Plateresque. Literally meaning 'silversmith-like', it is a style of flat architectural ornament that developed in Spain in the first half of the sixteenth century and is formed of clusters of elaborate, intricate, often floral decoration. Gothic and Plateresque appear side by side in the earliest church in the Americas, the cathedral in Santo Domingo (2).

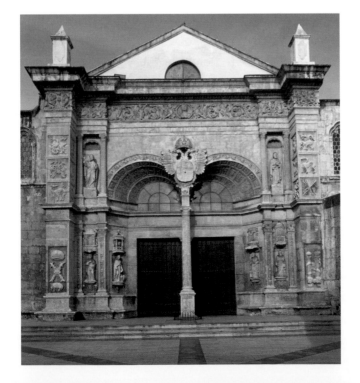

2
Rodrigo Gil and others, Cathedral, Santo Domingo, Dominican Republic, begun 1512

Begun in 1512 by teams of Spanish architects and masons, the church
has a ceiling of Gothic rib vaults on the interior while decorative details
on its façade derive from Plateresque models – a contrast that reflected
the two generations of masons who worked on it. Latin American
colonial art was profoundly influenced by a kind of Islamic art current
in Spain before 1492. Between 711 and 1492, large parts of Spain
were ruled by Muslim conquerors from Syria and North Africa, who
established powerful dynasties in the southern cities of Córdoba and
Granada, spreading their culture throughout the peninsula. This so-
called *mudéjar* style is characterized by fiendishly difficult geometrical
patterns in inlaid wood and mother-of-pearl. Carpenters in the Yucatán
(in Mexico), Quito and Lima all excelled in *mudéjar* ceilings, which can
still be seen in the sixteenth- and early seventeenth-century churches
there (see 165). Throughout both continents furniture makers applied
the *mudéjar* technique to chests, writing desks and bible stands (see 194).

In the mid-sixteenth century, the arts of Spain and Portugal resembled
each other more closely, as they adopted the structural clarity and
classical sobriety of the Italian Renaissance. This shift to Renaissance
style began with architects such as Juan de Herrera (c.1530–97), the
chief architect to King Philip II of Spain (r.1556–98), and the Italian
Filippo Terzi (1520–97) in Portugal. Philip hired Italian artists such
as Federico Zuccaro (1542/3–1609) to adorn his colossal palace
and monastery at El Escorial (1563–82; see 78) and other Italians and
Italian-inspired Flemings worked elsewhere in Spain and Portugal. A
second wave of Italian influence arrived with Philip III (r.1598–1621),
whose favourite, the Duke of Lerma, brought to Spain the work of the
so-called 'reformist' painters of Tuscany. The duke acquired paintings
by artists such as Bernardino Poccetti (1548–1612), who emphasized
naturalism and clarity over artifice and complexity. He also favoured
fellow Tuscan Bartolommeo Carducci (Bartolomé Carducho in Spanish;
1560–c.1608), who had become a royal painter in Spain in 1598. Mean-
while, Portuguese and Spanish artists trained and worked in Italy,
beginning with the Spaniards Fernando Yáñez (1489–1536) and
Fernando Llanos (fl.1506–25) in the early 1500s and the Portuguese
Francisco de Holanda (1517–84) and António Campelo (fl.1540s–60)
in the 1540s. Many Spanish and Portuguese architects and artists were

also inspired by Italian engravings and printed books, allowing the new style to spread throughout Europe – and the Americas (see 61 and 132).

By the turn of the seventeenth century Renaissance style gave way to the Baroque, a more decorative, theatrical and emotive style that originated in Rome and was associated with the Catholic Church's response to the rising threat of the Protestant Reformation that began with Martin Luther's challenge to Catholic authority in 1517. Again, the style was brought to Iberia and the Americas through engravings and building manuals, as well as by actual artists and architects. The Baroque and its later progeny the Rococo, or 'Ultrabaroque' (*Ultra-Barroco*) as it is often called in Spanish America, would flourish on American soil – in some places right up to the early nineteenth century (see 161 and 134). In the eighteenth century, particularly in Brazil and the Southern Cone of South America (present-day Argentina, Chile, Paraguay and Uruguay), Italian influences were combined with a heavy dose of central European Rococo thanks to architects such as the Swabian Johannes Friedrich Ludwig (1670–1752), who established the style at the Portuguese court, and the Jesuit Franz Grueber (1715–after 1767), who built the Bavarian-style church of San Miguel in Santiago, Chile (1766). With the accession of the Bourbon monarchy in Spain (1700) the decorative arts of Spanish America also began to reflect the Rococo culture of Bourbon France, particularly that of King Louis XV (r.1715–74).

This book will investigate these styles and their variants in greater detail. However, one remark remains to be made about style labels in general. Almost all of the art and architecture of this book can be categorized on one level as belonging to the 'Renaissance' or 'Baroque'. Latin American colonial buildings and artworks used the stylistic and structural vocabulary of these European art movements, shared many of their ideologies and referred to the same models used in Europe. Nevertheless, it is dangerous to make too much of these labels in Latin America. Received terms such as 'Renaissance' and 'Baroque' are problematic even in the history of European art, as they were created after the fact and scholars disagree on their parameters. People continue to use them because they are convenient labels for large volumes of buildings and artworks and can serve as an indicator both of period

and of a group of agreed-upon stylistic features. However, the problem is more acute in Latin America, thousands of miles and many climatic zones away from the birthplace of these styles. There, art and architecture are characterized by what has been termed 'chronological anarchy'.

Owing to the great distances between Europe and the colonies, and the often greater distances between the far-flung regions of the colonies themselves, older styles often persisted decades and even centuries after they fell out of fashion in Europe, and styles from different periods mingled with an ease impossible across the Atlantic. In Latin America a church could be built from scratch in a combination of medieval, Renaissance and Rococo forms, and a Baroque vault could be later than one built in the Neoclassical style. In fact, one of the main differences between European and Latin American art has to do with what is often referred to as the 'centre' and 'periphery' (roughly, city and country), the two broad categories into which Latin America can be divided. Although European art production could also be divided between cultural centres and the rural hinterlands, the distances were greater in Latin America and the mixture of cultures more complex. Styles from Europe were transmitted relatively quickly to major metropolitan centres such as Mexico City or Salvador, Brazil, but took much longer to get to the back country, where other factors such as a greater presence of indigenous or African cultures and deep-rooted preferences for earlier styles had an impact on their reception. Another issue is the presence in Latin America of so many artists and architects who lacked formal training and knew a few quotations from a variety of styles which they used interchangeably. The speed at which a new style travelled also depended upon who was bringing it. Missionaries and parish priests had different priorities from those of professional artists or colonial aristocrats, and while a friar would be happy with a late Renaissance painting showing a biblical scene in the most basic and legible way, a marquis wanted to wow his guests with the latest fashions from Paris. Sometimes stylistic choices were made simply for climatic, economic or demographic reasons. Ultimately, the best label to use for the art in this book is 'Latin American', an admittedly vague term yet one that allows for the ethnic, cultural and stylistic diversity of the society that made it.

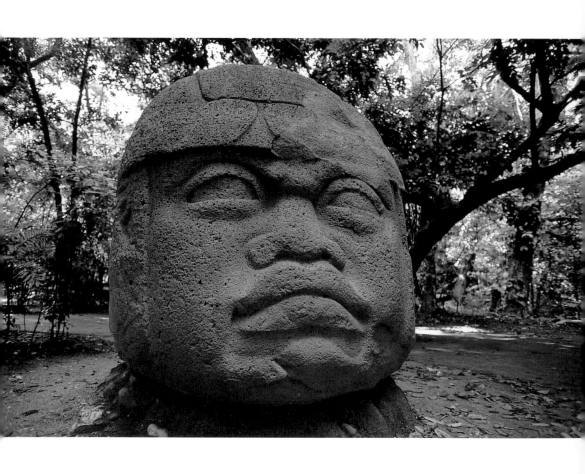

Few episodes in the history of the world evoke at once the awe, wonder and sadness of Europe's encounter with America. When the Spanish and Portuguese conquered what they called the 'New World', tens of millions of people occupying a land mass several times larger than Europe fell under alien kings and governments whose very existence they had known nothing about before. As these same powers had also made incursions into Asia and Africa, five of the world's continents were now linked together for the first time. For better or worse, ancient civilizations that had existed in isolation for centuries now participated in a new global culture of trade, conquest and religion. It was a time of cataclysmic change, especially for the indigenous peoples of the Americas, but also for their European conquerors. It was a time when ancient traditions and ways of life were altered or shattered, a time of treachery and exploitation, and a time of terrible plagues. But it was also a time of extraordinary cultural flowering, especially in the fine arts. The product of a unique collaboration between Europeans and non-Europeans of every walk of life, the art and architecture of the Iberian empires in America during the three-century colonial period is one of humanity's greatest and most pluralistic cultural achievements.

3
Olmec colossal head,
c.1000 BC.
Basalt;
h.2·85 m,
9 ft 4 in.
La Venta Park,
Villahermosa,
Mexico

In the year 1492, North and South America were home to advanced civilizations, with populous cities, stone architecture, elaborate forms of public ceremonial, written languages, and extraordinary literary and artistic traditions. Although they shared an origin in the steppes of northeast Asia, these Amerindian societies were vastly different from each other, spoke entirely different languages (hundreds of them, relating to ten different major groups) and in many cases knew nothing of each other's existence. America was a world unto itself, as varied as the Europe that 'discovered' it. Although Amerindians quickly spread over the entire hemisphere, from the Canadian Arctic to Tierra del Fuego at the southernmost tip of South America, the most complex

civilizations occupied only a small part of the two continents, a densely populated strip running from central Mexico, through Central America and into the northern and central Andes. The rest of both continents (places like Brazil, Argentina, the Amazon and the southwestern United States) were home to much less populous groups of nomadic or semi-nomadic tribes. Although these latter groups, including the Moxos of lowland Bolivia and the Mapuches of Chile, did not build great cities or found empires, their mythology, religion and culture were as ancient and complex as those of their settled counterparts, and they had flourishing arts traditions of their own.

Despite their extraordinary diversity, Amerindian societies had certain cultural features in common. These commonalities included religions in which religious specialists – popularly known as 'shamans' – gained access to the spirit world through dreams or trances and under the

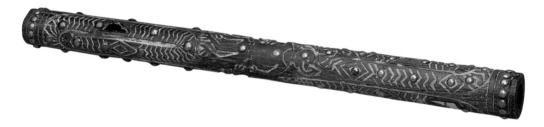

protection of animal patrons. Sometimes these visions were achieved by smoking tobacco, a plant indigenous to the Americas, as in this eighteenth-century pipe (4). Used by the Payaguá people of Paraguay, its decoration, featuring men who mutate into animals or mythic beasts, is typical of the Amerindian understanding of the cosmos. For Amerindian peoples the spirit world was a place of danger, but it was also the source of power and wealth, and the secrets learned there could be used to combat illness, poor harvests or inadequately stocked hunting grounds. The first peoples of the Americas also had a highly advanced understanding of the solar and lunar cycles. This celestial knowledge informed everything from their town planning, which in many cultures was based on the science of geomancy (divination by signs from the earth), to their advanced calendrical and mathematical sciences. Most Amerindian societies saw the universe as having three levels, including a celestial

upper world, the earth and the watery underworld of the dead. Religious specialists gained access to these worlds via the World Tree, a vertical *axis mundi* (link between the worlds) sometimes located at the centre of the world and sometimes at each of the four cardinal directions of the cosmos. In this depiction of the World Tree from a pre-Hispanic manuscript (*c*.1350) by the Mixtec Indians of southern Mexico, the tree serves as a conduit for human creation with its origins in a severed head or sacrificial 'seed' (5). The *axis mundi* was often combined with an opening in the earth, such as a cave or a subterranean spring, which served as a gateway to the underworld.

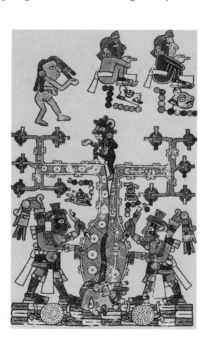

4
Payaguá
shamanic pipe,
18th century.
Wood.
Museo de
América,
Madrid

5
Mixtec World
Tree,
from the *Codex
Vindobonensis
Mexicanus I*,
c.1350.
Pigment on
deerskin.
Österreich-
ische
National-
bibliothek,
Vienna

Unlike in the Judaeo-Christian tradition, Amerindians believed that animals, plants and natural features such as water, mountains or rocks also possessed souls or spirits.

The first high cultures emerged in Mesoamerica (Mexico and Central America) and the Andes in the second millennium BC, including the Olmecs of eastern coastal Mexico (*c*.1200–600 BC) and the Chavín of Highland Peru (*c*.900–200 BC). Both these civilizations focused on large, open-air ceremonial complexes, with a temple mound shaped like a mountain or a pyramid fronted by a ceremonial plaza, outdoor

altars and a cluster of outbuildings, all arranged according to the four cardinal directions. Representations of animal spirits such as jaguars or serpents attest to the animist nature of these societies' religions, as seen in a stone relief carving from the sunken circular court in front of the Old Temple at Chavín de Huantar (c.400–200 BC), which shows the final stage of the transformation of a human religious specialist into a jaguar (6). Mesoamerican civilizations were unique in developing a ritualistic ball game, played on an outdoor court with rubber balls, which related to the movement of the sun and often resulted in the sacrifice of one of the players. These civilizations based their economy on subsistence agriculture, particularly native American crops such as

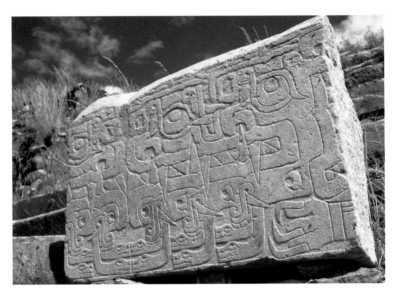

6
Stylized jaguar plaque,
c.400–200 BC.
Stone;
2·27 × 3 m,
7 ft 6 in
× 9 ft 10 in.
Chavín de
Huantar, Peru

7
Jaguar Temple,
Tikal,
Guatemala,
731 AD

maize, squash and potatoes, and they engaged in long-distance trade, which was carried out entirely by relays of human carriers, as they had no pack animals and used the wheel only for children's toys. The Olmecs introduced a sophisticated tradition of monumental stone sculpture, in particular strikingly naturalistic heads carved from basalt like this example from La Venta Park (c.1200–900 BC; see 3). Stone sculpture would thrive among the peoples of Mesoamerica up until the time of the Conquest. Although the Chavín also had an advanced sculptural tradition, their descendants in the Andes would excel more in the ceramic and textile arts.

The so-called 'Classic' civilizations – Teotihuacán, the Zapotecs, the Maya of Mesoamerica and their equivalents, the Nazca and Moche of the Andes – built on the foundations of these earlier cultures between about 100 BC and around 800 AD. Many scholars consider this period to be the apogee of Amerindian civilization, particularly in the arts and sciences. Focused on true cities, including not only open-air ceremonial centres but also residential quarters, these states were ruled by hereditary princes who held authority in both the secular and sacred worlds as they assumed many priestly functions. These rulers lived in spacious palaces arranged around

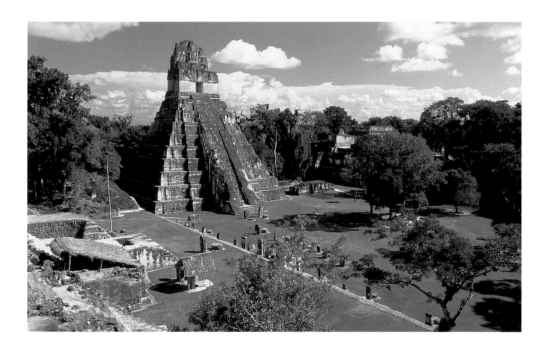

courtyards and were buried in elaborate tombs or pyramids, as at the spectacular Mayan Temple of the Giant Jaguar at Tikal in Guatemala (731 AD; 7), which was built over the tomb of King Hasaw Ka'an K'awil. Although urban planning was still based fundamentally on the four cardinal directions, the architecture of the cities became more complex and hierarchical, based on a grid of streets and plazas with multiple pyramids, ceremonial ball courts (in Mesoamerica) and astronomical observatories. The site of Teotihuacán, near Mexico City, is especially impressive.

It is dominated by giant stone pyramids such as the Pyramid of the Sun (the name is not original), which was over 200 m (700 ft) square and almost 60 m (200 ft) high and located over an ancient cave that served as a gateway to the underworld and a place of oracles. Palaces were arranged around open courtyards, their walls adorned with elaborately carved columns and friezes, and large-scale mural paintings. Their inhabitants may have ruled over a population as great as 200,000 people.

The Classic Maya (250–830 AD), in cities like Copán in Honduras and Tikal, developed an advanced and intricately carved figural sculpture, and narrative painted murals and ceramics. They were also the first and only Amerindian culture to establish a fully written language, based on syllabic glyphs that have only recently been deciphered, many of them surviving on painted ceramic vessels that preserve vivid descriptions of Mayan history, society and religion (8). The glyphs surrounding the seated ruler and figures of noblemen on this cylinder vase describe a palace ritual involving a sacrificial dance and they end with a discussion of the painting and polishing of a vessel and the signature of the artist Chuk-Hi Ti Chan. Maya artists were unique among pre-Hispanic peoples in signing their name. Their kings were believed to be supernatural beings and their highly stratified official religion, focusing on human sacrifice and ritual warfare, favoured elaborate public spectacle. The Classic Maya civilization dispersed sometime in the ninth century AD, as people abandoned the rainforest cities, probably for ecological reasons or because of warfare, and moved to the more arid Yucatán peninsula.

8
Chuk-Hi Ti Chan,
Maya cylinder vase with glyphs,
700–800 AD.
Ceramic;
diam.
16·4 cm,
6½ in.
Dumbarton Oaks Collection, Washington, DC

Although the Nazca and Moche civilizations of the coastal Andes in South America also built grand ceremonial centres – the Moche built terraced pyramids of adobe bricks reminiscent of those in Mesoamerica – their greatest legacy was in textiles and ceramics. The Nazca created the most brightly painted pottery in the Americas, featuring complex compositions of animals, plants and geometric patterns, and in an unprecedented variety of shapes, from panpipes to effigy jars. Geometrical patterns and animal and humanoid

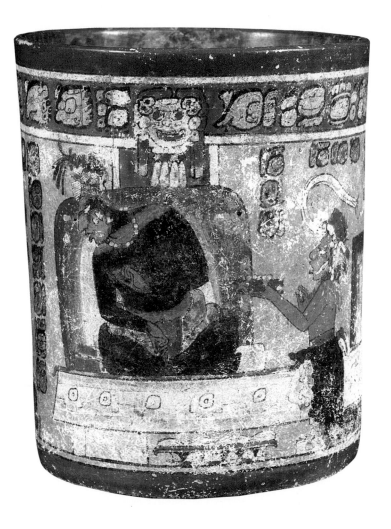

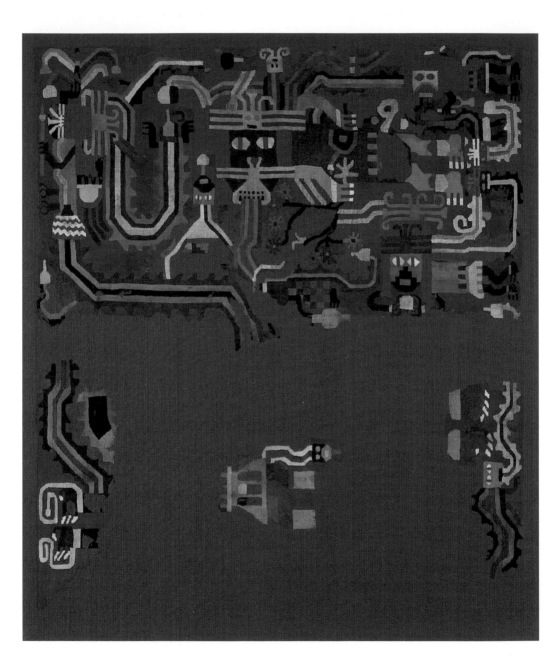

figures also dominated the production of Nazca textiles (a tradition inherited from their precursors, the Paracas people, c.600–175 BC), possibly the most sophisticated fibre-arts tradition in the history of the world. Tunics, mantles, shirts, wigs and other pieces such as this fragment of a hanging (9) from around 500 AD were made of wool and cotton fibres and woven on backstrap looms using a dizzying array of embroidery methods. Their most remarkable achievement was the extremely laborious discontinuous warp and weft technique (where neither the warp nor the weft pass uninterrupted across the loom but are made up of different colours linked together) – such a difficult method that the weaver has to erect a cumbersome

9
Paracas-Nazca transition textile, 200 AD. Wool; 69·9 × 113·6 cm, 27¹₂ × 44¹₂ in. Museum of Fine Arts, Boston

10
Moche stirrup-spout vessel depicting a laughing man, 400–500 AD. Ceramic. Museo Nacional de Arqueología, Antropología e Historia del Perú, Lima

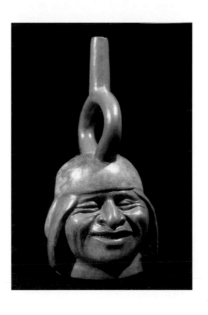

scaffolding of threads over the intersections of the colour warps to hold them in place while it is being made. The colours, including primary reds, yellows and blues as well as pinks and oranges, are strikingly vivid, even well over a thousand years later. Moche ceramics provide us with an even more remarkable body of work than their Nazca counterparts. Tens of thousands of highly burnished clay vessels survive, in a wide variety of shapes, some of them extremely virtuosic, and they are animated by an intense realism, a sense of movement and even of humour. One of the key features of these vessels is the ingenious stirrup-spout (which serves both as a handle and a pouring

spout), allowing minimal evaporation in the hot, arid climate. Types include vessels featuring three-dimensional portraits of individuals, such as this laughing man, which allows great insight into the personality of the sitter (10). Others display scenes of everyday life from childbirth to fishing trips, and depictions of disease and deformities that are so accurate that medical historians use them today as evidence.

The civilizations encountered by the European conquerors date from a later era, when large empires ruled the day and the visual arts reflected a new emphasis on military symbolism. During the

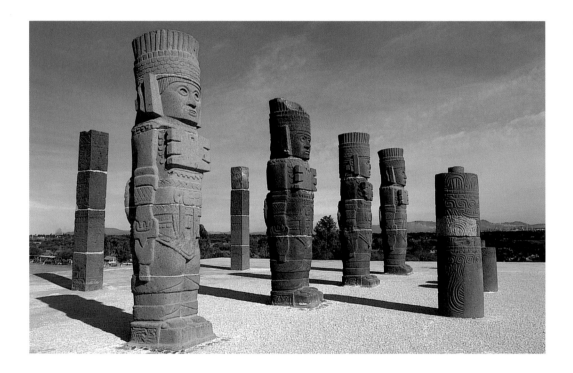

so-called 'Post-Classic' era, civilizations such as the Toltecs of central Mexico (750–1150 AD) expanded beyond their ethnic boundaries to subjugate neighbouring peoples and found multinational states. However, these were not empires in the European sense. Although the ruling powers sent army garrisons and sometimes settlers into conquered territory, the emphasis was on rendering tribute, and these vassal regions could keep their own élites and even rulers. Amerindian empires also facilitated trade, as far-flung areas were now part of the economy of large, centralized powers. By the twelfth

century, the proto-Puebloan people of Chaco Canyon, New Mexico, could participate in a trade network of macaws, turquoise and other luxury items extending as far as Central and even South America. The American empires also allowed for a freer exchange of artistic ideas, so that in the distant Yucatán carved temple guardians among the Toltec Maya (a late Mayan civilization conquered by the Toltecs c.900–1200 AD) bore a strong resemblance to these counterparts in Tula, the Toltec capital north of present-day Mexico City (11).

The Toltecs began as a warlike tribe of nomadic hunters, who swept into the basin of Mexico and adopted the civilization of the settled

11
Atlantean figures, c.900–1000 AD. Stone. Temple of the Morning Star, Tula, Mexico

12
Templo Mayor, Tenochtitlán, Mexico City, Mexico, 15th–16th century

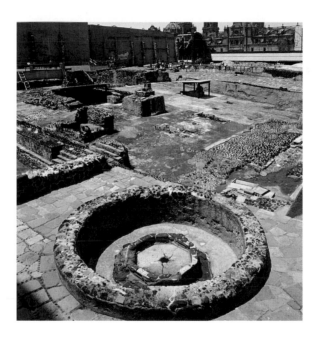

peoples. This pattern repeated itself with the Aztecs (literally, 'the people from the land of the herons'), a people from the west who reached central Mexico sometime around 1375, consolidated their power there and quickly expanded into the largest empire in North America. A Nahua (Nahuatl-speaking) people like the Toltecs before them, the Aztecs eventually ruled from the Pacific coast to the Atlantic, from central Mexico to Central America, with their capital Tenochtitlán (Mexico City) built on land they reclaimed from a lake bed. Laid out on a grid plan according to the four cardinal directions, linked to the

land by causeways and served by an aqueduct, Tenochtitlán had
a population of as many as 150,000–300,000 people. Tenochtitlán's
monumental stone architecture included a main temple precinct
(recently excavated) and the adjacent but separate palace of the Aztec
rulers (12). The city had a bustling economic quarter called Tlatelolco
which featured a vast outdoor market with produce from the four
corners of the empire. The Aztec system of tribute from subject
states focused on the need to obtain human sacrificial victims;
these were sometimes acquired through ritual warfare known as
'flowery wars', fought by jaguar and eagle knights, the élite warrior
cults of the Aztec regime. Although they borrowed the style of
their arts and architecture from their predecessors in the region,
the Aztecs were particularly masterful carvers and their stone figural
sculpture, with its deep, bevelled carving and geometric symmetry,
is one of the greatest artistic legacies of pre-Hispanic America.
The monumentality and emphatic three-dimensional character

13
Quetzalcóatl,
c.1440–1521.
Green
porphyry;
h.44 cm,
17⅛ in.
Museo
Nacional de
Antropología
y Historia,
Mexico City

of Aztec sculpture is captured in this green porphyry sculpture
of the feathered serpent god-king Quetzalcóatl (c.1440–1521; 13),
who is engulfed in a sensuous pattern of plumage. Other art forms
flourished as well, especially picture-writing, which recorded
proper names, places and dates using boldly outlined glyphs, but
which could only be read with the help of a knowledgeable reciter
because it did not record complete thoughts as with the Maya.
Only fragments of Aztec writing survive, primarily in early post-
Conquest manuscripts such as this History of the Chichimec Indian
Nation from the Codex Xolotl (14), painted by the Nahua convert
Don Fernando de Alva Ixtlilxochitl (1578–1650), and the Founding
of Cuauhtinchan (c.1578; see 33) from the Historia Tolteca-Chichimeca,
which are characterized by bold black outlines, crouching figures
in profile and a tendency to spread glyphs and other symbols evenly
across the page without their overlapping. Aztec books, including
religious works (such as almanacs), historical chronicles and practical
manuals, were painted on screenfold scrolls (long scrolls that fold
together like a concertina) of deerskin or fig bark. Another art
form at which the Aztecs excelled was that of feather mosaics, a
painstaking craft that produced hangings, clothing and other items

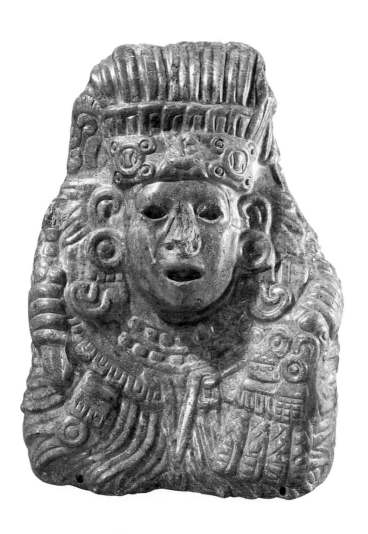

14
Don Fernando de Alva Ixtlilxochitl, History of the Chichimec Indian Nation, from the *Codex Xolotl*, c.1542. Ink and pigments on cotton paper; 42 × 48·5 cm, 16¹⁄₂ × 19¹⁄₈ in. Bibliothèque Nationale, Paris

using the brilliant feathers of exotic birds kept in special aviaries
or imported from distant lands.

In South America, the Inca state (c.1427–1532) became the largest
empire in the Americas, extending from Ecuador to Chile and
Argentina. With their capitals at Cuzco and later also Quito, the
Inca rulers maintained contact with their far-flung empire through an
extraordinary system of paved roads, and made their Quechua language
the civilization's lingua franca. Although they also lacked a complete
written language, the Incas kept records through rows of knotted
and coloured strings called *quipus*, an alternative form of literacy
that similarly employed professional readers. Through differentiations

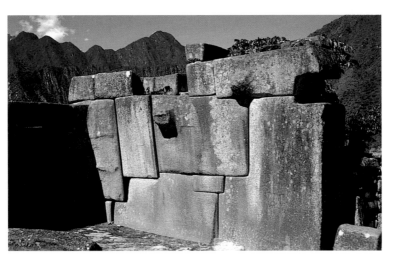

15
Detail
of masonry
from ritual
structure,
Machu Picchu,
Peru,
1450–1530

in knot type and position, as well as fibre colour, the Incas were
able to encode a prodigious amount of information ranging from
astronomy to history and poetry. Their greatest achievements
were in diametrically different media. One was their stone archi-
tecture, built without mortar using giant, often multifaceted blocks
that bulged outwards and were so tightly stacked that it is impossible
to insert a razor blade between them. Such buildings, seen at
Sacsayhuaman (before 1532) and Machu Picchu (1450–1530; 15)
possess a solidity and sculptural grandeur that makes all decoration
superfluous. Textiles known as *qompi* or *cumbi* (fine cloth), were another
of the Incas' greatest achievements, particularly the tunics worn by

the nobility, such as this *uncu* (male tunic; 16) of interlocked tapestry from *c*.1476–1534, whose intricate, chessboard-like patterns spoke of rank and familial ties. The most élite textiles were those made by men and women who had been chosen for religious service and they learned their traditions in a secretive and rarified atmosphere. The Incas worshipped a creator god Viracocha and his progeny the Sun, Moon and other celestial beings. Their worship focused on phenomena like thunder and rainbows as well as natural forms such as rocks or hills

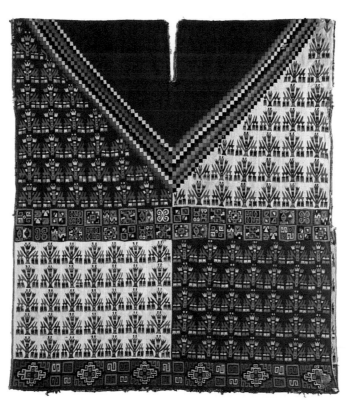

16
Inca period
uncu (male
tunic),
c.1476–1534.
Camelid fibres
Museo de
América,
Madrid

called *huacas*. Consequently, the figural arts were not as important to them as they were among the Aztecs, although some fine naturalistic portrait sculpture survives, as do numerous intricate silver and gold figurines of people and animals.

Although these Native American worlds were forever changed by the events that unfolded after 1492, and their people were decimated through disease and other hardships, Amerindian cultures continued to thrive under colonial rule. Despite having to make profound changes

and adaptations to fit into their new Euro-Christian context, Amerindians still spoke their own languages, practised their own religions and made works of art derived from their own traditions. Even today, Guaraní is an official language in Paraguay with a flourishing contemporary literature, the Puebloan peoples of New Mexico still perform ritual dances every year to bring rain and fertility from the heavens, and Mayan priests teach traditional forms of medicine to their disciples. Nevertheless, Amerindian cultures after the Conquest were not preserved like a hothouse flower, withheld from the events of history and kept in a primordial pre-Hispanic state. Dynamic and active reflections of a people, they transformed and evolved with the times, borrowing and exchanging ideas with their European overlords and taking part in contemporary culture.

The Europeans first came to America by mistake. The incentive that drove the Spanish and Portuguese to travel thousands of miles into the unknown vastness of the Atlantic Ocean was another continent altogether: Asia. Since the time of the Crusades, spices, ivory, precious metals and other luxury items from Asia and Africa were controlled by Muslim powers in the eastern Mediterranean, keeping prices high and making such products scarce in Europe, where they were monopolized by the great Italian trading cities of Venice and Genoa. Beginning with Portugal, the Iberian nations sought direct access to these riches by bypassing Muslim-controlled territory. The Portuguese explorer Bartolomeu Dias made a series of exploratory trips to the coast of North and West Africa under Prince Henry the Navigator, and finally rounded the Cape of Good Hope in 1487. Dias paved the way for Vasco da Gama's first voyage to India in 1498, the first time a European had reached Asia directly by sea without going through the Mediterranean. Soon afterwards, on his way to India, the Portuguese captain Pedro Alvares Cabral landed for the first time in Brazil (1500), which became a convenient stopping point between Lisbon and Asia.

Meanwhile, Portugal's Iberian neighbour was jealous of these successes. Even before the kingdoms of Castile and Aragon united (1479) to form modern Spain, Queen Isabella of Castile commissioned the Genoese explorer Christopher Columbus to find an Atlantic passage to Asia.

Between 1492 and 1504, Columbus, who had been turned away by the Portuguese king John (r.1481–95), would make five voyages to America in Spain's name, both in the Caribbean and to modern-day Panama. While it would take several years before it dawned on the Spanish that they had not yet found a western passage to Asia (Columbus thought he had landed in Japan and named the indigenous people 'Indians'), Portugal and Spain had now both entered the fray as direct competitors, and the pope was compelled to step in to divide their territory. Drawing boundaries was especially important as the exploratory phase was now over and both nations were beginning the long and slow process of colonization and evangelization.

In Pope Alexander VI's (r.1492–1503) Bulls of Donation of 1493, the year after Columbus's first voyage, the Catholic Church entrusted the Spanish Crown with the Christianization of America, leaving Africa and Asia to Portugal. The line of demarcation was more substantially sketched out for both sides in the Treaty of Tordesillas of June 1494, when the pope drew a boundary in the Atlantic from pole to pole 370 leagues west of the Cape Verde Islands. The Spanish were given responsibility for everything west of that point, and the Portuguese everything east of it. Both nations soon differed in their interpretation of that boundary, which was why Portugal slipped in Brazil on the grounds that it extended sufficiently to the east, as seen in this 1519 map (17) by Lopo Homem-Reineis (d.1565), and why the Spanish pushed the westward boundary across the Pacific to take the Philippines in 1565.

17 Overleaf
Lopo
Homem-
Reineis,
map of Brazil
from the *Atlas
Miller*,
1519.
Pigments on
parchment;
42 × 59 cm,
16½ × 23¼ in.
Bibliothèque
Nationale,
Paris

By the first decade of the sixteenth century, when Michelangelo was still a young man, the colonization of the Americas had begun. Lisbon and Seville became the exclusive ports for ships going to the Indies from Europe for much of the colonial period, and these cities would have a profound impact on the culture of the colonies. By 1496 Spanish missionaries and colonists were already permanently settled in the Caribbean, especially the island of Hispaniola, divided today between Haiti and the Dominican Republic. The Portuguese worked just as quickly. Between 1505 and 1515, viceroys Almeida and Albuquerque established the Portuguese mercantile empire in Asia by founding settlements in places like Goa, Ceylon (Sri Lanka) and

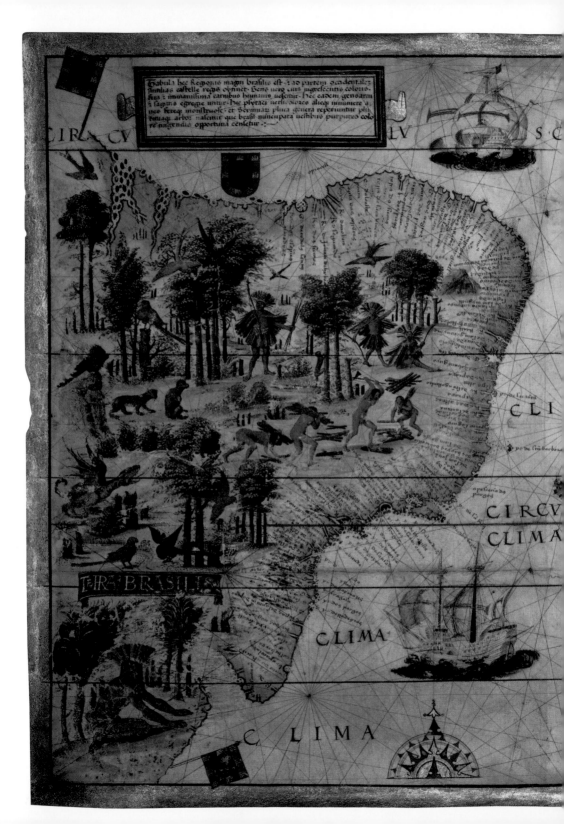

Habula hec Regionis magni brasilis est: ad partem occidentalez similias castelle regis obtinet. Gens uero eius ingrescentis coloris: fus: t immanissima carnibus humanis uescitur. Hec eadem gens arcu t sagitis egregie unitur. hic plurici uerbi oluaes alietq innumere a uer feteq monstruose: et Seymias plura genera reperiuntur phi tinietq arbos nascitur que brasil nuncupata uestibus purpureo colo re tingendis opportuna censetur:

CIRA CV LV SC

CLI

C
P de lã barbos

apstcaria do
pargos

CIRCV
CLIMA

TERRA BRASILIS

CLIMA

C LIMA

V I NOC CIAL IS,

OCCEANYS

MA PRIM VM

LVS CAN CRI

SECV N DVM

TERCI VM

QVAR TVM

Malacca in present-day Malaysia, and they began exploring the coast of Brazil and harvesting the native brazilwood. But the most dramatic moment was still to come.

Until now, most of the Amerindians encountered by Europeans were nomadic or semi-nomadic peoples who lacked a political organization beyond the local level and explorers dismissed them as 'naked savages'. This situation changed dramatically in 1519, when the Spanish officer Cortés sailed from Cuba to the Yucatán and found that he had landed at the easternmost extremity of a great empire of twenty million inhabitants that extended to the Pacific. The European discovery of the Aztec state and its subsequent invasion and conquest by 1521, depicted vividly in a seventeenth-century Mexican oil painting of The Conquest of Tenochtitlán (see 87), sent shock waves throughout Europe. Here was a great civilization, with stone cities, monumental religious buildings and a pictographic written language. It also had an emperor, Moctezuma II (or Montezuma; r.1502–20), whom the Spanish could easily equate with their own Charles V (r.1516–56). More importantly perhaps for a Europe in thrall to its classical past, they were an ancient civilization. Although the Aztecs themselves had only been in Mesoamerica since the fourteenth century, they were part of a cultural lineage that went back to before the time of Christ and were very conscious of this heritage. Cortés only succeeded in his conquest because he was able to secure alliances with tribute peoples, such as the Tlaxcalteca, who bore a grudge against their Aztec overlords.

Similar revelations soon followed that of Cortés. In 1524, the Spaniard Bartolomé Ruiz made a reconnaissance mission south from Panama and discovered an Inca trading ship laden with treasure. Acting quickly on this news, the adventurer Francisco Pizarro led a band of Spanish soldiers to Peru in 1531, where they encountered the even greater Inca Empire, whose society and culture equally astonished its conquerors. Thanks to their mountainous homeland in the upper Andes, the Incas managed to stave off the Spanish longer than their counterparts in Mesoamerica. Although the capital of Cuzco was occupied and the Inca emperor Atawallpa executed as early as 1533, striking a powerful ideological blow to the people, a combination of hostile geography

and squabbles between the conquistadors meant that the conquest of Inca territory was not secure until 1581. Even afterwards the cultural conquest was never as thorough as elsewhere in Latin America.

The European conquerors and missionaries arrived in America during the height of the Renaissance. This cultural movement, which began in Italy and was refracted through Spain and Portugal, shaped their world-view and gave form to their first art and architecture in the New World. In Europe the Renaissance meant a new interest in empirical knowledge and also a return to antiquity and the intellectual and literary movement known as humanism. This fascination with antiquity also signalled a desire to evoke the purity and glory of a classical Golden Age. A similar utopianism, coupled with religious fervour, fuelled the Spanish and Portuguese advances into the New World, a region that many saw as a survivor from purer times, ripe for civilization and indoctrination. In a way that is difficult to understand today, the conquerors and missionaries were able to reconcile this idealistic vision with much more profane desires for adventure,

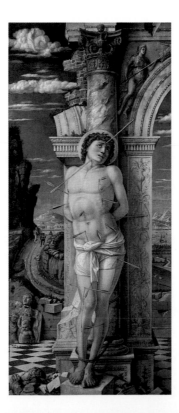

18
**Andrea
Mantegna**,
*Martyrdom of
St Sebastian*,
1457–8.
Oil on panel;
68 × 30 cm,
26�'t × 11¼ in.
Kunst-
historisches
Museum,
Vienna

commercial gain, gold and conquest. Likewise, Renaissance artists strove towards a classical idealism in the visual arts, which they founded in pictorial realism. They were especially concerned with anatomical accuracy in depicting human figures and painters were preoccupied with recreating the third dimension through spatial illusions and shading. Many of these traits are seen in the *Martyrdom of St Sebastian* (1457–8; 18) by the Italian artist Andrea Mantegna

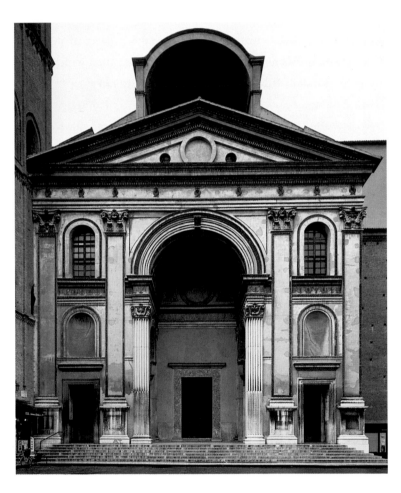

19
Leon Battista Alberti, Sant'Andrea, Mantua, Italy, designed 1470

(1430/1–1506), including a subtle modelling of the main figure, the use of a panoramic landscape to suggest distance, and a nod towards antiquity with the Roman relief fragments and Sebastian's pose. Architects also sought a return to ancient models, and the architecture of the period was composed of elements taken from Greek and Roman temples: components such as columns and pediments, which were

as easily reconstructed in the Americas as they had been in the far-flung reaches of the ancient world. Here, in the church of Sant' Andrea in Mantua by Leon Battista Alberti (1404–72), a Roman-style triumphal arch serves as a façade, alluding to the spiritual conquest of Christianity (19). This same motif became a powerful metaphor for Christian victory in the New World.

The Spanish and Portuguese conquerors transplanted these new forms and principles to the Americas. Thus, the Aztec capital of Tenochtitlán was rebuilt in 1521 as Mexico City on an ideal grid plan with buildings based on Italian and Spanish Renaissance building manuals, signifying what the conquerors felt to be their right to rule: an administration based on European concepts of moral virtue and rational thought (see Chapter 3). Likewise, the earliest mission churches in the Lake Titicaca region of Peru were even more strictly classical in style than those of Spain or Portugal, demonstrating that Renaissance ideals could be a more potent mark of legitimacy overseas than in the homeland (see Chapter 5). Even in the seventeenth and eighteenth centuries, when newer, more exuberant styles such as the Baroque and Rococo blossomed in church architecture, Renaissance classicism persisted in the palaces and fortresses of the imperial government, proclaiming an authority redolent of ancient Rome. In many ways the Americas were a showcase for the aspirations and hopes of European peoples who felt their own society to be decrepit and corrupt. In rectifying their own past, however, they showed scant concern for the aspirations and hopes of the people who already lived there.

Before the age of exploration and conquest in the late fifteenth century, Europeans divided the world into Christians and 'infidels', Good and Evil. This binary conception persisted for almost two centuries after the time of Columbus. The 'infidels' were primarily the Moors (Muslims). The Crusades in the Middle Ages (eleventh–thirteenth centuries) had been Europe's response to the rise of Islam in the Middle East and North Africa, and the later conquest and Christianization of America and parts of Asia were a direct extension of the Crusader mentality – after all, it was to circumvent the Muslims that the Iberian powers first encountered the Americas. Spain and Portugal were

themselves ruled entirely or partly by Muslim leaders from 711 AD until 1492. In Spain the Crusader spirit manifested itself in the *reconquista*, the reconquest by Christian forces of those regions under Islamic control, ending with the fall of Granada. The conquest of the Americas began on the heels of the *reconquista*, in Spain's case quite literally, since Granada fell in 1492, the same year Columbus made his first voyage. Small wonder that when a ragged band of Spanish adventurers first set eyes on an Inca temple in the sixteenth century they called it a 'mosque', and when missionaries in Mexico built their first churches for the Nahua Indians they sometimes used the design of the Great Mosque of Córdoba (begun 784 AD; 20), with its forest of columns, partly in the naive belief that it would be more familiar to the new converts.

Europeans had an unrealistic view of America because it was something completely new. When Europeans came into contact with Amerindians, a people totally isolated from the Eurasian world recorded by the classical geographers, it took them a very long time to realize the enormity of the encounter. Europeans stubbornly held on to the belief that the social norms of all people were universal. This need to find cultural unity led many to make connections with their own past, so that the Aztec and Inca empires were ceaselessly related to ancient Rome and Egypt and the peoples of the Americas were held to be one of the ten Lost Tribes of Israel. It also meant customs that differed from European ones – especially religion – were seen as errors by a culture in need of correction. Yet, despite this blinkered view of the world, the problem of how to deal with this new 'Other' became a major ethical question that occupied the Spanish (less so than the Portuguese) government and intellectual community for most of the sixteenth century.

The Spanish were the first to examine the legalities of how to approach and govern Amerindians, leading to a famous debate over the nature of the inhabitants of the New World that had repercussions for future encounters with non-Europeans around the globe. The Spanish government was especially concerned with the ethical questions of conquest. How could they justify enslaving Amerindians and declaring

20
Great Mosque,
Córdoba,
Spain,
begun 784 AD

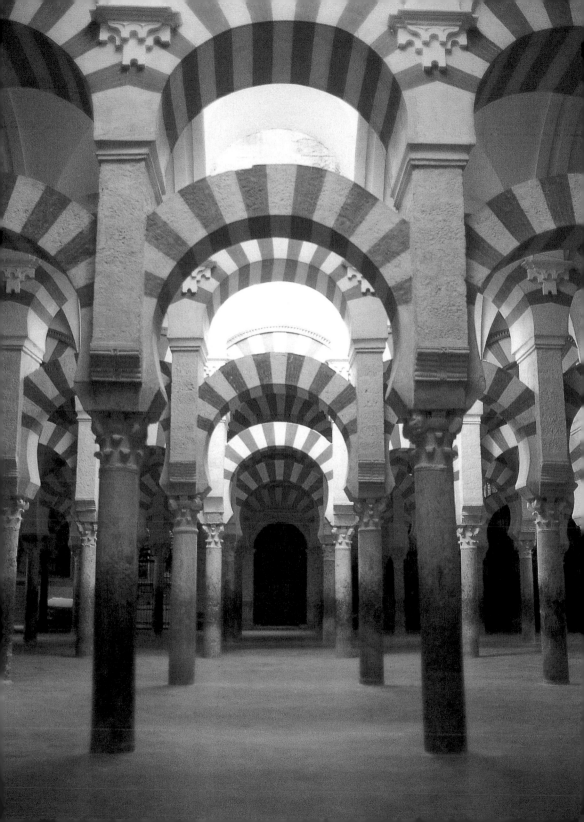

war on non-Christians with the purpose of converting them? Spain's legal fastidiousness had little impact on how the conquerors and colonists actually treated the indigenous people, as many of them were merely interested in exploiting the human and natural resources of the new territories. These atrocities sparked calls for justice from missionaries working in the New World, such as the Dominican friar Antonio de Montesinos in Hispaniola, who declared famously in 1510: 'are these Indians not men?'

The Spanish monarchy was concerned enough to host a public debate on the matter of slavery in the Castilian capital of Valladolid in 1550–1 between the Dominican missionary Bartolomé de las Casas and Juan Ginés de Sepúlveda, a leading Aristotelian humanist from Córdoba. The protagonists represented the two camps into which most European intellectuals had grouped by the middle of the sixteenth century. The first were against forced Amerindian labour and defended cultures such as those of the Aztecs or Incas as being equivalent to the civilizations of the ancient Greeks or Romans. The other had a crusader attitude towards non-European peoples; they believed that slavery and subjugation was not only justified but also liberating, and they used the Greek philosopher Aristotle to back them up. Aristotle believed that there were certain people who were naturally born to serve and those whom it was just to conquer, a doctrine that was later strengthened in the minds of Christians by the writings of the thirteenth-century medieval scholastic St Thomas Aquinas.

Las Casas, who unlike Sepúlveda had actually been to America as a missionary in Hispaniola and Guatemala, won the debate, but his radical ideas that Amerindian rulers should be restored and that Spain should rule as an 'Emperor over many Kings' never caught on. Most people in Europe felt that Amerindians should be treated with greater leniency, but as subjects of the Spanish crown and as Christians. This was the official response that had already been taken in the so-called New Laws of the Indies promulgated in 1542, which abolished Amerindian slavery. Most also believed that non-Europeans were equivalent to children, people who had fallen into error and required guidance. One tragic result of these debates, based on a ludicrous legal

distinction, was that Spanish colonists started using African slaves instead of Amerindian ones because they had been captured by the Portuguese and were therefore not Spain's legal responsibility. The first Africans to come to America arrived in 1510–11; over 200,000 were brought to Mexico alone in the seventeenth century and millions more were brought to Peru, Brazil and the Caribbean throughout the colonial period. The conditions suffered by Africans in the Americas – particularly in Brazil, where slavery was only abolished in 1888 – were arguably worse than the fate of the Amer-indians. Nevertheless, these men and women showed an astonishing resilience and would play a crucial role in colonial Latin American culture over the next three centuries.

Las Casas's ideas did leave a more positive legacy in the Iberian policy towards America and Asia in centuries to come. One was a new European respect for 'high' cultures such as the Aztecs and Incas who had cities and some form of written communication. Las Casas also changed how Europeans studied non-European peoples. One of his most important contributions to literature was his *History of the Indies* (written in 1588 but only published in 1875), the first empirical description of Amerindian societies, which was soon followed by a similar work on the Indians of Peru by the Jesuit missionary José de Acosta called *Natural and Moral History of the Indies* (1590). Both men grounded their research in the belief that Europeans had to understand Amerindian societies on their own terms by living among them, learning their languages and exposing themselves to their cultural traditions, a radical belief at the time.

The Iberian conquests were a strange mixture of avarice and religious zeal. Performing missionary work was central to Spanish and Portu-guese expansion. Once the conquistadors had done their work, the missionaries moved in to convert the newly 'discovered' indigenous people. The earliest missionaries came from the so-called mendicant (begging) orders, such as the Franciscans, Dominicans, Augustinians and Mercedarians. They were accompanied later on (in Brazil in 1549, elsewhere beginning in the late 1560s) by the Jesuits. The Jesuits were a new order (founded in 1540) of priests and lay brothers, but

not friars, primarily conceived to function in small groups over wide expanses of territory and they soon became the leading Catholic missionary order in the world. They were especially known for adapting to indigenous ways, a methodology that they borrowed from the Franciscans, and it helped them gain access to remote areas that other orders were unable to penetrate. Missionaries were especially affected by their era's spirit of utopianism. They saw their mission as equivalent to that of Christ's Apostles among the ancients (they often arrived in groups of twelve) and saw the indigenous peoples of the Americas as lost children, pure in heart but in need of

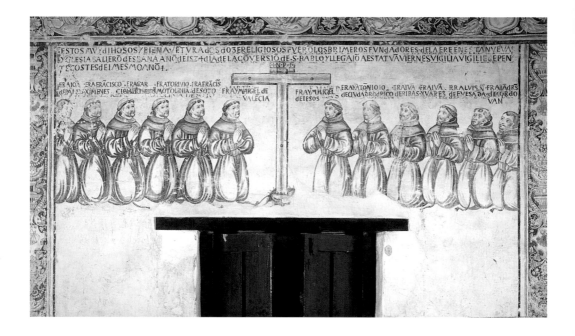

spiritual guidance. The first twelve franciscans to arrive in New Spain in 1524 were depicted in a wall-painting by indigenous artists at the Franciscan mission in Huejotzingo, Mexico (21), lined up like the Apostles at the Last Supper. The paternalistic attitude of the friars sometimes led to abuses. Some friars baptized thousands of 'converts' without teaching them the basic tenets of Christianity, especially in New Spain between 1524 and 1536 – on one day, the Franciscans baptized 15,000 Nahua in the town of Xochimilco, so many that the friars reportedly felt that their arms would fall off. Other friars, such as the Franciscan Martín de Valencia, who was born in 1466, beat their

charges into submission. Many missionaries treated the Amerindians as if they were mentally deficient. Europeans had such poor knowledge of indigenous languages that they assumed that the Amerindians were incapable of the abstract terms necessary for higher thought.

Not all missionaries were cut from the same cloth and missionary idealism also had a positive side. Some churchmen fought avidly for indigenous rights even when it placed them in political danger. Friars fought also to keep native communities separate from colonial centres, allowing Amerindians to preserve their unity and ancient traditions. As Chapter 4 will explore, some missionaries were inspired to adopt features of indigenous culture and led a push for education among Amerindians, not only training in crafts and practical trades but higher degrees that allowed some to rise to the top of the social ladder, publish books and travel in Europe.

21
Portraits of the first twelve Franciscan friars in Mexico, c.1570. Mural. Franciscan mission of San Miguel, Huejotzingo, Mexico

In terms of territory and authority, the Spanish and Portuguese empire could not have been more different, a disparity even maintained through the sixty years when both nations were under the same crown (1580–1640). Most obviously, although Pope Alexander VI (r.1492–1503) gave both nations comparable areas of responsibility, in reality the Spanish area was much larger. The Spanish ruled an empire on land, the Portuguese an empire on the sea. At its fullest extent, Spain held huge tracts of territory in Mesoamerica, the Andes, the Caribbean, the so-called 'Southern Cone' of South America, and the Philippines. Portugal, by contrast, held very little land in the interior of Brazil until the late seventeenth century, maintaining instead small fortified towns on the coast, often nothing more than a *feitoria*, or trading post. In its first two centuries of conquest and settlement, Brazil could boast no cities of the size of the Portuguese-Asian metropolis of Goa in India. Spain also had an easier time holding on to its conquests. Portugal lost its supremacy on the seas in the seventeenth century and was forced to give up many of its Asian possessions to the English and Dutch. The Dutch even captured northern Brazil between 1624 and 1654, after which they held on to Guiana (now Surinam) and Curaçao. In fact, although Portuguese Brazil would expand and prosper in the eighteenth century, Portugal was no longer a great seafaring power.

Both nations appointed viceroys or governors to rule in the place of the king over vast tracts of territory, men who would live in palaces and enjoy all of the pomp, splendour and intrigue of a royal court and who would be one of the most important patrons of the arts. The Spanish kings had already used this form of representation in European colonies such as Sicily or Naples, and the Portuguese had done so in Asia. The first viceroyalty in the Spanish Empire was New Spain (Mexico) in 1535, which also ruled over the Philippines after 1565. Peru was the second viceroyalty (1542) and held sway over South America until two new viceroyalties were carved out in the eighteenth century: New Granada (Ecuador, Colombia, Venezuela and Panama; 1718) and La Plata (Argentina, Paraguay, Uruguay and Bolivia; 1776). Smaller regions within the viceroyalties were called 'captaincies general', such as those of Venezuela and Guatemala. The Portuguese had a similar system, but as their attentions were focused on Asia, where a viceroy was installed in Goa in 1505, they only established a viceroy in Brazil in 1694. Before that, they had experimented with feudal captaincies (beginning in 1531), in which plots of land were awarded to 'donatory captains' and their descendants, and then they centralized the colony under a governor based in Salvador (1549). Although the Portuguese monarchy actually moved briefly to Brazil in the nineteenth century (1807–21), no Spanish king ever set foot on American soil.

The viceroys were usually military aristocrats, but they were also sometimes churchmen or lawyers. Although they represented royal power and were paid princely salaries, the Crown kept them in check to prevent them from using their post for personal gain or from declaring independence. Viceroys were responsible for collecting the 'Royal Fifth', or tax on revenues from the mines, as well as a share of treasures found in pre-Hispanic temples or shrines. They were also responsible for building mints near the mines and fortifying the coasts and ports. In the Spanish Empire, viceroys presided over the royal tribunals, or *audiencias* (such as the *audiencia* of Lima, 1544), and were also the head of the *cabildo*, or municipal council of the viceregal capital. They could not, however, draw upon funds in the colonial treasury without royal approval and they had no power over important appointments. The *audiencias* had some of their own governmental

and supervisory powers, and when the viceroy and the *audiencia* disagreed, the king did not always rule in the viceroy's favour. Nevertheless, the viceroys were the most important symbol of European rule. In the entire history of Spanish America, only four viceroys were born in America.

Secular entities were not the only ones answerable to the viceroy and to the Crown. Even Church government rested in royal hands. The Spanish and Portuguese kings managed the Church, including missions, by right of an authority granted by the pope beginning in the early sixteenth century and codified by Philip II in 1573. According to this law, the rulers of Spain and Portugal were empowered to appoint bishops, to license churchmen and control their movements, to intervene in matters of religion and spiritual jurisdiction, to collect tithes and even to approve the construction of religious buildings – an authority the Spanish kings did not even enjoy in most of Spain until the eighteenth century. Primary religious authority in the colonies was vested in the archbishops and bishops, who often lived in splendour in palaces with private libraries and art collections. On a village level the Church was represented by parish priests (secular clergy), who were directly answerable to the bishops. Together with these secular clergy were the religious orders (regular clergy), who were not appointed by the bishops and therefore enjoyed a certain degree of autonomy. In the cities they lived according to the rule of their order in giant monasteries and convents, and they operated universities and charitable foundations. Outside the cities they ran the missions, which were free of episcopal control because their communities were not considered fully converted. Taken together, these various church bodies were the most active art patrons in colonial Latin America. By the end of the seventeenth century the Catholic Church in the Americas could boast 70,000 churches and 500 monasteries, possibly the largest and swiftest building campaign in the history of the world.

The Spanish and Portuguese were most interested in parts of America that could be exploited for their precious metals. Sometimes, as in the optimistically named Río de la Plata ('river of silver') in Argentina, they looked in vain. But elsewhere they found unprecedented riches.

CIVDAD
LAVILLARICAENPERE

al de potochi por la chamina, es castilla roma es roma el papa
es papa y el rey es monarca del mundo y la señora maryste
cia es esendida y nuestra señora se guardada por los quatro
reys de las yngas y por el emperador ynga - agora lo pode
ra el papa de roma y nuestro señor rey don phelipe el terce
ro

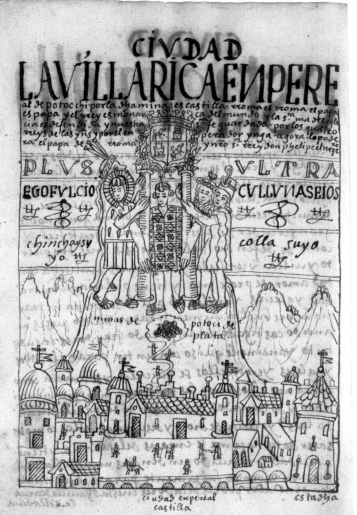

PLVS VLTRA

EGOFVLCIO CVLLVNASEIOS

chinchaysu colla suyo
yo

minas de potoci de
 plata

ciudad enpereal estadya
castilla

The most important was the silver mine of Potosí, founded in 1546 in present-day Bolivia, under the suzerainty of the viceroyalty of Peru, seen here (22) in a drawing by the Andean historian Guaman Poma de Ayala (1534–1615). Its centrepiece was the Cerro Rico, or 'rich hill', a mountain of silver ore that has been mined for over four centuries and even today looms like an open wound over the southern flank of the city (23). Potosí was a place of such astounding wealth and such unspeakable horrors that it defies the imagination. The second largest city in the world in 1600, Potosí produced so much silver that it flooded the European market and was almost single-handedly responsible for Spain's rise to pre-eminence in the world. It also meant that Latin American silver and gold objects, primarily altar frontals and

22
Guaman Poma de Ayala,
Rich Imperial City of Potosí, from *Nueva Corónica*, 1613–15.
11·5 × 20·5 cm, 5¹⁄₂ × 8 in (book).
Det Kongelige Bibliotek, Copenhagen

23
Cerro Rico, Potosí, Bolivia

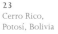

monstrances (containers for the host during the Eucharist), were among the most lavish and intricate in the world (see Chapter 7). But these riches carried a human price. The working conditions in Potosí were the grimmest in the Americas and they depended for the most part on Indian labour, exploiting a pre-Hispanic mode of migrant rotational work called the *mita* system. Under this system, indigenous communities were called upon in turn to provide labourers for public works for a fixed period of time and a fixed salary. The death toll from the mines was enormous, especially from overwork, but also from the various plagues, including smallpox, that ravaged the town. Similarly horrible mines existed in nearby Huancavelica (1566), which provided

mercury to purify Potosí's silver, as well as the silver mines of New Spain such as San Luis Potosí, Guanajuato and Zacatecas. In eighteenth-century Brazil, the gold and diamond mines of Minas Gerais (1693) and Matto Grosso (1720) brought about a similar combination of wealth and misery, with African-American slavery in the Brazilian back country fuelling Portugal's Golden Age at home.

The *mita* system was one of several ways Europeans exploited indigenous people. These methods were intended – ironically – to guarantee the spiritual wellbeing of the workers, but usually amounted to little more than slavery. First came the infamous *encomienda* system, introduced by Columbus into Hispaniola in 1499, and later spread throughout Spanish America. In a procedure similar to feudalism, colonists were given tracts of land called *encomiendas*, which included the people already living on them. In cases where the indigenous people were nomadic, they were forcibly settled into towns, a policy made official in the 1512–13 Laws of Burgos. The indigenous community was assigned to a colonist for the long term in return for spiritual guidance, protection and a small wage. This system began to be replaced in the second half of the sixteenth century by the *repartimiento*, by which smaller parties were divided among different colonists for shorter periods. In addition to these and other systems of exploitation, indigenous people were compelled to pay the king in goods such as agricultural produce and manufactured items, and later in cash.

In the Portuguese Empire, exploitation of the indigenous and African peoples was even more arbitrary and heartless. The Tupí-Guaraní Indians of Brazil were forcibly moved far from their homelands in the interior to live in shanty towns near colonial cities, where they served as convenient labour pools for Portuguese settlers. Indians in the Paraguayan hinterlands were regularly kidnapped in the seventeenth century by roving bands of slave hunters from São Paulo, who were called 'Mamelucos' after the Islamic rulers of medieval Egypt. However, the worst exploitation was reserved for the African slaves, 3·5 million of whom were brought to Brazil from various nations in West Africa before the abolition of slavery in 1888. Beginning in the sugar plantations of Bahia and Pernambuco in the sixteenth century and

culminating in the gold and diamond mines of Minas Gerais in the eighteenth, the institution of slavery was the basis of the Brazilian economy. Lives were brutal and short, with harsh working conditions reducing slaves' life expectancies to about seven to twelve years from the time of arrival in Brazil. Some slave owners worked their charges to death in the belief that it made economic sense to get all the work out of them in a few years and replace them with new recruits – a method later used in Nazi death camps. Escapees were punished by branding, amputation or death, and in 1755 the citizens of the town of Mariana introduced the custom of cutting slaves' Achilles tendons to prevent them from running away. Nevertheless, many African slaves were introduced into more humanitarian environments as domestics for urban households (aside from Brazil and the Caribbean, Lima, Nueva Granada and Mexico City all had substantial African populations).

Ironically, the institution most notorious for its policies of torture and punishment had comparatively little effect on the Amerindian or African populations. The Inquisition, or Holy Office, was established in Lima in 1569, in Mexico City in 1571 and in Cartagena in 1610. Although the Inquisition was never formally established in Brazil, beginning in 1591 the Portuguese Inquisition regularly sent commissaries to Brazil. However, contrary to popular belief, the institution had no jurisdiction over non-converted Indians, and even Indian and African Christians were punished much less frequently and more leniently than their Spanish and mestizo counterparts. The investigative office of the Catholic Church, the Inquisition focused instead on people of European descent and mixed blood, attacking Protestants, Freemasons, and apostate Jews and Muslims. These people were tried and often tortured and burned at the stake for 'heresy', or deviation from Catholic norms. Frequently the trials were trumped up to gain more wealth for the inquisitors. Only one Indian was burned at the stake in sixteenth-century New Spain and it caused such a public outcry that the incident was never repeated. On the other hand, the Inquisition also monitored real abuses and tried priests accused of mistreating their indigenous congregations.

Colonial forms of labour exploitation created constant tension between the colonists, who needed indigenous and African workers to turn a profit, and the missionaries, many of whom were genuinely concerned about the rights of native and African peoples. This was the kind of conflict that erupted in Hispaniola in the early sixteenth century, when Bartolomé de las Casas and Antonio de Montesinos made urgent appeals to the Spanish crown against the ill-treatment of Amerindians by Spanish settlers. In New Mexico, where the Spanish

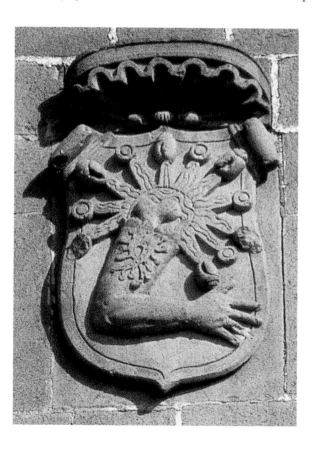

24
Aztec place glyph, incorporated in the façade of the mission church of San Agustín, Acolman, Mexico, 16th century

had a colony from 1598, the conflict between the missionaries and colonists over labour and tribute contributed ultimately to the bloody Pueblo Revolt, which drove the Spanish from the territory for more than a decade. On 10 August 1680, 17,000 Pueblo Indians representing more than twenty communities rose *en masse* to expel the Spanish from their lands – a rare example of such unified political activism in the colonial era. Incited by the bickering between the Spanish colonial

government and the friars over indigenous labour, and also by the friars' increasing conservatism on the missions, the Puebloans under their leader Popé attacked Spanish settlements, burned churches and ranches, and killed some 400 colonists, including twenty-one priests.

One way the missionaries kept Amerindians away from the mines and from paying tribute was through large-scale building projects on the missions themselves. Employing pre-Hispanic *corvée* labour systems that had been used to raise temples, mission building projects allowed Amerindians to devote their energies to creating their own living environment. Many indigenous communities, after they had been converted, considered their church as a symbol of civic pride and identity, and sometimes their architects proudly signed their names, such as the Nahuas Juan Gerson (named after a French theologian), who painted the vault of the church at Tecamachalco (see 45) in Mexico, and Francisco Juan Metl, whose signature adorns the sixteenth-century church at Cuitzeo in Michoacán. Elsewhere the community put its stamp on the church with a symbol of their village, as in the Aztec place glyph showing a severed arm with radiating streams of blood that was incorporated into the façade of the sixteenth-century church at Acolman, outside Mexico City (24). The image refers to the Aztec creation myth in which the first human being was carried by his arm from Lake Texcoco and deposited at Acolman, the very site of the Augustinian mission.

These mines and rich plantations helped create a world of wealth and privilege for the colonial élites, shown here (25) enjoying a royal festival in Chapultepec Park, Mexico City, in the eighteenth century. The extravagance of aristocratic lifestyles in the metropolitan areas such as Mexico City, Lima, Salvador and Rio de Janeiro at their height was staggering and the source of much jealousy in Europe (see Chapter 7). Dressed in imported silks and laces, and adorned with diamonds and pearls, élite men and women divided their time between urban palaces and country estates, both furnished with gold and silver objects, Asian ceramics and lacquers, English and French furnishings, and Middle Eastern carpets. During the height of the social season, they travelled to opulent balls and soirees in sedan chairs and

gold-plated carriages, attended by legions of liveried servants, and they
financed musical and theatrical entertainments that could last for days.
However, there was more to Latin American urban culture than pomp
and circumstance. These centres were home to some of the leading
intellectuals of their day, such as the Mexican poets Sor Juana Inés
de la Cruz (see 193) and Carlos Sigüenza y Góngora, as well as vision-
ary art patrons such as Bishop Juan de Palafox y Mendoza of Puebla
and Bishop Manuel de Mollinedo of Cuzco, who transformed their
two cities into the jewels of the New World in the middle of the
seventeenth century. The universities of the Americas, beginning with
Mexico City in 1553, Lima in 1574 and Cordova (Argentina) in 1613,
rivalled their counterparts in Europe and made crucial contributions
to the study of the American landscape, its languages and its peoples.

Although the wealth of élite Latin America was enjoyed by both
sexes and women such as Sor Juana were able to gain critical success
in a male-dominated field, Latin American women in general wielded
less power than their European sisters. The Iberian empires were
founded on conquest and missionary work, neither of which was
open to women, and in the early period very few European women of

25
The Royal Festivals of Chapultepec, 18th century. Oil on canvas; 1·75 × 5·4 m, 5 ft 9 in × 17 ft 8⅛ in. Banamex Collection, Mexico City

any kind travelled to the New World. It is estimated that of the 600,000 to 700,000 Spaniards to settle in the Americas in the sixteenth and seventeenth centuries, as many as ninety per cent were men. Consequently, most of the women in early colonial Latin America belonged to other races, a double mark against them in the eyes of European and *criollo* men – although this social distinction did not prevent Spanish and Portuguese men from interbreeding on an extraordinary scale, resulting in the huge *mestizo* components of both empires by the eighteenth century. In Brazil, there were so few women of European descent that the government published a decree in 1720 drastically limiting their freedom to leave the colony. Although the balance between white men and women evened out as the urban settlements expanded, the latter were still in the minority and could not enjoy the power of their husbands, sons or brothers. Nevertheless, women could secure great wealth and prestige through marital unions and were legally permitted to inherit titles. Women also formed lay religious sisterhoods called *sodalidades*, social groups that gave them a collective voice within colonial society. Women could gain even greater freedom and authority through widowhood. Widows had more

control over family fortunes, legal claims and territorial possessions than women whose husbands were still alive, and could leave important legacies in their own names as patrons of the arts.

Many of the European women who came to the Americas in the early colonial years were nuns. Such were the Franciscan Sisters of Santa Clara, who arrived in the sixteenth century. Although nuns were not allowed to work on the frontier mission areas where their mendicant and Jesuit brethren were learning how to adapt to indigenous cultures, they did play an important role in the cities. They cared for the sick and sheltered travellers, priorities which differed little from those in Europe. However, the life of a nun was not necessarily one of asceticism and selfless service. By the seventeenth and eighteenth centuries, nunneries could be as luxurious as an urban palace; such was the mammoth convent of Santa Catalina (founded 1575; 26) in Arequipa, Peru, a city within a city of luxurious private suites, calming courtyards and gardens, delightful fountains and picturesque passageways. Many daughters of wealthy families paid huge dowries to enter such nunneries where they were attended by legions of servants and became leading lights in society (see Chapter 7). Nuns of Sor Juana's class could hold court at a convent, receive visitors (including men), accumulate great libraries and collections of curiosities, play music and organize concerts, and even pursue scholarship and write poetry. However, not everyone could afford Sor Juana's lifestyle. Poorer women had far fewer options, and their only escape from marriage and a life of servitude was by taking refuge in hospices set up by pious patrons or confraternities for their lodging and protection.

Spanish and Portuguese colonial society may indeed have been the most diverse and cosmopolitan on earth before the nineteenth century. Latin America was home to the peoples and traditions of five continents: not only North and South America and Europe, but also Africa and Asia – the former, as we have seen, through slavery and the latter through immigration from the Philippines, China, Japan and India.

Despite the horrors of slavery, Africans in the Americas preserved their religion, costume and language throughout the colonial era. The most

26
Convent of
Santa Catalina,
Arequipa,
Peru,
founded 1575

celebrated cultural survival is Candomblé, a religion brought from Africa by the Yoruba and other West African peoples that continues to flourish today in Bahia (northeastern Brazil) with elaborate ceremonies featuring dancing and chanting in the Yoruba language. Santería, a syncretic Cuban faith that also derives from Yoruba religion, adopted Catholic saints as *orishas*, or African gods and goddesses. The greatest expression of African culture took place in the eighteenth century in places like Pernambuco and Minas Gerais, Brazil, where the Africans vastly outnumbered their white overseers. Africans

27
St Elesbão,
18th century.
Polychrome
and gilt wood;
h.120 cm,
47¼ in.
Super-
intendência
Regional/
Instituto do
Patrimônio
Histórico
e Artístico/
Ministério
de Cultura
(IPHAN),
Pernambuco

had their own neighbourhoods and worshipped in black churches with statues of black saints like St Ifigênia and St Elesbão (27), seen in an eighteenth-century polychrome wooden sculpture from Pernambuco in which the saint is triumphing over a white adversary. A remarkable number of Africans were able to buy their freedom. Some of them organized themselves into lay religious confraternities, such as the 'Black Brotherhood of the Rosary' in Ouro Prêto, which was wealthy enough to finance extravagant parades and other

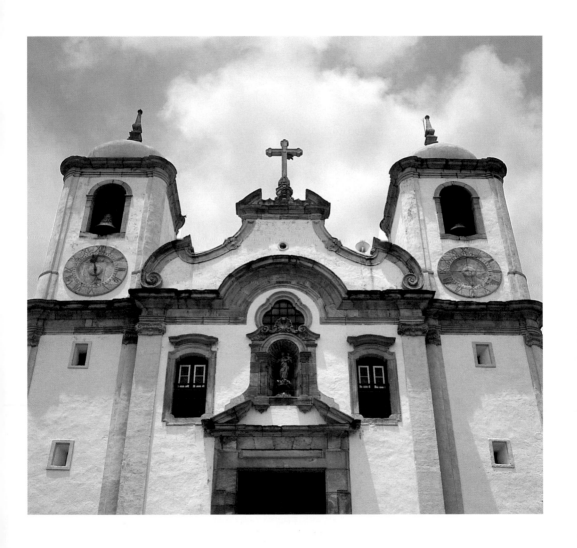

28
Santa Ifigênia
dos Pretos,
Ouro Prêto,
Brazil,
1733–80

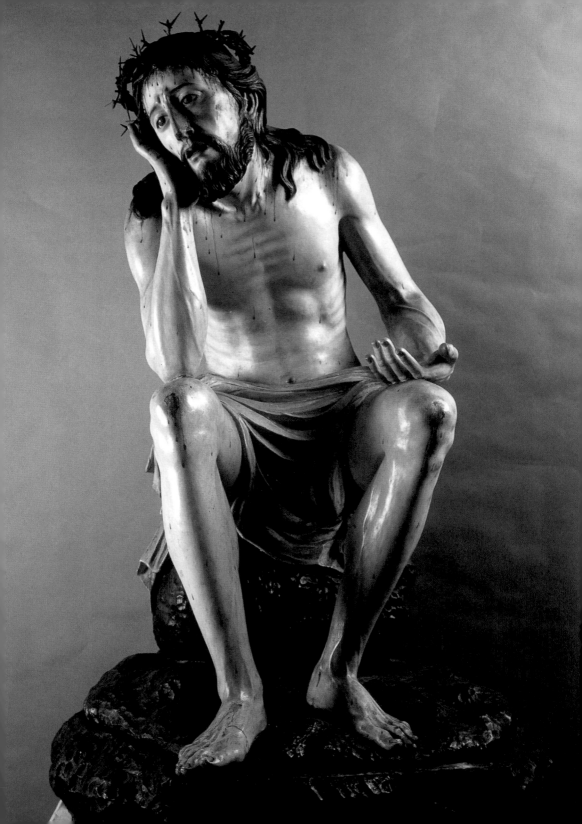

festivities. This black confraternity built the Baroque church of Santa Ifigênia dos Pretos (1733–80; 28), also in Ouro Prêto, entirely at their own expense. This church is associated with one of the most celebrated African leaders in Minas Gerais, Galanga, called 'Chico-Rei' ('Little King'; before 1700–74). A king in Congo, he was kidnapped with his entire tribe by the Portuguese in the early eighteenth century and sold to a mine operator in Ouro Prêto. Chico-Rei worked there as a foreman and eventually purchased not only his own freedom but also that of his entire people. After buying his own gold mine, Chico-Rei and his son Muzinga set up court in town as a royal family and financed lavish festivals on African holidays. Other slave groups were able to escape at great risk to their lives and form separate villages in the forest called quilombos, often made up of hundreds of inhabitants, which subsisted on agriculture and periodically raided plantations for new members. The most famous quilombo was at Palmares (Pernambuco), which had a population of 20,000 at its height and lasted through most of the seventeenth century. Its last ruler, Zumbí (r.1678–95), finally succumbed to the Portuguese only in 1695. Perhaps the most beloved African figure in the Americas was St Martin de Porres, born in 1579 to a Spanish officer and a free black woman of Angolan background, who joined the Dominican order in Lima and ministered to the sick and abandoned using his extraordinary knowledge of herbal medicine.

Asians reached the Americas on the famed trans-Pacific trade route of the 'Manila Galleon' that ran between Manila and Acapulco from 1565 to the early 1800s, an immensely important conduit for Asian products into Spanish America and Spain itself. The Parián (Chinatown) of Mexico City and also districts of nearby Puebla became home to communities of Chinese, Japanese and Indian immigrants, as they lay directly on the overland trade route, or 'China road', from Acapulco to Veracruz, where ships took Asian products to Europe. The Japanese and Chinese may even have organized themselves into craft ateliers, perhaps as early as 1618, although scholars have recently raised doubts about the veracity of these reports. Occasionally Asians in Spanish American towns would rise to prominence, as happened to Catarina de San Juan, an Indian immigrant who claimed descent from the Mughal emperor Akbar and lived as an extremely popular recluse and visionary in

29
Attributed to Esteban Sampzon, *Christ of Humility and Patience*, c.1788–93. Polychrome and wood, h.99 cm, 3 ft 3 in. Church of la Merced, Buenos Aires, Argentina

Puebla. Another key link between Asia and the Americas was the trade route between Goa in India and Salvador (and later Rio de Janeiro) in Brazil, a connection that brought Indians and possibly Chinese to Brazil and the Spanish territories of the Cono Sur. While most Asians who came to the Americas served humble roles as domestics and labourers, in eighteenth-century Buenos Aires a Filipino sculptor named Esteban Sampzon (fl.1780–after 1800) became one of the leading lights of the colonial art world of southern South America. Sampzon was probably of Chinese heritage, not only because he called himself 'Indio de la China' (an Indian from China) but also because the Chinese neigh-bourhood in Manila had been a thriving sculpture centre since the sixteenth century and was responsible for most of the art in the colony. Sampzon was in Buenos Aires from 1780 to 1800, where he lived at the monastery of Santo Domingo. Later, he lived and worked in Cordova, and at one point joined the military as the leader of a battalion of *mestizos*. His naturalistic and moving sculptures, such as a statue attributed to him, *Christ of Humility and Patience* (29) in the church of La Merced, Buenos Aires, still grace a number of the city's churches. The sculpture demonstrates an expert hand and a delicate sense of line that is also reflected in Filipino ivories (see 219). Especially noteworthy is the realism of the facial features, with parted lips and the intense expression in the eyes, enhanced – as was traditional in Latin American sculpture – by glass inserts.

In eighteenth-century Spanish America, colonial society's conscious-ness of its racial subdivisions bordered on obsession as intermarriage between the races increased. While status played a major role in this new fascination – the white ruling class felt threatened by the blurring of racial boundaries – it also reflected a general eighteenth-century interest in scientific taxonomy. The highest level of society was occupied by the so-called *peninsulares*, or those born in Europe, and the *criollos*, each of whom thought themselves superior to the other. Throughout the colonial period these two groups would vie for prominence and the independence movement of the early nineteenth century was largely a victory for the *criollos* (as was the independence of the United States a few decades earlier). Everyone else in colonial society was categorized as one of many *castas* (castes), mostly persons

30
Luís de Mena,
Casta painting,
c.1750.
Oil on canvas;
120 × 104 cm,
47¹⁄ × 41 in.
Museo de
América,
Madrid

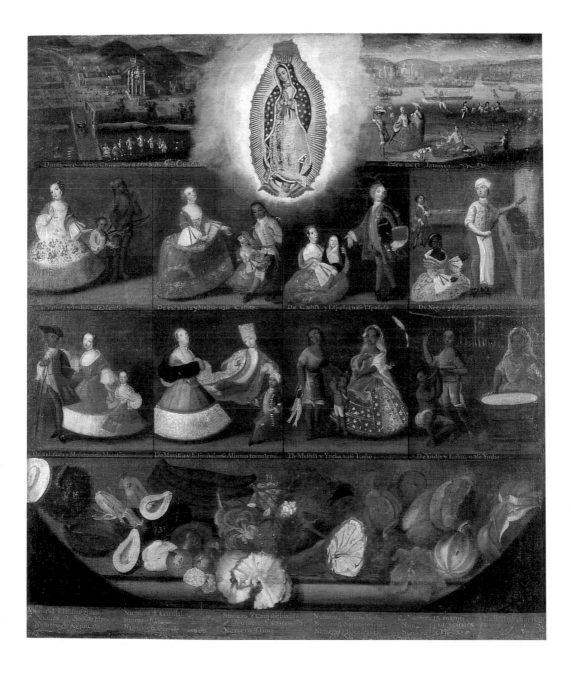

of racially mixed ancestry, a process that was immortalized in a curious fad for paintings that depict with zoological precision the different categories of race and ethnicity. In one of these so-called '*casta paintings*' (30) by the Mexican artist Luís de Mena, the Virgin of Guadalupe looks down over eight different categories of intermarriage in New Spain, represented by husband, wife and child, the fertility of their union reflected by a display of ripe fruit below. *Casta* paintings were more usually produced in sets of sixteen individual scenes, each depicting a man and a woman of different races with one or more of their offspring, and they were accompanied by a label identifying the resulting racial mix. The pictures begin with the 'pure' race of the Spanish, usually dressed in upper-class costume and engaged in activities that denote their higher status and this social status visibly diminishes as the paintings move on to the mixed races.

The names given to the different castes reflect colonial society's preoccupation with race. They included a person born of a Spaniard and an Amerindian (*mestizo*); a Spaniard and a *mestizo* (*castizo*); an African and a Spaniard (*mulato*); a Spaniard and a *mulato* (*morisco*); an Amerindian and a black (*zambo*), a Spaniard and a *morisco* (*albino torno-atrás*, or 'turn-back'); a *mestizo* and an Amerindian (*lobo*); and an Amerindian and a *lobo* (simply an *indio*). Similar race and status-consciousness existed in Brazil, where the African presence was much greater and interbreeding even more common. Despite this persistent sense of racial division, *mestizos*, Amerindians and African-Americans could rise to positions of prominence through education and wealth, and could hold positions of responsibility in such crucial colonial institutions as the army and the Church. Particularly in the eighteenth century, in Spanish Latin America and Brazil alike, an increasing number of non-whites used this wealth and prominence to gain a political voice, speaking out – sometimes violently – against their treatment by the *criollo* and European élite.

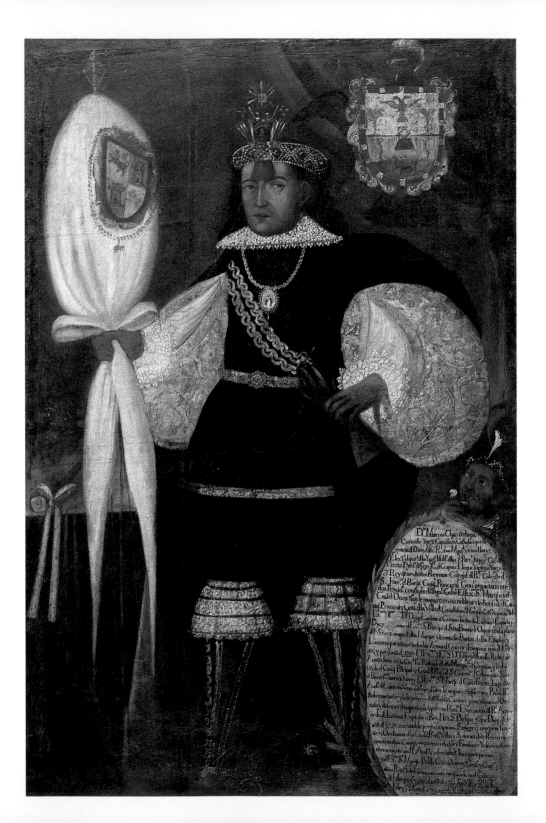

Dⁿ Marcos Chiguathopa
Coronel. Inga Cauallero Catholico por la
gracia de Dios Alf^z R^l de el Ayu^o y uno de los 24
Electo de la q^a de Ag^{to} del el de las 8 Parr^{as} de esta Ciu^d del
Cuzco Pat^{al} de que es R^l Capitan Jurez perpetuo Ynga
3 Rey q^e de estos Reynos, Colegial de el R^l Colegio de
S. Fran^{co} de Borja Casa Principal Con propietaria en
dos Provin^{as} con tit^o de el Sup^{or} Gov^o E.S. V^R Marques de
Casтel Dos Rios le ampararon en su nobleza y de tit^o de Ca
siq Principal y Gov^{or} de la Villa de Gualfan de la Quiquixa...

[the remainder of the text on the cartouche is largely illegible]

Until quite recently, histories of the conquest of the Americas focused almost entirely on the actions of the European conquerors and settlers. They treated the indigenous people as a silent backdrop to their Spanish and Portuguese protagonists, and paid scant attention to their cultures after the fall of the great pre-Hispanic civilizations. But these pre-Hispanic civilizations did not die. Although profoundly altered by European contact and rule, indigenous cultures persevered and evolved throughout the entire colonial period and beyond. Some aspects of these cultures even thrived through contact with the new lifestyles and beliefs. Social and economic structures, mythology, legend and language are only a few facets of indigenous culture that lasted through the era of Spanish and Portuguese domination. Going underground, many people even continued their pre-Hispanic religious practices in the guise of Christian ones or, more often, in a harmonious synthesis with the new faith. This phenomenon, dubbed by Anita Brenner in 1929 as 'idols behind altars', has meant that peoples such as the Nahua or Aymara have been able to worship in traditional ways even to the present day. In the outlying regions such as Paraguay, Chile and the southwestern United States, converted Amerindians stayed in contact with their unconverted brethren who roamed freely in the hinterlands and kept the indigenous world alive alongside the Euro-Christian one. Anyone who listens to the haunting strains of a Paraguayan folk melody in Guaraní or observes a Good Friday procession in rural Yucatán can have little doubt as to the resilience of the indigenous world.

31
Portrait of Don
Marcos Chiguan
Topa,
c.1740–5.
Oil on canvas;
199 × 130 cm,
78⅜ × 51⅛ in.
Museo Inka,
UNSAAC,
Cuzco

This perseverance of ancient traditions took place primarily at the hands of the indigenous peoples themselves. But it was also encouraged by the Christian missionaries and colonial officials. Missionaries felt that they could enhance Christianity's appeal to Amerindians by adapting to their culture and the colonial administration found it convenient to use pre-Hispanic systems of taxation and labour rotation to govern their new subjects. More directly relevant for us is the continuation of

indigenous architecture, painting, sculpture, ceramics, textiles and featherwork, all of which transformed the arts of the colonies. Without this voice from another world, the art and architecture of Latin America would have been little more than a regional interpretation of European models. This chapter will look at the indigenous contribution to architectural sculpture, painting and the so-called 'minor arts'. I will return to this blending of European and Amerindian artistic forms in later chapters, especially Chapter 5, which will look at some pre-Hispanic architectural forms that were revived on the colonial missions.

Art historians and anthropologists are partly to blame for the scholarly silence about the indigenous contribution to colonial culture. They have tended to prefer studying 'pure' cultures, civilizations supposedly untouched by the complex changes wrought by contact with others. Therefore, although there is a longstanding tradition of scholarship on Aztec, Maya and Inca cultures – to name but three – comparatively little attention has been paid to the culture of these peoples in the colonial period. Nevertheless, the past two decades or so have witnessed a major reassessment of indigenous societies in the colonies, particularly by scholars such as James Lockhart and Frank Salomon who are returning to written documents from the sixteenth to nineteenth centuries in languages such as Nahua, Quechua, Aymara and Guaraní. These sources, usually legal documents about things like property ownership but also histories and mythologies, provide a tool for recapturing the lost voices of the non-European participants in colonial culture. Such is an early seventeenth-century manuscript from the Huarochirí province of Peru commissioned by Fr Francisco de Avila, in which the anonymous Andean author writes about the religion and mythology of the Incas in Quechua using Roman letters (32). This rich account revolves around the interaction between the goddess of the coastal valleys, Chaupi Ñamca, and the god of the Highlands, Paria Caca. The page depicted comes from the Chapter 12, 'How Paria Caca's children Undertook the conquest of All the Yuca People'.

32
Untitled Quechua manuscript, early 17th century. Ink on paper. Biblioteca Nacional, Madrid

The visual arts can serve the same function. Throughout colonial Latin America, Amerindians made a profound contribution to the arts, not just by building the buildings and carving the sculptures

y may na runa cunapas tucoy ni llan as van cuan
suyac carcan chay mi ña chay man chaya mug hinca
ancha say cos cam amun nispa as vallan yanca
y chaspa runa sauapas pacha pipas chay llacsatam
bo man yai cunam na poneo llapi y na yelac cancan
paicuna ura manta amuc cunam as lla ay chata
yaicu nas puy non pa si minsaua churaque carca
cay tasta pueblo cospam ñatac tucoy ynantin
runa cuna pam papi ñay cospa ac ño nis catequidor
ña calla xir can chay cunam cañan. chancos tucioc
chay mantam ña chan cup tinca pachepos nañispa
tamyamuc cay chan cup mitampis ysquicaya nisca
chay yan cap Suasingi Suc sachecos ol y mactuyas
 mantell
nis canan chay cacha nis conchic yaco sapa urma
rayata chay cunadas conan pay cona en chay y
suelta ticuspa churuan Suatuca alli pucoy mi canca
nispa nir cancu / mana tamya nampues i chaquisca
cac chaysi ancha mucheoy mi carca nispa nir casca cu

Capitulo 12 y manam cay
puri a cacap Surin cunatucoy
y un ca culnaeta atijta ña
calla xir can

y nam cuxi cay chun campi capitulo pi ximar conchic
cay puria cacap churin cunapa tis can ~~caual~~ si victa
y pas nas pa villac conchic tacmi cuxi y manam tu
coy y nantin llacta cuna yunca sapa carcan chay
cunaeta canan mi scay. Suc paico. chancharina
Suari ruma. Ut c chuco tutay quize. sasin mani pa
cha chuy ro nis conchic cunaeta ximason y mañam
pai cuna puxic car canes chay chay cunaeta cay
cuna nis conchic cunas ñaupa pacha tucoy hin

but also by assimilating their own styles, iconographies and beliefs into the framework of Renaissance and Baroque art and architecture in creative and original ways. In so doing they endowed colonial Latin American art with their own unique stamp of identity and forged links between their pre-Hispanic past and the indigenous present. This Amerindian artistic voice is most strongly felt in the former Aztec and Inca empires, areas with the most advanced traditions of architecture, sculpture and other arts at the time of the Conquest. We can try to reconstruct Amerindian attitudes and reactions to the colonial world by tracing these links to pre-Hispanic traditions, but we must also keep in mind that the indigenous world was not only a thing of the past. The colonial era gave birth to new indigenous forms – or new interpretations of ancient ones – that are just as genuinely Amerindian as the art traditions before 1492.

Especially in the first century after the Conquest, the period of the most feverish building activity in the colonies, almost all of the architecture and much of the painting and sculpture was executed by indigenous artists. Adapting with extraordinary speed and agility to foreign styles, indigenous artists and masons erected the very Christian churches and viceregal palaces that proclaimed the glory of an alien motherland. In the most highly settled regions the *mestizos* and Africans took their place as the centuries progressed and native populations dwindled and intermarried. In the seventeenth and eighteenth centuries it was only on the outer missions and villages that indigenous people made up the majority of architects, sculptors and artists. Often these artistic and architectural projects were frankly exploitative, making use of unwilling labourers assigned through *encomiendas*. But sometimes, as in the case of the missions, building and decorating churches gave them a way of avoiding tribute and was a much more humanitarian alternative to back-breaking labour in the mines. Architectural and artistic activity on the missions also allowed them to construct their own living environment.

This sense of continuity and connectedness with the indigenous world is perhaps best seen in the artworks Amerindians commissioned for themselves, objects that attempted to counteract the harsh realities of

conquest with a statement of indigenous authority. One of the most characteristic of these artworks is the Inca portrait. In the viceroyalty of Peru two different kinds of Inca portrait appeared in the seventeenth and eighteenth centuries. The first, playing to European expectations of conquest and succession, was a kind of multiple portrait showing the Inca emperors arranged in rows next to those of the colonial viceroys, so that when read from left to right the Inca dynasty proceeds seamlessly into the colonial period in a logical and peaceful succession. These portraits were inspired by an engraving by the Lima artist Alonso de la Cueva Ponce de León (c.1724–8) showing the complete Inca dynasty and Spanish kings, and its celebration of the legitimacy of the Spanish crown made it very popular in metropolitan centres such as Lima, Santiago and Potosí. Yet the Andean nobility commissioned another kind of Inca portrait series, which did not emphasize the inevitable march toward conquest and instead featured full-body portraits of pre-Hispanic Inca rulers and princesses (ñustas) as well as their contemporary descendants, emphasizing the link between the living Andean nobility and their Inca ancestors.

An eighteenth-century painting from Cuzco, *Portrait of Don Marcos Chiguan Topa* (see 31), is a case in point. It features a contemporary Andean noble dressed for a festive procession in a combination of imperial Inca regalia, including the traditional headdress and the royal scarlet fringe on his forehead, as well as the kind of costume, chains of office and heraldic standards worn or carried by Spanish aristocracy. Ironically, this monumental kind of portraiture had its origins in European and *criollo* commissions. One was a series of Inca portraits commissioned by Viceroy Francisco de Toledo in 1572 for Philip II of Spain and another a cycle of Inca portraits sponsored by the Jesuits in 1644 in the Colegio de San Francisco de Borja, Cuzco, a college founded to educate the sons of Andean nobles in the old Inca capital. These pictures emphasized the link between the historical Inca past and the Christian present, but they also affirmed that there was an Inca present and that the Andean nobles of today deserved the same status as their predecessors.

This affirmation of the Inca heritage can also be seen in the writings of prominent sixteenth-century colonial Andeans such as Garcilaso

de la Vega and Felipe Guaman Poma de Ayala, who rewrote Inca history so that it fitted a Christian model. These historians used their combination of aristocratic Andean lineage and Spanish education to try to persuade the Spanish that Christianity and Andean religion were compatible, and stressed the legitimacy of their own pre-Hispanic noble roots. But in doing so, they also allowed people to conclude that the Andeans were the true heirs to colonial Peru, a more subversive view that culminated in an independence uprising by a descendant of the Incas called Tupac Amaru II in 1780–1. This event drove

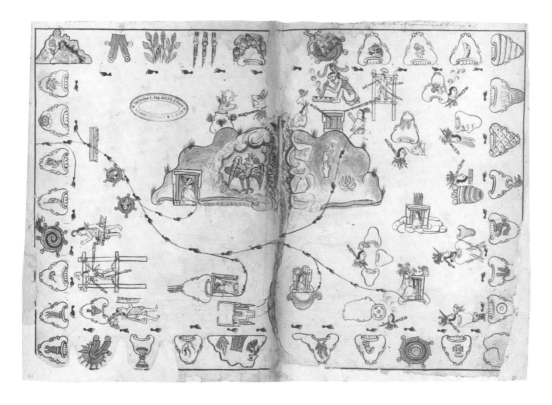

the Spanish government to forbid painted portraits of Incas or the wearing of Inca regalia, both of which practices would resurface in the independence era. A similar manipulation of pre-Hispanic history took place in early colonial New Spain, with authors such as Fernando Alvarado Tezozomoc, a Nahua who claimed descent from Moctezuma II and wrote a history of Mexico called the *Crónica Mexicana* (c.1598), and the *mestizo* historian Fernando de Alva Ixtlilxochitl (see 14), a descendant of the lords of Texcoco.

Another attempt to legitimize pre-Hispanic status and identity can be found in the legal documents of colonial New Spain, many of which were illustrated. As we have seen, the Aztecs had a highly developed tradition of pictographic writing, merging painting and text into one (Aztec painters were called *tlacuiloque*, meaning both 'painters' and 'scribes'). Among the most common post-Conquest documents produced by *tlacuiloque*, especially between 1530 and 1630, were maps recording communal property holdings (in Spanish, *relaciones*, or 'accounts'). Many Nahua communities used these maps to restructure their official histories so that they corresponded with European notions of genealogy and validity. This reorganization was crucial, since such important issues as titles to goods and land, as well as social privilege and genealogical ties, were at stake. This sixteenth-century map (33) shows the foundation of Cuauhtinchan and is bound into the *Historia Tolteca-Chichimeca*. The map presents a narrative of land rights and legitimacy. It shows footprints representing people entering the region from the left, after which they are shown defeating the people who lived there before and founding the town itself in the centre of the map. Other footprints beat the bounds, walking between place glyph and place glyph to establish the community's claim to certain territorial limits. Although Inca portraits and Nahua maps represent a rewriting of the past and should not be taken as historical fact, they give us valuable insight into how indigenous people identified themselves in the face of colonial society and help us understand the survival of pre-Hispanic forms in the arts of the colonies. In fact, it is not quite correct to speak about 'survivals', since many of these indigenous images and symbols were consciously reinstated after the Conquest – sometimes many generations after – and they have more to do with the social and religious issues of the colonial era.

The myriad of indigenous cultures of colonial Latin America reacted to European art and architecture in comparably diverse ways. Some, when given the opportunity, rejected and resisted them outright. Others adapted to these imported forms and blended them with their own traditions. For the past fifty years or so, scholars have increasingly focused on the dynamics of artistic interchange between these groups of cultures, resulting in a sophisticated series of scientific labels and

33
Founding of Cuauhtinchan, bound into the *Historia Tolteca-Chichimeca,* c.1578. Bibliothèque Nationale, Paris

categories. The field itself is often called 'acculturation theory', an anthropological method developed in the USA in the 1930s to look at what happens when two cultures coexist for long periods. Although the original theorists tended to look at the relationship as one of dominance and submission, more recently scholars, especially in Latin America, have increasingly emphasized the recipient culture's role in creating its own post-contact culture. In the visual arts these studies have looked at two phenomena: the persistence (or reappearance) of pre-Hispanic symbols and techniques in the colonial period, and the reaction of indigenous artists to European art and architecture, part of a greater emphasis on reception in contemporary art history.

The issue of indigenous traditions persisting or reappearing after the Conquest has brought out strong passions in the scholarly community. Until the last decade, most North American and European scholars tended to believe that surviving traditions were few and superficial, and that looking for them at all was, in the words of the late George Kubler, 'like a search for the fragments of a deep-lying shipwreck'. Other scholars, especially in Latin America where the survival of pre-Conquest traditions has always been more accepted than elsewhere, have created scientific categories of pre-Conquest motifs and styles in the colonial arts, and developed a vocabulary to deal with them. Recently US scholars have also joined the naming game, producing scientific labels for every degree of artistic convergence. It is not necessary to know all of these names, as many such definitions overlap in meaning and sometimes verge on the finicky, but it is useful to review a few commonly used terms before examining the art itself.

It is important to keep in mind that pre-Hispanic symbols and styles in colonial art appear almost exclusively in the earliest years of the Conquest, when the old traditions were the most alive, and later on mainly at the peripheral regions, areas beyond the colonial sphere of interest where indigenous culture remained strongest. Amerindian traditions rarely made any impact on the art and architecture of the metropolitan centres after the first fifty years or so. In certain later periods, such as the late seventeenth and early eighteenth centuries in the Andes, pre-Conquest symbols or motifs appear again, this time

as part of a conscious revival by a community making a political or social statement. However, most of the so-called 'indigenous' elements in the later colonial arts are in reality far removed from such roots. In many cases, buildings or paintings look different from European models only because they were made by people far away from Europe with little training in European ways and not because of borrowings from the Aztec or Inca world. Distinguishing between features of indigenous culture and the products of artistic inventiveness is difficult and we must always proceed with caution.

Two words that scholars frequently use to describe the cultural blendings of indigenous and European arts in the Americas are *mestizo* and *tequitqui*. *Mestizo* was first used by Ángel Guido in 1925 to describe a style of architectural decoration that proliferated in the late seventeenth and eighteenth centuries in southern Highland Peru from Arequipa to La Paz and Potosí in Bolivia. Beginning in the late 1670s with the church of Santo Domingo in Arequipa, the *mestizo* style is characterized by profuse carved ornament, especially on the façades and around the doorways of churches and secular buildings. Typically, it uses dense patterning and has a flattened appearance, despite the depth of its carving, and it often incorporates native flora and fauna such as chirimoyas (a kind of fruit), cacao, pumas and monkeys, as well as the occasional Inca symbol such as the *ccantu* lily and a kind of masked head that resembles pre-Hispanic prototypes. Although artists copied European models such as maps and engravings when executing these decorated areas, they arranged them in ways that were quite alien to European style and resembled pre-Hispanic Andean arts.

An excellent example of *mestizo* style is the profusely embellished façade of the Jesuit church of Santiago in Arequipa (1698), which is overwhelmed with carved decoration so that the architectural units such as entablatures and pediments seem to dissolve into the richness of the scrolls, flowers and figures adorning them (34 and see 36). The anonymous artist has obtained some of the individual floral, faunal and geometrical patterns from European printed books, but instead of linking them together into a coherent whole as a European artist would have done, he has divided them into discrete units that he places next to

each other without allowing them to intersect. This mosaic-like grouping of decorative elements can best be seen in the section around the central window where the units of pattern are enclosed in individual squares. Although it does not resemble European prototypes, this segmental arrangement does recall the grid structure of motifs found in Inca textiles, especially the *uncu* (see 16). It resembles even more closely the distribution of carved motifs found in pre-Hispanic architecture, such as the Gate of the Sun (500–700 AD; 35) or more contemporary examples at Chanchan (fourteenth–fifteenth centuries) – themselves derived from textile patterns – which also share its flattened carving style. The decoration of the Santiago façade achieves unity not by connecting these disparate motifs, but through an overall, unifying flatness, which allows the eye to roam over its surfaces with little to hinder it. The sculptor has further enlivened the façade with figural elements, such as the fanciful Amerindian figures at the lower right and left who display emblems spelling out 'Christ Our Lord', or the roosters, hummingbirds and monster masks which dwell in the surrounding vegetation (36). In other *mestizo*-style façades artists

34
Façade of the church of Santiago (La Compañia), Arequipa, Peru, 1698

carved suns and moons, symbols extremely important to Andean religion that continued to resonate within colonial society.

In the generic sense of a blend of styles, the term 'mestizo' is sound enough. Where we run into problems is when people use the term – curiously, given its inherent meaning as an ethnic mixture – to refer to art done solely by pure blood Amerindians. Scholars such as Harold Wethey have tried to find proof of Amerindian craftsmanship, what he calls the 'expression of the naïveté of the Indian' in mestizo style. The sculptors of these Peruvian and Bolivian façades certainly included some 'pure' Amerindians, but they likely also included people of mixed blood and many of them lived in large cities (such as Potosí or Arequipa) with diverse populations and influences. More importantly, the blossoming of this style also took place a century or more after the Conquest, making it unlikely to be a continuation of Inca culture. Instead, it was more likely a conscious return to the indigenous past by a largely colonial society seeking a visual identity that could separate

35
Gate of the Sun, Tiahuanaco, Bolivia, 500–700 AD

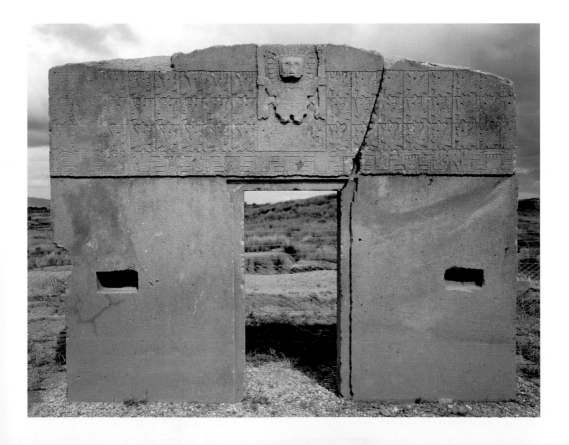

it from that of Europe. As is the case anywhere else in the world, it is pointless to try to link style with race.

The same goes for another popular term used in Mexico: *tequitqui*, which comes from the Nahuatl word for 'vassal'. *Tequitqui* is used to refer more specifically to the Aztec symbols and motifs that persist in early colonial stone sculpture in New Spain, although the same symbols occur in wall and manuscript painting. It also refers to the style alone, which shares with *mestizo* style a flattened appearance, deep and bevelled

Art of Colonial Latin America

36
Figural
elements,
façade of the
church of
Santiago (La
Compañía),
Arequipa,
Peru,
1698

carving, and a tendency to divide decorative elements into discrete units with spaces in between. As with *mestizo* style, *tequitqui* implies a racial connection, because it suggests that the artists were all full-blooded Nahua Indians, which was not always necessarily the case. But like *mestizo*, *tequitqui* is now used in the more generic sense of a hybrid style and has become a convenient label for art historians.

Tequitqui is best exemplified by the date stone of the Franciscan monastery at Tecamachalco (37), which displays the Aztec imperial

symbol of the eagle and includes both European dates in Arabic numerals and the Nahua date-glyphs 5-house (1589; on the left of the text) and 7-reed (1590; on the right of the text). It is *tequitqui* in its style, with its deep carving, rounded edges and flattened appearance, as well as in its use of pre-Hispanic symbols. Compare it with this wooden drum (*huehuetl*; 38), carved by Aztec sculptors around 1500, just twenty years before the Conquest. The two eagles are strikingly similar, with the same pose and almost identical handling of the feathers. Another example of *tequitqui* is the sixteenth-century battle scene painted on the borders of a mural at the mission church at Ixmiquilpan (39), showing Aztec knights in their cotton armour, war shields (*chimalli*) and feathers, leaping among Italian Renaissance

37
Foundation date stone, mission church, Tecamachalco, Mexico, 1589–90

38
Upright drum (*huehuetl*), c.1500. Wood. Museo de Arqueología e Historia del Estado de México, Toluca

39 Overleaf
Battle of Aztec and Chichimec Warriors, 1570s. Mural. San Miguel, Ixmiquilpan, Mexico

scroll patterns. Most intriguing is the use of tongue-like scrolls to suggest speech, a traditional symbol used in Aztec picture-writing (see 14). Unlike *mestizo* style in Peru, these works were made early enough for the artists to preserve a collective memory of pre-Hispanic traditions and can be considered genuine survivals of pre-Hispanic forms.

One of the finest examples of *tequitqui* as a style alone can be found at the church of Santiago (40) in Angahuan, Michoacán, in the western part of New Spain and further from the main colonial centres. Although there are no motifs or symbols here that can be traced to the arts of

either the Purépecha Indians who lived in this region or the neighbouring Aztecs (this area was never part of the Aztec Empire), the carving of this exuberant façade is unlike anything found in Europe and is unique to the area. The sculptor has copied from European printed books, probably Spanish or Flemish pattern books or the decorative borders from a bible or catechism, yet the way he treats the ornament is quite distinct, fundamentally altering the essence of the floral ornament in a way strikingly similar to that of the *mestizo*-style artists. Once more, the artist has separated the decorative elements into square blocks of pattern, set next to one another but never interrelating, like a mosaic. This treatment of the surface does

40
Façade of Santiago, Angahuan, Michoacán, Mexico, 16th century

41
Stone of the Five Suns, 1503. Stone; h.55·9 cm, 22 in. The Art Institute of Chicago

recall sculptural works such as the Aztec *Stone of the Five Suns* (c.1503), whose distribution of date glyphs is also mosaic-like, and its deep and bevelled carving relates to Aztec technique (41). In Aztec sculpture, convex sides cast deep shadows over the surface and give the designs a powerful linearity, an effect made by using stone tools and carving with splitting and abrasion rather than cutting.

The flattening of three-dimensional forms, which we have seen in *mestizo* and *tequitqui* carved decoration, is called planimetricism and is not unique to Mexico or Peru. In fact, planimetricism occurs all

over the Iberian empires. Look, for example, at the bold relief
stucco ornament on the façade of the church of La Merced in Antigua,
Guatemala, with its lush but flattened floral motifs (42, 43), or the
equally compressed fruit garlands surrounding a doorway at the Jesuit
reduction (or mission) church of San Ignacio Miní in Argentina
(1727; 44). It even turns up in places completely unrelated to Latin
America, such as Poland or Russia, where artists not used to Italianate
forms tried to recreate Renaissance or Baroque churches in their
own countries. This ubiquity has led some scholars to refer to plani-
metricism as a universal phenomenon, something that inevitably
results when artists unfamiliar with Renaissance conventions of
modelling and perspective copy Renaissance models. It has also
been related to the artists' use of two-dimensional prints and draw-
ings as their main sources. These statements are partly true. Yet the
planimetric carving of two cultures only look alike at first glance
and closer inspection will always reveal something unique to each.
A specialist can tell the difference immediately between planimetric
carving from Mexico or Peru, Brazil or Paraguay. Planimetricism is
therefore both an artistic reaction to an unfamiliar art form, namely
European pictorial realism with its effect of three dimensions, and a
genuine reflection of culture.

More recently, scholars have devised terms to describe what happens
to symbols from two cultures when they interact. Juxtaposition is

the rare case where a motif from one culture appears next to one from another without changing its original meaning. The two operate independently, the one meaning one thing to Culture A and the other meaning something else to Culture B. The Tecamachalco date stone is an example of juxtaposition. The Spanish would understand the Christian-era dates written in Arabic numerals but would not understand the Aztec date glyphs, which would resonate with the Nahua community, who would not necessarily be able to read the Arabic numerals. Neither motif would have much bearing on the other. 'Convergence' and 'syncretism' describe what happens when two different cultures make use of a single symbol, in the first case allowing it to maintain its dual meaning and in the second letting it fuse to create something new – although the symbol can also address each

42–43
Façade of
church of
La Merced,
Antigua,
Guatemala,
before 1767

44
Anonymous
Guaraní
sculptor,
detail of a
doorway,
San Ignacio
Miní,
Argentina,
1727

audience in a distinct way. An example of convergence would be the carving of a passionflower on the reduction church of San Ignacio Miní. The Jesuit missionaries would interpret it as a reference to Christ's Passion, while the Guaraní carvers would recognize it as a symbol of the trance-like hallucinogenic state that was a crucial feature of indigenous religion. A hypothetical example of syncretism would be an Amazonian statue of Christ the Saviour that is shown wearing the traditional garb of an indigenous healer. The indigenous audience would recognize it as Christ, but a Christ legitimized by his association with Amazonian religion, while the Portuguese missionaries would see it simply as an image of Christ carved by someone unfamiliar with European Baroque conventions. It is precisely these differences in meaning between convergence and syncretism (some have called them 'slippages') that allow artists from one culture to encode messages into a symbol that could remain undetected by the other. Some Peruvian and Mexican examples can serve to illustrate these phenomena further.

45
Juan Gerson,
Noah's Ark,
1562.
Pigments on
papel de amate.
Church of
Tecamachalco,
Mexico

A celebrated example of juxtaposition can be found in the illustrations to the early seventeenth-century Nueva Corónica (see 22 and 102), the history of Peru addressed to the King of Spain, Philip III, by Guaman Poma de Ayala in an attempt to stop colonial abuses of the Andean people. Aside from its importance as a record of pre-Hispanic and colonial life, the Nueva Corónica is also a striking example of artistic hybridization. After hearing of the King's fondness for the visual arts, Guaman Poma generously illustrated the book with 398 pen-and-ink drawings that imitate the style and crosshatching of engravings. Guaman Poma may have been a professional painter or an illustrator of legal documents and good evidence has recently come to light that he studied drawing under the Mercedarian friar Martín de Murúa (fl.1560–1616), who wrote his own illustrated history of Peru in 1590. While Guaman Poma used a variety of European (especially German) engravings and woodcuts as sources in many of his illustrations, he drew in a distinctively flatter style, with an emphasis on line, no shading and little perspective. Like early colonial Mexican manuscript painters, he showed less interest in realism than in symbolic meaning.

Guaman Poma's illustration of the Rich Imperial City of Potosí (see 22) demonstrates his characteristic juxtaposition of European and Andean features. Below we see a European-style aerial view of the city, with its plaza in the middle and the mountain above with its silver mine. Above, however, is a hybrid symbol in which the Inca emperor in his traditional *uncu* tunic is shown flanked by the lords of the four parts of the empire. They crown him with the coat of arms of Castille and León hoisted on two columns representing Gibraltar, Spain's gateway to the

46
**Anonymous
Nahua
muralists**,
*The Garden
of Paradise*,
mid-16th
century.
Mural.
Augustinian
mission
church of
San Salvador,
Malinalco,
Mexico

Americas. Thus, Guaman Poma boldly asserts the legitimacy of the Inca nobility over the Spanish colonial city.

New Spain's most celebrated creator of juxtaposed imagery was Juan Gerson, the painter of the Old Testament and Apocalypse vault at Tecamachalco (see Chapter 1). A noble of Tecamachalco, Gerson was recorded in the town annals, allowing us the rare pleasure of being able to identify a sixteenth-century artist in Latin America. Gerson

had the challenge of depicting some extremely arcane episodes from the Bible (the original engravings he copied were probably from a French Bible). He took up his challenge with aplomb, designing some of the most unusual and acculturative images in the history of colonial Mexican art, such as this depiction of *Noah's Ark* (45), with its ghost-like human forms and the ubiquitous blue background that defies European conventions of perspective. The juxtaposition comes into play when Gerson inserts occasional Nahua glyphs or other symbols into the scene, such as the glyph for water (a curving wave) that appears right in front of the ark in this painting. Gerson's painting juxtaposes two very different traditions of depicting a scene, the one having to do with meaning and the other with physical appearance. Yet, it is unlikely that a European looking at them at the time would recognize these Aztec features as anything more than bad painting. Incidentally, Gerson applied the paints to a surface of *papel de amate* (fig bark), an indigenous technique going back to pre-Hispanic times.

Examples of convergence and syncretism are harder to read than juxtaposition, because scholars need to know both traditions thoroughly before they can understand this kind of merging of form and meaning. Recent work on religious mural painting in early colonial New Spain has shown how deeply embedded the messages contributed by the two cultures can be. Mural paintings of paradise painted by Nahua Indians in the cloisters and stairwell of the Augustinian mission church of Malinalco (46) from the 1570s use floral and faunal imagery to fuse indigenous concepts about the afterlife with those of Renaissance Europe. On the whole, the mural displays more similarities than differences between the two traditions and could therefore be described as a case of syncretism. Water, which predominates in the paradise gardens, was an important symbol of the fertility of heaven in both cultures and the murals also include native and European plants that symbolized the afterworld for Nahuas and Europeans alike. The two cultures also related the afterlife both to mankind's beginning and end, although the Aztecs associated this concept with caves, a feature absent in the European tradition, and the Europeans used the symbol of the enclosed garden, meaningless to the Nahua. Other symbols in the Malinalco murals are examples of convergence. Such are the images

of monkeys in a cacao tree. For the European audience, monkeys have associations with evil and are used here to represent original sin. Yet monkeys and cacao trees have positive meanings for their Nahua audiences, for whom these items are valued products of tribute. Instead of discouraging indigenous viewers, this depiction of evil appears attractive to them. Similar examples of convergence and syncretism in murals can be found all over the Basin of Mexico.

Some indigenous people in the colonial world took advantage of convergence to worship images from their own religion in the guise of Christian ones. In early colonial Mexico and Peru many Amerindians actively resisted Christianity and continued to serve their traditional gods and oracles. Two of the most famous examples were the Nahua priest Martín Ocelotl (named after the ocelot cat), who openly challenged the new religion in the 1540s, and the Andean movement from the 1560s known as Taqui Onqoy (Dance of Disease), which aimed to reverse the changes wrought by the Spanish missionaries. But usually this preservation of old rites was secret or subtle enough not to anger the authorities, done in distant rural areas or in private homes. Indigenous communities would place images of pre-Hispanic deities inside Christian altars or statues of saints, or they would worship what appeared to be a Christian saint but that carried attributions relating to pre-Hispanic religion. The Jesuit missionary José de Acosta described this kind of religious syncretism in late sixteenth-century Peru: 'They adore Christ yet follow the cult of their gods; they fear God, yet do not fear him.' In the next century, Andeans kept stone figures of the Inca in their household shrines and received messages from him in their dreams. As late as the nineteenth century, priests in more secluded parts of Guatemala were still finding Christian altars hiding indigenous idols.

One alleged example of such convergence is the substitution of the Virgin Mary for the Andean earth mother goddess Pachamama, a matter of some controversy in scholarly literature. Some maintain that the indigenous and *mestizo* painters of colonial Cuzco and Potosí regularly painted images of the Virgin Mary as thinly veiled references to the Andean deity (see Chapter 4). Typical are vibrantly coloured

47
Luis Niño,
Our Lady of the Victory of Malaga,
c.1735.
Oil on canvas;
149·9
× 109·2 cm,
59 × 43 in.
Denver Art
Museum

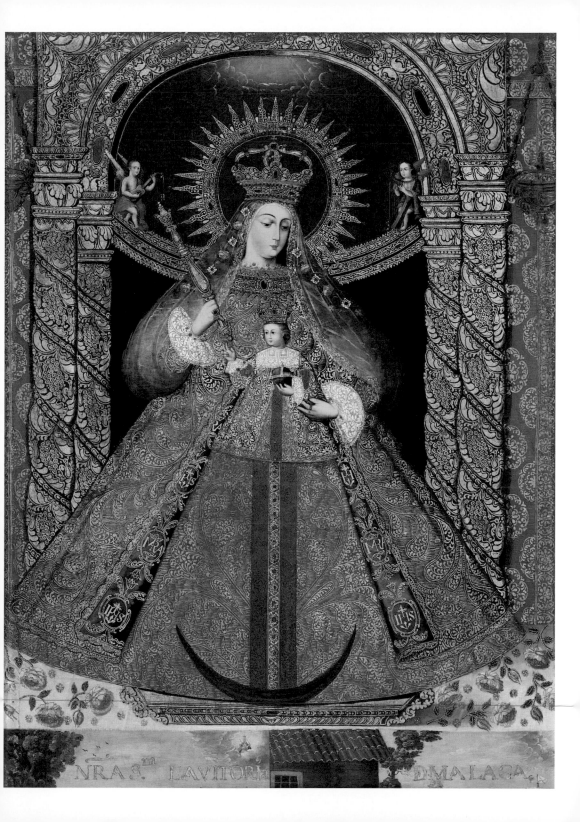

NRA Sᵗᵐ. LA VITORIᵃ D MALAGA

and intricately detailed paintings of the Madonna, often shown with a wide triangular gown, whose profile scholars have related to Pachamama's symbol of a mountain. This splendid *Our Lady of the Victory of Malaga* (47) by the Potosí painter Luis Niño (fl.1716–58) is typical of this kind of image. Her clothing is covered with a lavish, lace-like pattern of gold tooling, which also incorporates an image of the new moon below. When the viewer links this moon to the vertical lines above it, the resulting form takes on the profile of an Inca ceremonial knife (tumi) and a pin worn by Inca princesses, which some scholars believe was an intentional reference to pre-Hispanic royalty. The artist has further enhanced her holy character by scattering petals and blossoms at her feet, which scholars have related to Andean ritual offerings.

48
The Virgin Mary of the Cerro Rico of Potosí, 18th century. Oil on canvas; 134·6 × 104·1 cm, 53 × 41 in. Casa Nacional de Moneda, Potosí

Many of these connections are very suggestive and painters were probably conscious of some of these pre-Hispanic references. We should treat with caution, however, the notion that the mountain-like profile of her dress is proof that she is not the Madonna but the earth mother Pachamama. Madonnas with the same shape of dress were common throughout Europe at the time, and they appear on the prints and paintings that these artists used as models. Nevertheless, there is one kind of Madonna that has been quite literally merged with the image of a mountain. The evocative *Potosí Madonna* (48) combines a depiction of the Cerro Rico in Potosí (see 23) with the face of the Virgin Mary to produce a hybrid figure that unites the Madonna as protector of miners with the Andean notion of a hill being the embodiment of a deity. Although Spanish civic and ecclesiastical authorities look on from below, an Inca dressed in royal garb can be seen on the hill itself, receiving the homage of his people working in the mines.

These Cuzco and Potosí Madonnas are less an example of convergence and more one of syncretism, in which the Andean artists and their patrons united the Christian figure of the Virgin with elements of indigenous religion, fusing the two traditions into one. It is neither Pachamama *per se* nor the Virgin Mary in her European guise, but a new, Andean Madonna. A European audience would not understand most of the Andean references, such as the symbols relating to Inca

lineage, but neither did these Virgins represent a revolution against Christianity. Like Nahua sculptors in Mexico, the Andeans brought the two cultures together in a way that allowed them to hold on to their own identity while surviving within colonial society.

Styles and iconographies were not the only indigenous legacies to colonial art. Many traditional media and techniques of making art were continued or revived in the colonial era, some of them profoundly meaningful – even in a religious sense – to their Amerindian audience. One of the most splendid of these media is the art of Andean textile making. The sixteenth-century viceroy Francisco de Toledo had been so impressed by the textiles he found in Peru that he sent some to the King of Spain as 'the summed record of their intelligence'. Toledo was concerned about preserving this ancient tradition and he ensured that weavers were regularly reported in local censuses. Andean weavers, still women, did preserve the textile traditions after the Conquest, continuing to manufacture cloth in the old way for tribute and for their domestic needs, even in the face of new weaving technologies, materials, and standards imported by Spain.

One of the most enduring types of traditional Andean garments to thrive after the Conquest was the *lliclla*, a rectangular woman's tunic. A fine example of such is an interlocked tapestry from the sixteenth or early seventeenth century, depicting siren figures, flowers and animals in the wide bands on either side of the centre (49). *Lliclla* are usually constructed of two identical panels joined in the middle, with areas of patterns divided by stripes. They blend European motifs, such as floral and faunal ornament, as well as human figures, with traditional Andean geometric patterns. Throughout the colonial era the essential Inca structure of these garments remained intact, meaning that they were potentially subversive, due to their link to a social hierarchy and religion that had been outlawed by the Spanish. They were so laden with pre-Hispanic symbolism that the colonial government routinely prohibited *lliclla* garments up until the end of the eighteenth century, fearing that they would help foment rebellion. The powerful associations the *lliclla* had with position and rank helped these women maintain their identity behind the backs of the Spanish rulers throughout the colonial period.

49
Lliclla,
16th–early
17th century.
Cotton and
wool;
95·5
× 127·5 cm,
37⅝ × 50¼ in.
Museum of
Fine Arts,
Boston

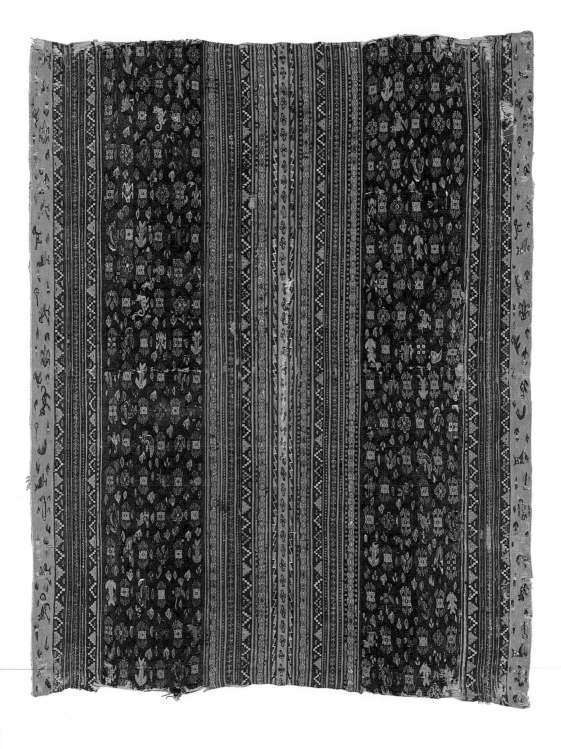

Another important indigenous survival in Peru is the *kero* cup, the focus of recent scholarship. Traditionally produced in pairs, *keros* were used to drink *chicha* (maize beer) in ritual drinking ceremonies in pre-Hispanic Andean societies and had religious and political associations. Before the Spanish arrival, the wooden beaker-shaped *keros* were primarily adorned with incised geometrical symbols. After the Conquest, however, as seen in an example from the late seventeenth to early eighteenth centuries (50), *keros* were inlaid with resin depicting figural and other representational ornament, including portraits of Incas as in

the upper register of this cup where the Inca wears an *uncu* with a chessboard pattern. *Keros* preserved their ritual significance in the colonial era, a role that is reflected in their depiction of pre-Hispanic ceremonies and scenes, as well as motifs such as the rainbow, a symbol of Inca royal authority. In the colonial period, rainbows acquired a far more subversive meaning, relating to the renewal of the Inca regime and overthrow of the colonial government, a process known as *pachacuti*. Like traditional textiles, the *kero* cups could therefore seem perfectly

innocuous to a European viewer but communicate important non-Christian, and even anti-Christian, messages to their Andean audience.

One indigenous Peruvian technique was adopted by colonial authorities because it saved lives. Churches built in Lima in the seventeenth century used an Andean technique for vaulting with quincha (mud and rushes) to prevent earthquake damage. Using this lightweight material, similar to that used in medieval England where it is referred to as 'wattle-and-daub', they constructed false barrel vaults for their churches that would be less prone to collapsing and less likely to kill their congregations during earthquakes than brick or stone vaults. Quincha roofing, used for the first time on a large scale in the grand monastic church of San Francisco in Lima (1657–74; see 167), proved to be a valuable lesson learned during the terrible earthquakes of 1687 and 1746 and set the standard for church building in Lima for the rest of the colonial period.

50
Kero,
late 17th–18th
century.
Wood and
pigment inlay;
h.20 cm,
7⅞ in.
Brooklyn
Museum of
Art, New York

In New Spain many Amerindian media and techniques prospered in the colonial era. One example is religious sculpture produced with a combination of corn pith and glue made from ground-up orchid bulbs that was prevalent in Michoacán. These statues were modelled (like clay) instead of carved, a flexible technique that allowed them great realism and expressiveness. First, artists would form a skeleton of corn leaves tied together with the fibres of the agave cactus and cotton cloth, using turkey feathers for the fingers and toes. Then the paste was applied over this armature and modelled by the artist, before it was allowed to harden. Finally a layer of gesso was applied on top and the statue was painted. Typical of this technique is this sixteenth-century crucifix from Morelia (51), an extremely lifelike image whose palpable feeling of pain and visceral gore are enhanced by the expressiveness of the medium. These lightweight images of Christ and the saints were eminently suitable for use in processions and therefore served a very practical purpose, but the medium also had religious significance for the Purépecha Indians who made them. Corn was a staple food and the Mesoamericans worshipped corn deities such as the Aztec gods Centeotl (Corn-Ear Deity) and Xilonen (Young Corn-Ear Doll). Xilonen was a female deity called the 'Hairy One' because of the

appearance of corn tassels, and Centeotl was a male deity who had formerly also been female. The Purépecha had made images of deities such as these from dough formed of grain or seeds, much like the corn pith paste used in Christian statues. Missionaries recognized the material's excellence and encouraged its development despite its associations with the forbidden religion. Vasco de Quiroga, Bishop of Michoacán, even hired a Purépecha religious leader to lead a workshop in corn-pith statuary. Most of the statues that survive today were made there while Quiroga was bishop between 1538 and 1565.

Another remarkable adaptation of indigenous media is the Aztec art of featherwork, one of the greatest of the pre-Hispanic arts. Feather-work was a highly skilled, painstaking and expensive process. It was so prized by the Aztecs that royal houses maintained special aviaries of exotic birds to supply feathers for these artworks, a feature of palace architecture that archaeologists have recently found in a palace belonging to the predecessors of today's New Mexican Pueblo Indians. Nahua featherworkers, called *amanteca* after the Tenochtitlán neighbourhood of Amantla (now part of Mexico City) where most of them lived, worked together in groups on a single piece. Workers knotted feathers on to a base of small wooden strips or glued them one by one on to a sheet of paper made of cotton and paste and attached to a bark backing. The glue was made from orchid bulbs. They attached the feathers in a mosaic so that they overlapped like roof tiles to produce patterns. Using an infinite number of tiny feathers, beginning with plain ones and finishing off with more brilliant colours, they produced an effect of great richness and subtlety. Each worker finished his own segment of the mosaic and afterwards they were all sewn together to form a whole, like a quilt, after which the surface was burnished (rubbed until shiny), to give it a unified appearance. In the mid-sixteenth century the Franciscan missionary Fr Bernardino de Sahagún recorded the intricate process for posterity in his treatise on the Aztec world illustrated by Nahua artists (see 116). The Aztecs used featherwork for a wide range of prestige items, including capes, head crests, fans and cords for their nobles, coats of arms and banners, and tapestries and canopies to hang in their palaces. Similar featherwork traditions existed elsewhere in the pre-Hispanic world, for instance among the pre-Inca peoples of Peru.

After the fall of Tenochtitlán in 1521, the aviaries and *amanteca* were briefly shut down, but only a few years later the Franciscans hired the same workers in their own feather workshops to produce Christian liturgical vestments as well as pictures. On the one hand the friars wanted to preserve a tradition that impressed the Europeans with its sophistication. Their hopes were justified, as the great European families like the Medici and Habsburgs snatched them up as soon as they were made and most of the finest examples are now in places like the Pitti Palace in Florence or the Kunsthistorisches Museum in Vienna.

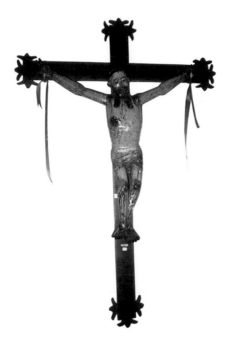

Even the Chinese emperor Wan Li (r.1573–1619) was suitably pleased with four Nahua feather paintings he received as gifts from Franciscan missionaries, apparently preferring this delicate art to the crude oil paintings most Westerners brought to China. On the other hand, the friars wanted to harness this native tradition in the service of Christian propaganda and benefit from the prestige enjoyed by such featherwork in the pre-Hispanic era.

The new feather paintings, extremely detailed copies of Flemish engravings in brilliant colours, had the breathtaking beauty and delicacy of their pre-Hispanic predecessors. The earliest are the most intricate, especially those predating the middle of the seventeenth century. They were made as banners and were attached to a cotton cloth and backed with fine palm or rush mats tied together with twine or similar material. Some of the smaller feather paintings were pasted on to a hard backing, such as wood, leather or copper. The earliest dated feather painting is also one of the most magnificent. *The Miraculous Mass of St Gregory* (52), dated 1539 and commissioned

52
The Miraculous Mass of St Gregory, 1539. Feather on wood; 68 × 56 cm, 26¹⁄₄ × 22 in. Musée des Jacobins, Auch

53
Israhel van Meckenem, *Mass of St Gregory*, c.1490–5. Engraving; 46·3 × 29·5 cm, 18¹⁄₄ × 11⁵⁄₈ in

from the feather artisans of the Franciscan college of San José de Belén de los Naturales in Mexico City, reproduces in brilliant colours and striking detail the lines of a fifteenth-century German engraving (53) by Israhel van Meckenem (1440–1503) that was also copied in black and white in the mission church of Tepeapulco. The *Miraculous Mass of St Gregory* panel is associated with the Nahua noble Diego de Alvarado Huanitzín, the first colonial governor of Tenochtitlán, who commissioned it as a gift for Pope Paul III (r.1534–49). This noble patronage fitted into Aztec tradition, where featherworking was an élite craft.

Although they carefully emulated the German style of the engraving, the *amanteca* brought their black-and-white models to life with brilliant colours and a textural richness never equalled in oil painting.

Unusually for the arts of early colonial New Spain, a few feather paintings are even signed by the master featherworkers, such as the Purépecha artist Juan Baptista Cuiris of Tiripetío, Michoacán, who made two of the finest examples to survive today. This rare honour attests to the unusually high status artists like Cuiris enjoyed in colonial society. Nevertheless, unlike the Peruvian *lliclla*, which helped Andean women preserve the memory of their past and reinforce their present, these Nahua feather paintings did not serve anyone but the friars and their European collector patrons. Other than a few flowers that look vaguely Aztec in style, these feather paintings do not incorporate Nahua glyphs or symbols in the same way that early colonial mural paintings or architectural ornament do. In the end, the tradition was sustained not by Nahua artisans or their descendants but by *criollo* nuns, who preserved the art of featherworking into the nineteenth century.

One final example of an indigenous technique that flourished in early colonial Mexico was also enhanced by influences from Asian art. The famed lacquer workshops of Michoacán and Guerrero, which still flourish today, made exquisite lacquered wooden trays and other objects throughout the colonial period. In pre-Hispanic times, artisans in these regions made lacquered gourds, which in Michoacán were an élite product. Beginning in the second half of the sixteenth century, missionary friars encouraged these lacquer traditions and founded new lacquer workshops. Following a pre-Hispanic technique, the lacquer workers applied a layer of oil, limy powders and colours on to the polished surface of a gourd, as well as on to wood (which was not used in pre-Hispanic times) and then the surface would be burnished to a shine. Some of the oils were made from the cochineal insect or seeds. The colours included mineral, animal or vegetable pigments and the limy powder was made from grinding soils and stones. Sometimes designs would be carved through the paint into the original wood with a sharp stylus, and then these patterns would be painted in different colours and

54
Batea,
17th century.
Inlaid lacquer
wood;
diam. 125 cm,
49⅛ in.
Museo de
América,
Madrid

the whole burnished again and given a unified surface. Others, not true lacquers, would have a thick layer of slip over the vessel, on to which artists would then paint the patterns directly.

The earliest workshops were in Uruapan and nearby Peribán, where artists copied patterns and motifs from Renaissance printed books and engravings, favouring an Italianate pattern of plants and human figures called a 'grotesque'. The main product was a flat tray of wood called a *batea* that was destined for the households of the wealthy, where they were esteemed as decorative accents. This early *batea* (54), made in the

seventeenth century in Peribán, focuses on a double eagle and mitre motif, indicating the patronage of a member of the Spanish royal family who held a position in the Church. The concentric circles surrounding this motif are filled with patterns, including floral bands (some of which resemble pre-Hispanic glyphs), deer and Europeans on horse-back. Artisans also produced a plethora of smaller items like trunks, boxes for paper and writing desks. Guerrero vessels are the most brightly coloured, painted in green and red against an orange background.

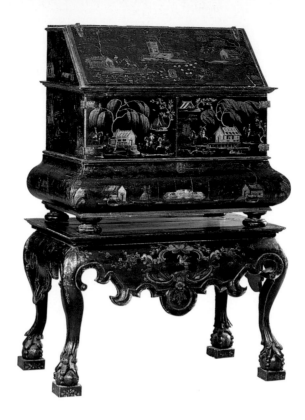

55
**Manuel de la
Cerda**,
Japanned
writing desk,
c.1760.
Lacquered and
painted wood;
h.155 cm,
61 in.
The Hispanic
Society of
America,
New York

Beginning in the eighteenth century, in the wake of an increasing vogue
for Asian-inspired patterns, lacquer workers began to copy a kind
of lacquer that was native to Japan which they called *maque* (after the
Japanese word for the technique, *maki-e*). The Michoacán pieces (from
Pátzcuaro and Uruapan), which ranged from *bateas* to larger pieces of
furniture, most closely resemble Asian models. Set against a black
background, patterns included gold filigree work inspired by Japanese
models, Japanese temples and landscapes, as well as European-inspired
ornament and figures, all of which appear on an eighteenth-century
writing desk (55) from Pátzcuaro, by the lacquer master Manuel
de la Cerda. Many of them also included scenes of pre-Hispanic life,
as remembered or reconstructed by these extraordinarily creative
painters, a combination of Asian and indigenous imagery that was
typical of colonial New Spain and will be discussed at greater length
in Chapter 7. These fascinating combinations of two kindred worlds –
the Amerindian and that of Asia – were an ingeneous alternative to the
dominant culture of Europe.

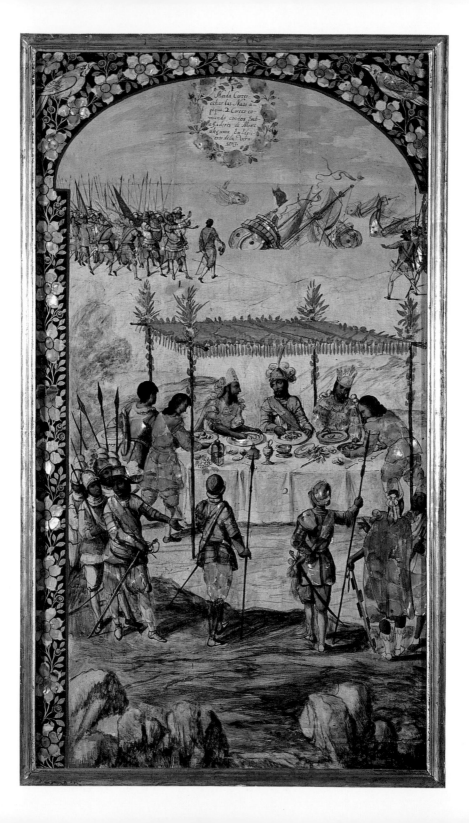

In 1664, the citizens of the Mexican port city of Veracruz anxiously awaited the arrival of the most exalted official in the realm. Rehearsing the role they had played every few years for almost a century and a half, brightly attired municipal and military officials marched in ordered ranks to meet a messenger ship from the Yucatán fortress of Campeche. Soon afterwards, a fleet of royal galleons appeared over the horizon and docked at Veracruz, which was the first city to be conquered by Cortés and New Spain's main link with Europe. Accompanied by his hunting birds, greyhounds, chargers, personal staff and crates filled with his furniture, clothing, jewels, money, books and personal correspondence, the guest of honour and his wife climbed into a launch for the final few hundred feet to the shore, where they received the keys of the city, attended a Te Deum mass (a hymn of joy and thanksgiving) in the church and inspected the fortress of San Juan de Ulúa. Thus began the *entrada*, or entrance, of the twenty-fifth viceroy of Mexico, Don Antonio Sebastián de Toledo, Marquis of Mancera, and his brilliant and cultured wife, Vicereine Doña Leonor Carreto. This ritualized re-enactment of the Conquest, from Veracruz to Mexico City, was performed upon the inauguration of every viceroy. Replete with allegories about the colony's ties with Spain, the conquistadors and the Aztecs, and the unity of the people, the *entradas* were a combination of processions, musical and theatrical performances, liturgical celebrations, bullfights and speechifying that involved the full range of Mexican society: Indians, Spaniards, *criollos*, *mestizos* and other non-European castes. They were also one of the most flourishing venues for secular art patronage in colonial Latin America.

Although the vast majority of surviving Latin American colonial art is religious in nature, secular art and architecture were an equally important facet of colonial society. The grandest and most important branch of secular art patronage came from the viceroys, the Spanish and Portuguese kings' representatives in the Americas, and the closest

56
Miguel and Juan González, *The Dinner at Veracruz*, from *The Conquest of Mexico*, c.1698. Panel painted and inlaid with mother-of-pearl; 97 × 53 cm, 38⅛ × 20⅞ in. Museo de América, Madrid

thing Latin America had to European royalty. This patronage extended
to nearly every branch of architecture and the visual arts. It included
the very urban structure of Latin American cities, with their trade-
mark grid patterns, as well as monumental civic architecture such
as palaces, fortresses, hospitals and villas. It also included history
painting, portraiture and an extravagant but temporary branch
of the arts called 'ephemera' created for the *entradas*, state funerals
and other public spectacles.

The designs, placement and styles of these buildings, and the subjects
chosen for these paintings and ephemera, did not simply satisfy
practical or aesthetic needs. Viceregal art and architecture were
specifically intended to project an image of empire related to the
distribution of power and control of knowledge in colonial society.
This ideology is best seen in viceregal buildings. These monuments
represented what their designers held to be the highest standards
of European architecture, employed in the belief that they would
impress the indigenous people with the superiority of European
civilization. Chief among these standards were the classical styles
of Greece and Rome, and their revival in the Italian Renaissance.
Aside from being related to a great civilization of the past – the
Roman Empire – classicism was also seen as embodying characteristics
such as reason, order and endurance. Even after tastes shifted in Europe
towards the Baroque and Rococo in the seventeenth and eighteenth
centuries, Renaissance classicism remained the style of choice for
the architecture of the viceroys and governors, and in Spanish
America it received a final boost at the end of the eighteenth century
as the Bourbon crown championed an even more strictly classical
style called Neoclassicism – a last-ditch attempt to reassure European
and American audiences alike of their authority over an increasingly
unstable hemisphere. The same was not true of church architecture
in the Americas, which embraced some of the world's most creative
and decorative forms of Baroque style beginning in the mid-
seventeenth century. Because church architecture and religious art
belonged more to the people, it followed different models (including
indigenous ones) and was more expressive of their tastes and goals
(see chapters 5 and 6).

The arts of the viceroys were only part of a larger system of colonial control, which was predicated on the social distance and superiority of the ruling class and a carefully ranked hierarchy of castes that categorized the population into governable groups, as already seen in the *casta* paintings in Chapter 1 (see 30). Many of these groups, notably those with non European blood, were depicted as traditional, archaic or primitive people who required the wisdom and order of European civilization for guidance. These relationships are reflected not only in the arts of the viceroys, but also in things like maps, histories, gazetteers and public rituals. Yet, perhaps surprisingly, it was not only the viceroys who supported these ideological fictions.

Even though it explicitly championed an overlord/subject relationship, Europeans, *criollos*, *mestizos* and Amerindians alike participated in this image of empire because it could be used to further differing agendas of power and prestige. Indeed, the pre-Hispanic past was a key component of this image. Amerindians made a show of respect for the Spanish monarchy to legitimize their own position in the face of *criollo* pre-eminence, promoting the idea that their pre-Hispanic rulers were the natural forebears of the Spanish kings and that their nobility was equivalent to that of the Iberian Peninsula. The *criollos* promoted the idea of the Spanish Empire because it represented their very right to live in the New World, but they also used the pre-Hispanic past to enhance their standing in the eyes of their Spanish cousins, as it gave their homeland an antiquity comparable with that of Europe. *Mestizos*, occupying a more ambivalent position, felt affinities with both Amerindian and Spanish heritage. Meanwhile, even though the Spanish officials championed their own Greco-Roman past – refracted through the Italian Renaissance – as a symbol of enlightened rule, they were also careful to emphasize their rightful inheritance of the Aztec and Inca thrones, maintaining the myth of a seamless transfer of power from the pre-Hispanic regimes to the Spanish king (as we have seen with the Inca portrait series in Chapter 1). The preservation of this delicate balance of ethnic pride was Spain and Portugal's greatest challenge in maintaining authority over their far-flung empires.

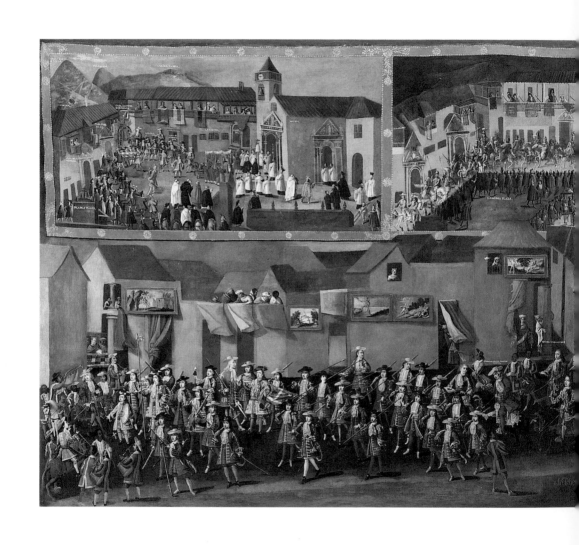

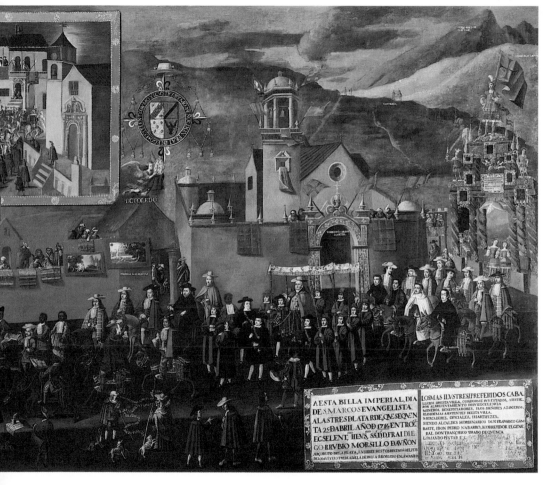

57
Melchor Pérez
Holguín,
The Entrance of
Viceroy Morcillo into
Potosí,
1716.
Oil on canvas;
2·3 × 6 m,
7 ft 6 in
× 19ft 8¼ in.
Museo de
América, Madrid

The *entradas* are a particularly rich manifestation of this image of empire and they also bring together the full range of art forms, from architecture to painting. An unlikely combination of Roman triumphal iconography, Aztec imperial symbolism and Catholic spirituality, the Mexican *entrada* processions stopped at cities that represented, in turn, imperial power (Veracruz), Indian civilization (Tlaxcala) and *criollo* society (Puebla). When the viceroy reached the city of Tlaxcala, a historic ally of the Spanish against the Aztecs, he rode behind a phalanx of Tlaxcalteca nobles holding ribbons attached to his horse's bridle. In front of a temporary architectural structure decorated with 'hieroglyphs' symbolizing his just administration, he watched a theatrical performance called a *loa* (a brief prologue to a principal entertainment) before continuing on to the church to hear another Te Deum. Similar events awaited the viceroy in the *criollo* town of Puebla, although with fewer references to indigenous culture. At either Cholula or Otumba (both are sites of important victories over the Aztecs) the new viceroy exchanged the sceptre of administration with his predecessor. The entry into Mexico City recapitulated the themes of his trip from Veracruz, including a visit to the Aztec park of Chapultepec as well as the Christian shrine of Guadalupe, both significant to the indigenous populations – the one secular, the other sacred. The *entrada* culminated in two events which were held under temporary triumphal arches, the first in front of the church of Santo Domingo, where the viceroy received the keys of the city, and the second in front of the cathedral, where he heard a final Te Deum before taking his oath of office in the nearby viceregal palace.

Similar ritualistic *entradas* existed in other parts of Spanish America. An extremely rare depiction of one by the *mestizo* painter Melchor Pérez Holguín (c.1660–1742; 57) shows the entry of Viceroy Archbishop Morcillo into Potosí in 1716. Fr Diego Morcillo Rubio de Auñón was a Trinitarian friar (a member of the Catholic Order of the Holy Trinity), who at the age of seventy-four became not only Archbishop of Charcas (modern-day Sucre) but the interim viceroy (clerics were often called in at short notice to fill in for

58
Manuel de Arellano,
Translation of the Image and Inauguration of the Shrine of Guadalupe,
1709.
Oil on canvas;
176 × 260 cm,
69¼ × 102⅜ in.
Private collection

departing viceroys), which meant that the elderly friar had to march over 1,000 km (600 miles) from the Bolivian Highlands to Lima. Fr Diego's route was a marked change from the traditional entry of Peruvian viceroys, in which the incumbent would arrive at the port of Paita, significant as the landing place of the conquistador Francisco Pizarro, and make a quick march southward to the capital. The proud city of Potosí commissioned this painting to record the event. The parade reveals the same combination of indigenous, classical and European symbolism as its Mexican counterpart. Adorned

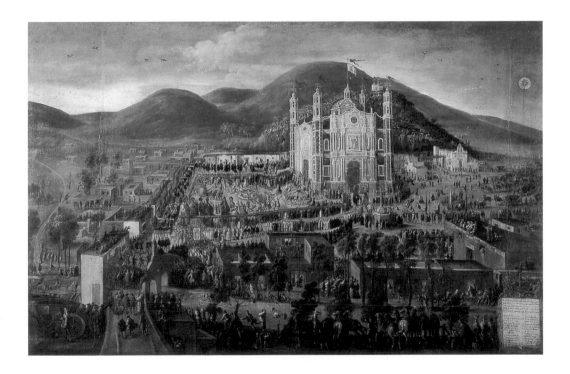

with brightly coloured Andean textiles and ephemeral paintings of Greek mythological figures – including the Colossus of Rhodes and the Fall of Icarus – the decorations were strikingly different from the religious subjects that decorated the same route during Corpus Christi processions. The event gave the citizens of Potosí an opportunity to show off their finest textiles, including *lliclas*, identified by their characteristic divisions of pattern, and also textile-woven covers or small hangings, recognized by their wide borders and central fields. The *lliclas* probably belonged to the women shown standing on

the rooftops, and recall an Inca tradition of hanging textiles outside
buildings during festivities such as the wedding of a monarch. A
temporary wooden triumphal arch in classical style stands at the far
right of the painting, festooned with twisted columns and finials of
imitation marble, statues, gold-framed paintings and inscription
panels. The viceroy rides under a silk brocade palanquin accompanied
by troops, local nobility (including black or Indian figures) and

Art of Colonial Latin America

59
*Funerary
Catafalque of King
Philip IV in
Mexico City
Cathedral,*
1666.
Engraving:
47·5
× 31·5 cm,
18⅟₄ × 12⅟₄ in

members of the church hierarchy. In the scenes shown in miniature
above, we see the viceroy's arrival in the cathedral and a nocturnal
play performed in his honour in the Plaza Mayor. Holguín places
himself in the canvas just above his signature as a spectator of
the event, palette in hand. Next to him two townspeople praise the
event in the local dialect. The city of Potosí lavished 150,000 pesos
on this festival.

Not all viceregal spectacles were so secular in nature. A religious event is the occasion for similar splendour in New Spain in *Translation of the Image and Inauguration of the Shrine of Guadalupe* (1709; 58), by Manuel de Arellano. In this bustling scene, commissioned by the thirty-third viceroy Francisco Fernández de la Cueva, the Duke of Albuquerque, we witness a grand procession in front of the new church (built between 1684 and 1709 by Pedro Arrieta and others), set in a panoramic landscape that includes the river Guadalupe, Tepeac Hill, a bridge, villages and houses. Amerindians, *criollos, mestizos* and Spaniards join forces to celebrate the new home of Mexico's most beloved sacred image, including the viceregal couple, the archbishop, canons, members of religious orders and other clerics, the town council, soldiers, confraternities and foreign dignitaries. On the patio to the left of the church an allegorical parade is in full swing around the star-shaped fountain, featuring eight giant allegories of the Four Continents – a pair of turbaned Asians, feathered Aztecs, liveried Africans and periwigged Europeans. In the background a parade float startles a group of horses with its representation of St Michael and the Beast of the Apocalypse, the latter based on a pre-Hispanic dragon called a Tarasca monster. A mixture of religious and secular imagery, the procession not only celebrated the links between Church and State, but also between Europeans and non-Europeans.

The triumphal arches prepared for these *entradas* provided abundant work for artists, as events of this kind occurred with great frequency – the viceroys only served for multiples of three years and the state also sponsored processions commemorating royal births, marriages and coronations, as well as victories won in far-off European battles. The meanings of these structures, which often had allegorical names such as the 'Catholic Mars' or 'True Ulysses' that related to the viceroy's name, were so arcane that the state commissioned prominent literary figures such as Sor Juana Inés de la Cruz and Carlos de Sigüenza y Góngora to write interpretative guides, as well as poetry and theatre pieces to accompany them. An equally important kind of monumental ephemeral structure was the catafalque, or funeral bier, that was set up inside metropolitan churches to commemorate royal deaths.

An engraving from 1666 (59) preserves the appearance of the funeral catafalque of the Spanish king Philip IV (r.1621–65) in Mexico City Cathedral and it also happens to be the earliest depiction of the interior of that church (see 160). Using an iconography and classical architectural style reminiscent of the triumphal arches, the catafalque was conceived as a dynastic apotheosis of the Habsburg dynasty, with sculptures and paintings serving as allegories about the permanence of the monarchy and associating it with the great heroes and gods of ancient Greece and Rome.

We can get a taste of the erudite mythological imagery that adorned these long-lost structures by looking at this two-sided screen, or *biombo* (60), by the prominent Afro-Mexican painter Juan Correa (1646–1716). Popular in aristocratic homes, *biombos* were painted folding screens adorned with landscape and urban scenes that derived from the Japanese tradition of *byobu* screens. The *biombos* were either done in oil on canvas or – in another Japanese-inspired medium – as *enconchado* paintings executed on wooden panel with mother-of-pearl inlay, so that the inlay provides a glittering counterpart to the narrative. This *biombo* is entitled *The Liberal Arts and Four Elements* (c.1670) and was commissioned by Viceroy Archbishop Don Fr Payo Enríquez de Ribera. Derived from seventeenth-century Italian illustrated books on classical symbolism and allegory, such as Vincenzo Cartari's *Imagini delli dei de gl'antichi* ('Images of the Gods of the Ancients') and Cesare Ripa's *Iconologia*, Correa's screen shows female allegorical figures of the four elements riding on triumphal carts and accompanied by mythological figures. On the other side (shown here) similar figures represent the liberal arts, such as Grammatica and Astronomia, and display complex scientific instruments copied from the Jesuits' commemorative emblem book, the *Imago Primi Saeculi Societatis Iesu* ('A Portrayal of the First Century of the Society of Jesus'; 1640) – all accompanied by Latin epigraphs. The rich and inclusive landscape in the background is populated by a plethora of birds, animals, fruit and trees, and Correa's trademark warm palette lends the whole an inviting appearance that suggests fertility and prosperity. Colonial society had long shown a fascination for mythological imagery, which it encountered in atlases, maps and other publications. This *biombo*

60
Juan Correa,
*The Liberal Arts
and Four Elements,*
c.1670.
Oil on canvas;
242 × 324 cm,
95¹⁄₄ × 127¹⁄₂ in.
Museo Franz
Mayer,
Mexico City

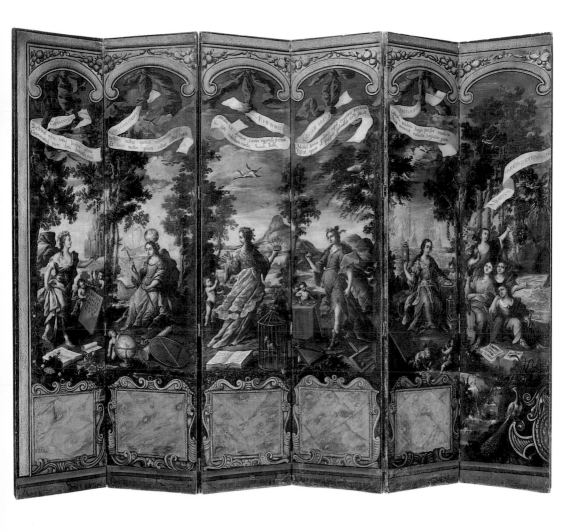

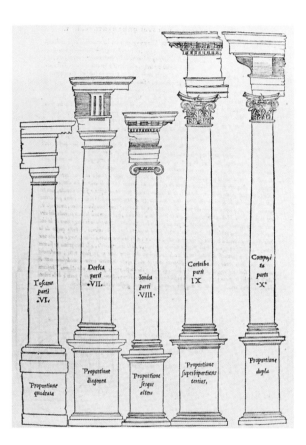

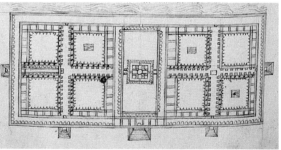

61
**Sebastiano
Serlio**,
The Five Orders,
from *Tutte l'opere
d'architettura et
prospettiva*,
Venice, 1537

62
Filarete,
Plan of the
Spedale
Maggiore,
Milan,
from the
*Trattato
d'architettura*,
Milan, 1460–4

also demonstrates a particularly Latin American fascination for scientific instruments. The sixteenth and seventeenth centuries witnessed the publication of numerous manuals of scientific instruments, which were eagerly read by figures such as Sor Juana and Sigüenza y Góngora, who incorporated scientific metaphors into their poetry. The screen gives us a rare glimpse of a refined colonial lifestyle that now exists mostly in written descriptions.

If most viceregal ephemera are lost to us today, the same is not true of viceregal urbanism and architecture: the fortresses, the grid-plan cities, the viceroys' and governors' palaces, the mints and state hospitals. Yet these public spaces and buildings were less welcoming than the *entradas* with their imagery of inclusiveness and ethnic harmony. Viceregal public architecture was massive and austere, with long, low expanses of flat wall enlivened only by plain windows and a few classical details. It left little room for indigenous styles or symbolism, and relied heavily on the vocabulary of the Italian Renaissance, championed by Spanish monarchs such as Philip II as a symbol of their just and enlightened rule. Such monuments were designed to impress.

The Renaissance movement in Italy and Spain resurrected the architectural forms of ancient Greece and Rome, an architectural system based on the 'orders' (61), styles composed of a system of coordinating structural forms derived from temple architecture, identifiable especially in the capitals (the crowns) of the columns. The orders ranged from the plain and austere Tuscan and Doric to the elaborate Corinthian and Composite, and they were often meant to represent different human traits, from solidity to gracefulness, or even differences between the sexes. The structural elements of the classical orders include columns, entablatures (the horizontal element, including the frieze), pilasters (flat, rectangular column-like structures embedded in the wall) and pediments (the triangular or semicircular cap to a façade, derived from Greek temples).

This universal 'language' of architecture was transmitted through Italian architectural manuals, especially those of Sebastiano Serlio (1475–1555) and those which reflected the ideas of the architect

and sculptor Filarete (Antonio Averlino; c.1400–c.1469). Filarete's
utopian models for public architecture, championed in his fantastical
Trattato d'architettura (1460–4), included centralized building and city
plans such as the Spedale Maggiore in Milan (62) and the unexecuted
city of Sforzinda. Latin Americans had access to these manuals from the
very beginning of the colonial era. Translated into Spanish in the mid-
sixteenth century, books by Serlio, Leon Battista Alberti and Vincenzo
Scamozzi (1552–1616) found their way into the libraries of the

viceregal palaces, great urban monasteries, cathedrals and far-off
missions alike. Masons made sketches from them as they designed
window dressings and doorways, and friars and civic officials copied
their plans in their own designs for churches and government build-
ings. Colonial officials who continued to build state structures in an
austere Renaissance style throughout the colonial era may even have
been heeding Serlio's advice that sober structures in the Doric order
were suitable for buildings devoted to men of robust character.

Viceregal architecture differs strikingly according to location. If we were to follow the route taken by the incumbent viceroys, we would notice a surprising change between the Crown's buildings on the coast and those of the interior. Since it swarmed with pirates eager to seize treasure-laden Spanish flotillas, the Caribbean coastline was heavily defended, with some of the most imposing and impregnable fortresses in the world. The Spanish king constructed a chain in strategic positions in places like Havana, San Juan, St Augustine (in Florida),

Veracruz, Campeche and Panama – as well as the giant fortress of San Diego on the Pacific coast at Acapulco, built to guard the equally important trade route of the Manila Galleon, the vastly profitable trade ship which sailed annually from 1565 to 1815 bringing Asian goods to the Americas and Europe in exchange for New World silver. The Crown contracted with European military engineers, most notably the Italian Battista Antonelli (fl.1582–1616), commissioned by Philip II in 1581 to inspect and repair the Caribbean forts.

The most impressive fortress of all was the military installation at Cartagena (63) in present-day Colombia, an extensive walled complex built on a group of islands between the swampland and the open sea. The town's site was difficult to defend because it included two separate entrances, making Cartagena a regular victim of French and English pirates, including the Elizabethan adventurer Sir Francis Drake. Antonelli enlarged the fortifications in 1586, including a ring of no fewer than five forts to guard the entrances to the port. The urban ramparts, designed in 1603 by Antonelli's Spanish nephew Cristóbal de Roda (fl.1595–1603) to guard the city from a siege by land, took almost a century to build. Yet these structures paled in comparison with Cartagena's crowning landmark, the massive fortress of San Felipe de Barajas, built between 1630 and 1657 under governor Pedro Zapata de Mendoza, and rebuilt in 1697 by Juan de Herrera y Sotomayor (fl.1697–1730) and again in 1762 by Antonio de Arévalo (fl.1762–79). Dominating the city from its hilltop location, the Castillo San Felipe is guarded by walls over 20 m (65 ft) thick at their base and its summit is linked to the sea by miles of subterranean passageways. Rising on a series of massive stone platforms with sloping sides and visible from a great distance, the unforgettable profile of this monument to Spanish might bears a striking resemblance to the pyramids of Teotihuacán.

63 Previous
page
Fortress of
San Felipe
de Barajas,
Cartagena,
Colombia,
1630–57,
rebuilt 1697
by Juan de
Herrera y
Sotomayor,
1762 by
Antonio
de Arévalo

In sharp contrast to the coast, the continental interior had almost no fortifications. Their absence would have shocked anyone from Europe, where every town and even village was walled and protected with turrets and fortresses. As one English observer noted about a Spanish American capital in the seventeenth century: 'this city, as all the rest of America (except the sea towns) lieth open without walls, bulwarks, forts, towers or any castle, ordinance or ammunition to defend it.' The truth was that there was little threat of piracy beyond the coast, and indigenous uprisings were few and far between. Few realize that Spanish America enjoyed relative peace for almost the entire three centuries of its colonial era – a time when Europe was embroiled in some of the bloodiest battles of its history.

The grandest reflection of Renaissance idealism in colonial Latin America was the standardized grid plan of the cities, whose main

inspiration came once again from manuals by ancient Roman or Italian Renaissance architects such as Vitruvius (first century BC), Alberti and Filarete, and it was codified officially in the ordinances of the Laws of the Indies, compiled in 1573 by King Philip II to regulate the foundation and appearance of new settlements in the New World. Even though these books came from Europe, this grand experiment in city planning was first tried out in the Americas and there were no sizeable examples in the Old World before 1600. Built to recall the Imperial

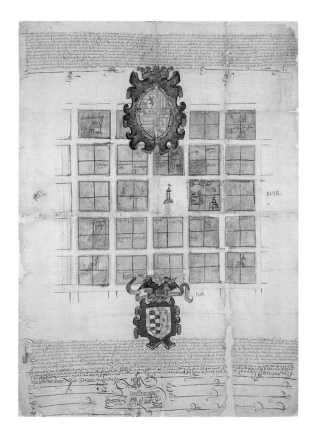

64
Thomas Suárez,
Plan of the city of San Juan de la Frontera, Argentina, 1562.
Ink and pigments on paper.
Archivo General de Indias, Seville

Roman city type, in which two principal streets (*decumanus* and *cardo*) intersect at a forum, grid-pattern towns surrounding a central square were also practical because they were not only easy to design, but could be expanded in any direction as far as the geographical setting would allow. This is suggested in an early plan of the city of San Juan de la Frontera (64) in present-day Argentina, where the streets are intentionally left unfinished on the sides. The most impressive examples

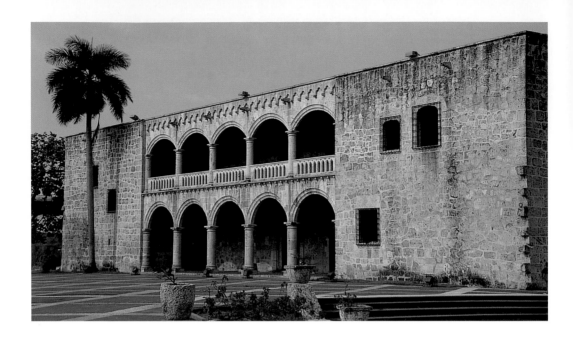

are in the flat Argentine pampas, where cities like Rosario extend, block after block, as far as the eye can see. Unlike European medieval cities with their haphazard streets, grid-pattern towns did not derive from the specific needs of the site but were designed in advance and only later adapted to their setting. The first grid-plan cities were laid out in Santo Domingo (present-day Dominican Republic) and Mexico City, and they soon spread throughout Spanish America. By contrast, the grid-pattern model never made much headway in Brazil, at least not before the eighteenth century. In part because most early Brazilian towns were little more than coastal fortresses and space was limited, they tended to follow the haphazard plans of their medieval Portuguese counterparts instead of the more expansive schemes of Spanish American cities.

Rome was not the only ancient model for the Spanish American grid plan. Another, more direct, inspiration came from the pre-Hispanic world. Several pre-Conquest cultures built cities in a grid or chess-board pattern surrounding an open square (see Chapter 1), including the pre-Aztec ritual centre of Teotihuacán (1–650 AD) and Mexico City's predecessor Tenochtitlán (after 1325). Sometimes the colonial cities were built directly on top of them. Aztec cities focused on a large

open square with four main roads exiting from the sides. These squares housed the main pyramid or temple, and often the main administrative building as well, as in the case of Tenochtitlán where both the palace of Moctezuma II and the great pyramid flanked the square. To the Aztecs this public space was a sacred ceremonial zone, called the 'heart of the one world', and its location next to the residence of the ruler gave the centre of the city a combined sacred and secular significance. By replacing the grid-plan cities of the Aztecs with those of the colonists, the Spanish monarchy proclaimed once again the seamless transition from indigenous rule to European dominion.

65
Reconstructed
west façade,
the Alcázar,
Santo
Domingo,
Dominican
Republic,
after 1510

The first real city in colonial Latin America was Santo Domingo (founded 1496), on the island of Hispaniola in today's Dominican Republic, although its slightly imperfect grid plan was far less impressive to visitors than its buildings. Santo Domingo was the centre of the Spanish Empire in the Americas until the 1550s, losing its importance only with the opening up of the continental interior. Santo Domingo was founded by Bartolomé Colón, the brother of Christopher Columbus, and a monumental stone town was built between 1500 and 1509 by his successor Nicolás de Ovando. Travellers remarked on its superiority to Italian cities, favourably contrasting its rectilinear streets with Florence's urban congestion, and also noting with satisfaction that the buildings of Santo Domingo reflected the latest styles from Spain and Italy. The masons and architects came from Andalusia and Castile, the older ones working in the late Gothic and Plateresque styles of their generation, and the younger ones in the purer Italian Renaissance style that was now fashionable in Spain. Santo Domingo captured the transition between Gothic and Renaissance at the very moment when it was happening in Spain itself or even earlier.

The most impressive building was (and is) the palace, or Alcázar (65), built after 1510 for Diego Colón, Christopher Columbus's son and the Admiral of the Indies and governor of Hispaniola from 1508. Together with their small court, Diego and his noble wife, María de Toledo (the niece of the Spanish king and kinswoman of the dukes of Alba), ushered in the kind of aristocratic lifestyle that would become typical of the Spanish governors and viceroys in the centuries to come.

The Colóns aspired to the ideals of the Italian nobility, who fostered a tradition of contemplative leisure at their villas which were traditionally located just outside the city walls. The greatest promoters of the villa lifestyle in Italy were the Medici family of Florence, the most celebrated art patrons of the Renaissance in the fifteenth and sixteenth centuries. The Medici presided over a revival of Greco-Roman aristocratic villa life that played into a general enthusiasm for Antiquity and also related to the Florentine poet Petrarch's notion that the life of artistic and philosophical creativity could only exist in the countryside. Consequently, the Medici set up their most important centres of learning in their villas, most notably that of Careggi, just outside Florence, where Lorenzo the Magnificent established the celebrated Platonic Academy, home of illustrious philosophers such

66
Jacopo Sansovino,
Villa Garzoni,
Pontecasale,
Italy,
1526

67
Filippo Brunelleschi,
Spedale degli Innocenti,
Florence, Italy,
begun 1419

68
Attributed to Diego Díaz de Lisboa,
Palacio Cortés,
Cuernavaca,
Mexico,
1523–8

as Giovanni Pico della Mirandola and Marsilio Ficino, who studied and emulated classical literature and founded the movement known as Humanism. Although security required the Colóns to build their Alcázar inside the town, the architecture closely mimicked the design of these Italian villas.

The Alcázar predated any structure of this kind in Spain. A rectangular, two-storey building, it features an elegant double loggia in the centre of both sides which looks as if it has been lifted from the Tuscan countryside or the Veneto – in fact, it closely resembles the Villa Garzoni (1526; 66) at Pontecasale, Italy, built more than ten years later by the great Venetian architect Jacopo Sansovino (c.1467–1529). Both buildings have façades divided into three parts, with the two flanking ends closed and the central section open in a two-storey, arcaded

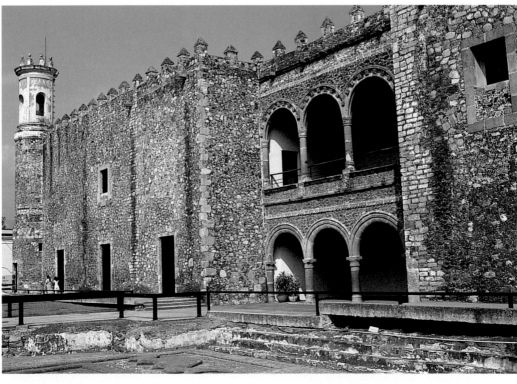

loggia. The Alcázar's loggias, with arches rising directly from columns, also pay homage to a more famous Renaissance structure in Florence, the arcade in front of the Spedale degli Innocenti (the Foundling Hospital; 67) begun in 1419 by Filippo Brunelleschi (1377–1446). Colón's villa soon became the model for similar structures in the Caribbean and Central America, including the house of Cortés (68) in Cuernavaca, Mexico, which the conquistador commissioned in the 1520s (possibly from the Portuguese architect Diego Díaz de Lisboa)

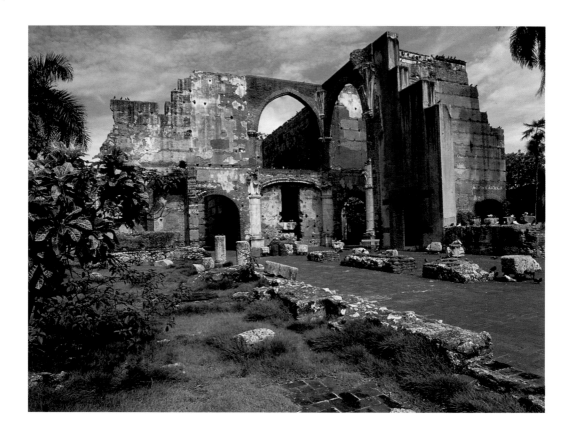

to proclaim his newly acquired aristocratic status.

A desire to emulate the European princely courts led to other grand building projects in Santo Domingo. One of the first structures was the Hospital of San Nicolás (before 1509–c.1549; 69), founded by the namesake governor Nicolás de Ovando primarily to administer to the sailors who passed through the port. Again evoking Renaissance Italy, the town built a permanent structure between 1533 and 1552 on the

model of the vast hospital of Santo Spirito in Sassia, near the Vatican in Rome, which had been reconstructed by Pope Sixtus IV (r.1471–84) between 1473 and 1478. Two storeys high with four separate wings built on a cruciform plan, the Hospital of San Nicolás merged secular and sacred with a chapel at its core, another transitional building with a Renaissance portal but Gothic rib vaults inside. Its giant sick wards could hold fifty to seventy people – comparable in scale to its Roman model. The hospital's symmetrical plan goes back once again to Filarete, this time his Spedale Maggiore in Milan (see 62), which was included in his manual on architecture and had likewise inspired a series of royal hospitals built in Spain in the early sixteenth century. The Hospital of

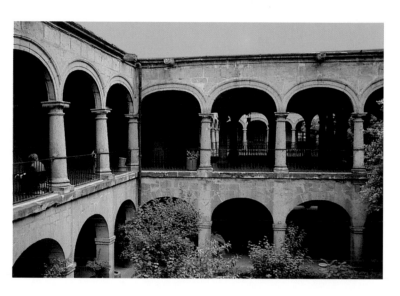

69
Hospital of San Nicolás, Santo Domingo, Dominican Republic, before 1509–c.1549

70
Attributed to Pedro Vásquez and Diego Díaz de Lisboa, Hospital de la Concepción (Jesús Nazareno), Mexico City, 1524

San Nicolás was copied throughout Latin America, most importantly in Mexico City where Hernán Cortés erected the Hospital de la Concepción (later Hospital de Jesús Nazareno, 1524; 70), possibly designed by Pedro Vásquez and Diego Díaz de Lisboa. Also formed of two grand arcaded courtyards (one for men and one for women), this hospital recalled not only Italian prototypes but also Spanish palace architecture.

Santo Domingo could not compare with its successor Mexico City, the capital of New Spain and the main prototype for urban Latin America. Designed between 1523 and 1524, its streets extended in an unbroken grid into the surrounding countryside, as is vividly illustrated by a

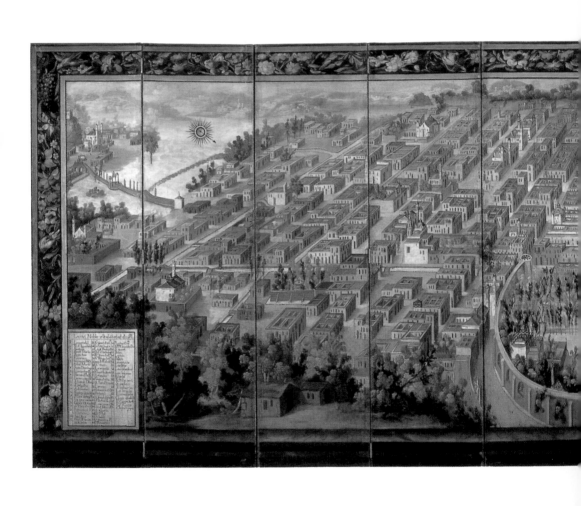

71
Biombo
depicting
bird's-eye view
of Mexico City,
17th century.
Oil on canvas;
2·13 × 5·5 m,
6 ft 11⅞ in
× 18 ft 6 in.
Museo Franz
Mayer,
Mexico City

seventeenth-century *biombo* (71). The ten-panel screen, meant to serve as an accent in a large reception room, shows the city radiating outwards from the main plaza (called the Zócalo in Mexico) with the cathedral on the left and viceregal palace at the top – in Spanish American cities the principal buildings of the Church and the State were usually located on the main plaza. Here, the Zócalo also houses the Royal and Pontifical University of New Spain, founded in 1551. This panoramic view shows that, despite its size, Mexico City was an orderly and uniform settlement of two-storey housing blocks surrounding multiple courtyards.

As decreed in the 1573 Laws of the Indies, Mexico City had no privately owned buildings on the main square, and the lower floor

72
Roman
Aqueduct,
Segovia, Spain,
1st century BC

73
Aqueduct,
Morelia,
Mexico,
1785

74
**Claudio de
Arciniega and
others**,
Viceregal
Palace (Palacio
Nacional),
Mexico City,
begun before
1562, enlarged
1563–4,
reconstructed
after 1692,
third floor
1926

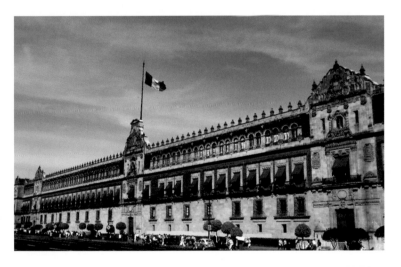

of the buildings fronting it sometimes featured covered arcades for shade or protection from rain. Two streets exited this square from each corner (so that the four winds blew across the corners) and the surrounding blocks were given over to shops and dwellings for merchants, the meat market and slaughterhouse, private homes, a hospital and the churches of the religious orders, each with its own smaller plaza. The view of Mexico City shown on the *biombo* also includes the aqueduct of Chapultepec – itself of Aztec origin – at the lower right, a long arcade resembling a fortified wall. Some Latin American aqueducts also drew upon classical models, especially Roman aqueducts such as one in Segovia (first century BC; 72). A later

example is the aqueduct of Valladolid (now Morelia, Mexico; 73), built of stone in 1785 with 253 arches by Fr Antonio de San Miguel, which is longer than the main expanse of the Segovia aqueduct.

The grandest reflection of imperial rule was the Viceregal Palace (74) in Mexico City. It had a long, low façade with minimal decoration and it projected an image of authority and rationalism derived from Spanish prototypes, themselves based on Italian Renaissance models. The block-like exterior of the viceregal palace, with its corner towers,

is especially close in spirit to the imposing Alcázar in Toledo, begun in 1537 by Alonso de Covarrubias (1488–1564/70), and the original two-storey structure featured spacious rectangular courtyards like a Renaissance palace. The main decoration was reserved for an ostentatious doorway crowned by the royal coat of arms, an emphasis on the entrance that was typical of Spanish American government buildings. The palace's military-style rusticated walls, plain windows and battlement-like bell tower, seen in this drawing from 1595 (75),

were only meant for show. A 1692 reconstruction gave the building a more unified focus on the central door and projecting corner towers, bringing it closer to the Toledo Alcázar (the third floor was added in 1926). The Viceregal Palace had been purchased from Hernán Cortés' son Martín in 1562, who had built it on the site of Moctezuma's palace. Like the city itself, the palace's location was symbolically significant – even its shape echoed that of the pre-Hispanic structure, with galleries surrounding patios – and it helped underscore the myth of a seamless transition of rulership.

A later depiction of the Viceregal Palace in Mexico City (76), again on a biombo meant to adorn a grand viceregal home, shows the building as it appeared around 1660. The most outstanding feature is the golden Balcony of the Queen, a delicately carved wooden oriel window built in 1640 by the engineer Juan Lozano Ximénez de Balbuena and destroyed by a fire in 1692. Inspired by imperial models such as the Goldenes Dachl (Golden Roof; 1494–6) built by the Habsburg emperor Maximillian I (r.1493–1519) in Innsbruck, Austria, the Balcony of the Queen served as a viewing stand for the viceregal court to watch civic spectacles in the square below and it symbolized the Crown's vigilance over its colonies. The biombo scene shows the kind of ceremonial procession that would have accompanied the viceroy when he arrived at his palace. Seated safely inside his massive black leather carriage pulled by a team of six black horses and guarded by footmen, the viceroy is awaited by courtiers who watch from the palace windows above. The surrounding scenery embraces the full spectrum of colonial society, from the Indians and Africans selling their goods in the shops in the Zócalo below to the Spanish aristocrats strolling in the promenade along the canal of Santa Anita Ixtacalco on the left. The golden clouds that float in the middle of the scene are a motif borrowed from Japanese screens of the Momoyama period (1573–1615), demonstrating not only viceregal society's enthusiasm for visual splendour, but also for the kind of Asian artworks that were beginning to flood the market in Mexico City and would have a powerful impact on the decorative arts in the seventeenth and eighteenth centuries (see Chapter 7).

75
Plaza Mayor of Mexico City, 1596. Ink on paper; 46 × 65·5 cm, 18⅛ × 25¾ in. Archivo General de Indias, Seville

Arts of the Viceroys

Mexico City's design may have been an echo of Tenochtitlán, but Latin American urbanism was not always meant to resonate with pre-Hispanic traditions. The viceroyalty of Peru consciously avoided building their capital on the site of the Inca city of Cuzco, choosing instead to build a new city along the Pacific coastal lowlands where the lifeline with Europe was much more secure than in the rugged Highlands. Founded on the Rímac River in 1535 as the 'Ciudad de los Reyes' (City of the Kings), Lima quickly became the premier city of Spanish America, with its spacious streets, regal façades and showy balconies. To its planners and residents Lima was a clean slate, and its uniformity and clarity of design were a reflection of its moral superiority. This idealism is echoed by the Jesuit Bernabé Cobo, who remarked at the beginning of the seventeenth century that what made Lima one of the world's great cities was that, unlike European cities,

76
View of the Viceregal Palace, Mexico City, mid-17th century. Oil on canvas; 1·84 × 4·88 m, 6 ft ¹⁄₂ in × 16 ft. Museo de America, Madrid

it was uniquely free of the constrictions and limitations of the past and that it was a visual embodiment of the 'court and seat of government of this kingdom'.

Lima's Viceregal Palace, on the north flank of the Plaza Mayor (completed 1603; now destroyed), was even more splendid than its Mexican counterpart. Although it had a similar profile, its central doorway was much more imposing, with a full Renaissance stone portal framed by pilasters and columns and culminating in a pediment with a royal coat of arms. This portal is the focal point of a lively painting of a Good Friday procession in front of the palace in Lima's Plaza Mayor (77). Gazing down regally from a balustrade above the main doorway, the viceregal couple and their attendants are dramatically set apart from the crowds of courtiers that throng the building's other

balconies. The luxury of the Lima palace was a reflection of the Peruvian viceroy's seniority over the viceroy of New Spain – a pre-eminence based on Peru's greater wealth from its abundant silver mines. The monumental doorway at the Lima palace is a quotation from Philip II's gargantuan palace-monastery of the Escorial (78), built between 1563 and 1582 outside Madrid by the royal architects Juan Bautista de Toledo (fl.1547–67) and Juan de Herrera. Philip's main residence and the focus of his art patronage, the Escorial used an austere, Renaissance classicism – greatly influenced by Sebastiano Serlio – to recall the grandeur of the Roman emperors. The palace's profile takes up the entire background in the *Good Friday Procession in Lima*. Like its counterpart in Mexico City, it had elaborate wooden balconies on the upper floor, a style that derived ultimately from Spanish Muslim architecture, but these were

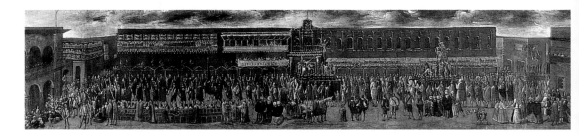

much more extensive, taking up half of the entire upper floor. Elaborate balconies became typical of Lima in general, and many extraordinary examples survive on the city's palaces to this day (see 186). In this painting the Viceroy is most likely Diego Benavides y de la Cueva, the Count of Santisteban.

The first colonial towns in Brazil presented a sharp contrast to their idealized Spanish counterparts, largely because the two empires had different approaches to colonization. Portugal's American possessions were merely a footnote to their growing Asian and African empires, whose capital of Goa in India was founded along much grander lines in 1510 (see Chapter 8). The first settlements in Brazil, like São Vicente (1532) or the first capital, Salvador (1549) in Bahia, were fortress towns whose main function was not to create colonies of Europeans but to mark their territory, establish plantations and protect their trade

77
Good Friday Procession in Lima,
c.1660–5.
Oil on canvas;
1·03 × 4·95 m,
3 ft 4¹⁄₂ in
× 16 ft 2⁷⁄₈ in.
Cofradía de la Soledad,
church of
San Francisco,
Lima

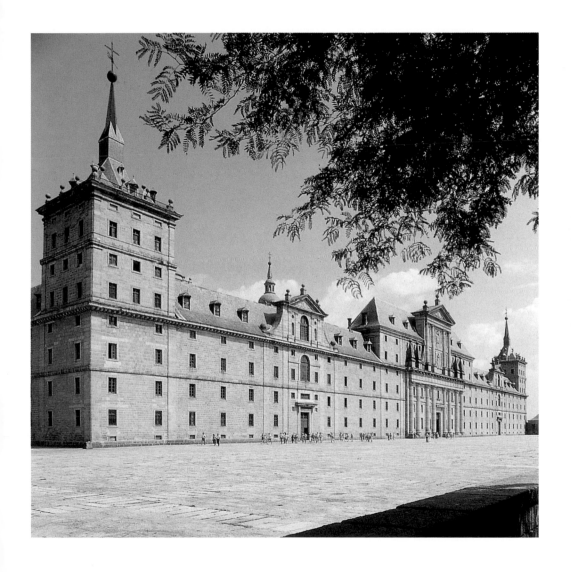

78
**Juan Bautista
de Toledo and
Juan de
Herrera**,
The Escorial,
Madrid, Spain,
1563–82

network. There was very little willingness – or opportunity – to colonize the interior. These towns were usually built on defensible hills on islands or peninsulas, and they were small enough so that the entire population could hide inside the walls in times of siege. Their streets and squares were crowded and irregular, like those of Portugal, and they had separate squares for the church and the governor's palace, unlike in Spanish America. Their buildings were even more bluntly austere, with undressed stones and mortar and a dearth of windows. Salvador was typical of these early fortress towns, with a fortified upper city including the fortress of the Portas do Carmen and the governor's and bishop's palaces, and a lower city in the plain fronting the harbour (see 79). The upper city was more formal than

79
View of the Pelourinho district of Salvador, Brazil

80
House of the Tower of Garcia d'Ávila, Praia do Forte, Brazil, begun 1551

the lower one and had relatively straight streets and public squares, such as the Praça Municipal with its Governor's Palace, but in general the winding hilly streets provide a strong contrast to its Spanish-American counterparts.

Like the Colóns in Santo Domingo, the first Portuguese landowners in Brazil tried to project an image of cultured Renaissance villa life as they grappled with the challenges of establishing an Old World aristocracy in the New World. One of the most striking of these villas in the jungle is the sixteenth-century House of the Tower of Garcia d'Ávila (80), 80 km (50 miles) north of Salvador, one of the earliest surviving

colonial buildings in Brazil. Rising dramatically on a hill 150 m
(500 ft) above a lush tropical forest near the mouth of the Pojuca
River, the startlingly rational and geometrically planned building
would look more at home in the rolling hills of Tuscany – the only
difference being the thick granite fortifications, built to defend the
site against pirates and other raiders. Noteworthy is the hexagonal
chapel which is its most striking feature. Built in the round, with a
simple rectangular doorway and a classical oculus window above,
the centralized church was precisely the sort of structure that Italian
Renaissance architects like Filarete held up as an ideal, and the spacious
and symmetrical arcaded courtyard at the back also derives from

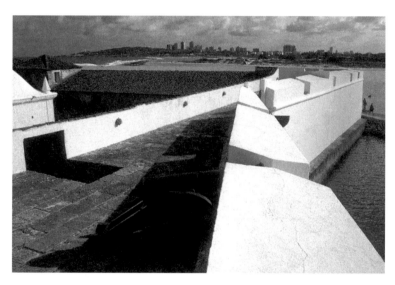

81
**Gaspar
Samperes and
Francisco
Frías da
Mesquita,**
Forte dos Reis
Magos,
Natal, Brazil,
begun 1598,
rebuilt
1614–28

Renaissance roots. The house was begun in 1551 by Luis de Brito
de Almeida de Garcia d'Ávila, one of the first settlers in the region.
Although not high aristocracy by European standards, the Ávilas were
landowners on a grand scale only possible in the New World. Their
property extended over 800,000 sq. km (500,000 sq. miles) – almost as
much as Portugal, Spain and Italy put together – and they raised cattle
for the fledgling colony.

Although Brazil had nothing to compare with the gargantuan Spanish
fortresses of the Caribbean, the Portuguese were very concerned with
fortifications, since most of their settlements were on the coast.

Between the sixteenth and eighteenth centuries, Brazil boasted almost 300 military architects, many of them Jesuit priests, who worked on civic structures as well as garrisons, bulwarks and redoubts. One of the most beautifully proportioned of Brazil's many coastal forts is the Forte dos Reis Magos in Natal (81), begun in 1598. Dedicated to the three Magi, on whose feast day (6 January) the first stone was laid, the fort was part of Portugal's attempt to secure Brazil for the Crown after much of the land left private hands. The Jesuit military architect Gaspar Samperes designed a structure of mud, stakes and sand whose walls formed a five-pointed star surrounding a spacious open plaza, echoing the Spanish forts in the Caribbean. This design was retained when Francisco Frías da Mesquita (fl.1603–34), the head military architect of Brazil from 1603 and 1634, built the present structure of whitewashed stone between 1614 and 1628. It is similar in design to some of Portugal's forts in Africa and Asia, such as Fort Jesus in Mombasa (present-day Kenya, 1593–6; see 213), designed by the Italian architect Giovanni Battista Cairato (fl.1580–96). Brazilian ties with Africa and Asia were strong and many Portuguese military architects served there before coming to Brazil. Typical was the career of Master Field Engineer Miguel Pereira da Costa (fl.1699–after 1716), who refortified Salvador in the early eighteenth century after tours of duty in Cape Verde and Angola.

Brazil did not have any palaces comparable in size to those of Mexico City or Lima until the eighteenth century, when the Portuguese colony began to enjoy the benefits of its gold and diamond mines, and grand palaces began to appear in cities like Rio de Janeiro. The Governor's Palace at Belém do Pará (1762–71; 82), the largest public structure ever built in colonial Brazil (now the Palácio Lauro Sodré), reflected the importance Brazil had gained when the Portuguese possessions in Asia and Africa were on the wane. It was designed by the Bolognese Antonio Giuseppe Landi (1713–91), a pupil of the renowned Giuseppe Galli Bibiena (1696–1756), the main theatrical engineer and architect to the Viennese court of Charles VI. Yet, in contrast to the wedding-cake Rococo designs of his mentor, Landi chose a relatively austere rectangular structure that echoed Italian villa architecture of the sixteenth century. In fact, the upper-storey arcade resting on pairs

of columns in the side elevation is a direct quotation from the Palazzo del Te in Mantua (1526–34; 83) by Giulio Romano (1499–1506) – one of the grandest country palaces of the Italian Renaissance and an attempt by Raphael's pupil to recreate an Imperial Roman villa – while only a hint of the more contemporary Rococo style is suggested by the window dressings of the main façade. By going back to a famous Renaissance building – itself with Roman pretensions – Landi invests the building's residents with symbolic ties to antiquity. These sober Renaissance ideals of morality and just rulership endured even in an era when southern Europe (and Latin American church architecture) was in thrall to the most extravagant, light-hearted Rococo.

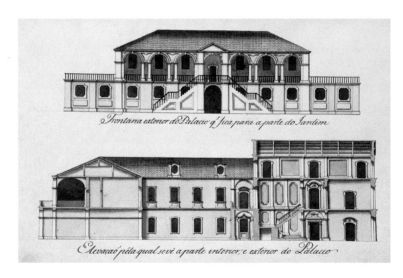

Tronteira exterior do Palacio q' fica pare a parte do Jardim

Elevação pela qual seve a parte interior, e exterior do Palacio

82
Antonio Giuseppe Landi, Rear façade and longitudinal view of the Governor's Palace, Belém do Pará, 1771. Ink on Paper; 29 × 43 cm, 11½ × 17 in. Arquivo de Dom Gonçalo de Vasconcelos e Sousa, Porto

Their enthusiasm for the classicizing architecture of the Renaissance made viceregal patrons in Spanish America and Brazil particularly receptive to the Neoclassical style at the very end of the colonial era. A severe and regulated version of classicism, Neoclassicism dominated Europe in the late eighteenth century. It was the architectural language of the art academies, such as Mexico City's Real Academia de San Carlos (founded 1785; see Chapter 4) and it reflected the idealism of the Enlightenment. In Spanish America, Neoclassicism was also tied in with the Bourbon monarchy's attempt to fortify its weakening hold on its colonies. Based on an almost cultish return to the sobriety, logic and morality of Greek antiquity and Renaissance architects like

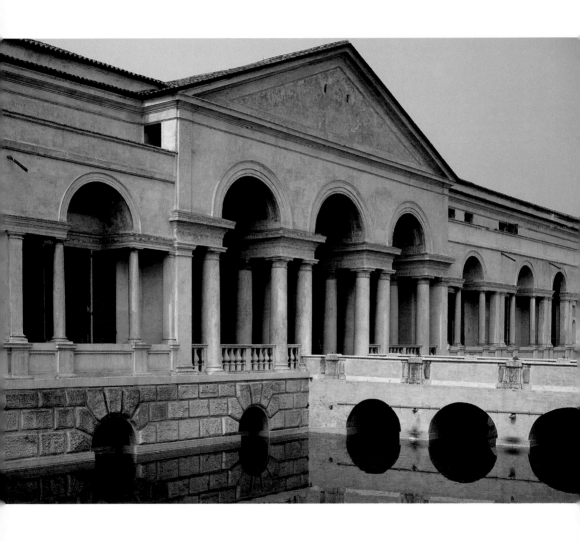

83
Giulio
Romano,
Palazzo del Te,
Mantua, Italy,
1526–34

Palladio, Neoclassicism swept through northern Europe at the end of the eighteenth century, and had a particularly strong impact in France and England. Its appearance in Latin America was the first sign of a shift of attention from Italian models to those of France that would increase in the independence era and help finish off the Baroque.

The best examples of the new style in Latin America are the School of Mines in Mexico City (1797–1813; see 112) and the Royal Mint (Moneda) in Santiago, Chile (1795–after 1799; 84), the first by the Spaniard Manuel Tolsá (1757–1816) and the second by the Italian Joaquín Toesca y Ricchi (c.1745–99). Both men were committed academicians: Tolsá was an architecture professor and later director

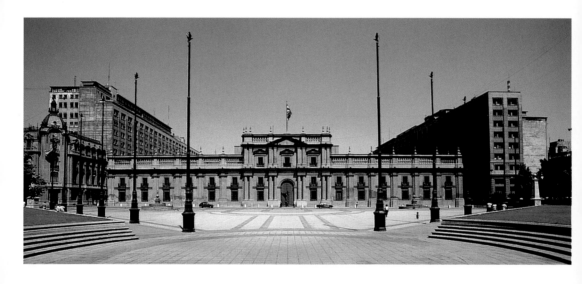

of the Academia de San Carlos, and Toesca had been chosen because of his credentials from the Accademia di San Luca in Rome, one of the first of the Renaissance academies. Both buildings are built on a colossal scale – the Moneda takes up an entire city block, with a mint, hospital and chapel all included in the massive rectangular structure fronting the square – and feature grand open courtyards, austere Doric columns and plain rectangular windows. Their grey stone surfaces are almost entirely devoid of ornament. The School of Mines lightens the effect on the courtyard interiors with the elegantly curved Ionic upper arcade, but in general these buildings are forbidding expressions of autocratic rule.

While viceregal architecture was the most visible image of empire in colonial Latin America, the patronage of the viceroys went beyond these grand cities and monumental structures into media that were much more inclusive of non-European elements – as we have already seen with ephemera. Behind the stalwart exteriors of the palaces was a cultured and opulent world of poetry, theatre, music and visual arts that only a few European courts could surpass. Latin American cities were among the largest and most prosperous in the world and the free flow of wealth from silver, gold and diamond mines allowed Lima, Potosí, Mexico City and Rio de Janeiro to flourish as centres of arts patronage. The handsomely paid viceroy and vicereine were often members of the top nobility and they lived the lifestyle of a royal couple, promoting themes and ideologies that echoed those of the *entradas*. Their extravagant lifestyle made a crucial political statement.

Typical were the Marquis of Mancera and his wife, Doña Leonor, with whom we began this chapter. She had been lady-in-waiting for Queen Mariana of Austria before going to New Spain in her early thirties. Both the Marquis and his wife were intimately familiar with the ways of the royal court. They were famous for their extravagant soirees and lavish balls, and they hosted scores of concerts, dances and other social events. They also returned to Spain 100,000 pesos in debt and gave colonial society a taste of the intrigue, flattery and officially condoned flirtatious games of Madrid or Paris. The viceregal couple commissioned original music, poetry and theatre for their courtly spectacles. Doña Leonor's greatest legacy was her encouragement of the literary skills of her young lady-in-waiting, Juana Inés de la Cruz, who became one of Mexico's greatest poets and one of the most important literary figures of the international Baroque.

Inside the palaces and villas of the viceroys, governors and local gentry was a world of furniture, textiles and decorative arts that aspired to the same European standards of courtly splendour (see Chapter 7). The viceregal courts were also one of the main patrons of secular painting. The most common and overtly symbolic genre was the

portrait. Since no Iberian monarch set foot on Latin American soil before the nineteenth century, portraits of the kings served as proxies for their royal sitters and reminded their distant colonial subjects of their loyalty. This tradition goes back to ancient times, when emperors would send their portraits to vassal states so that their subjects could pay homage to the images in lieu of the monarchs themselves. Portraits of the Spanish monarchs circulated as engravings and paintings, and they were replicated with almost industrial efficiency by local artists throughout the empire. For example, the Guaraní Indian painting workshops in eighteenth-century Paraguay had a profitable sideline making portraits of Spanish kings from engravings to satisfy the needs of the rapidly expanding colony in the Southern Cone of South America.

Spanish and Portuguese kings were not the only ones featured in viceregal portraiture. Beginning in the late sixteenth century, the viceroys commissioned portraits of pre-Hispanic monarchs as part of their ongoing attempt to equate Mexican antiquity with that of Europe and proclaim a seamless succession from ancient times. In Chapter 2 we looked at one of these genres, the multiple portraits made of pre-Hispanic and Spanish rulers beginning in seventeenth-century Peru. One of the most splendid portraits of a pre-Hispanic ruler is the full-length oil painting of the Aztec emperor Moctezuma (85) commissioned by one of the viceroys for the Medici Grand Duke of Florence Cosimo III, an avid collector of Mexican objects whose collections at the Pitti Palace include several examples of Aztec sculpture and early colonial featherwork. Inspired by paintings of the monarch in sixteenth-century colonial manuscripts like the Codex Ixtlilxóchitl, this grand portrait depicts Moctezuma in a magnificent cape (tilmatli) and loin cloth (maxtlatl) with a royal headdress adorned with quetzal feathers and tassels and a feather shield. Although there are slight anachronisms in the jewellery and some of the patterns on his clothing are Europeanized, the portrait is strikingly realistic and shows that the artist was making an attempt to provide a historically accurate representation. The artist has depicted Moctezuma as a powerful and noble figure, staring with a forceful and aristocratic gaze and standing in classical contrapposto

85
Portrait of the
Aztec Emperor
Moctezuma II,
after 1680–97
Oil on canvas;
182
× 106·5 cm,
71⅝ × 42 in.
Museo degli
Argenti,
Florence

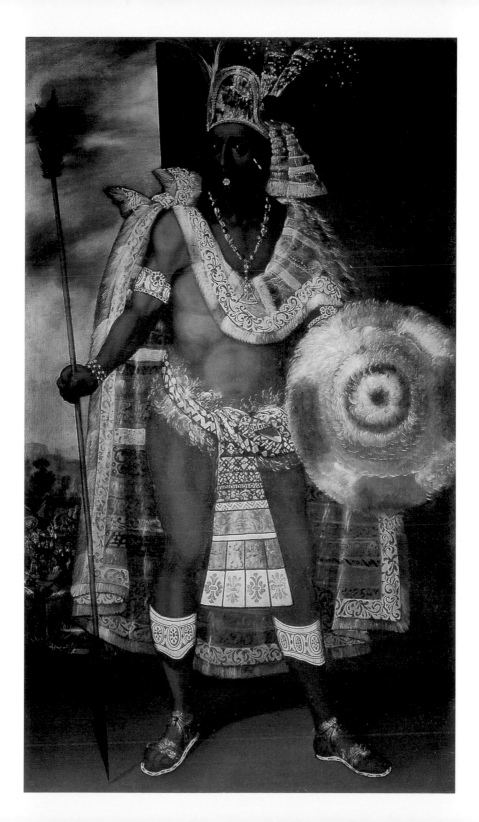

(a balanced Greco-Roman and Renaissance treatment of the human figure in which the parts of the body are counterposed along a vertical axis).

Moctezuma's great adversary Hernán Cortés was a particular source of pride in colonial New Spain. As the conqueror of Mexico, Cortés was a symbol of viceregal rule, but he also represented the patriotic feelings that many criollos had for their American homeland. Thanks to the publication of his letters, and to histories of the Conquest by Bernal Díaz (1632) and especially Antonio de Solís (1684), Cortés became a hero for the young colony and his exploits were soon one of the most popular secular subjects in colonial painting. As the founder of New Spain in 1520, Cortés was considered the first viceroy, an honour made explicit in the portrait gallery of the Viceregal Palace in Mexico City, where his was the first of a series of viceregal portraits. Cortés was also seen as a kind of missionary, who baptized the Aztec capital and purged it of its sins. This religious aspect of the conquistador is best seen in this painting (1605–7; 86) attributed to Alonso Vázquez (c.1565–c.1608) showing Cortés witnessing the martyrdom of St Hippolytus, whose feast day of 13 August was also the date of the surrender of Tenochtitlán. Recalling the elongated poses and luminous colours of El Greco (1541–1614), the painting sets its subject in front of the church of San Hipólito, which still stands on the Paseo de la Reforma in Mexico City.

Cortés most commonly appeared in grand action scenes of his battles and conquests. Beginning in the second half of the seventeenth century, these paintings were usually executed as part of a series depicting the conquest of Mexico, either as separate canvas paintings or in ten-panel biombo screens. The Conquest of Mexico paintings can also be seen as a sort of visual record of the entrada celebrations, as the entradas served as a metaphor for these very scenes, and both the paintings and the entradas have a processional format. One of the finest such series is a group of eight canvases, now in the Library of Congress, by an anonymous artist of the later seventeenth century. In The Conquest of Tenochtitlán (87), a teeming mass of warriors and horses swarms over the city and its grand pyramid like ants – the effect is enhanced by their antenna-like

86
Attributed to
Alonso
Vázquez,
The Martyrdom of
St Hippolytus with
Hernán Cortés
Praying,
1605–7.
Oil on canvas.
Museo
Nacional de
Historia,
INAH,
Mexico City

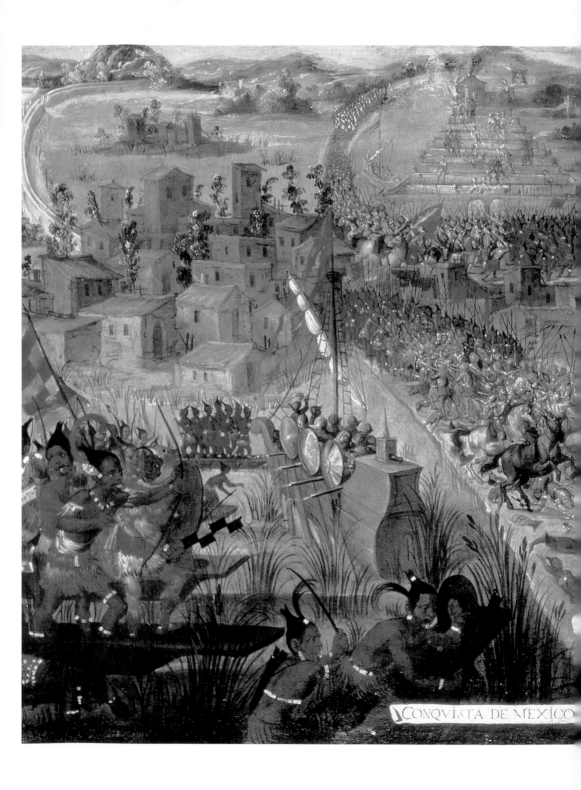

CONQVISTA DE MEXICO

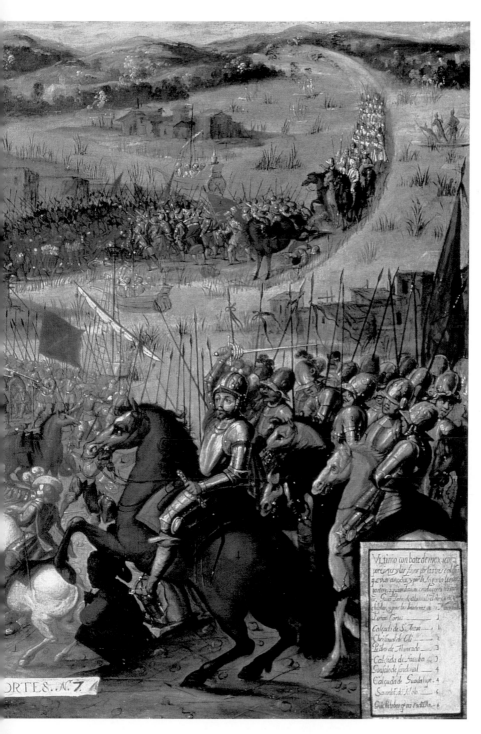

87
The Conquest of
Tenochtitlán,
from
The Conquest of
Mexico series,
17th century.
Oil on canvas;
122 × 198 cm,
48 × 78 in.
Jay I Kislak
Collection,
Library of
Congress,
Washington,
DC

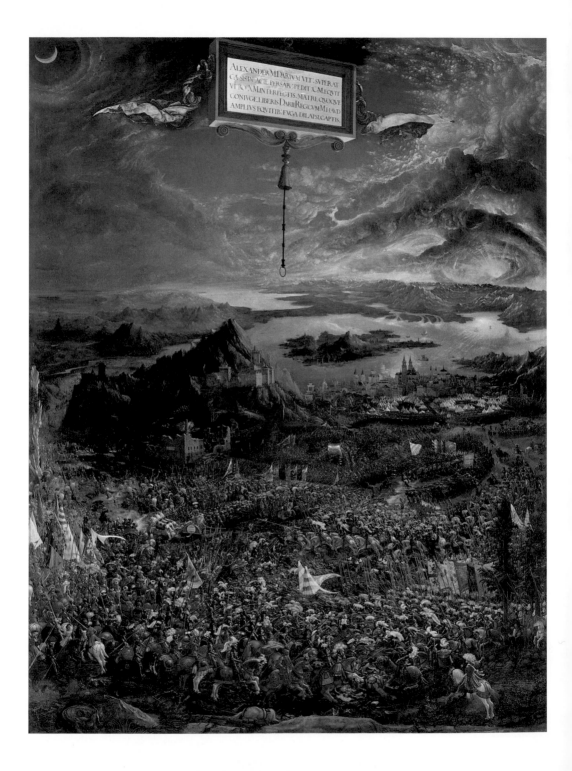

halberds and spears – while a sea battle between Spaniards in glistening armour and brightly dressed Aztecs takes place on the lake below. This kind of panoramic battle scene, with its richly detailed landscape, suggests the influence of engravings by the Italian painter Antonio Tempesta (1555–1630) and northern European works such as the *Battle of Darius and Alexander* (c.1529; 88) by the German Renaissance master Albrecht Altdorfer (c.1480–1538) – one of the most expansive battle scenes ever conceived and, coincidentally, one that was copied in India in the same period. In *The Conquest of Tenochtitlán*, Cortés rides triumphantly into battle on the lower right, announced by his trumpeter. The scene typically conflates different episodes into one and indicates them with key letters that relate to a text panel below.

88
Albrecht
Altdorfer,
*Battle of Darius
and Alexander*,
c.1529.
Oil on panel;
158·4
× 120·3 cm,
62⅜ × 47⅜ in.
Bayerische
Staatsgemälde-
sammlungen,
Munich

Another two series take the form of *biombo* screens. The first is a ten-panel *biombo*, whose reverse side we have already seen (see 71), showing the entire conquest of Mexico in a vast panorama, framed only by the Japanese-inspired gold arches above (89). In an endless stream of pulsating movement, Aztecs in feathers and Spaniards in armour do battle from Veracruz to Tlatelolco, allowing the artist to give us bird's-eye views of houses, palaces, temples and miles of landscape. The second *Conquest of Mexico* series is an *enconchado* screen (see 56), which includes this scene of Cortés dining with Moctezuma's ambassadors in Veracruz as his soldiers follow his orders to destroy his Spanish fleet to keep them from deserting. The artist makes brilliant use of the mother-of-pearl inserts, adding a natural glitter to the soldiers' armour and creating a Japanese floral pattern in the frame above. What is remarkable about these *Conquest of Mexico* series is that the Spanish and Aztecs are paid equal honour. Not only do the troops measure up in number and ferocity, but also the leaders of both sides possess the same regal splendour, the conquistadors with their flags unfurled and Moctezuma with his brilliant cape, headdress, throne and canopy. Like the Peruvian series of the Incas and Spanish kings, they affirm at once the legitimacy of the viceregal present and the pre-Hispanic past. It is fitting that one of them belonged to a seventeenth-century viceroy – José Sarmiento Valladares, Count of Moctezuma and Tula – whose wife was a descendant of that great emperor of the Aztecs.

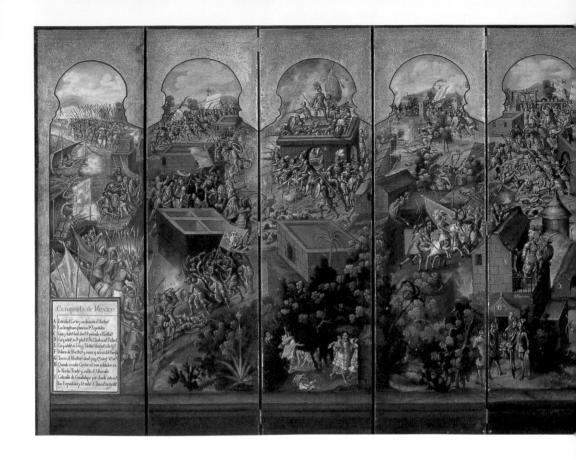

Respect for another non-European community characterizes *Portrait of the Mulattos of Esmeraldas: Don Francisco de la Robe and His Sons Pedro and Domingo* (1599; 90) by Andrés Sánchez Galque, the oldest signed and dated painting in South America. An Andean Indian, Sánchez Galque studied at Jodoco Ricke's school of arts in Quito (see Chapter 5). His skills attracted the attention of the principal judge in the *audiencia* of Quito, Juan de Barrio, who commissioned this work as a gift for King Philip III to accompany a report he was writing on the pacification of the Pacific coast of present-day Ecuador. With exacting detail and an insightful appreciation of the sitters' personalities, Sánchez Galque presents half-length portraits of the half-black, half-Indian governor of the region of Esmeraldas, Don Francisco de la Robe and his two sons. The 56-year-old governor ruled over a community of fugitive African slaves and Indians in a state of semi-independence, and this picture commemorates his trip to Quito to acknowledge

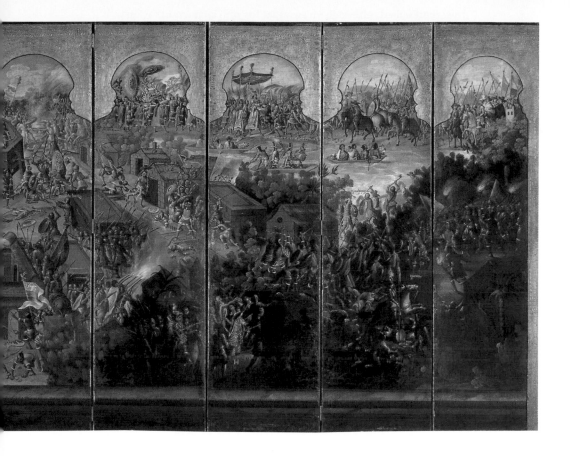

a peace treaty he signed in 1597 with the *audiencia*. Perhaps because
the painter himself was an Andean, Sánchez Galque depicts his subjects
with the greatest dignity and an air of authority. With expressions
of firm resolution, they stand regally with spears in hand and wear
not only the brocaded robes given to them by the Spanish government
but the golden labrets, nose rings, earrings and tooth necklaces of their
people – as splendid an attire as anything found in a Renaissance court.
Although they remove their hats in deference to the Spanish king,
making the painting a symbol of their homage, their fierce yet aristo-
cratic appearance gives them the dignity of semi-independent rulers.

Portraits of viceroys, governors and other aristocratic figures
proliferated in colonial Latin America, beginning with the series of
viceregal portraits in the palaces of Mexico City and Lima, and they
provided a visual reminder of their authority and of that of the Crown

they represented. Although viceroys sat for official portraits as early as the sixteenth century, such portraiture represented a far wider spectrum of the upper classes by the eighteenth century, reflecting the increasing visibility of secular culture in Enlightenment Europe. Local portrait painters painted military leaders, landed gentry, founders of universities, archbishops, aristocratic ladies and nuns. Although these portraits usually show the sitter standing still in three-quarters view with little facial expression, they are laden with the symbolism of power, lineage and learning. A prominent coat of arms usually looms overhead – just as over the doors of the viceregal palaces – and a red curtain denoting wealth and dignity serves as a frame. Depending

upon the pretensions and activities of the sitters, they are accompanied by props such as an ornate table, books, clocks or weapons, and the voluminous text panel in the lower part of the painting listing family and titles (a feature virtually unique to Latin America). It is not as important that these portraits be exact likenesses as it is that they project the appropriate image.

Such is the portrait *Viceroy of New Spain, the Duke of Linares* (91), by Juan Rodríguez Juárez (1675–1728). Fernando de Loncastre Norona y Silva, Duke of Linares, served two terms in Mexico between 1710 and 1716, and was the second viceroy of the new Bourbon monarchy of Spain.

The Bourbon dynasty succeeded the Habsburgs in 1700 with Philip V (r.1700–46), whose seizure of the throne incited the War of the Spanish Succession (1701–14) against the rival claim of the Austrian archduke Charles backed by British forces. Although Philip was eventually recognized as king, Spain was forced to give up much of its European empire, including Flanders, Luxembourg and its Italian possessions. Although most of his energies were devoted to defending the colony from incursions by England, Holland and Austria during the war, Viceroy Linares made a name for himself as a man of learning and public benefactor, and his greatest legacy is his foundation of New Spain's first public library. In this full-view portrait, the viceroy's costume proclaims his affinity with the Bourbon court. Inspired by the French fashions in vogue in Madrid (France was also ruled by a Bourbon dynasty), his clothes include a long powdered wig, a deep blue velvet coat rendered in exquisite detail and red-heeled shoes. Another symbol of his honoured position is his gold pendant with the red cross of the Spanish order of Santiago. Other props emphasize the enlightened nature of his administration. The clock shows him to be a man of efficiency and technology, and the petition in his hand suggests clemency. The setting is palatial, with the usual red velvet curtain and table acting as a frame, and there is a typically long-winded inscription on a plinth. Although his facial features are individualized enough to suggest that they are painted from life, the setting and props are stock motifs, probably copied from engravings.

90
Andrés
Sánchez
Galque,
*Portrait of the
Mulattos of
Esmeraldas. Don
Francisco de la
Robe and His Sons
Pedro and
Domingo*,
1599.
Oil on canvas;
92 × 175 cm,
36¼ × 68⅞ in.
Museo
Nacional
del Prado,
Madrid

A portrait from New Spain shows how convoluted – and, occasionally, ludicrous – colonial aristocratic titles could be (92). The Sixth Count of Santiago de Calimaya, who was also the Seventh Marquis of Salinas de Rio Pisuerga, was known by the Christian name of Juan Xavier Joaquín Gutiérrez Altamirano Velasco y Castilla Albornos, López Legaspi Ortiz de Oraa Gorraez Beaumont, y Navarra. Don Juan held title to lands in Spain and New Spain, and was the accountant for the Apostolic Court of the Holy Crusade, where he had the sinister job of selling indulgences. In this exquisitely rendered portrait from 1752 by Miguel Cabrera (1695–1768), one of eighteenth-century Mexico's most important painters, Don Juan stands in the usual rigid three-quarters stance with an impassive mien, but his clothing

91
Juan
Rodríguez
Juárez,
Viceroy of New
Spain, the Duke of
Linares,
first quarter
18th century.
Oil on canvas;
208 × 128 cm,
81⅞ × 50⅜ in.
Pinacoteca
Virreinal de
San Diego,
Mexico City

92
Miguel
Cabrera,
The Sixth Count
of Santiago
de Calimaya,
1752.
Oil on canvas;
206·4
× 134·6 cm,
81¼ × 53 in.
Brooklyn
Museum
of Art,
New York

El Sr. Dn. Juan Xa-
vier Joachin Gu-
tierrez Altamirano Velas-
co, y Castilla Albornos, Lo-
pez Legaspi y Ortiz de Oraa
Gorraez Beaumont, y Nava-
rra, Luna de Arellano Côde,
de Santiago Calimaya, Mar-
ques de Salinas del Rio Pi-
zuerga, Sr. delas Casas d Cas-
tilla, y Soza, y delas Villas de
Verninches, y Azequilla de Ro-
mancos, y de Azuquequa d Na-
res, Cavallero del Sacro Romano
Imperio, por mro. del Sr. Emperador Car-
los quinto Adelatado perpetuo dlas Islas
Philipinas, Contador d S. Magd. y del R
y Appco Tribl dela Sta Cruzada: murio
el dia 17 de Junio de 1752, de Edad
de 41 aos y 2 meses.

overpowers the whole painting, erupting in a riot of Asian-inspired silk floral and foliate decoration. Cabrera focused on this exotic costume rather than the sitter because it symbolizes his status and lineage. Don Juan descended from the conquistador of the Philippines, Miguel López de Legaspi (as well as from two viceroys of New Spain), and he consequently held the honorary but hereditary title of 'Adelantado Perpetuo' (High Governor-in-Perpetuity) of the Philippines, an honour he inherited from seven of his ancestors. The Philippines were governed from Mexico City at the beginning and were considered part of New Spain. Thus the Asiatic patterns of his costume recall the origin of his family's position in society. Cabrera brilliantly captures the pomposity of his sitter, with his French-inspired Bourbon clothes from his powdered wig and three-cornered hat to his long coat and waistcoat, knee breeches and black velvet pumps. The oversized coat of arms and text cartouche aptly reflect Don Juan's cumbersome name and titles, and they compete with his face for the viewer's attention.

Nothing more neatly summarizes the essence of the viceregal world than this portrait of Don Juan, with its delicate balance between Spanish rule, *criollo* pride, and indigenous culture, as well as the intimate bond between Church and State. It communicates an affinity with both the European motherland and the cultures of the sitter's adopted home, a combination that reverberates throughout most of the art produced for the viceroys and their officials. Finally, through its insistent claims to exotic lands that the sitter only ruled in name, Don Juan's portrait betrays the futility of the very notion of a European-style aristocracy where the Spanish and Portuguese were mere interlopers in an ancient land. Some may have built Renaissance villas in the jungle, but, as is the case of the now ruined House of the Tower of Garcia d'Ávila (see 80), the jungle returned in the end.

In the colonial towns, art production was intimately linked to society, religion and politics. A world apart from the modern notion of 'art for art's sake', the paintings, sculptures, decorative arts and buildings of viceregal Latin America were woven into the very fabric of life. The men and women who produced them represented every segment of this diverse civilization, from Indians, *mestizos*, blacks and Asians to *criollos* and Europeans. This ethnic diversity enriched the arts, as we have seen repeatedly throughout this book. Yet art production also revealed the negative relationships between these groups. The organization of crafts guilds and artists' fraternities reflected racial tensions and competitiveness to a degree that was unheard of in Renaissance Florence or Baroque Seville. Riven with caste differences and dominated by the colonial hierarchy, art workshops were frequently structured to exclude non-white artists or place them in an inferior position to their *criollo* or European-born masters. Fortunately, circumstances of art production were also varied and flexible enough to allow non-European groups increasing freedom from these societal pressures. By the later seventeenth and eighteenth centuries, Amerindian and African artists and craftsmen worked independently of white overseers, becoming a serious rival to the élite workshops and achieving their own voice in stylistic and iconographic matters. The corporate power enjoyed by non-white ateliers was extraordinary for their time, and their status is especially impressive when compared with the plight of Amerindians and Africans in Anglophone North America during its colonial era.

93
Melchor Pérez Holguín,
Rest on the Flight to Egypt,
c.1710.
Oil on canvas;
127·5 × 100 cm,
50¼ × 39½ in.
Museo Nacional de Arte, La Paz

In the cities and towns, artists worked under very different conditions from those in the mission art studios or the workshops of the religious orders that will be discussed in Chapter 5. Although the Church also dominated art production in this urban setting, both through its patronage and the role played by artists' and craftsmen's confraternities, metropolitan artists were professionals and their primary concern was to make a living. Art was not the product of a utopian community,

as it often was at the missions, which provided an endless amount of work for Amerindians as a way of instilling Euro-Christian moral values and preventing the laziness that the Spanish believed was inherent in the Amerindian character. In an urban setting the profession was much more volatile, as it had to meet the shifting demands of society, and competition was rife. The art market depended upon the financial situation of the Church and ruling class, whose wealth fluctuated with income from the mines, vacillations in the market value of farm products like textiles and foodstuffs, and the intensity of taxation from Spain or Portugal. Artists were also at the mercy of decrees of the state, which were frequently arbitrary and meddling. Throughout most of the colonial era, artists were limited to serving local patrons, usually in the towns and regions in which they lived. Nevertheless, art workshops expanded their scope by the eighteenth century, exporting their work over long distances, from Cuzco to Santiago or from Quito to Bogotá – especially after 1778, when the Free Trade Edict of the Bourbon kings permitted direct trade with Spain. Some workshops responded to these new markets on an industrial scale, such as the sculptors of Quito, who shipped no fewer than 260 crates of wooden statues to Spain between 1779 and 1787.

Even though they derived from the same roots, Latin American urban art workshops differed from their metropolitan counterparts in Europe. Although most colonial art and architecture bore at least a superficial resemblance to European models, it was often produced under vastly different circumstances from those in Spain, Flanders or Italy. One major distinction had to do with materials and techniques. Sometimes Latin American artists had a richer supply of natural resources on hand, such as luxurious hardwoods and bold vegetable pigments, while elsewhere people made do with only the crudest materials, as when South American painters had to make their canvases by sewing together pieces of cloth used as packing material. Frequently the tools of the trade were extremely hard to find, causing challenges – and creative solutions – unheard of in Europe. Another difference had to do with the transmission of models and styles. Although European ateliers also worked from engravings, they did not rely on them as significantly, and throughout the Renaissance and Baroque eras they

gave increasing importance to life drawing. By contrast, life drawing was unknown in Latin America before the late eighteenth century. Here, the copying of engravings was a fundamental aspect of nearly all art production and, instead of sketching from life, artists relied on a kind of visual shorthand, with stock ways of painting or sculpting hands, faces or eyebrows varying from region to region or between workshops. Even European artists who migrated to the Americas, like Simón Pereyns (c.1530–89) or Bernardo Bitti (1548–1610), worked exclusively from engravings once they reached their new homes and their styles changed accordingly.

Copying is at the core of Latin American colonial art. Like jazz, the best viceregal art is an art of improvisation, of variations upon common themes and creative manipulations of standard models. The genius and originality lie not in the original concept, which is usually borrowed, but in the execution. Therefore it is pointless to criticize Latin American art for being derivative, because it is in the very derivations that the creative spark appears. This concept is diametrically opposed to the Italian Renaissance tradition of *disegno* (design), by which the greatest focus was placed on the preparatory sketch – which represented an original, and supposedly divinely inspired, idea – with the result that the finished painting or sculpture is often less vivid and more conventional than the original drawing. In fact, preparatory sketches were relatively rare in Latin America and artists often applied paint directly to the canvas, with only the barest outline blocked out in advance. It is also meaningless to label Latin American colonial art as 'provincial' or 'folk art', as such derogatory labels oversimplify what happens in the interval between model and copy, a complex dialogue between the model and the various personal idiosyncrasies and ethnic traditions that the artist brings to it – ethnic traditions that may bear no relationship whatever to the artist's own background. It is equally mistaken to overemphasize the homogeneity of Latin American art. Superficial affinities in style make the art of different regions of Latin America appear alike – for example, architectural sculptures from New Spain and Bolivia share a certain flatness of form, as we have seen, and paintings from Cuzco and Quito have a common

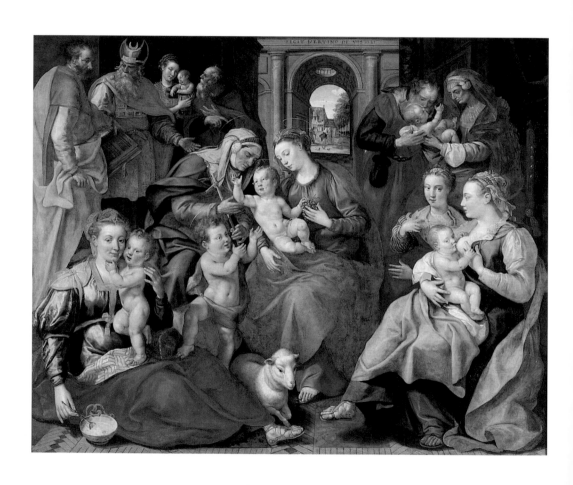

richness of pattern or colour. Yet a closer inspection always reveals striking regional differences.

Even though European models served merely as the artists' departure point in Latin America, it is still important to learn what they were. Many Latin American artists had the opportunity to study original paintings and sculptures from Europe, some of them of the highest quality. Although the art of Spain was the most influential, Italian and Flemish artists had a powerful impact on Latin American art, as they did in Spain itself. As both Flanders (since 1516) and most of southern Italy (since 1442) were part of the Spanish Empire, Spain and its colonies could benefit from having two of Europe's most influential artistic centres – Naples and Antwerp – within its grasp. Artists like the Flemish painter Maarten de Vos (1532–1603), who was extremely influential in Europe thanks to a prolific career as a printmaker, sent their canvases to New Spain and helped encourage colonial society's taste for the Flemish-Italianate style with its luminescent colours and rich landscapes. The Family of St Anne (94) by de Vos is typical of the kind of painting which the artist sent to Spanish American patrons. It owes its appeal not only to the richness of the palette but also to its narrative interest, bringing Biblical stories down to the level of the everyday. Flemish landscapes travelled to the Americas literally by the shipload in the sixteenth and seventeenth centuries, underwritten by dealers like the Forchondt family, who specialized in the American market. Both merchants and artists, the Forchondt family specialized in scenes such as *Penitent Magdalene in a Mountainous Wooded Landscape* (95) by Willem Forchondt, whose landscape so overwhelms its religious subject matter that the latter looks like an afterthought. According to one estimate, almost 25,000 Flemish and Spanish paintings were exported to the Americas in the second half of the seventeenth century alone. The workshops of Spanish artists such as Juan de Luzón and López Carrasco (both fl.1650–1700) were exclusively devoted to supplying paintings on order for American patrons, especially cathedral chapters and religious orders. Even Francisco de Zurbarán (1598–1664), one of the greatest painters of the Sevillian Baroque, acted as a dealer in Flemish landscapes and even in art supplies for the Americas from 1638. Zurbarán's own workshop also executed commissions for Latin

94
Maarten
de Vos,
*The Family
of St Anne,*
1585.
Oil on panel;
127·6
× 104·8 cm,
50¼ × 41¼ in.
Museum of
Fine Arts
Ghent

American clients, including the Convento de la Buena Muerte in Lima
and the monastery of Santo Domingo in Guatemala, and Zurbarán
sent portraits of Roman emperors and other artworks to sell in the open
market in Peru and Buenos Aires. Zurbarán specialized in individual
full-length portraits of saints (96), often depicted in ecstasy or inward
meditation – works which appealed to the fervent religious climate
of the time. Spanish sculptures from the circle of Montañés and signed
works by the Granadine carver Pedro de Mena (1628–88) reached
Mexico and South America when they were still in fashion in Europe.
Important Italian artworks also reached American shores. The Roman

95
**Willem
Forchondt**,
*Penitent Magdalene
in a Mountainous
Wooded Landscape*,
mid-17th
century.
Oil on copper;
55 × 73 cm,
21³⁄ in
× 28³⁄ in.
Musées Royaux
des Beaux-
Arts, Brussels

Baroque sculptor Melchiorre Cafà (1635–67), possibly the greatest
successor to the Italian sculptor Bernini (1598–1680), executed
a sculptural group in marble of *St Rose of Lima* (97) in 1665 for
the Dominican monastery of Santo Domingo in Lima. Commissioned
by Pope Clement IX (r.1667–9) to celebrate the canonization of this
first American female saint, Cafà's sculpture is still considered his most
important work and was exhibited to great acclaim in Rome before
being shipped to Peru in 1670.

Nevertheless, the vast majority of European prototypes available to
colonial Latin American painters and sculptors were engravings, mostly

96
Francisco de Zurbarán,
St Bruno,
c.1640–50.
Oil on canvas;
192 × 109 cm,
75⅛ × 42⅞ in.
Convento de la
Buen Muerte,
Lima

from Flanders, the Flemish city of Antwerp being one of the most prolific printmaking centres in Europe. Especially prominent was the work of Philipp Galle (1537–1612), Jan Collaert (1566–1628), Pieter van der Borcht (1600–33) and the Wierix brothers (sixteenth–seventeenth centuries), responsible for this richly detailed engraving of the Virgin of the Apocalypse battling the armies of Satan (98), a later version of the kind of image which would have served as a model for the Virgin of Guadalupe (see 1). As already noted previously, even

97
Melchiorre Cafà,
St Rose of Lima,
1665.
Marble;
h.82 cm,
32¼ in.
Santo Domingo,
Lima, Peru

98
Hieronymus Wierix,
Maria op de maansikkel.
Copper engraving;
15·8
× 10·6 cm,
6¼ × 4⅛ in

Latin American architecture quoted from printed building manuals such as those of Sebastiano Serlio (see 61), Giacomo Vignola (1507–73) and Jan Vredeman de Vries (1527–c.1606), copies of which frequently appear in colonial-era library inventories, such as the eighteenth-century Jesuit mission of Santa Cruz in Paraguay. Latin American artists' responses to these engravings varied tremendously. Sometimes they incorporated the actual print into the final product, painting directly

over it like a paint-by-numbers, or embroidering it with silk or metal threads and fixing it on to wood panels to form a miniature altar. Even when copying an engraving into another medium, such as a mural or textile, some artists followed it very closely, only adding the most minor details, although the hues were entirely the product of the artist's own imagination. However, the best Latin American artists made much bolder interpretations of their models. These artists only copied the basic composition from the engraving or used it like a copybook, borrowing one or two figures and arranging them into novel patterns or settings, frequently in reverse. Once certain motifs and compositions had entered the artists' repertory, they no longer referred to the original at all, as was the case with the Nahua masons who carved window dressings and doorways derived from Serlio, but who transformed them over time and through repetition. Some 'copies' are so far removed from their models that it is impossible to identify the sources of their inspiration. The delightful façades of the Rococo churches of Bahia or Pernambuco in Brazil, with scrolls and feathery curlicues arranged in an entirely liberal manner over windows and pediments, have more in common with the confectioner's art than anything found in a Rococo design manual. Such is the crowning cornice in the church of the Carmo in Recife (99), an ingenious juxtaposition of curve and counter-curve unique to the region.

99
Church of the Carmo, Recife, Brazil, begun 1685, façade 1767

Colonial Latin American artists invariably added something new. This element could be something minor like slight shifts in composition and additional landscape elements added by the Peruvian-Italian painter Angelino Medoro (1565–1632; 100) in his interpretation of *The Raising of the Cross* by Peter Paul Rubens (1577–1640; 101) for the Monastery of San Francisco in Lima – made necessary by his transformation of a model in triptych form into a single horizontal canvas – or an intriguing way of carving knees or moustaches as decorative scrolls as seen in the Rococo sculpture of the Brazilian Aleijadinho in Minas Gerais (see 107). It could also be something more substantial, such as the common incorporation of indigenous flora and fauna into Latin American painting. For example, one scene of the *Rest on the Flight to Egypt* (see 93) by the Potosí painter Melchor Pérez Holguín is set in a South American landscape and includes costume worn by Amerindians

in the country. All over Latin America, figures and buildings from European prints took up residence in lush Latin American landscapes and coexisted with tropical birds, capybaras, pumas and viscachas. Most significantly, the artist could incorporate symbols or stylistic features derived from non-European cultures. The most prominent of these contributions were made by the Amerindian world, as we have seen in Chapter 2. Nevertheless, we should not overlook the impact of styles and iconographies of African religious art felt in northeastern Brazil and Bahia, where private sacred sculpture made by blacks often recalled African prototypes and played a role in religious ceremonies that blended Christian and traditional African rites, nor the reflection of Chinese, Japanese, Indian and

100
Angelino
Medoro,
*The Raising of
the Cross*,
early 17th
century.
Oil on canvas;
78 × 117 cm,
30¹⁄₂ × 46 in.
Monastery of
San Francisco,
Lima

101
**Peter Paul
Rubens**,
*The Raising of the
Cross*,
1610–11.
Oil on panel;
central panel,
4·62 × 1·5 m,
15 ft 1⁷⁄₈ in
× 9 ft 10¹⁄₈ in;
each side
panel,
4·62 × 3 m,
15 ft 1⁷⁄₈ in
× 4 ft 11 in.
Cathedral,
Antwerp

Filipino culture seen in the decorative arts of New Spain, Ecuador and Brazil (see Chapter 7).

It is hard to understand how work of such originality, enlivened by the character of the artist, can often be completely anonymous. Yet the colonial Latin American art world was a far cry from the art scene of the past two centuries, or even the European Renaissance and Baroque with its culture of the personality, its Michelangelos and Murillos. Today's notion of an artist working independently in a studio, creating works in an individual style representing his or her own artistic statement, was completely alien to the colonial era. Art was a communal effort and it was almost invariably manufactured in a workshop, where each

member contributed a specific role to the final product – whether a retablo, painting or cathedral. Although the workshop masters (*maestros*) sometimes gained considerable renown and signed their works, the majority of the artists and artisans were content to remain nameless in the service of their craft, whether *criollo*, *mestizo*, Indian or African.

No Latin American artist, no matter how eminent, ever worked completely alone. On the missions and in rural areas, as we will see in the next chapter, artistic activity went on in monastic cloisters or parish churchyards under the supervision of friars, but in the towns and cities such production was regulated by arts and crafts organizations called guilds. Descended from medieval European corporations, guilds arose out of the need to organize and regulate arts and crafts activity, maintain standards of quality and protect the artists' and artisans' social condition. Unlike in Italy, most artists in Latin America and Iberia did not enjoy a particularly high social status and they were taxed as common labourers. In Brazil, for example, the arts were considered beneath the dignity of the best Portuguese or *criollo* families, an attitude that paved the way for blacks and mulattos to contribute strongly to art production by the eighteenth century. Guilds were an important means for artists to gain solidarity and to voice their concerns collectively during economic slumps or when faced with unfair treatment by patrons.

Guilds reached Latin America via Spain and Portugal in the first decades after the Conquest. In 1530 Guatemala already had a guild of gold- and silversmiths, a type that tended to be closely regulated by the government owing to the costliness of materials. In 1536 the city council of Lima entrusted the carpenter Juan de Escalante with the formation of a craft organization to regulate fees and limit abuses by unscrupulous carpenters, and this group was followed by a formal carpenters' guild in 1549. In 1557, before Simón Pereyns reached its shores, New Spain's painters and gilders had already organized themselves formally. In 1568 they were joined by a guild of carpenters. By the early seventeenth century there were artisanal guilds in Cuzco, a town that would become one of the most productive on the continent. Although guilds proliferated in Latin America in the

ensuing centuries, their structure and effectiveness varied considerably from city to city. In some areas they appeared very late. Although Brazil already had nascent artisans' corporations in the first two decades of the seventeenth century in Olinda (Pernambuco) and Bahia, it would be many years before more permanent guilds appeared in other urban centres such as Rio de Janeiro. Brazil was dominated instead by monastic workshops until the religious orders declined in the eighteenth century. Quito's first guild of painters and *encarnadores* (who specialized in creating *encarnación*, or flesh-like tones on sculptures) was first mentioned only in 1741, and a sculptors' and gilders' guild followed the next year, even though Quito had been one of Latin America's premier centres of sculpture and painting for over two hundred years and would boast over thirty guilds by the middle of that century.

As in Renaissance Europe, guilds were organized according to profession, with different guilds related to architecture (masons, carpenters, bricklayers), painting (painters, gilders, *encarnadores*), sculpture (sculptors, retablo makers, furniture makers), ceramics, and gold- and silverwork. Some of them, like the 'geometricians' who designed roofs and coffered ceilings, were learned men competent in calculus, design and building techniques. Others were extremely specialized, such as the artisans who attached false hair, eyelashes, eyebrows and fingernails to statues. Architects took their place alongside these other artisans, not assuming the pretensions of theoretical knowledge until the rise of the art academies in the eighteenth century. Some guilds were traditionally more prosperous, particularly the gold- and silversmiths, while others, like bricklayers or carpenters, rarely enjoyed impressive financial returns. Like their European models, Latin American guilds were closely tied to the urban fabric of their city, as different crafts tended to be located in specific parts of town. This relationship still exists in places like Mexico City or Lima, where several streets in a row will be devoted to furniture makers, auto mechanics or purveyors of plastic kitchen goods. This ancient clustering of professions, with roots far into medieval Europe and the Islamic Middle East, also coincided with indigenous Amerindian traditions, such as the ancient Mesoamerican organization

of craft communities into neighbourhoods (called *calpolli* in Nahuatl), seen already in Teotihuacán in the first centuries after Christ.

The municipal government often regulated guild activities with ordinances (*ordenanzas*), although the degree of control varied considerably according to time or place (in New Spain most ordinances date from the sixteenth century, whereas elsewhere they are predominantly from the seventeenth or eighteenth centuries). Ordinances tended to deal with the adoption and training of apprentices, the graduation to the post of master, the election of guild officials, standards and rules for the guild's activities in the public market, and its relationship with municipal institutions. Typical are the ordinances issued in 1653 by the viceroy of New Spain for the new guild of ceramicists in Puebla, the famous Talavera workshop that was one of the most productive in Latin America. These directives gave very specific rules about everything from membership examinations to the way to process clay and glaze mixtures and how finished pieces were to be sold, and they divided production into three grades of ceramic ware, from cooking pots to fine ceramics. Guilds and ordinances also prevented guild members from undertaking illegal work or charging exorbitant prices, and they maintained official documentation for accreditation in the profession.

An important aspect of guild life that is often overlooked is the guild's role in the religious life of the community. Each guild had a patron saint, usually related to its craft, such as St Joseph, the carpenter of Nazareth, who was the patron of carpenters, and St Luke, the portraitist of the Virgin Mary, who was the patron of painters. Guilds supervised processions, spectacles, banquets, theatrical events and other celebrations on the patron saint's feast day, which they were responsible for decorating with temporary triumphal arches and altars, paintings and statues. In the later colonial period, guilds undertook charity work, such as the Mexican silversmiths' guild, which began to administer care to the sick and needy in 1773. This intimate relationship with the Church reflects guild practices in Europe, as well as those of the nascent academies like the Accademia del Disegno in Florence (founded 1563). In Latin America, guilds were also associated with craft confraternities, lay religious organizations headed by a chaplain,

such as the St Joseph's confraternity, founded in 1560 in Lima for carpenters and bricklayers, which maintained and decorated its own chapel in Lima Cathedral. Cuzco boasted two confraternities devoted to this saint, the older of which was in the church of Santo Domingo. Confraternities were responsible for the upkeep of their altars and chapels, for regular prayer meetings such as the novenae (nine-day prayers), masses, charitable work and the saint's-day festivities. Paintings and sculpture formed a crucial part of these confraternal activities.

One of the most carefully regulated aspects of guild life was the training of artists. The structure of guilds was very hierarchical, with apprentices, journeymen and masters, as well as a senior master, deputy, majordomo and overseer. Promotion through the ranks depended on a series of examinations and years of experience, as well as the personal abilities of the artist. Apprenticeship was an obligatory first stage in an artist's career. Usually young boys, apprentices would be adopted into the household of an artist at the age of nine or slightly older and given food and lodging in addition to their training over several years. Such was the relationship between the Peruvian-based Italian immigrant painter Matteo da Leccio and his apprentice Pietro Paolo Morón (possibly Moroni; c.1570–1616), a boy of thirteen at the time of his first apprenticeship in 1583. In small towns or rural settings, boys could be sent hundreds of miles to the nearest city to study with a master. Elaborate legal contracts drawn up between the boy's parents and the master at the beginning of these apprenticeships give us tremendous insight into this period of early training. Apprentices were not only trained in their craft but were also taught reading, writing and account keeping, not to mention the tenets of Catholicism. In return, the boys cleaned the workshop and prepared pigments, and sometimes also helped in the drawing and painting of the backgrounds or applying colour over the costumes of paintings. The duration of apprenticeship varied according to the age of the apprentice and the type of work involved. Sculptors and goldsmiths tended to need six years, while painters needed four and bricklayers and smiths only three.

Sometimes the apprentice would be related to the artist and many families in colonial Latin America (such as the Correa family of New

PINTOR

LOSARTIFICIOS PÑTOR

escultor entallador bordador seruicio de Dios y dela S.ª yglecia

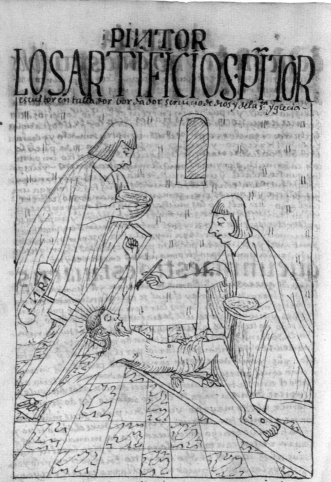

JURI

so reina pintor

ŋgun naper sona cristiano pue da tocar ningun nr
gen ni borrala por quien do aq llo no creen los yn fie
no hazen caso en el año de 16 13 bcitador dela yglecia ma
erras en el puello de s.º de uarochiri pintado pecado sacre
por ello los mugeres Acreo tanto miedo grandicimo ŋ

Spain) created veritable dynasties of artists in this way. In fact, it was in such a family setting that the only known women artists were able to practise their art. One of the most famous was Isabel de Cisneros (or Santiago; c.1666–c.1714), the daughter of the Quito painter Miguel de Santiago (1633–1706) who made a career painting canvases for local churches and religious orders. Like the famous Italian Baroque painter Artemisia Gentileschi (1593–1653), Isabel could only paint professionally because she was brought up in her father's workshop but, like her Italian counterpart, she continued to do so after his death. Regrettably scholars have been unable to attribute works to Cisneros with certainty – a task it is hoped a new generation of scholars will attempt.

Once the apprenticeship was over, the apprentice would sit for an examination, which tested aspects of the specific craft as well as academic subjects. If he passed the test, he would attain the rank of a journeyman and be allowed to practise his trade under the supervision of a master of his choice in a workshop, as depicted in an illustration of a sculpture workshop by Guaman Poma de Ayala (102). The workshop was a combination training centre, factory and saleroom. The more humble were attached to the master's house, whereas the larger ones had separate quarters in the city. The seventeenth-century Andean architect, sculptor and painter Juan Tomás Tuyrú Túpac (d.1718), designer of the church of San Pedro in Cuzco (103), had a workshop directly on the Plaza de Armas which specialized in retablos and church sculpture. In many cases the artists or artisans set up temporary workshops at building sites, especially furniture makers, retablo makers, sculptors, musical instrument makers, architects and masons. It was traditional for artists to finish the piece in the workshop before shipping it to the client, although this method changed with the onset of mass production in the eighteenth century.

After the journeyman gained several years of experience in the workshop he could take another test and become a master himself. First he had to present a request to the town council to sit for a promotion examination, in which he produced a work of art that displayed his knowledge and could be labelled a 'masterpiece' (the term actually

102
Guaman Poma
de Ayala,
Artisano,
from Nueva
Corónica,
1613–15.
14·5
× 20·5 cm,
5³⁄₄ × 8 in
(book).
Det Kongelige
Bibliotek,
Copenhagen

comes from guild practices). An artist only had three chances to take this test, which, when passed, would give him the right to run his own atelier and have his own journeymen and apprentices at his disposal. Masters were the leaders of their craft and the only ones to sign their names or produce self-portraits, such as that of Holguín (see 57) and a self-confident canvas by the New Spanish painter Juan Rodríguez Juárez (104) – a rarity in an artistic world where artists almost always made works to order and had no time for the luxury of artworks for their own enjoyment. In addition, only masters could draw up contracts with patrons for work. These contracts were often extremely

103
Juan Tomás
Tuyrú Túpac,
San Pedro,
Cuzco, Peru,
1688–99

104
Juan
Rodríguez
Juárez,
Self-Portrait,
c.1719.
Oil on canvas;
66 × 54 cm,
26 × 21¼ in.
Museo
Nacional
de Arte,
Mexico City

detailed and, in the case of retablo makers and sometimes painters, they included sketches of the work to be executed.

Such was the contract signed by Simón Pereyns, the most prominent professional artist in early colonial New Spain, with the town of Huejotzingo to provide their church with a retablo (see 148). Drawn up in the presence of the local Nahua leaders, the contract is so detailed that we can almost hear the crew at work. In addition to money paid in instalments, the town provided Pereyns with three

journeymen painters to grind gesso and pigments, three carpenters, two Indian women to grind corn and make tortillas for the work crew, and other Indian labourers for odd jobs. In addition, the town had to give the artist grass for his horses and one load of firewood a day, as well as additional corn to be distributed by the prior of the monastery. In return, Pereyns had to follow specific guidelines. The contract dictates the dimensions of the retablo, specifies which saints had to be full-size and which ones only busts, spells out what architectural elements were to be included (including the exact location of pilasters, columns, friezes, architraves, finials and a plinth) and dictates the placement of cherubs, shields, and garlands of flowers and fruit. It even stipulates that the retablo had to be provided with a dust cover.

If the master was especially successful in his trade, he could rise through the ranks of the guild government. The municipal council had the right to appoint senior masters, syndics of the confraternities and other government officials, while overseers had to be elected by the viceroy or president of the *audiencia*. Senior masters were not merely in charge of the practical aspects of their craft, but were also responsible for the guild's spiritual life, supervising its religious activities and maintaining its moral code. Overseers were responsible for enacting the ordinances of the guild and also meted out punishments to transgressors.

One important practicality monitored by the guilds was the material their members used, much of which had to be produced locally. Latin American painters could generally depend upon excellent earth, animal and vegetable pigments, including cochineal red (a dye made of crushed female insects which fed on the nopal cactus) and an indigo blue (more intense than the Asian version of the dye), which were so fine that they were exported to Europe. Other local pigments included ochre, raw or burnt sienna and umber, a yellow called 'Roman saffron' and greens derived from copper silicate or green earth. Nevertheless, the palette throughout colonial America was limited. Paintings are dominated by different shades of red and highlighted by vermilion, blue, ochre, black, green, yellow and earth tones, with more sombre hues dominating in the seventeenth century and lighter, more pastel

reds, blues and whites in the eighteenth. The subtle gradations possible in Europe, such as the glittering shot-silk colours of the Florentine late Renaissance and the shimmering blues and pinks of the Rococo, were absent throughout most of colonial Latin America.

Canvases tended to be coarser than in Europe, as were Latin American brushes. While European painters enjoyed tightly woven canvases of flax stretched over wooden frames, these were costly and rare in the Americas, where other options had to be found. Small pieces of flaxen cloth were sometimes sewn together to form a single canvas, which was then often glued on to the frame. In the eighteenth century, cotton and wool were used more frequently, especially in places like Quito where there was a local industry making ships' sails. In Peru the most common sort of canvas used was *ruana*, a cloth made of densely woven sheep or llama wool, and muslin and burlap were also widely employed. In some regions these canvases were primed with a blend of gypsum and chalk mixed with charcoal and ashes, and finished with varnish from tree resins. Elsewhere, most notably in Cuzco, they were sized with a clay emulsion, made red by ferrous oxide. The oils used for the pigments were usually extracted locally from linseed or walnut, and artists also used a tempera binder made of egg yolk as in medieval and early Renaissance Europe.

Artists in other media could also draw upon a variety of local products. Latin American sculptors tended to use local cedar instead of the pine favoured by Iberian artists. Throughout forested parts of South and Central America sculptors had the advantage of superior hardwoods with mellifluous names like *nogal, caoba* and *jacarandá* which were as good or better than imported wood and had rich, deep colouring and often also a fragrant aroma. Sculptors in Ecuador made imitation ivory using a local nut called *tagua*, seeds from a type of lowland rainforest palm that are the size of a chicken's egg. Known as 'vegetable ivory', *tagua* hardens when carved and becomes indistinguishable from the best ivory from Asia or Africa. This miniature carving of the *Holy Family with God the Father* (105), carved inside an egg-shaped sphere which opens in the middle, is an imitation of a kind of ivory carving made in the Philippines for export, and as with most pieces it is difficult

to determine which ones are ivory and which ones are made of *tagua*. In Brazil, especially in the seventeenth century, sculptors preferred to use local terracotta, which was cheaper and easier to handle than wood. The potters of Puebla had the advantage of two kinds of local clay that could be combined to form a material of extraordinary plasticity and consistency that rivalled the best clays of Europe. Silversmiths were the most fortunate of all, since silver was an abundant local product and also one that fetched high prices in the international market.

Guilds and other art workshops could only survive if they closely monitored expenses of materials and responded to market fluctuations. By the second half of the eighteenth century, many ateliers had begun to produce works more cheaply and in greater numbers, resulting in a kind of mass production that anticipated the industrial era. Contracts for painting workshops in eighteenth-century Cuzco typically list multiple paintings, sometimes in staggering numbers. In one case as many as 435 paintings were to be made over the course of seven months (at a rate of more than two a day) and another contract dictated that fifty-two large and ninety-six small paintings were to

be executed within a mere three-month timescale, all of these documents paying particular attention to the amount of gold filigree to be included in the work. A similar scale of production existed at the sculpture workshops of eighteenth-century Quito, which exported great quantities of their work to cities in present-day Colombia and Peru, and to Europe. In order to meet increasing demands for sculptures, Quito workshops devised a system of short cuts, so that simplified versions of certain iconic models (such as the Virgin of Mercy and Christ of the Flagellation) were repeated over and over again. In many cases, sculptors would simply make boxes of heads, feet and hands in advance, shipping them to their clients to be finished with torsos and clothing upon arrival. Similar systems of short cuts were devised by the eighteenth-century sculpture workshops of Bahia.

The guild system was introduced into the Americas in the first place partly to protect European and *criollo* artists from what they felt to be unfair competition. The first generation of Spanish artists in New Spain, people like Cristóbal de Quesada (fl.1535–50) and Juan de Illescas (fl.1548–60), felt the need to organize because of the overwhelming competition offered by Amerindian painters who were just as skilled but worked for less. As one English observer wrote in 1572: 'Indians will do worke so good cheape that poore young men that goe out of Spaine to get their living, are not set on worke.' The careers of European immigrant painters were clearly in jeopardy, which is why the first guilds were frankly discriminatory, giving whites a near monopoly over the standards and organization of artistic production. According to laws inherited from Spain, only Spaniards of 'pure blood' could serve as masters (ie no converted Jews or Muslims) and later laws added that they must be of good moral fibre as well. However, as was often the case in the Spanish Empire, the letter of the law did not reflect what was really going on. There were simply too many excellent non-European artists for patrons to turn their backs on them and scholars are increasingly acknowledging that the colonial art world was more inclusive than the decrees would suggest. An early example is Marcos de San Pedro, a Nahua gilder who worked with Simón Pereyns at Huejotzingo in the 1580s, performing a task that a Spanish law of 1570 had restricted to masters (and therefore whites). Similarly,

the prominence of Andean masters in the seventeenth-century viceroyalty of Peru or black masters in eighteenth-century Minas Gerais demonstrate how loosely these rules were applied. Although it was admittedly more difficult for Indians, *mestizos* or blacks to become masters in colonial Latin America, many of them rose to the challenge and they rank among the most successful artists of the colonial era.

One of the most famous was Diego Quispe Tito (see 176), a native of Cuzco. Like most indigenous artists in the Americas who signed their name, Quispe Tito was a member of the nobility and he owed his high status in the Cuzco artistic community to his standing in the Andean social hierarchy. He drew attention to his exalted status in both the Spanish and Inca manner, sometimes using the name 'Don Diego Quispe Tito' and sometimes applying to it the suffix 'Inga' (Inca). Quispe Tito had a workshop in the village of San Sebastián near Cuzco, where he trained Andean pupils such as Diego Callaymara, Alonso Yunca (fl.1634–50), Diego Huallpa (fl.1600–50) and Andrés Juantupa, and he participated regularly in confraternal processions. His noble status and prodigious skill allowed him to work as a master and arrange his own contracts. The viceregal government even awarded him the Cross of Calatrava, a heraldic emblem belonging to a prestigious Castilian *reconquista* order, which he wore on his cape during official ceremonies. Quispe Tito enjoyed the patronage of indigenous lords, such as the town officials who commissioned his painting cycles in the parish church of San Sebastián between 1634 and 1663, and he also found ample employment from Cuzco's religious orders, especially the Franciscans.

There may be no greater testimony to the ability of non-European artists to overcome racial prejudice than the Afro-Mexican painter Juan Correa, who was one of the two most prominent artists in New Spain during his lifetime. The son of a mulatto doctor with the same name from Cádiz, and a free black woman called Pascuala de Santoyo, Correa's family was almost an artists' guild unto itself, with his brothers, sons and cousins all making their careers in the arts. Correa's workshop was not only one of the most celebrated in the Americas but also one of the most active, producing devotional paintings on

106
Juan Correa,
*Immaculate
Conception*,
1701.
Oil on canvas;
250 × 210 cm,
98½ × 82⅝ in.
Convento
de Madres
Dominicas
de Clausura,
Tudela,
Spain

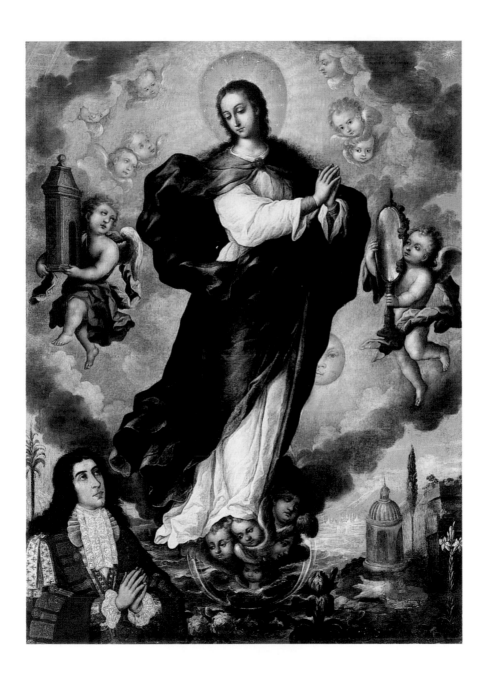

an impressive scale for a varied clientele, as well as for the export market elsewhere in Latin America and in Spain and Italy. Correa was particularly known for his images of the Virgin of the Immaculate Conception, whom he depicts here (106) as the Virgin of the Apocalyse (see 1 and 98), flanked by her symbols (such as the gateway to Heaven and the mirror without a reflection) and a detailed portrait of the painting's patron on the lower left. Although this painting is now in a convent in Spain, no documentation survives to suggest when it travelled across the Atlantic Ocean. The quality of the paintings from Correa's workshops differ according to the level of the patronage, with the lesser works produced almost entirely by his assistants and the more important ones by his hand alone.

107
Attributed to
Aleijadinho
(Antônio
Francisco
Lisboa),
St George,
18th century.
Polychrome
and gilded
wood;
h.203 cm,
79⅛ in.
Museu da
Inconfidência-
Ministério de
Cultura/
Instituto do
Patrimônio
Histórico,
Ouro Prêto

Even Correa's fame pales in comparison with that of another black artist, this time the Afro-Brazilian sculptor Antônio Francisco Lisboa (or Aleijadinho, 'little cripple'). The most important artist of colonial Brazil, Aleijadinho almost single-handedly created a Brazilian form of Rococo that would be imitated throughout the colony in the eighteenth and early nineteenth centuries – and faked by many an unscrupulous antiquities dealer today. The unique style of his St George (107) is characterized by a decorative treatment of costume and hair (the beard, moustache and the segments of his armour are reduced to scrolls and leafy patterns) and an angular, faceted rendition of flesh. The saint's nose, neck and also the veins of his hands are sharply defined. Aleijadinho was born in the town of Bom Sucesso in Minas Gerais to a Portuguese architect and carpenter who had come to find his fortune in this region so rich in gold and diamond mines. His mother was an Afro-Brazilian slave whose family came from the west coast of Africa. Aleijadinho probably studied his trade with his father and uncle, and also learned the technique of bas-relief carving under the Portuguese master João Gomes Batista, who was active in Brazil between 1751 and 1788. He may then have worked as a journeyman under the local sculptors Rodrigo Melo Franco de Andrade and Francisco Xavier Brito (fl.1735–51), who would have taken him with them to different church commissions. At the age of thirty-nine the sculptor was stricken by leprosy or syphilis and over the course of the 1770s he lost his fingers and toes and was reduced to walking

on his knees like a beggar. It is a sign of Aleijadinho's pre-eminence in his craft that he was able to continue despite his illness. He strapped his tools to his forearms, worked under a tarpaulin to hide his deformity from the outside world and relied increasingly on the help of his three slaves Maurício, Januário and Agostinho, who handed him his tools, moved him around and almost certainly assisted with the carving. In addition to these assistants, Aleijadinho also headed a small army of stonecutters, carpenters and woodcarvers who roughed out the figures from the soft wood or blue soapstone in advance for their ailing master.

Non-European artists and craftsmen were never successfully suppressed by the guild system and they soon found that the most effective way to get beyond government restrictions was to found workshops and confraternities of their own. These foundations arose in a piecemeal fashion depending upon the region, but became especially prominent in the late seventeenth and eighteenth centuries. There were black artisanal confraternities, like the Confraternity of San Juan Bautista de los Pardos, which was founded for masons and carpenters in the parish church of Santa Ana in Lima, and Amerindian confraternities like the Confraternity of San Miguel Arcángel, also in Lima, which provided Andean masons with professional representation. Black and mulatto artists, either born free or liberated, made up a substantial proportion of the woodcarvers and sculptors in eighteenth-century Brazil. These men operated their own ateliers, often executing altarpieces for black confraternities, which favoured images of black saints such as Saints Ifigênia, Moses the Hermit and Elesbão (see 27). There were even black silversmiths' guilds in Bahia as early as 1621, even though blacks were forbidden from working with silver under Portuguese law, and they put on extravagant parades featuring the 'Kings of Congo' dressed in rich finery. Goldsmiths in eighteenth-century Minas Gerais were pre-dominantly black as well, which is not surprising since blacks were in the majority there and were responsible for almost all of the mining operations in the region. In 1618, communities of Japanese and other Asian Christian immigrants outside Puebla and in Guadalajara were involved in the trade of Asian goods and may even have produced Asian-inspired artworks for an eager local clientele. Although they were quite influential and their products were extremely popular

in a colonial society fascinated with exotica (see Chapter 7), the Asian mercantile community only gained official status in 1703, with the foundation of the Parián (Chinatown) district in Mexico City, a city in miniature where merchants and artisans – including those from China and the Philippines – sold their brocades, ivories, fans and other Asian or Asian-inspired products. Scholars believe that a group of Chinese artists was also active in eighteenth-century Bahia, painting Asian details on furniture and church interiors, following the example of Brother Charles Belleville (1656–1730), a French Jesuit who had painted for Emperor K'ang-hsi of China (r.1661–1722) and who retired in Bahia in the late seventeenth century. His best work is the

108
Charles Belleville, Chinese-style ceiling, Sacristy of the Jesuit novitiate of Belém de Cachoeira, Bahia, Brazil, after 1709

exquisite wooden ceiling of the sacristy at the church of Belém de Cachoeira (108), with its plethora of Chinese peonies and chrysanthemums, painted in seal-red and gold.

The most famous and distinguished of these non-European artists' organizations were the workshops of the so-called 'Cuzco School' in Peru, founded in the second half of the seventeenth century in the midst of an intensive building campaign that followed the 1650 earthquake, vividly depicted in a large oil painting (109) from c.1650–60 in Cuzco Cathedral. Andean artists and artisans played a crucial role in transforming Cuzco into the splendid Baroque city seen today, several of

109
*The Cuzco
Earthquake of
1650 and
Procession of
Christ of the
Earthquakes,*
c.1650–60.
Oil on canvas.
Cathedral,
Cuzco, Peru

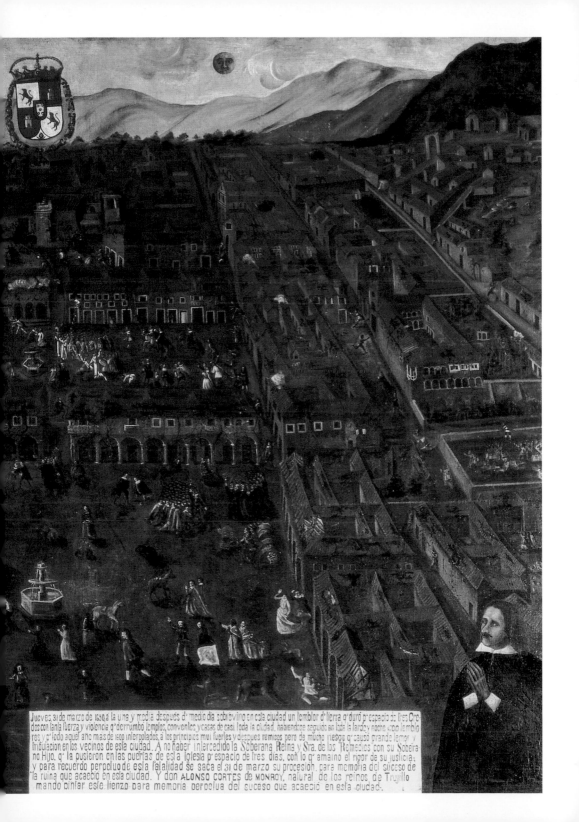

Jueves, 31 de marzo de 1650, a la una y media despues d' medio dia sobrevino en esta ciudad un temblor d' tierra q' duró p' espacio de tres Cre
dos con tanta fuerza y violencia q' derrumbo templos, conventos y casas de casi toda la ciudad, habiendose seguido en este la tarde y noche otro temblo
res, y p' todo aquel año mas de 1600 interpolados, a los principios muy fuertes y despues remisos pero de mucho riesgo q' causo grande temor y
tribulacion en los vecinos de esta ciudad. A no haber intercedido la Soberana Reina y Sra. de los Remedios con su Sobera
no Hijo, q' la pusieron en las puertas de esta Iglesia p' espacio de tres dias, con lo q' amaino el rigor de su justicia;
y para recuerdo perpetuo de esta fatalidad se saca el 31 de marzo su procesion, para memoria del suceso de
la ruina que acaecio en esta ciudad. Y DON ALONSO CORTES DE MONROY, natural de los reinos de Trujillo
mando pintar este lienzo para memoria perpetua del suceso que acaecio en esta ciudad.

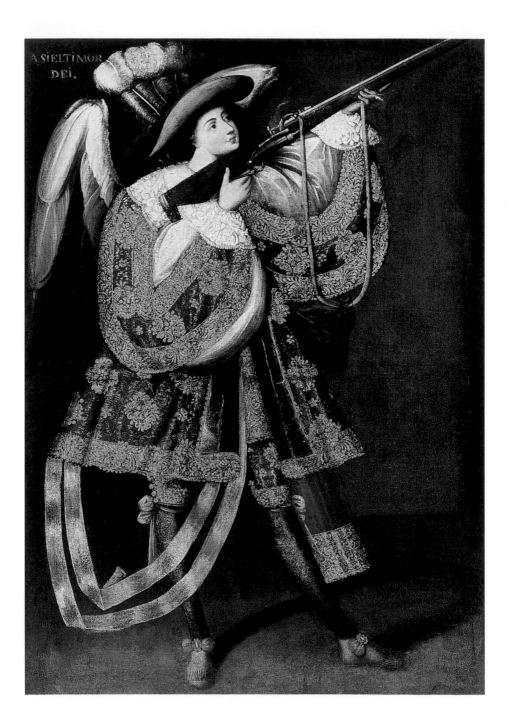

them attaining the position of master despite Spanish reluctance to allow them this honour. More than fifty names of indigenous artists have come down to us from the seventeenth century and even more names of *mestizos*. Inevitably, competition broke out between these non-European artists and their European and *criollo* rivals. In 1687–8, eight Spanish masters were ordered to reply to a complaint from Andean painters that they were being mistreated and wanted to form their own guilds. Shaken by the possibility of such formidable competition, the minority Spanish masters resorted to labelling the Andean painters as 'malicious' and as 'people who are accustomed to getting drunk'.

110
Master of
Calamarca,
Archangel Aspiel,
c.1660–80.
Oil on canvas;
135·5
× 87 cm,
53⅛ × 34¼ in.
Museo
Nacional
de Arte,
La Paz

The Andean painters got their way, however, and by the end of the century indigenous guilds and confraternities overwhelmed the European competition with vivid and exquisite renditions of the Madonna, the saints and biblical scenes for Andean and non-Andean patrons throughout Highland Peru and present-day Bolivia (see Chapter 6). Among their most celebrated products were paintings of archangels, including apocryphal ones, dressed in foppish court clothing and holding arquebuses, such as this elegant canvas of the apocryphal archangel Aspiel (c.1660–80; 110) by the celebrated Master of Calamarca (associated with the workshop of José López de los Ríos). The archangel's coat is covered in delicate gold filigree and he raises his arquebus heavenwards. These apocryphal angels were associated with the stars and natural phenomena, which gave them great appeal to an indigenous Andean population accustomed to worshipping celestial bodies. The majority of documented painters in late seventeenth- and eighteenth-century Cuzco were of indigenous backgrounds, and although most of them were anonymous they included better-known figures like Basilio de Santa Cruz Pumaqallo (fl.1661–99), Francisco de Moncada and Pablo Chile Tupa, as well as virtual unknowns such as Antonio Chakiavi and Lucas Willka (fl.1615–51). These artists were responsible for an astonishingly high volume of production. The mid-eighteenth-century Andean painter Marcos Zapata (c.1710/20–c.1773) alone is thought to have executed more than 200 paintings, including his celebrated *Life of St Francis* series for the Capuchin convent in Santiago, Chile, indicating that he ran a substantial workshop prominent enough to earn long-distance commissions.

In some places, most notably Quito, the guild system reached its height immediately before its demise. The system began to fade in the later eighteenth century, with the rise of Bourbon absolutism, the Industrial Revolution and the academies. Guilds began to cede power to more centrally controlled governmental institutions, like the Junta de Policía formed in 1780 in Mexico City that monitored all architecture in the city. Soon guilds were suppressed altogether, as in 1813 in Guatemala and in Brazil in 1825. In Quito, the region's leading producer of sculpture, the proliferation of independent work-shops in the later eighteenth century led to a rule allowing artists to work outside the guild system in 1782 and finally to the abolition of the guilds in 1793. One of the most damaging factors for the guilds was the increasing importation of cheap manufactured goods from England, which had an unfair advantage over local products. However, the most critical ideological blow came from the academies, founded at the end of the eighteenth century in imitation of the Real Academia in Madrid (1752), formal art colleges that in addition to art training taught a full liberal arts education including Latin, history, philosophy, music, law and astronomy. Art instruction now emphasized life drawing, the copying of plaster copies of Greek and Roman statues, and reading art theory. Reformulating art production as an élite activity, the academies created rigid canons of 'good taste' that favoured Greco-Roman classicism and attacked Baroque aesthetics. Artists were expected to be philosophers and theorists, and this gentlemanly status was meant to liberate them from the control of their masters. Ironically, the academies enjoyed even more control over their artists than the guilds and they served to denigrate the 'minor arts' (such as furniture making, ceramics or gilding) to the level of manual labour. There were also racial repercussions. Whereas there had been guilds of Amerindians, *mestizos* and blacks, the academies were dominated entirely by whites, especially those born in Europe. Never before in the history of Latin American art had non-white groups been so marginalized.

The Real Academia de San Carlos was founded by Charles III in Mexico City in 1785, and was staffed by Spanish professors such as the painters Ginés de Aguirre (1727–1800) and Cosme de Acuña, the sculptor

Manuel Arias and the architect Antonio González Velázquez (1723–93). Its most prominent professor was the Spanish sculptor Manuel Tolsá who arrived in New Spain 1792 and who did a monumental bronze equestrian statue of Charles IV (111) in Mexico City (1803), an imitation of the statue of Marcus Aurelius in the Campidoglio in Rome and a clear statement of the victory of Neoclassicism. Tolsá, who later

111
Manuel Tolsá,
*Equestrian Portrait
of Charles IV*
('*el caballito*'),
1803.
Bronze.
Mexico City

became director of the academy, also designed the austere School of Mines (112)building in Mexico City (1797–1813), a building whose sober lines and rigid rationalism heralded the demise of the decorative and expressive forms of the Baroque and Ultrabaroque – a development that was soon echoed in churches throughout New Spain,

112
Manuel Tolsá,
The School
of Mines,
Mexico City,
1797–1813

whose retablos and interiors were recklessly removed and updated
with staid classical replacements. Later academies, formulated
along similar lines and all exhibiting close ties with the European
motherland, were founded in Guatemala (1797), Buenos Aires (1799)
and Lima (1812). In Brazil, where an academy based on French models
was founded in 1820 in Rio de Janeiro, the relationship with Europe
was even closer since the Portuguese royal family had moved to Brazil
to escape Napoleon.

The ironic conclusion to this story was played out in the republican
era, after the revolutions of the 1820s that severed the ties of most
Latin American regions with Europe. Despite their rhetoric of freedom
and liberty, borrowed from France and the United States of America,
the newly independent nations of the Americas only intensified their
commitment to the European academic tradition, as republican paint-
ers, sculptors and architects made the journey to Paris and Madrid
to study, and Latin American presidents awarded prestigious prizes
and positions to European artists instead of to their own citizens.
Especially emblematic was the fate of the first academy founded
on American soil. When General López de Santa Anna, president
of Mexico, refounded the Academia de San Carlos in Mexico City in
1847 as a republican institution, he went to Spain and Italy to hire its
professors just as his viceregal predecessors had done fifty years earlier,
ignoring a new generation of talented Mexican artists and architects.

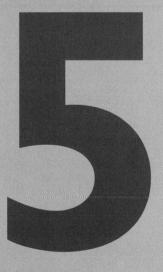

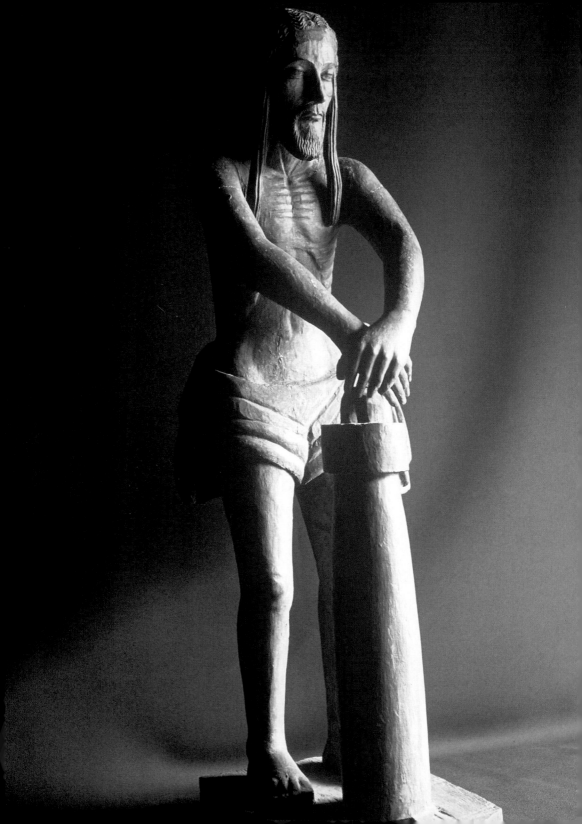

The intense wave of mission building that transformed Latin America in the decades after the Conquest may have been the greatest architectural endeavour in history. Never before were so many complexes of such size built in such little time. In New Spain alone, by 1600 there were some 400 missions – many of them more like small cities with extensive outbuildings – not to mention around 1,000 smaller chapels called *visitas* built for itinerant friars in outlying areas. There was a similar building boom in Andean South America in the late sixteenth and early seventeenth centuries, when scores of missions were founded over a huge tract of land ranging from Colombia to Argentina. When we add to these the hundreds of missions the Jesuits and Franciscans built in places like Paraguay, Brazil, New Mexico and California between the sixteenth and eighteenth centuries we arrive at a fantastic sum. In the past, scholars have viewed this phenomenon as an architectural conquest, an unremitting suppression of indigenous culture and exploitation of native labour. But recent scholarship reveals a partnership between a handful of missionaries and the Indians who far outnumbered them. Surviving contracts and the evidence provided by the arts of the missions themselves show that the Indians had an active say in everything from mission design and decoration to the saints chosen for their altars.

113
Christ at the Column, late 17th century. Polychrome wood. Santa María Museum, Paraguay

Indigenous people made key contributions to their built environment. It is becoming clear that the church itself was considered by many indigenous communities to be a symbol of community identity and – for better or worse – a replacement for their pre-Conquest religious structures. Christian life on the missions merged with ancient pre-Hispanic traditions of ritual and liturgy that in many cultures included singing, dancing and processions, and these activities focused on the public spaces of the mission compound, particularly the atrium. Scholars are now demonstrating that in New Spain different public spaces in the missions were claimed by different sectors of indigenous

society, descendants of the Aztec kinship groups known as *calpolli*. More is being learnt about the role played by the community in the mission, particularly its connection with the physical landscape of the town and village ceremonial.

Throughout the Iberian empires, missions were founded in similar ways, aptly described as 'ceremonial games'. First, scouts would select an existing indigenous village as head of the mission, which would have jurisdiction over the smaller *visitas*. The Spanish words for missions preferred in New Spain were *doctrina* or *congregación*, as opposed to *reducción* favoured in Spanish South America and *aldeia* in Brazil. Eventually the head mission centre would have a church and permanent residence, while each *visita* would have an additional chapel and a house for the priest. When the missionaries first entered the non-Christian area (a procedure known as the *entrada* – the same term used for viceregal inaugurations), they brought trinkets, metal tools and artworks to entice the people to join their new settlement. They would display paintings of Christ and the saints and invent religious jingles in the native language, appealing at first to children and then their parents. After this came the conversion, when the non-Christians attained the status of neophytes (recent converts). The most enthusiastic of the converts were essentially bribed with special titles, often together with economic benefits. During the final stage, when the permanent mission began to operate, indigenous officials under the leadership of a *cacique* (a Caribbean term for chief) were made responsible for temporal affairs. Usually, these people had already been leaders in their villages or at least came from noble families. The local élites continued to be responsible for the collection of taxes and the supply of labour for communal projects as they had been in pre-Conquest society. Aside from its value for spreading Christianity, the mission system was important as a means of sequestration of indigenous labour and of tribute collection – a situation that was sometimes abused, most notably in Brazil.

Cultural hybridism on the missions was only possible because of the relatively tolerant attitude of many missionaries, who operated in a spirit of utopianism receptive to indigenous practices, talent

and creativity. Throughout the Americas, this idealism was often a characteristic of missionaries from Flanders. The first three missionaries to reach New Spain, in 1523, were all Flemish: Fr Jan Dekkers, Fr Jan van den Auwera and, most importantly, the Franciscan lay brother Pieter van der Moere of Ghent (Pedro de Gante). One of the most remarkable missionaries in the history of the Americas, Pedro de Gante was a relative of the emperor Charles V and an intimate of the Dutch pope Adrian VI (r.1522–3). These were heady times for Christianity in the Low Countries, where the humanist scholar Desiderius Erasmus championed the role of learning in Christian life and whose attacks on medieval scholasticism inspired clerics elsewhere to start the Reformation. A man of learning himself, Pedro de Gante embodied this educational spirit, bringing to New Spain his expertise in the liberal arts, particularly music and geometry, which related to architecture and the visual arts. He was followed in 1524 by twelve more Franciscans (the apostolic number was no coincidence, as we have seen; see 21), including Martín de Valencia and Toribio de Benavente (known by the Nahuatl word 'Motolinía', or 'he who inflicts suffering on himself'), both of them scholars whose millennialist expectations and life of poverty reminded Indians of their indigenous priests and attracted them many followers. The early friars pressed for a native clergy, but the racist policy of the Church in general prevented any Amerindians from becoming priests before the end of the eighteenth century, unlike in Asia, where the Jesuits ordained Japanese as early as 1601–3.

Language study was in the forefront of mission efforts. The first Franciscans in Mexico, who were joined by Dominicans (from 1526) and Augustinians (from 1533), wrote Nahuatl and Mayan grammars and dictionaries, translated indigenous plays and poetry, compiled histories of the pre-Conquest world and helped set the stage for the convergence of cultures that would characterize mission life. Adapting Aztec picture-writing to Euro-Christian concepts, friars and their Nahua congregations collaborated in devising picture-books known as 'Testerian Catechisms' which attempted to spell out prayers like the Our Father in rebuses inspired by Nahua glyphs. Such is an early example (114) by Pedro de Gante, which articulate prayers using simple figures such as the orb of the world to represent the earth or

a disembodied face to represent God the Father. Texts like these sometimes form the words phonetically, according to the syllables of the Nahuatl language, and sometimes symbolically – although the symbols they use are of European, not Aztec, derivation. Beginning in the 1530s, South American missionaries also paid close attention to the study of languages, including Quechua and Aymara, languages spoken in the Inca Empire, as well as Guaraní and Lingua Geral, the lingua franca of Brazil. In Peru, the Jesuits even produced grammars and dictionaries of the African languages spoken by

114
Pedro de Gante ,
Testerian
Catechism,
1525–8.
Ink and
colours
on paper;
7·7 × 5·5 cm,
3 × 2¹⁄₈ in
(page).
Biblioteca
Nacional,
Madrid

the Angolan slaves who lived in a suburb of Lima, the first in those languages to be published anywhere.

The first friars were not afraid to make concessions to indigenous culture. They frequently drew connections between Christianity and indigenous myth and religion, even borrowing the names of indigenous gods for Christian figures. Even though they often chose the wrong god for the job, the fact that they made the effort in the first place shows that they had a remarkable sensitivity to indigenous ways in their attempt to proselytize. The substitution of aspects of

pre-Conquest ritual was just as deliberate. The friars in New Spain allowed Catholic feast days to coincide with earlier rituals of the Aztec year in order to put existing customs to work for the Church. Pedro de Gante took great pains to record the ritual dances of the Aztec temple compounds in an attempt to re-choreograph them in a Christian mode. He composed a Christian song for native instruments and even designed new patterns for the mantles to be worn by the dancers. There were attempts to harness the grandeur of Amerindian prayer, as in Peru, where the Franciscan Fr Luis Jerónimo Oré tried to employ invocations written by the Inca Pachacuti in Christian worship – although it was a short-lived exercise. The motivation of the first missions was not only utopian in spirit. Don Vasco de Quiroga, Bishop of Michoacán from 1538, made Thomas More's *Utopia* the literal model for a series of Indian towns he founded in his diocese, each of them centred on a church and community hospice.

Education formed the cornerstone of the mission enterprise in New Spain and South America. Admittedly, such instruction would have been unnecessary if the Amerindians had not been conquered in the first place, but in the colonial world it provided Amerindian youth with vital training to survive in their new environment. Pedro de Gante founded the first college of the New World, in Texcoco in 1523, where he taught the sons of Nahua nobles. Juan de Zumárraga, the Franciscan first bishop of Mexico (r.1528–48), whose heavily annotated copy of More's *Utopia* can still be read today, established the Colegio de Santa Cruz at Tlatelolco in 1536 to teach Nahua boys Latin and the liberal arts (including painting and music), and founded there the first college library in the Americas. These institutions replaced a type of Aztec school called the *calmecac* and the friars quietly revived the role these pre-Hispanic institutions had played in Nahua society. Located near the main temple in each district, the *calmecac* would instruct the sons of the ruling and religious élite in history, astrology and religion, as well as the art of picture-writing. In the same way, the Franciscan schools focused first on the sons of the nobility, including former students of the *calmecac* and, like their Aztec predecessors, they incorporated the visual arts into their curriculum. The Church did not neglect Nahua girls either. In 1530, six nuns arrived in Mexico City as teachers,

followed by eight more in 1534, and one of them, Catalina de Bustamente, brought three more in 1535. These nuns were as active as their male counterparts, founding no fewer than eight girls' schools by 1534, in places like Mexico City, Otumba and Cholula. Although the girls primarily learned domestic arts such as embroidery and sewing, they may also have been taught to read and write.

In the centre of Mexico City, Pedro de Gante founded the school of San José de Belén de los Naturales ('of the Natives') adjacent to the monastery of San Francisco. The most famous trade school of colonial America, San José taught Nahua adults the arts of painting, sculpture, carpentry, music, embroidery, jewellery making and feather mosaics. Its alumni probably included the sons of *tlacuiloque* (Aztec picture-writers). Some of the artists rose to prominence, most notably Marcos, who designed the retablo in the school's chapel (1564), and his assistants Francisco Xinmámatl and Martín Mixcohuatl. Artisans worked full-time at the school making paintings, sculptures, ecclesiastical vestments and other arts to supply the new churches and missions being built throughout the realm. Paintings were periodically tested by Church authorities to ensure that they were not 'injurious to God', but the overwhelming success of the school shows that this was an unnecessary precaution. The drawing master may have been Diego de Valadés (1533–82), a *mestizo* friar and pupil of Gante's who was not only a talented painter and engraver but also a skilled Latinist, and he taught at Santa Cruz as well. Valadés published an influential treatise on Christian life in Mexico called *Rhetorica Christiana* (Perugia, 1579), the first book ever published by an American-born author, which contained a famous image of an ideal Franciscan mission in New Spain (115), set inside the kind of spacious atrium that fronted most Mexican mission churches. An Italian named Fr Daniele, whose last name is lost to history, taught embroidery at the school, an important skill since not only did every priest need liturgical clothing, but every church also needed textile adornments such as altar frontals, as well as clothing to dress the statues. These skills were extremely useful for the Nahua pupils, who could avoid more onerous tribute obligations by working on arts and building projects on a rotational basis. Many of the San José graduates returned to their villages to teach painting in mission schools

far from the capital, and they are probably responsible for the explosion of mural painting in the countryside of New Spain from about 1535 to about 1585. The Franciscans founded similar schools for the Maya in Maní and Mérida in the Yucatán, and the Augustinians led arts workshops for the Purépecha in Michoacán, particularly the college at Tiripetío (founded 1540), a combination of liberal arts college and trade school with painting classes taught by Spanish artists from Mexico City.

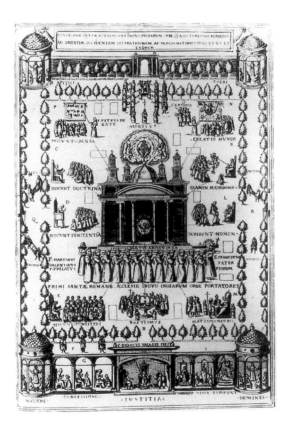

At the Colegio de Santa Cruz in Tlatelolco, the Franciscan Bernardino de Sahagún taught indigenous youths Spanish and Latin, as well as science and music, and became especially proficient in the Nahuatl language. When his superior ordered him to compile a compendium of Aztec history and customs he gathered together seven leading Nahua elders of the region (including four of his own students) and spent seven years collaborating on this twelve-volume encyclopedia (116).

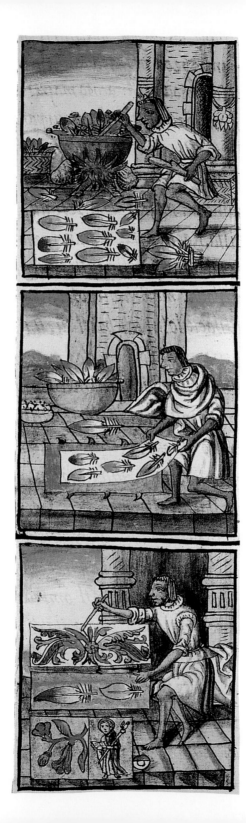

One of the most remarkable things about Sahagún's encyclopedia is its use of illustrations drawn by Nahua picture-writers from the college in a style that combines conventions drawn from Aztec pictographs with European methods such as shading and perspective. This depiction of the Aztec art of featherworking recalls pre-Hispanic picture-writing (see 5) in the crouching pose of the figures shown in profile, the heavy outlines and the distinctive appearance of the feathers. Yet the episodes are set against Italian Renaissance architectural backdrops, with chessboard floors done in linear perspective.

The colonial arts in South America had a similar beginning. In Quito, the Flemish friar Jodoco Ricke de Marselaer and his Spanish colleague Fr Francisco de Morales founded the Colegio de San Juan Evangelista in 1551 – it changed its name to the Colegio de San Andrés in 1555 – to train Andean Indians in practical trades. Born in 1494 in Ghent, Ricke came to Ecuador with the first Franciscans in 1535 and stayed there until 1569 when he was transferred to Popayan (now Colombia). The Colegio de San Andrés taught liberal arts such as grammar and music (including plainchant and organ music), while it also trained Quechua and Aymara Indians, *mestizos* and poor Spaniards in canvas and miniature painting, sculpture and carpentry, silver- and gold-working, watchmaking, ironworking, carpentry, weaving, shoemaking, hatmaking and clothes design. Painting and sculpture were taught by fellow Fleming Pedro Gosseal. No small affair, the college was given royal patronage by Philip II and was directly promoted by Viceroy Andrés Hurtado de Mendoza, in whose honour the college was named. As in New Spain, its pupils went on to train people throughout the region and by the 1560s the school was already hiring indigenous teachers.

Chapter 2 has already considered the acculturation that took place in mission art workshops. Borrowings from the indigenous past were equally important in mission architecture. Although this used to be a hotly debated issue among scholars, it is becoming clear that the first mendicant friars in New Spain and South America adapted features of pre-Hispanic temple architecture to make their mission churches more comfortable and palatable to the converted Indians. New Spain was the

116
Feather-
workers,
from Book IX
of Bernardino
de Sahagún,
Florentine Codex,
1570–85.
Biblioteca
Laurentiana,
Florence

pioneer and by about 1530 the friars of all three mendicant orders had worked out a mission design as uniform as that of the urban grid plan that would remain the model for a hundred years, copied not only in New Spain but also in South America and even in the Philippines. Many of the elements supposedly derived from temple architecture can also be traced to European precedents, but such forms are rare in Europe and were never used with the consistency of Mexican examples or on so grand a scale. The adoption of Aztec forms would also have been a natural result of the missions' location. In an attempt to create a sense of continuity between the Aztec faith and Christianity, friars built many of these churches directly on top of temples, often using the same stones, a ploy used by early Christians in their evangelization of places like England in the seventh century AD. The most visually impressive example is the church of Nuestra Señora de los Remedios at Cholula (117). The present church dates from the nineteenth century, but it replaced a sixteenth-century original, which was built on the summit of the massive Tlachihualtepetl, or 'Handmade Hill', the largest pyramid in America.

The main feature of Aztec sacred space borrowed by the early missions was the tradition of outdoor worship. Even though these missions often had large, barn-like churches, many services, sermons and other liturgical performances were held in the large walled open atrium in front of the church. A variety of open chapels opened on to this same atrium or a similar enclosure on the northern flank of the church. The grandest type was the 'open chapel' (capilla abierta), or 'Indian chapel' (capilla de indios), an apse-like enclosure open on one side that ranged considerably in size and splendour. Among the most impressive is the open chapel at the Franciscan mission of San Luis Obispo in Tlalmanalco (118), with its delicate arcade of columns adorned with detailed and deeply carved Renaissance floral motifs and grotesques, or the one at Cuilapan, a full three-aisled basilica built in a grand Renaissance style copied from treatises by Sebastiano Serlio. Open on three sides to allow congregations to surround the structure on the outside yet attend a service going on within, Cuilapan took an

early Christian structure with Imperial Roman overtones and made it accessible to Nahua patterns of worship. Others borrowed from Islamic architecture to embrace their giant congregations. The original open chapel at San José de los Naturales in Mexico City was based on the mosque of Córdoba (see 20), with a forest of columns holding up a vaulted roof, a design that survives today in the Capilla Real in Cholula (119). The Capilla Real, attached to the Franciscan mission church of San Gabriel, was built on the site of a temple to Quetzalcóatl, and it is thought that the friar architects chose the mosque form as a model in part because it possessed sufficient grandeur to rival the memory of the many temples that once graced this important Nahua religious centre.

117
Nuestra Señora de los Remedios, Cholula, Mexico, 1594–1666, mostly rebuilt 1864

This focus on outdoor ceremony consciously echoed Aztec tradition, in which worshippers stood in a plaza facing the pyramid, whose only enclosed section was a pair of small shrines at the top, dedicated to deities and open on the front. Both Aztec temples and mission open chapels usually faced west, a concession of geomantic significance as temple axes were placed on the annual zenith setting of the sun (21 June). Recent work has shown that the Franciscans in the Yucatán adapted the open chapel to accommodate Mayan traditions that differed from those of central Mexico, creating vaulted masonry spaces attached to thatched *ramadas* (rectangular huts open on all sides). These structures combined a form related

to Mayan domestic architecture with the pre-Hispanic veneration of caves, or *ts'onotob*, often natural springs where the worshippers believed the rain deities dwelt.

Posa chapels are smaller, kiosk-like buildings with domed or pyramidal roofs, positioned on two or four of the corners of the atrium. *Posas* were used as stopping points during processions, especially the Corpus Christi procession, as well as for other purposes that are still unknown but that probably related to individual kinship groups within the community. As the processions would enter the chapel from one direction, pause for prayer before the altar and exit in another direction, *posa* chapels are open on two sides. The anti-clockwise direction

118
Open chapel
of San Luis
Obispo,
Tlalmanalco,
Mexico,
c.1560

119
Interior of the
open chapel
('Capilla
Real'),
church of
San Gabriel,
Cholula,
Mexico,
begun 1575

of these processions in Mexican tradition was unique in the Christian world and derives from pre-Hispanic ritual. The finest *posa* chapels are at the missions at Huejotzingo (120) and at Calpan, where elaborate carved decorations adorn the entrance archway, including angels, Madonnas and saints, whose *tequitqui* style of carving makes them look as much like the Aztec deities Coatlicue or Xochipilli as Christian images. Another kind of open structure facing the atrium was the *portería*, an entrance porch attached to the friar's residence and the cloister, which served as a shelter for new converts and sometimes as a hospital or confessional. Occasionally the *portería* had an open chapel built into it.

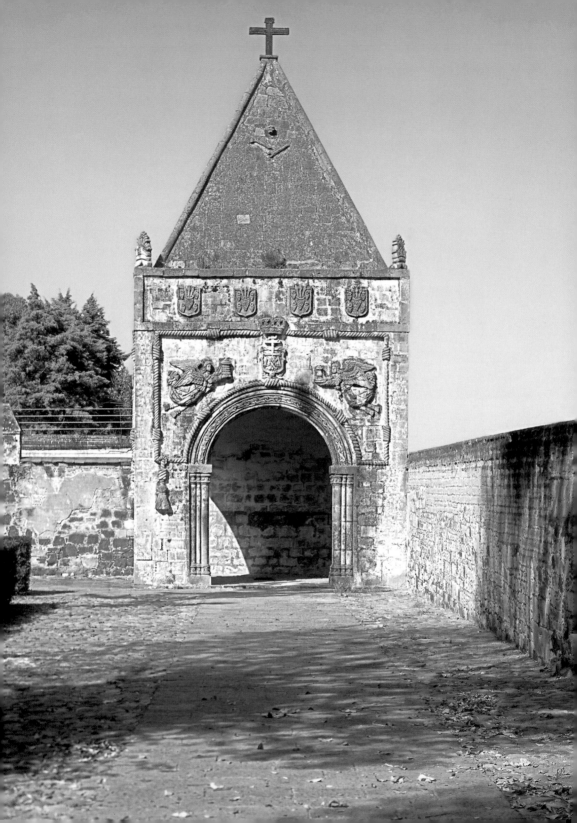

Another form commonly found in New Spanish missions which has reminded scholars of Aztec prototypes is the atrium cross, a monumental stone cross set on a platform at the centre of the atrium, as at Ciudad Hidalgo (121). Instead of showing the full Crucifixion, with the body of Christ attached to the cross, these works of sculpture usually show only Christ's face at the centre (or no face at all), adorning the cross itself with a glyph-like conglomeration of symbols of Christ's Passion. Some scholars believe that this way of representing Jesus was

an attempt to make it appear as if he was inside the cross, recalling the traditional Mesoamerican principle that the human race was born from the World Tree (see 5). The skull of Golgotha, placed at the bottom of some of the crosses, recalled the human head or seed which fertilizes the World Tree in Mesoamerican tradition. Furthermore, the crosses are mounted on top of a stepped platform of rubble masonry intended to represent an Aztec pyramid, making an obvious statement of

Christian triumph. Occasionally, as at Ciudad Hidalgo, atrium crosses incorporate indigenous elements such as flower-shaped obsidian or jade disks into the centre, drawing upon an Aztec tradition in which these materials symbolized the heart of the universe and goal of human sacrifice. Although similar crosses existed in Europe, where their juxtaposed symbols were a common tool used by friars to preach about the mysteries of the Passion and the Incarnation, their flat, mosaic-like decoration is unique to New Spain and is an example of *tequitqui*.

The churches and monastic buildings in New Spanish missions were less unusual, although their monumental size and fortress-like appearance gave them a dominant position in their villages which recalled that of pre-Conquest temples. As elsewhere in Latin America, the first generation of churches in the basin of Mexico were rudimentary wooden and adobe affairs, built like large rectangular halls divided into three aisles by wooden posts and crowned with a pitched thatch

roof. Although none of these early basilical structures survives intact in Mexico, we can get an idea of what they looked like from the Jesuit mission churches among the Chiquitos in Bolivia, such as Concepción (1752–6), a long hall made of a wooden frame with adobe walls, a pitched wooden roof and two rows of wooden columns separating the aisles. The position of the colonnades and the church's internal structure is echoed in the columns of the façade (122). This church type was chosen throughout America, not only because it was a convenient echo of Early Christian architecture but, more practically, because it could be built quickly and without prior architectural experience. In most cases these primitive basilicas were replaced (Bolivia is a rare exception), and in New Spain this new building boom took place in the mid-1500s.

The churches that replaced these modest 'basilicas' in the second half of the sixteenth century were huge rectangular, single-naved structures of stone whose solid and often dour appearance make them resemble fortresses – this impression is made even stronger by the battlements that run around the edge of the roof. Such is the Augustinian church at Yuriria (1550–67; 123), with its thick walls and merlon-shaped crenellations. Until recently, scholars believed that these structures were actually used as fortresses – places where the vastly outnumbered friars and their converts could hide during attacks by hostile tribes. However, as seen in Chapter 3, such attacks were rare in the interior of the country and it has now become clear that these battlements were merely for show, a symbolic reference to the Church militant and victorious. This triumphalist aspect of Mexican mission churches is also communicated by their giant scale, sufficient to accommodate the Amerindian congregations before they were struck down by the diseases of the 1570s but far larger than was necessary for the four or five friars who staffed them. The style of the missions of New Spain was very eclectic. Renaissance elements were juxtaposed with Gothic vaulting and Plateresque ornament, and many of the church ceilings were done in the intricate geometrical mudéjar style of Islamic Spain.

While the mission churches of the three great mendicant orders were very similar, each order had its own preferences. The Franciscans

122
Martín
Schmid and
Juan Mesner,
Jesuit mission
church of
Concepción,
Chiquitanía,
Bolivia,
1752–6

tended towards plainer structures in keeping with their vow of poverty, although they occasionally indulged in elaborate ornament, as in the marvellous *tequitqui* doorway already seen at the church of Santiago in Angahuan (see 40). Augustinians had no such vow and were less afraid to show off – after all, their churches were meant to represent celestial, not worldly glory. The finest of all Augustinian foundations is the convent at Acolman (124 and see 24), whose regal Plateresque façade (1560) ranks among the best Spanish examples. Although this masterpiece of architectural sculpture is emphatically European in style, scholars have still been able to identify small details in the carving that

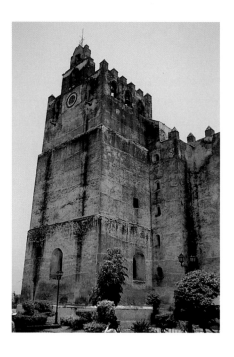

123
Pedro del Toro and others,
San Agustín, Yuriria, Mexico, 1550–67

recall Aztec manuscript painting traditions, suggesting an Amerindian hand. Typical of Augustinian foundations is the *espadaña*, a wall built over the façade that is pierced to hold bells. The Dominicans' speciality was thick-walled structures, designed primarily to sustain the earthquakes that ravaged Oaxaca, their main area of activity. However, this practicality did not prevent them from commissioning stately façades in an academic Renaissance style and voluminous Gothic vaulted interiors. The soaring vaults of the church of San Juan Bautista Coixtlahuaca (completed 1564; 125) reflect the splendour of this order, which

became wealthy by trade and tithes. The Society of Jesus (Jesuits), who were not a mendicant order, arrived only in the 1570s and were not part of this early missionary movement in New Spain.

To the right of the church lay the monastic buildings, which enclosed another key public space: the cloister. These were often two storeys high, in many cases featuring double arcades of the finest masonry with

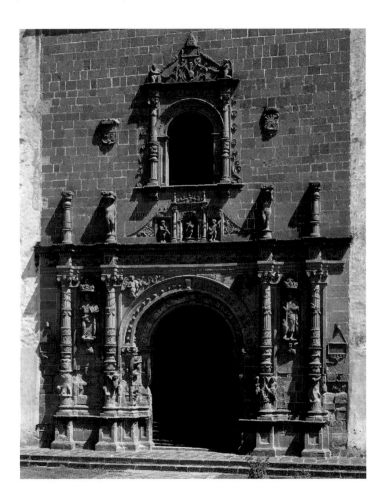

124
San Agustin,
Acolman,
Mexico,
1540,
façade 1560

columns and other classical elements as in the soaring arcades of the cloister at Cuitzeo (126). Cloisters were the focus of theatrical pageants and processions involving the entire community. The Malinalco murals (see 46), for example, with their references to Aztec cosmology, were located in the cloisters and, with their representation of the Garden of Eden after the Fall, they may have served as a backdrop for theatrical

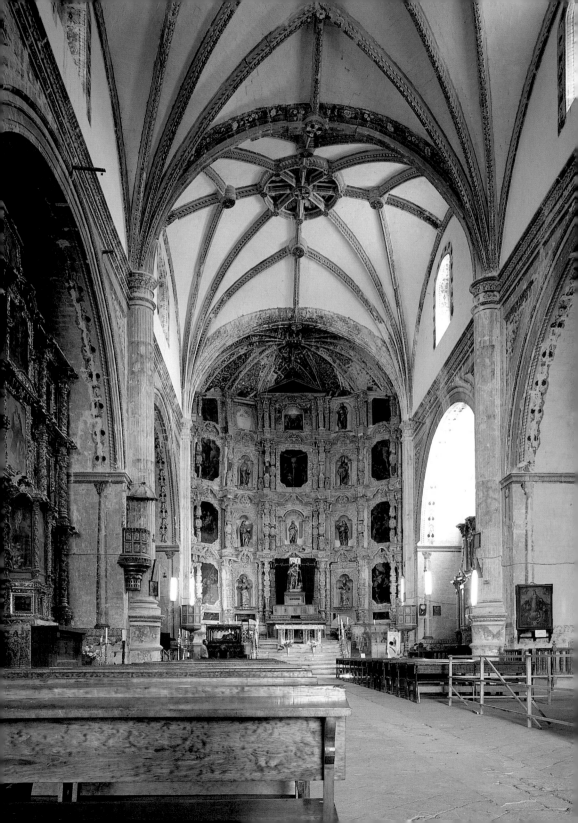

125
San Juan
Bautista,
Coixtlahuaca,
Mexico,
interior,
completed
1564.
Retablo
by Andrés
de la Concha,
1575

126
Cloister,
Augustinian
mission
church of
Santa María
Magdalena,
Cuitzeo,
Mexico,
begun 1550

performances of the Fall of Man. Cloisters usually had recessed openings for images on each of the four corners of the ground floor, arranged in such a way that those viewing them had to walk in an anti-clockwise manner, as in the atrium procession. The cloister led to public and private areas of the monastic buildings. On the lower floor were the *sala de profundis* (audience hall), schoolrooms and other public rooms. The upper storey contained dormitories, the friars' cells, the prior's lodge and sometimes a library. Other monastic offices, a kitchen, workrooms, gardens and orchards were situated at the back.

In Michoacán it became traditional to have a hospice at the mission as well, which became a focus for family-based community activity and a potent symbol of renewal and salvation. The tradition was inspired by Bishop Vasco de Quiroga, who had founded the hospice of Santa Fé in the Valley of Mexico in 1531 and his example was followed by Franciscan friars in places like Uruapan and Tzintzuntzán, both of which survive in part today. The hospice at Tzintzuntzán (127), near Pátzcuaro, included a grand open-air chapel formed of elegant rounded arches and supported by buttresses, which opened on three sides on to a spacious patio. This design, inspired by utopian architectural manuals like that of Filarete (see 62), allowed those in the sick wards to attend mass from their beds. Following the text of More's *Utopia*, Quiroga and his friars made these institutions the focus of a quasi-socialist

128
Church of San Salvador, Ayo-Ayo, Bolivia, begun late 16th century

community centre, with an orphanage, school, home for the elderly and a hospital. They also housed community banquets and social activities. Each of the children who worked for the friars put away part of their produce for hard times and the friary gave the rest to the sick, widows and orphans. In 1563, Quiroga ordered that every town in Michoacán that had a church should also have such a hospice.

In Spanish South America, where most of the country missions were founded only in the second half of the sixteenth century, the friars used the Mexican missions as a general model. Although smaller than their Mexican counterparts, missions in the Viceroyalty of Peru tended to be built on high promontories, inspired both by pre-Hispanic temple platforms and idealized reconstructions of the Temple of Jerusalem that were circulating in the Spanish Empire at the time. A particularly important cluster of mission churches survives on the southern shore of Lake Titicaca, founded by the Dominicans in the 1540s and handed over in the 1570s to the Jesuits. Other groups were founded southeast of Cuzco and in the Highlands of present-day Bolivia. These missions had imposing, thick-walled churches, which made up for their lack of height by being extraordinarily long (often over 60 m or 200 ft in length), such as the church of San Salvador (128) at Ayo-Ayo, Bolivia. Typically rectangular

like Mexican examples, the churches are usually single-aisled and often have two lateral chapels. The only exterior decoration is around the doorways, which are usually the single stone element in the brick and adobe walls – stone was a costly material that had to be transported from as far away as Panama. Massive bell towers often herald their presence from afar. Unlike Mexican examples, Peruvian mission churches tend to be roofed with wood and reeds, a more simple and earthquake-proof solution than stone vaulting.

As in New Spain, missions in the Andean Highlands accommodated outdoor worship, since Inca religious complexes also focused on large outdoor platforms in front of temples. The church often flanks or fronts on to a large atrium, which is enclosed together with the cemetery by extensive arcaded walls and sometimes has a raised cross in the centre. Although they did not appear as often as in New Spain, Peruvian missions occasionally had open chapels (as at the shrine at Copacabana, Bolivia) and they sometimes incorporated two or four posa chapels on the corners of the atrium, as at Oruro in Bolivia. One of the finest atriums is at the eighteenth-century mission church at Manquiri (129) in Bolivia, where a delicate tracery of arches and finials is flanked on both ends by cave-like posa chapels. Some Peruvian examples also have a unique type of open chapel, a large, often arcaded balcony over the front door, as at Urcos (130) and Andahuaylillas (131), which could serve as musicians' lofts, theatrical stages and pulpits for outdoor worship. The wooden porch at Andahuaylillas, dating from the early seventeenth century, is adorned with bright paintings of the martyrdoms of the patron saints, Peter and Paul, which could have assisted preachers during sermons. At Urcos, the porch becomes an elegant Renaissance double loggia of brick and stone, similar in design to the one used at the Alcázar in Santo Domingo (see 65).

The Lake Titicaca and other Highland missions in the Andes were built in a much more consistent and academically correct kind of Renaissance architecture than their counterparts in New Spain. Peru inherited a version of the so-called 'plain style' of late sixteenth-century Spain, derived in part from Serlio and other Italian treatise writers, and Peruvian churches did not encourage indigenous

129
Posa chapels, church at Manquiri, Potosí, Bolivia, late 18th century

130
Church of Our Lady, Urcos, Peru, 16th century

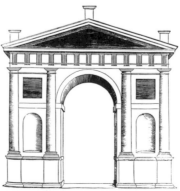

contributions comparable to Mexican *tequitqui*. The doorway at the stone church of Santiago at Pomata, with its engaged columns (ones that are sunk into the wall), entablatures and empty niches, is an example of this austere classicism. Many of these doorways, as at Pomata, are framed with giant arches, which make a reference to Roman triumphal arches as a symbol of Christian victory. Others, like Andahuaylillas, evoke the triumphal arch in the door frame itself by flanking the door with a pair of niches and pairs of columns or pilasters in a pattern taken from Book IV of Serlio's *Tutte l'opere d'architettura et prospettiva* (132). This strict classicism and Christian triumphalism has been cited as evidence of a new, anti-Utopian spirit that seized mendicant friars in the 1570s in reaction to the permissiveness of the early decades in New Spain. But the lack of indigenous influence also owes something to Inca tradition; the Incas did not pay as much attention to figural imagery as the Aztecs and they did not have as great an impact on post-Conquest architectural sculpture as in New Spain.

131
Church of San
Pedro Apóstol,
Andahuaylillas,
Peru,
after 1572

132
Sebastiano
Serlio,
Triumphal arch
motif, from
Book IV of
*Tutte l'opere
d'architettura et
prospettiva*, 1537

In the early years of the mission effort in Latin America, the Amerindian missions were often not far away from the Spanish and Portuguese settlements, which were still in their infancy. The missionaries operated with relative freedom from colonial control and their independence was supported by Crown law, which regarded neophytes as being free from the control of local bishops and parish priests. This situation changed quickly towards the end of the sixteenth century in New Spain (later in South America) as the Indian population was decimated by a wave of epidemics and the colonial settlements grew into major metropolitan areas. The great missions of the friars were handed over to local parish priests between 1573 and 1583 and lost their special status. Their communities were swallowed up by the colonial system. Although reorganized to meet the demands of their new colonial environment, these country and small-town parish churches were still heir to the mission enterprise, and they continued to reflect the tastes and world views of their still largely Amerindian and *mestizo* communities. Furthermore, as colonial society expanded, new waves of missions were founded beyond the constantly advancing border of the colonial world, often hundreds of miles from the colonial heartland in regions that still had thriving indigenous populations.

In the seventeenth and eighteenth centuries, these regions came to include California, Texas, New Mexico, the upper Orinoco and Amazon rivers in present-day Venezuela and Peru, the Brazilian hinterlands, eastern Bolivia, Paraguay and the Chiloé archipelago in Chile.

These foundations were established after a new cultural era had dawned in Europe based on very different aesthetic principles from the Renaissance: the Baroque. The Baroque was associated with the Counter-Reformation, a resurgence of Catholic culture following the crisis of the Protestant Reformation, and it was marked by an emphasis

133
Santiago
Apóstol,
Lampa, Peru,
rebuilt
1678–85

on persuasiveness, visual splendour and grandeur. Championed in seventeenth-century Rome by architects such as Gianlorenzo Bernini and Francesco Borromini (1599–1667), the Baroque style differs from Renaissance architecture through an increased interaction of structural forms (columns and entablatures no longer simply connect, they interconnect) and by a greater love for ornament and fanciful shapes – especially what are called mixtilinear forms (those that blend curved and straight lines or juxtapose concave forms with convex ones). Baroque architectural ornament is also more three-dimensional and stands out more dramatically in profile than its Renaissance precursors.

In Latin America, this style is best seen on façades such as this doorway of the seventeenth-century rural parish church of Santiago Apóstol in Lampa (133), Peru (late-seventeenth century), where layers of columns, scrolls and broken pediments protrude dramatically from the plane of the wall, allowing for a rich play of light and shadow.

In the eighteenth century an even more luxurious style took Latin America by storm, known popularly as Ultrabaroque (or Estípite-Baroque in Mexico), but more correctly a form of Rococo. It is characterized by a dissolving of structure and form and even more profuse ornament, so that the structural elements like columns or entablatures look more decorative than functional. This style differed considerably between Central and South America. In New Spain and Central America the Estípite-Baroque is characterized by an increase in polychromy and especially the *estípite* column, a pilaster that tapers towards the base (like an upside-down pyramid; see 154), giving it a weightless, anti-structural appearance. Both of these features can be seen at the delightful parish church of Acatepec (c.1730; 134), in a small village near Puebla, whose façade erupts in a riot of delicate *estípite* columns and other fanciful forms, all covered in multicoloured tiles. In Spanish South America, where the *estípite* is not as common, the same function is performed by 'solomonic' columns (also common in New Spain), a kind of twisted column first used by Bernini in Baroque Rome, which began to appear with profusion in the New World and can be seen flanking the door in many *mestizo*-style structures as in the splendid façade of the church of San Pedro in Sica-Sica, Bolivia (135), whose main portal is flanked by triple solomonic columns decorated with grapevines. In Brazil, where the Rococo style was much closer to Portuguese examples (themselves inspired by Germanic Rococo), there are generally no columns at all (see 28). Instead, Brazilian churches present a greater emphasis on sweeping curves and elaborately scrolling pediments, and most of the decoration is focused on the pediments, windows and doors, creating a striking contrast with the flat and plain whitewashed walls.

Although given the same name as its European inspiration, Baroque in Latin America was a very different style from that of Rome or even the

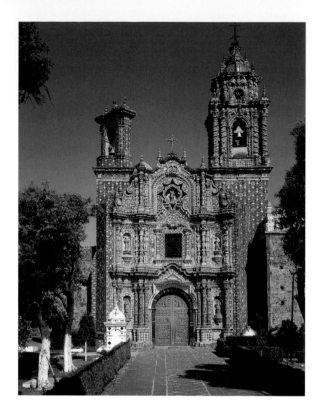

134
San Francisco,
Acatepec,
Mexico,
c.1730

Iberian Peninsula. One big difference is that European Baroque forms
affected the structures and spaces of buildings as well as their orna-
mentation, whereas in Latin America they were usually relegated to
the surfaces, specifically to doorways and retablos, while the churches
remained essentially rectangular in plan. The main exception is Brazil,
where dramatic oval-shaped plans and curving façades became com-
mon in the eighteenth century. Latin American Baroque also tends
to have more profuse ornament than European examples and a freer,
more creative interpretation of classical models. The development of
Baroque styles in the colonies happened almost autonomously, making
them unique in the world.

As the Latin American Baroque style especially prospered in the
metropolitan churches and in the new cathedrals, it will be
considered at greater length in the next chapter. However, that
is not to say that there were no Baroque missions. The churches of
the peripheral missions became the showcase for some of the liveliest

and most creative versions of the Baroque, some of it the work of Europeans and some the work of Amerindians. It is characteristic that one of the finest Baroque façades of colonial Mexico is on a mission in far-off Texas: the Franciscan church of San José y San Miguel de Aguayo (1768–82; 136, 137). Its intricate Estípite-Baroque stone doorway by the Mexican sculptor Pedro Huizar (1740–after 1790) reproduces the splendour of the eighteenth-century silver mining town of Zacatecas on a miniature scale, with its flickering light and shadow, made more dramatic originally by walls painted to resemble polychrome tiles. Known as the 'Queen of the Missions', this headquarters of the Franciscans in Texas ministered to Indian refugees from the war being waged between Spain and France in nearby Louisiana. Amidst curling tendrils carved in high relief, the façade celebrates its patron saint, with St Joseph shown at the top holding the Christ Child, Mary's parents Joachim and Anna on the flanks, a pair of Franciscan friars and, above the door, the Virgin of Guadalupe, Mexico's most celebrated devotional image and a powerful symbol of Indian and criollo pride.

A different kind of Baroque prevailed at the stone mission churches of Paraguay ('reductions'), built by Jesuit architects in the first half of the eighteenth century to serve the Guaraní Indians. The Jesuit reductions of Paraguay were founded in 1609, and firmly settled after 1641, in the jungles at the junction of present-day Argentina, Brazil and Paraguay. Probably the most famous Jesuit missions anywhere, they have been praised and blamed by writers from the time of the eighteenth-century wit Voltaire. Built by professional Jesuit architects, mostly Italian, in the latest Roman styles, these churches belong more to the

135
Solomonic columns on the façade of San Pedro, Sica-Sica, Bolivia, completed 1729

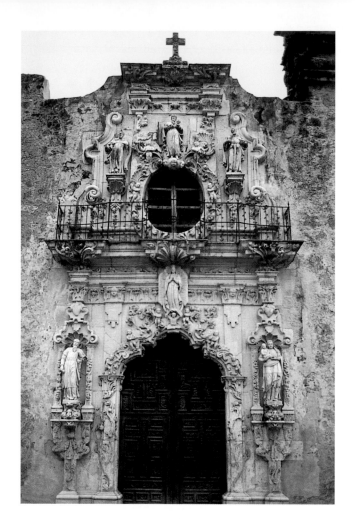

136–137
Façade,
Franciscan
mission
church of
San José y
San Miguel
de Aguayo,
San Antonio,
Texas, USA,
1768–82
Below
*St Joseph with
Christ Child*

history of European architecture than to that of the colonies. The best surviving of these churches, that of São Miguel in Brazil (1740–7; 138), is a bold synthesis of contemporary Roman-Baroque trends. Built by the Lombard architect Giovanni Battista Primoli (1673–1747), who had worked in Rome, the church was a three-aisled structure with a prominent dome and tall towers, all built of stone by Guaraní masons hundreds of miles from the nearest colonial settlement. Primoli left Rome in 1717, when the architectural life of the city was divided between two camps: the classicizing school of Bernini and Carlo Fontana, and the Rococo, derived from the legacy of Francesco Borromini. Primoli merges aspects of both schools at São Miguel, making the flanking sections of the austere and classical façade – it is based on an unfinished version of the Roman Gesù (139)– curve inwards like the architecture of Borromini.

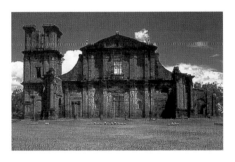
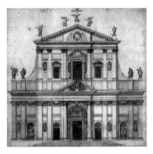

Despite this powerful statement of Roman authority, the Paraguay reductions and their descendants in Bolivia adopted aspects of indigenous urban planning and were the only settlements in Latin America that departed from the grid plan outlined in the Spanish royal ordinances of 1573 (see Chapter 3). As the reductions replaced Guaraní villages, the Jesuits designed their residential quarters to accommodate the specific social and kinship groups of Guaraní society. The long, one-storey stone Guaraní apartment blocks were arranged along the sides of a main plaza opposite the church, with individual cubicles for each family, and they were surrounded by a veranda on stone columns. These verandas are sometimes all that survives of these structures, as seen in the mission at Trinidad (140), where the elegant arcades that once surrounded

the apartments now look more like aqueducts. This type of veranda was unique to the Paraguay missions and was an accommodation to Guaraní lifestyle, as people tended to spend most of their time outside. They hung their hammocks between the columns, placed benches under the veranda and did their cooking there as well. As in New Spain, the plaza was the centre of religious spectacle, but here it was designed in a more theatrical way, with a main avenue leading directly to the church (entering the plaza from the centre of the opposite side instead of the corners) and by having the church, college and cemetery take up the entire side of the square. Dance, music and speeches were important features of pre-Hispanic Guaraní religion, and the Jesuits did their best to incorporate these features into the life of the mission. Missionaries like the Italian Domenico Zipoli wrote and staged full-

length operas in Guaraní and Chiquitos, complete with indigenous costume and instruments.

Some mission churches of the Baroque era borrowed so heavily from Indian styles and techniques that the European element plays only a secondary role. Such is the New Mexican pueblo of San Esteban Rey (141) in Ácoma, the oldest and largest of the New Mexican missions. Nowhere else in Latin America did indigenous architecture have such a powerful impact on that of the missions. While the basic proportions and outline of the church is European, the entire construction technique and modelling of forms is indigenous, related to a tradition of Puebloan building that may date back to the ninth century and earlier.

141
Franciscan
mission
church of
San Esteban
Rey, Ácoma,
New Mexico,
USA,
1629–44

The Franciscan mission of San Esteban Rey was built between 1629 and 1644, with repairs following the Pueblo Revolt of 1680 and early in the twentieth century. Situated in a dramatic and commanding site on top of a mesa (a flat topped mountain, often surrounded by cliffs), San Esteban was built by Puebloan Indians in the centre of a settlement that traces its roots back 800 years. In some respects it is similar in layout to a mission in New Spain, with a large, rectangular church fronting a walled atrium (here a cemetery called a *campo santo*), its monastic buildings adjacent to the church, and the paired towers on the façade and crenellations around the atrium. Some pueblo churches are also typically Baroque, as at Isleta Pueblo (1613) where the altar is lit by natural light through a transverse clerestory window, a technique employed in the churches of Baroque Rome. Everything else, however, came from Puebloan sources. San Esteban was made using the age-old local technique of adobe and stone, and like other Puebloan architecture it lacks domes and arches, both of which were the hallmark of European style in the period. The unique texture of the walls, made by a plaster of adobe and straw, is also distinctive to the area, as is the original roofing technique (the present roof is cement). The first roof at Ácoma, surrounded and hidden by a low parapet, was made of cedar twigs laid on top of crossbeams called *vigas* and then covered by a layer of adobe earth, a technique that can be seen in ancestral Puebloan ruins dating back to the twelfth century. The shape of Ácoma is unique to the region as well; the rounded contours and bevelled edges that have made the profile of New Mexican buildings so popular with twentieth-century artists such as Georgia O'Keefe (1887–1986) are very different from the sharp lines and corners of European predecessors, and they give these buildings a weathered and ageless appearance (see 241). Like other New Mexican churches, Ácoma lacks windows on the ground floor and has thick walls (they average about 2 m or 7 ft thick) that are completely unadorned. The church presents a powerful spectacle, grand in its plainness and austerity.

One distinctive feature of many New Mexican missions is the kiva, an indigenous structure that had been a central feature of Puebloan and proto-Puebloan culture for centuries. Usually a flat-roofed masonry

structure built in a circle or D-shape, the kiva is half submerged in the ground and inside are housed fire pots, benches and a symbolic navel of the earth called the *sipapu*. In Puebloan tradition, the kiva was the location of rituals involving kachinas, or ancestral spirits who help people communicate with the underworld. Although these periodic celebrations made them religious structures, kivas also served as a kind of town meeting hall and were at the centre of community life. Some of the largest and most complex kivas survive at Chaco Canyon in present-day New Mexico, one of the largest groupings of ceremonial centres and settlements in the ancient

142
Puebloan kiva,
courtyard of
the Franciscan
mission of
San Gregorio,
Abó,
New Mexico,
USA,
completed
1651

Americas (900 and 1125 AD). When the Franciscans first founded missions among the Puebloans between 1610 and 1680, they incorporated these structures into their mission buildings, in some cases directly in the centre of the cloister, as at the San Gregorio mission at Abó (142). Such a bold incorporation of a non-Christian religious structure into a mission complex would probably never have been possible closer to the colonial centres of power. The friars only dared to allow it here because they were so far from the settled part of New Spain and were completely outnumbered by the Puebloans

themselves. Recent scholarship has suggested that these kivas were used by the friars to stage religious plays representing the Indians' salvation from paganism and conversion to Christianity. It is clear that the Indians were in control of the situation and the friars had no choice but to include kivas in their buildings – the Indians refused to discard such a key aspect of their spiritual life. Puebloan Indians to this day practise a unique, syncretic form of Catholicism that includes kiva celebrations, kachinas and other ancient practices. This sacred

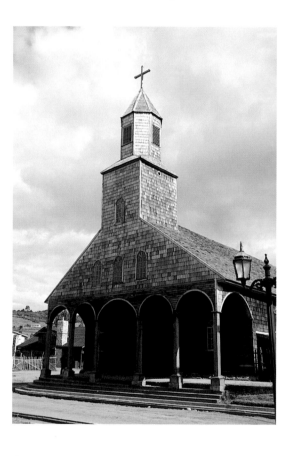

143–144
Anton Miller and others, Jesuit mission church of Santa María de Loreto, Achao, Chiloé Archipelago, Chile, before 1734; tower reconstructed 1873

cosmology has recently been depicted by artist Alex Seowtewa (b.1933) of the Zuni Pueblo, who has painted kachina celebrations of the four seasons on the inside of the seventeenth-century mission church of Our Lady of Guadalupe.

On the opposite end of the globe from New Mexico, the furthest south the Spanish Empire ever reached, the eighteenth-century Jesuit missions in Chiloé are so completely in harmony with indigenous

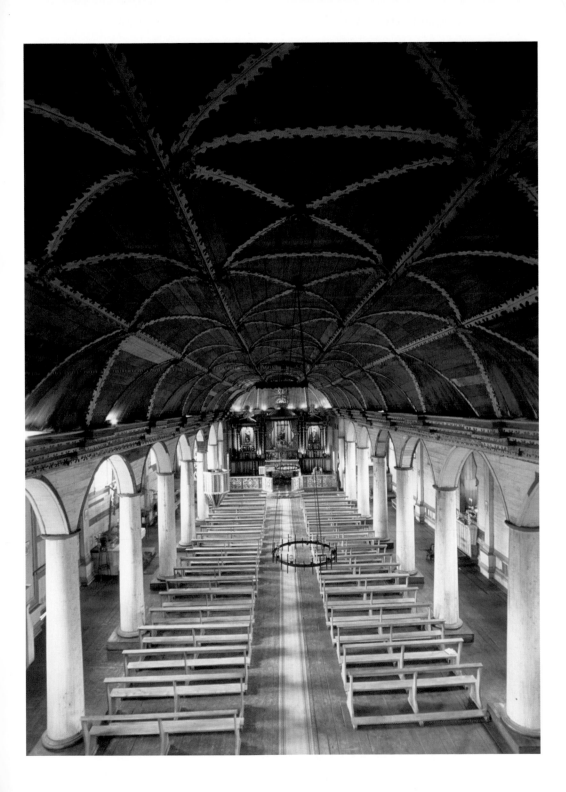

materials and techniques that they are also unique in Latin America. Plain, barn-like, shingled structures of wood, with few windows and adorned only with a single elegant arcade at the front supporting a solitary bell tower, the churches of Chiloé look more like the dour clapboard churches of New England than a relic of Spanish culture – appropriate in their Maine-like setting in the southern third of Chile. The finest and best preserved is Santa María de Loreto (143) at Achao, probably built before 1734 by Huilliche Indians under the tutelage of the Austrian lay brother, Anton Miller (1697–after 1760) and a *mestizo* or Amerindian lathe operator called Manuel. The Achao church is built entirely of local wood like larch and cypress, which grow in abundance in Chiloé's dense forests and the coasts of mainland Chile, and using methods the Indians employed for their wooden canoes, or *dalcas*, which were constructed from large wooden planks. Instead of nails the carpenters used strong wooden dowels, and they built on stone foundations to protect the buildings from humidity. The severe exterior does not prepare the visitor for the inside (144), which is an exquisitely rendered three-aisled basilica, with classical columns supporting an arcade and a delicate tracery of Austrian Rococo vaults with a hint of Gothic, all left in the original colours of the wood and highlighted with soft vegetable dyes. The wide planks of the floor contrast with the intricate carved foliage and geometric patterns on the altars and the pulpit. Churches like Ácoma and Achao are reminders that the art and architecture of the Iberian empires were sometimes profoundly receptive to indigenous culture.

The vast building programme of the Latin American missions and rural churches was accompanied by equally extensive campaigns in painting and sculpture, although, lamentably, much of this more fragile art has now been replaced by later additions, particularly in the late nineteenth and twentieth centuries with the rise of mass-produced plaster statues and lithographs. The earliest missions tended to rely on wall painting to recreate the interior splendour of European churches and to convey the tenets of Christianity. These murals, such as the ones already discussed at Malinalco (see 46), were usually the work of indigenous painters who used European engravings or pictures from printed books as their models. Such works did not just adorn the

church itself, but also public and semi-public areas in the cloister and mission buildings. Most were painted on to the dry plaster of the wall instead of directly on to wet plaster as in the fresco tradition in Italy.

In New Spain, murals often featured a central figural scene bordered by Renaissance-inspired ornament known as *a lo romano* (Roman style), often adapted from the borders of Bibles and prayer books, as well as treatises on ornament such as Diego de Sagredo's *Medidas del Romano* (1526) and Flemish engravings, which circulated from one mission to the next with amazing speed. Favouring a thick black outline and shading, these wall-paintings often shared the monochromatic tone of their engraved models, sometimes even copying the crosshatching and stippling effects of the engraver's art. Recent scholarship has traced this style to the alumni of Pedro de Gante's school of San José de los Naturales. Among the finest examples are the magisterial murals of Augustinian church fathers at Actopan (c.1574; 145), five tiers of black-and-white panels highlighted here and there with red. Adorning the grand staircase of the mission of San Nicolás de Tolentino, they depict the leading lights of the Augustinian order seated on Renaissance thrones in palatial settings, all framed by a lavishly decorated fictive arcade. At the base of the stairwell is a scene with portraits of Fr Martín de Acevedo, who may have invented the programme of the mural, as well as the Indian nobles Don Juan Inica Atocpa and Don Pedro Izcuicuitlapilco, who were also patrons of the church. This last scene, in which the Indians are depicted with an honour equal to that of the Spanish friar, serves as a reminder that the missions were a collective effort, and became a source of pride for the Indian community.

Peru had an especially refined tradition of mural painting. Its epicentre was Cuzco, but mural painting flourished even in sparsely populated regions as far away as northern Argentina. In Peru the humblest of mission churches were decorated with extensive, lively and brightly coloured murals in tempera (egg yolk) or oil-based pigments, applied on to dry plaster like their Mexican counterparts. The artists were teams of indigenous painters, who travelled from site to site as the job required. They based their images on Flemish engravings, but in a celebrated series of mural paintings adorning some wheat mills near

145
Martín de Acevedo, Juan Inica Atocpa and Pedro Izcuicuit-lapilco (?), *Heroes of the Augustinian Order,* c.1574. Mural. Mission church of San Nicolás de Tolentino, Actopan, Mexico

Acomayo (Peru) they included dignified depictions of Inca nobles
in their uncu tunics, feather headdresses and other costumes – the
textiles often reproduced with astonishing care and accuracy.
One striking difference from the Mexican murals is the use of
textile patterns as decorative accents, a reflection of the importance
of textiles as an art form in Andean communities before and after
the Conquest.

The finest of all is the staggering interior of the early seventeenth-
century Jesuit mission church of San Pedro Apóstol (146) in
Andahuaylillas. Known locally as 'the Andean Sistine Chapel', San
Pedro is saturated with brilliant mural paintings and canvases of the
life of Christ, the Virgin Mary, the Apostles and John the Baptist, among
other subjects. Based at least partly on drawings by Andean painters
Luis de Riaño or Diego Cusi Huamán (both fl.1618–26), who modelled
their images on the ostentatious engravings of the Wierix brothers
of Antwerp, the paintings almost overwhelm the inside of the church
and fragments show how they once did the same for the façade (see
131). In a didactic manner characteristic of late sixteenth-century

engravings, some of Andahuaylillas's murals have letters keyed to the action with explanations in captions below. The borders, doorways and dados of the church are covered with Renaissance arabesques in brilliant colours and fictitious architectural ornaments with finials, angels and urns – a cheaper alternative to marble and stone.

Even though the ornamentation at Andahuaylillas closely emulates Flemish prototypes, a recent study has shown that the man who conceived the programme of these murals, Father Juan Pérez Bocanegra (c.1598–after 1631), adjusted his themes to address his Andean audience, turning it into a sermon in paint. He made concessions to traditional Andean cosmology, including their hierarchy of the natural and celestial worlds, drawing a parallel to a series of instructions for missionaries he published in a manual in 1631. The painting programme at Andahuaylillas was intended to present Pérez Bocanegra's flock with a model for a perfect Christian life, beginning with the Baptism and ending with the Burial. But he went further than simply adding inscriptions in Quechua and Aymara to the usual Latin and Spanish. Pérez Bocanegra rearranged orthodox Christian figures and symbols in a way that resonated with the Andean concept of the cosmos, carefully polarizing the sexes and the celestial orbs to make them agree with an age-old Inca world view.

Unlike stone sculpture, which in New Spain proved to be fertile ground for *tequitqui*, most of the wooden sculpture that decorated the earliest Latin American missions and rural churches closely followed Renaissance trends in Spain and Portugal, showing a notable Flemish influence that was also felt in Iberia itself. The earliest sculpture on the missions was likely to have been made by Amerindian carvers, but it was usually replaced in the later sixteenth and seventeenth centuries by itinerant crews of European, *criollo* or *mestizo* artists from the towns and cities as the missions became more prosperous. Thus, the earliest sculpture that survives in many of the missions in places like New Spain is the work of professionals. Nevertheless, they can be said to represent the wishes of the Amerindian communities, as indigenous leaders chose the artists, stipulated which saints they would carve and even made specific requests about style.

Like Renaissance Spanish and Portuguese sculpture, the sculpture of early colonial Latin America focused more keenly on visual realism than its Italian counterpart. The Iberian tradition favoured brightly painted polychrome wood or gypsum sculpture, with drapery in gold leaf and decorated with tooled and painted decoration (called *estofado*), while the skin tones (*encarnación*) were done in oil over white lead in lifelike tones and varnished for brilliance. The intention was to create an effect of visual splendour, but also to elicit the emotional empathy of the viewer through its intense and sometimes disturbing naturalism, often enhanced through the use of glass eyes and human hair. This

147
Christ of the Tree, late 17th–18th century. Polychrome. wood; h.150 cm, 59 in. Museo Nacional del Virreinato, Tepotzotlán

hyperrealism is seen most vividly in the scenes associated with Christ's Passion, which were often depicted with visceral pathos, such as *Christ of the Tree* (147), carved from a single block of wood. Its medieval iconography, with origins in the twelfth century, may refer to Christ's death bringing forth life, an association which recalls the symbolism of the atrium crosses (see 121) and also the Mixtec World Tree (see 5).

In Latin America, sculptures were not made to stand on their own, but formed parts of elaborate gilt wooden retablos, which

incorporated sculptures, paintings and carved decoration in a
profusion of ornament, often taking up the entire wall behind the
altar, as in Andrés de la Concha's retablo at the mission at Coixtlahuaca
(see 125). Similarly, these complex structures were not the work of
one man, but involved careful planning between designers, sculptors,
painters, joiners and woodworkers, and are in reality more like archi-
tecture than sculpture. In New Spain, teams of professional retablo

148
Simón
Pereyns,
Pedro de
Requena
and assistants,
retablo,
1584–8
Franciscan
mission
church of
San Miguel,
Huejotzingo,
Mexico

makers crisscrossed the country from the 1570s onwards, setting up
shop on site in places like Cuauhtinchan, where the oldest surviving
retablo (c.1571) stands today. The most celebrated retablo is the one at
the mission of Huejotzingo (148), designed between 1584 and 1588 by
the Flemish painter Simón Pereyns and the sculptor Pedro de Requena
(fl.1584–8). Typically of the earliest generation of retablos in colonial

New Spain, the structure adheres to an austere, Renaissance style, basically a triptych whose wings are divided into a flat grid pattern of columns and entablatures that frame painted panels or sculptural niches. The lengthy contract for this retablo, discussed in the previous chapter, clearly stated that the Nahua nobles of the town helped choose the identities of the saints depicted on it and the style of the retablo, which 'must meet all the following conditions and names of saints ... that the father guardian and the Indian natives will wish'. This stipulation shows how difficult it is to draw conclusions about indigenous content on the basis of style alone. Even though it was made for an Amerindian mission and reflected the taste of its indigenous community – and despite an addendum to the contract in which Pereyns hired an Indian professional gilder from Mexico City to assist him – this early remnant of mission art bears no explicit trace of indigenous style or iconography.

As most of the earliest wooden sculpture from the missions no longer survives (the *pasta de caña* sculptures of Michoacán are a notable exception; see 51), it is only in the later seventeenth and eighteenth centuries in more distant places like Paraguay and California that a truly indigenous style of wooden sculpture exists. By this time the Baroque was in full swing. Baroque sculpture differs from its Renaissance precursors by its exaggerated emotions and sense of movement. This can be seen especially in figures' dramatic gestures, windswept drapery and theatrical facial expressions. Rather than standing rigidly within their niches like Renaissance statues, Baroque figures involve the space around them and directly address the viewers themselves, bringing them into a more active dialogue (see 27).

Paraguay was home to the most flourishing mission sculpture workshops in colonial Latin America. Each of the seventy Jesuit mission churches, of which only thirty remained when the Jesuits were expelled from Spanish territories in 1767, contained giant gilt and painted retablos housing what must have been thousands of sculptures in total. So many sculptures were made, in fact, that the reductions did a brisk trade with neighbouring regions both in retablos and statues. Although very few retablos survive today, hundreds of sculptures can still be seen

in the museums of Paraguay, Argentina and Brazil, works of astonishing power and originality, carved mainly from cedar wood by indigenous craftsmen. The artists worked in groups of eight to ten under the supervision of a master, who was usually a Guaraní noble, in the second courtyard next to the church, where they were supervised periodically by the Jesuit fathers. In addition to sculpture, Guaraní artists and artisans made retablos, furniture, gold- and silverwork, musical instruments, bells, ceramics, embroidery, and crafts (such as spoons) out of horn or antler.

The art of the Guaraní sculptors is at once eclectic and unmistakable, a testament to the skill and flexibility of its makers, who had an agility with native hardwood, but who – remarkably – had no pre-Hispanic tradition of sculpture. Art historians have coined the term 'Hispano-Guaraní Baroque' to describe the often flamboyant style of these sculptures, yet they are more complicated than such a term suggests. Surviving objects reflect the extraordinarily international make-up of the mission, including pieces that adhere closely to European canons in a range of styles, attesting to the wide variety of nations represented by the Jesuit missionaries themselves and the engravings they brought with them. In addition, they include objects, often scenes of Christ's Passion, the Madonna and angels, which mix European and indigenous facial and stylistic features. Scholars agree that the aspects that make this sub-group different – especially a schematization of the subject in which natural forms are turned into patterns – derive from pre-Hispanic Guaraní arts traditions, such as basketry, ceramics and body painting. Some of the most striking are scenes of Christ's Passion, such as the seventeenth-century Christ at the Column (see 113) in which the ribcage and loincloth are turned into parallel lines and zigzags, recalling similar patterns on the art works of neighbouring tribes (see 4). Some works, together with the stone carving on the churches, include depictions of local flora and fauna, like the passionflower or the tobacco plant, both of which played crucial roles in pre-Hispanic Guaraní religion.

This Baroque mission sculpture was not only made for retablos. Much of it was used to decorate temporary triumphal arches and processional altars set up during the many religious parades that punctuated Guaraní

life. Although we can read about these events in contemporary sources, we cannot be certain today where most of the surviving sculptures would have been used. Like the Mexican *posa* chapels with which we began this chapter, these statues will only reveal their secrets as we learn more about the societies who made them and how they lived their lives.

A very different sort of mission workshop – neither indigenous nor professional – was founded in the southern reaches of the Spanish Empire, among the Jesuits of eighteenth-century Chile. On a ranch called the Calera de Tango and in the courtyard of the Jesuit college in nearby Santiago, the Society of Jesus founded a mission art studio with Jesuit artists, which happened to be the greatest number of Central

Art of Colonial Latin America

149
Peter Vogl,
Courtyard of
the Jesuit
ranch Calera
de Tango,
near Santiago,
Chile,
1755–62

150–153
Georg Lanz,
Pulpit,
c.1760.
Polychrome
wood.
Church of
La Merced,
Santiago, Chile
Top left
St John the
Evangelist
Top right
St Luke
Below left
Angel
Below right
Caryatid

European artists to settle in a single region of Latin America, including over fifty Jesuit artists from Germany, Austria and Bohemia. Some of the courtyards still survive at the Calera de Tango, such as one adjacent to the church (149) which probably housed the iron foundry. Beginning in the 1720s, they built churches, carved retablos and statues, crafted furniture, founded bells, forged silver and gold vessels, made ceramic vessels, wove cloth and tapestries, and assembled organs and clocks. They did so on such a scale that they left a recognizably Germanic stamp on the arts of Chile, a legacy that lasted into the nineteenth and even twentieth centuries and distinguished Chilean arts from those of their neighbours elsewhere in South America.

As in most of the Jesuit missions worldwide, Jesuit artists were usually brothers, men who joined the Society but did not aspire to the priesthood. Usually from working class or artisanal backgrounds, and thus not trained in an academic tradition, Jesuit brothers provided the backbone of the organization, acting as carpenters, masons and stucco-workers, as well as cooks and gardeners. At a time when Spain was drying up as a source of such skilled brothers, the Jesuits of Chile turned to Central Europe, which was overflowing with young Jesuits talented in the manual arts, from painting and architecture to furniture making and weaving. Some of these brothers would later go on to teach indigenous artists, most notably on the southern missions of Chiloé.

One great masterpiece of the Chilean workshops is the pulpit in the church of La Merced, Santiago (c.1760; 150–153), the work of German sculptor Georg Lanz (1720–71). An exuberant wooden sculpture in the Rococo style, it recalls contemporary pulpits in Bavaria, especially an expressive style promoted by Egid Quirin Asam (1692–1750). The facets on the pulpit's main box feature four large figures of the Evangelists, some of them holding texts, all of whom seem to move in unison to the music of a ballet. Lanz's pulpit rests on figures of a lion and a bull, representing the Evangelists Luke and Mark, and elsewhere the pulpit is enlivened by angels, caryatids and an abundance of Rococo scrolls and leaves. A mass of sculpted clouds and cherubs spills down from underneath the monumental canopy, surrounding a scene of an apparition of the Virgin Mary. Two examples of pulpits adorned with similar sculptures can be found in Germany at the Augustinian church at Rohr (1717–25) and the Benedictine church at Zwiefalten (1739–65).

Latin American missions embraced an extraordinarily diverse variety of styles and techniques. Drawing upon the widest spectrum of indigenous styles and techniques, an entire hemisphere of building materials and the fullest range of European traditions – from the Gothic to the Ultrabaroque – the missions of the friars and Jesuits brought worlds together in a way that was rarely possible in the metropolitan centres, with their dominant criollo and mestizo populations, and they bear testament to one of the world's widest-ranging and longest-lasting experiments in intercultural relations.

The Church was by far the greatest art patron in colonial Latin
America. The western hemisphere had no secular rulers to compare
with the princes and dukes of Renaissance and Baroque Europe, and
most of the wealth that remained on American soil was lavished on
the cathedrals, parish churches and foundations of the religious orders.
Unhampered by the wars and famines of Europe and bolstered by the
staggering riches of the mines and the produce of their extensive farms,
Latin American bishops, friars and nuns joined forces with *criollo* aris-
tocrats to found massive churches, monasteries and convents, complete
with multiple courtyards, libraries, refectories and treasuries. These
visions of Heavenly Jerusalem, often large enough to seem like cities in
their own right, were the most important showcase for the visual arts.
The cathedrals and churches were adorned with gold-plated altarpieces
brimming with sculptures, panoramic cycles of paintings of the lives of
the saints or scenes from the Bible, intricately carved pulpits and choir
stalls adorned with relief panels and supported by caryatids, and
dazzling silver or embroidered silk altar frontals. Such magnificence
could not help but inspire resentment, particularly from local civic
officials, secular landowners and Protestant visitors. Legends of secret
ecclesiastical gold mines and hoarded treasure quickly took their place
in the popular mythology of the time.

Nevertheless, these churches touched people's lives more closely and
in a more egalitarian way than the viceregal buildings surveyed in
Chapter 3. The focus of the religious life of the community, the civic
churches hosted the masses, sermons, prayers, confraternity meetings,
processions and other spectacles that punctuated the liturgical year, as
well as the baptisms, confirmations, weddings and funerals that marked
the milestones of people's lives. If viceregal architecture was the vision
of empire, the churches were a reflection of community, not only
for the *criollos* and *mestizos* who made up the bulk of the metropolitan
population, but for the Africans and Amerindians who also lived in

154
**Jerónimo de
Balbás**,
Altar of
the Kings,
1718–37.
Polychrome
and gilded
wood;
h.26 m,
85 ft.
Cathedral,
Mexico City

the towns. Churches were also the greater creative outlet. Whereas the architecture of the Crown unstintingly expressed classicizing goals, the churches quickly gave rein to the fullest expression of the Baroque, Rococo and Ultrabaroque, styles also derived from Europe but more flexible in allowing regional variations and personal idiosyncrasies.

This inclusiveness was even true of the cathedrals. Of all the churches built in the Americas, the cathedrals were the most explicit expressions of royal might and had the most in common with viceregal civic architecture. Cathedrals are the seat of a bishop or archbishop, and since in the colonial era these prominent churchmen were appointed directly by the Spanish and Portuguese monarchs, they were as direct a symbol of imperial rule as the viceroys' or governors' palaces that invariably stood next to them. Cathedrals were also the largest structures ever built in the colonial era. Not surprisingly, the Crown paid close attention to cathedral architecture, spending great sums of money, hiring teams of professional architects from Spain and Portugal, approving plans and elevations with their royal seals, and closely monitoring construction, making alterations as fashions changed and techniques improved. Like viceregal civic architecture, cathedrals were built in a strictly European style, at the beginning in the same austere, Renaissance manner inspired by the Italian manuals and encapsulated in Spain in the Escorial (see 78), and more specifically in the cathedral at Valladolid (1585; 155), also by Philip II's architect Juan de Herrera. Flat walls punctuated by classical door frames, solid block-like profiles and protruding corner towers characterize the first century-and-a-half of cathedral building. On both continents, cathedrals adhered to strict guidelines, including a façade divided into three vertical sections and flanked by two towers, a fortress-like tradition from the era of the Holy Roman Emperor Charlemagne (r.768–814 AD) that proclaimed the triumph of the Church. They were also often raised on a stepped platform above the level of the square to add to their majesty. Nevertheless, more than in imperial secular architecture, the cathedrals changed with the times, incorporating the latest trends in the Baroque, Rococo and Estípite-Baroque from places like Seville, Cádiz and Granada, and advancing these new styles to a degree seldom matched in Europe. This creative explosion, focusing on rich textures, bright colours, intricate

patterns, manipulations of light and shadow, and a sense of drama, was inspired by a Counter-Reformation emphasis on spectacle and sensuality as a way of drawing people back to the Church. Nevertheless, since they were so closely monitored from Iberia, cathedrals do not as frequently display the kind of improvisation or regional variations seen in the other civic churches.

The cathedrals of New Spain are the main monuments to Western architectural principles in the Americas. Two of them – Mérida and Mexico City – provide a convenient summary of their stylistic

100 FEET

30 METRES

155
Juan de
Herrera,
Cathedral,
Valladolid,
Spain,
1585

development, from Renaissance, through to Baroque, Estípite-Baroque and Neoclassicism, the style that augured the twilight of the empire. New Spain already boasted seven bishoprics before the end of the sixteenth century, including the first cathedrals ever built in continental America (Santo Domingo, begun on the island of Hispaniola in 1512, is older; see 2). The cathedral at Mérida (156, 157), founded in the Yucatán Peninsula in 1562 and started the next year, is one of the purest examples of Renaissance architecture anywhere in the New World.

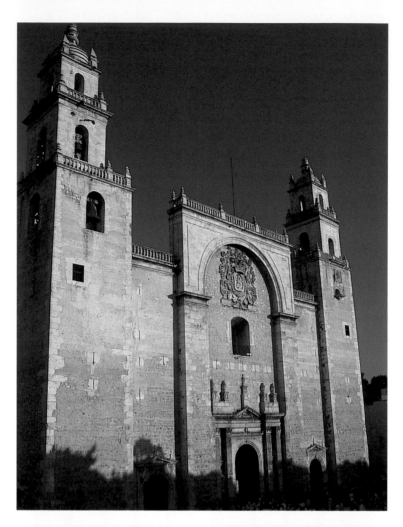
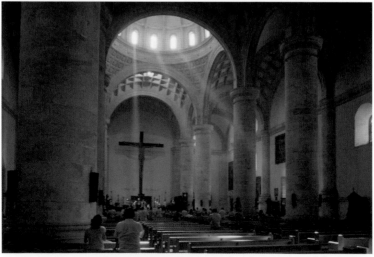

Mérida Cathedral was mostly built between 1585 and 1597 by a team of professional architects from Spain, including Juan Miguel de Agüera (fl.1580s–90s), a military engineer who had worked on the fortifications at Havana. Therefore, the cathedral not only shared its appearance with civic architecture, but also one of the same architects, and its fortress-like aspect with rough stone facing and the sombre classical pediments and columns of its doorways spoke at once of secular and ecclesiastical rule. Basically a rectangular block, with protruding corner towers like the Escorial, Mérida Cathedral is a type known as the 'hall church', with a nave and two side aisles of equal height. The hall church derived from a Spanish prototype at Jaén (1546) by Andrés de Vandelvira (1505–75) and, until the late 1580s, was the preferred model for Central and South American cathedrals including examples at Lima and Cuzco. Mérida's façade combines the imagery of Church and State with the bulky statues of Saints Peter and Paul flanking the central doorway and King Philip II's florid royal arms above, enveloped in fanciful strapwork and dated the last year of the sixteenth century. Inside, the subtle contrast of grey stone and white plaster recalls Brunelleschi's churches in Florence, with their typically Renaissance emphasis on structural elements like columns and entablatures, and their resistance to extraneous decoration. Especially subtle is the way the architect uses the vault decoration to call the viewer's attention to the Latin cross that is always the basis of the plan of a Latin American cathedral. The central nave, transepts (arms) and the triangular pendentives of the dome are highlighted with square coffering in a conscious echo of Roman buildings like the Pantheon (118–25 AD), while the side aisles are left plain and adorned only with whitewash.

Mexico City Cathedral (158) recounts the entire history of Latin American colonial architecture in a single building. Like so many of its European counterparts, its construction spanned generations. Founded within a decade of the Conquest, the church was only completed in 1817, four years before independence, by the academician Manuel Tolsá. The cathedral is the largest building in colonial America, over 110 m (360 ft) long and almost exactly half as wide and tall. The present building, dating mostly from the seventeenth and eighteenth centuries, embraces every Spanish style that ever reached the colonies,

156–157
Juan Miguel
de Agüera
and others,
Mérida
Cathedral,
Mexico,
1585–97

including Gothic ribs, Renaissance piers and vaults, Baroque scrolls and twisted columns, *estípites* and Neoclassical finials. It also accommodates the realities of its Mexican setting, with its low, wide profile and lightweight vaulting – designed to resist earthquakes – and the extensive sixteenth-century stone and wood-pile foundations, which have not succeeded in preventing the massive structure from sinking into the soft bed of the former lake reclaimed for the Aztec capital. The cathedral also faces south instead of the traditional west, a concession to the siting of the Zócalo (which replaced the main Aztec ceremonial plaza), and it partly covers the principal Aztec temple – a standard symbol of Christian victory over paganism (see 12).

The present cathedral's predecessor (1524–32), begun by Hernán Cortés and finished by Bishop Juan de Zumárraga and simply called the 'Iglesia Mayor' (Principal Church) until it gained cathedral status in 1546, was a simple rectangular basilica with octagonal wooden columns in the Tuscan order and a pitched roof – hardly a satisfactory symbol of imperial rule (see 75). Nevertheless, in a gesture of Christian conquest as old as the late Roman Empire, pieces of the main Aztec pyramid were placed as supports under the columns. The new building was begun to the north in 1573 while the old one was still being used (it lasted until 1626) and, had the new church been completed in the way it was intended, it would have looked like Mérida, a hall church in the Renaissance style (in fact one of its architects was the same Juan Miguel de Agüera). As it happens, styles changed, and in 1612 a new viceroy arrived with orders to alter the elevation to reflect the basilical form, with the side aisles lower than the main nave, a reflection of the profile of Valladolid Cathedral (see 155) and St Peter's in Rome and a shape that would become standard in the cathedrals of New Spain from that time forward. The original height was also lowered to make the church more earthquake-resistant. The man who left the strongest impact on the plan of the cathedral was Claudio de Arciniega (c.1520–93), whose original design of c.1569 survives today (159). Like Valladolid, his cathedral is a rectangular structure enclosing a Latin cross, with the crossing slightly closer to the apse than the main portal, and it was supposed to have a protruding tower at each corner (only two were actually built). Mexico City Cathedral also echoes its Herreran model

158
Claudio de
Arciniega
and others,
Cathedral,
Mexico City,
1573–1817

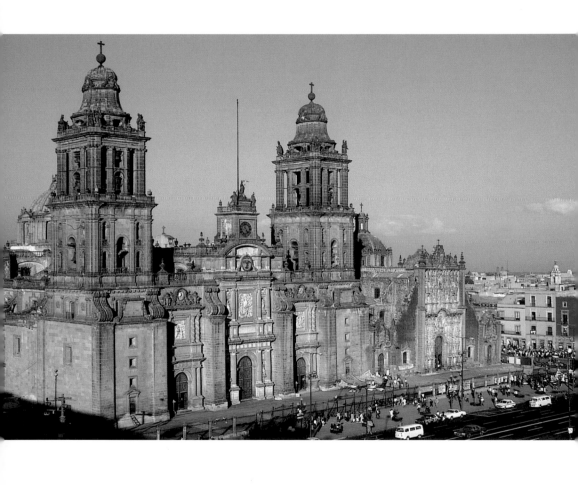

in the plain grey cut stone of its exterior. Arciniega was only one of
a whole chain of Spanish architects who left their mark on this great
communal effort, including Diego de Aguilera (1593–1603). The new
church was completed in 1667.

The façade introduces the first traces of Baroque style. Finished
in two main phases, in 1672 and then in 1687, its three sections
are articulated by bold buttresses and heavy scrolls that jut out from
the wall, a three-dimensional effect that places greater emphasis on
the vertical element and derives ultimately from seventeenth-century
Roman churches. Other Baroque touches are the appearance on the

159
**Claudio de
Arciniega**,
Plan for
Mexico City
Cathedral,
1567–9.
Sepia and grey
ink on paper;
Private
collection

flanking doorways of twisted solomonic columns, popularized by
Bernini and identified with the Temple of Solomon and St Peter's
in Rome, and the increasing importance accorded to richly sculpted
relief panels, giving a more textured effect to the whole surface.
As at Mérida, statues of Saints Peter and Paul on either side of the
panel above the main portal remind the viewer of the primacy of
the papacy. The soaring towers, finished only in 1791, help balance
the otherwise low profile of the main body of the church. Manuel
Tolsá added the square clock tower and tall cupola which were
completed a year after his death in 1817. The church was repeatedly

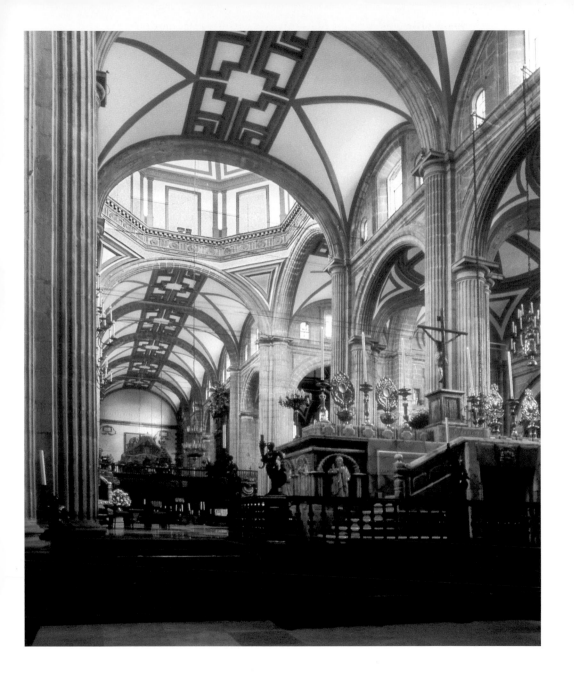

160
Juan de Rojas,
Interior with
choir,
1695.
Cathedral,
Mexico City

praised in the colonial era for its massiveness, a very basic but irrefutable sign of human achievement.

The interior (160), which preserves the Renaissance character of the original concept, features elegant fluted piers, an octagonal dome, a barrel vault in the nave and, in the aisles, dish vaults sectioned like an orange (an appropriate motif, as in Spanish the word for a cupola is a 'half-orange'). The vaulting employed new anti-earthquake techniques using brick and a porous volcanic rock called *tezontle*. Its designers, including Alonso Pérez de Castañeda and Juan Gómez de Trasmonte (1626–47), consciously emulated the great churches of Europe, with Trasmonte specifically naming St Peter's in Rome, the church of the Escorial and the Jesuit mother church of the Gesù (see 139) as models. The Gesù plan was a popular model throughout Latin America, because it allowed for a large open space with an uninterrupted view of the altar. It had already served as the model of the 1609 design for Havana Cathedral by Juan de la Torre (fl.1589–after 1609), although in the end that church was never built.

It is the Baroque, and not the Renaissance, that captures the visitor's imagination upon entering. Many of the city's religious orders, guilds and confraternities had their own side altar, brimming with gold, statues, paintings and silver adornments. However, the first structure to greet the eyes is a giant, U-shaped choir, with the gilt Estípite-Baroque Altar del Perdón (by Jerónimo de Balbás; fl.1706–50) blocking the view to the nave. This placement of the choir is traditional in some Spanish cathedrals, as at Salamanca (1513–60). Made of two levels of splendidly carved cedar seats and wooden statues by Juan de Rojas, the choir is flanked by two gargantuan Baroque organs (the largest in Latin America), whose Rococo wooden cases are adorned with gilt angels and topped by royal crowns. The choir incorporates an iron screen made in Macao in 1723 to the designs of Mexican artist Nicolás Rodríguez Juárez (1666–1734), and a lectern carved in the Philippines (a gift of the Bishop of Manila; 1762), two testaments to Mexico's strong cultural ties with Asia (see Chapter 7). At the north of the nave once stood another evocation of St Peter's in Rome, a tall gilt baldachin (or canopy) over the main altar, already planned as early as 1668 in emulation of

Bernini's masterpiece of 1624–33. The retablos of the eighteen side chapels add to the richness of the interior, although some of them were replaced with more austere Neoclassical retablos during the ascendancy of the Real Academia de San Carlos.

The final goal of the visitor to Mexico City Cathedral is the splendid Altar of the Kings (Altar de los Reyes), built by Balbás between 1718 and 1737 to fill the whole interior of the apse and serve as a reminder of royal authority (see 154). One of the first works in the Estípite-Baroque style on Mexican soil, the Altar of the Kings demonstrates a late development in retablo design in which paintings and sculpture cede their primacy to architectural ornament. Instead of the rational distribution of columns and entablatures in Simón Pereyns' altarpiece at Huejotzingo (see 148), which create a grid pattern to frame the sculptures and paintings, the Altar of the Kings allows structural elements like pilasters and niches to dissolve into a mass of jagged and curved lines, decorative scrolls, angels and garlands. The overall effect is one of textural richness, enhanced by the flickering light cast over the gilt surfaces by the candles. The trademark motif of the Estípite-Baroque is the *estípite* column, the daringly segmented vertical supports of the altar, formed of tapered, upside-down pyramids and other exotic shapes usually found only on finials. Jerónimo de Balbás came from Andalusia, where he was one of the leading retablo makers of Seville, creating such wonders as the pine wood retablo of the Seville Sagrario (1706–9), an influential composition of *estípites*, angels and mixtilinear forms. Yet his greatest contribution to world sculpture may have been his work in New Spain, where he was one of the first to popularize the *estípite* after he moved there in 1717.

Before having the commission approved, Balbás presented a plan and explanation of the altarpiece to the Cathedral Chapter. We know from this contract and other documents that he headed a team of carpenters, gilders and joiners, and contracted out for the more important details of the retablo. These artists included the Mexican painter Juan Rodríguez Juárez, who executed the two oil paintings at the centre, the sculptors Sebastián de Santiago (fl.1718–25) and a certain 'Don Pedro', who carved angels and other sculptural details,

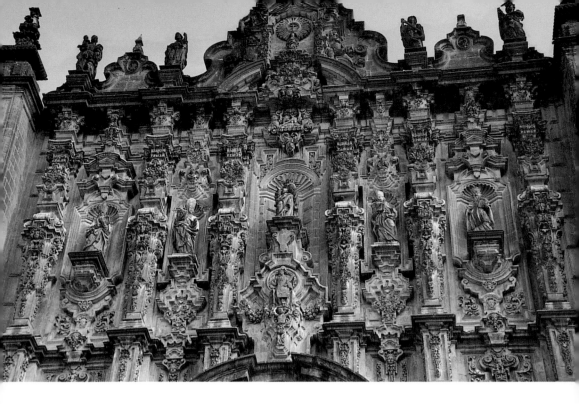

and the gilder Francisco Martínez (fl.1718–25). Balbás's patrons were
very anxious to keep up with the latest styles from Europe. In the
contract for the statues of king saints that accent the altarpiece, it was
stipulated that the sculptor should paint them not in the old-fashioned
estofado style (in gilt and painted patterns) but in naturalistic colours
'in imitation of Roman [statues]'. Even a sculptor of Balbás's calibre
did not hesitate to base his designs on engraved models. Balbás closely
studied sixteenth-century illustrated architectural manuals by Jan
Vredeman de Vries and Wendel Dietterlin when preparing his design,
not only for these Mexican retablos but also even for his earlier work
in Spain. One of the first works to show the influence of this great
altarpiece was the Sagrario Metropolitano (161), the cathedral's parish
church, which adjoined the east side of the cathedral façade (see 158).
The Sagrario's two façades were designed by another Andalusian,
Lorenzo Rodríguez (c.1704–74), who rebuilt the church between 1749
and 1768. Employing a grey *chiluca* stone in the centre to contrast with
the warm bronze *tezontle* of the sides, Rodríguez again emphasizes
colour and the play of light and shadow. Like the Altar of the Kings, his

surfaces break apart into different layers of deeply curved ornament that absorb the pilasters and statues alike into an overall pattern, blurring boundaries and distracting the viewer's attention from individual details. It is almost as if Rodríguez has transformed the façade from an architectural structure into a canvas, with its flickering light effects and almost impressionistic highlighting. He seems here to be enjoying a greater freedom of expression and more of a sense of rhythmic movement than had been possible in a work of architecture before. In the following pages we will see this same dissolution of forms in late Baroque painting and sculpture.

161
Lorenzo
Rodríguez,
Sagrario
Metropolitano,
Mexico City,
1749–68

The parish churches, monasteries and convents shared the cathedrals' affinity with European styles and they also quickly erupted into Baroque splendour in the later seventeenth and eighteenth centuries. But unlike their episcopal counterparts, these smaller churches were often built by local architects, many of them amateurs, and they show-cased more uniquely regional styles. While a handful of these styles relate to indigenous traditions, like the mestizo style of Highland Peru and Bolivia discussed in Chapter 2, most of them were novel creations, the product of flourishing local workshops, and had nothing to do with the ethnic background of the artists. Many of the interiors of these churches demonstrate an essentially Baroque concept in which sculpture, painting and architecture join forces in creating a unifying total effect. Unlike Renaissance churches, in which the different media are separated – sculptures kept within their niches, paintings within their frames and architectural units strictly reflecting their function – Baroque church interiors allow for overlap, so that sculptural stuccos climb up walls and spill into canvases, statues reach out from their frames and the whole interior is covered with similar patterns and motifs. Even objects from other periods, like a Neoclassical altar or Renaissance font, can be embraced by this overall sense of ensemble. The intention of this unity is to guide the viewers' eyes towards key focal points like the altar or pulpit and to seize their attention through the lavishness of the decorations. Readily understandable and providing solace in its promise of heavenly glory, the Baroque is an art for the people. It was this very popularity that led to the anti-Baroque move-ment of the highbrow Neoclassical academies in the eighteenth century.

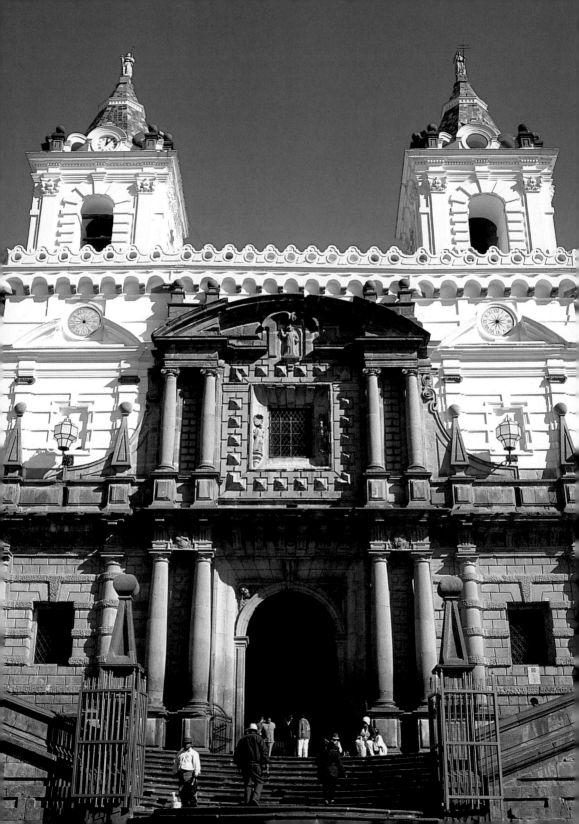

Although it is impossible to mention here all but a very few of the thousands of splendid colonial churches that survive in the towns and cities of Latin America, a handful of them can help illustrate the transition from Renaissance to Rococo, moving from designs that carefully emulate European models to ones that demonstrate an extraordinary freedom from Old World values. They also show how rare it is for any one church to represent a single style, since so many of them were added to and altered over the generations, reflecting the entire history of colonial art. The most splendid Renaissance exterior in South America is that of the Franciscan church of San Francisco (162) in

162
Benito de
Morales
or Alonso
de Aguilar,
San Francisco,
Quito,
Ecuador,
c.1586

163
Cloister,
San Francisco,
Quito,
Ecuador,
before
1553–81

Quito, a building that also happens to have one of the continent's most exuberant Baroque interiors. The first monastery ever founded in South America, it was begun one month after the Spanish occupied the capital of the Inca Atahualpa in 1533 and on land owned by the Inca Huayna Capac. Consequently, the theme of the victory of Christianity over paganism was built into its very foundations and the church made the most of its prominent position on the upper side of a busy square. Like most of the great monasteries of Latin America, San Francisco has many spacious cloisters, leading on to a library, refectory, kitchen, dormitories and other rooms. The main cloister (1553–81) is formed

of an elegant, two-storey arcade of grey stone and whitewashed arches (163). With its flower-shaped fountain in the centre and waving palms, it evokes the courtyards of Seville. Providing respite from the clamour of the city outside, these spaces were intended for contemplation and prayer, but like the cloisters in the mission churches of New Spain they were also open occasionally to the public, and their decoration would have been familiar to all.

Work on the church of San Francisco was well advanced by 1553, when King Philip II personally paid for the roof, and the entire building and the adjacent monastery were completed by 1581. Although San Francisco is best known as the headquarters of Jodoco Ricke's arts and crafts academy (see Chapter 4), this Flemish polymath is no longer credited with the design of its remarkable façade. The architect was most likely either Benito de Morales, a military architect who worked for the king at Cartagena and passed through Quito in 1586, or Alonso de Aguilar, a Master of Works of Quito Cathedral who collected books on Italian architecture.

Like the viceregal palaces, San Francisco expressed its spirit of victory through Italian Renaissance design. The dominant feature is the grand concave-convex circular staircase (see 162). Inspired by Bramante's Belvedere Palace in the Vatican and borrowed directly from an illustration in Book III of Serlio's *Tutte l'opere d'architettura et prospettiva*, it seems to spill down into the square below and invite passers-by into the church. This staircase was frequently copied, even in a secular setting as at the nearby Hacienda la Herrería (see 188), commissioned by Don Miguel Ponce de León in 1750. The grey stone of the staircase is also used in the central part of the church façade, a triumphal arch structure in the Doric and Ionic orders which encloses the doorway and a rectangular window. But the façade is much more than a student's exercise in the Renaissance mode. Its surfaces are punctuated with diamond points and different kinds of rustication – details favoured in the late Renaissance period in Italy and northern Europe – and the main entablature stands out boldly from the wall, casting shadows over the ornamentation below. Tiny scrolls, shell motifs and the knotted cords of the Franciscans help lighten the overall effect. The architect also

164
Esteban
Guzmán
and others,
San Francisco,
Quito,
Ecuador,
1769

subtly emphasizes the centre, as the columns on the sides are set into
the wall while those surrounding the door are not only paired but free-
standing – a focus that will become more apparent in the façades of
Baroque churches. San Francisco's façade, a type known as the 'retablo
façade', became the prototype for many churches in Spanish South
America and it was closely imitated not only in Quito, but also in places
as far away as San Francisco at Tunja in Colombia, built around 1610.

Inside (164), San Francisco has an entirely different effect, dazzling the
eye with ornate decoration, sparkling gold leaf and brightly coloured

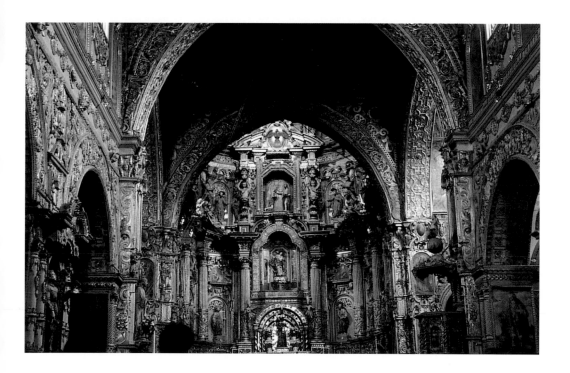

statues and paintings. If the exterior is one of Latin America's purest
statements of Renaissance style, the interior is one of its richest expres-
sions of the Baroque. The church owes this stylistic disparity to natural
disaster. An earthquake in 1755 sent the original towers toppling
into the nave, destroying the ceiling. A team of carpenters, sculptors
and gilders under the direction of Esteban Guzmán executed a new
ceiling in 1769 and much of the interior was also updated in the
eighteenth century, including the massive golden retablo that takes up
the entire apse chapel. Nothing could better characterize how Latin

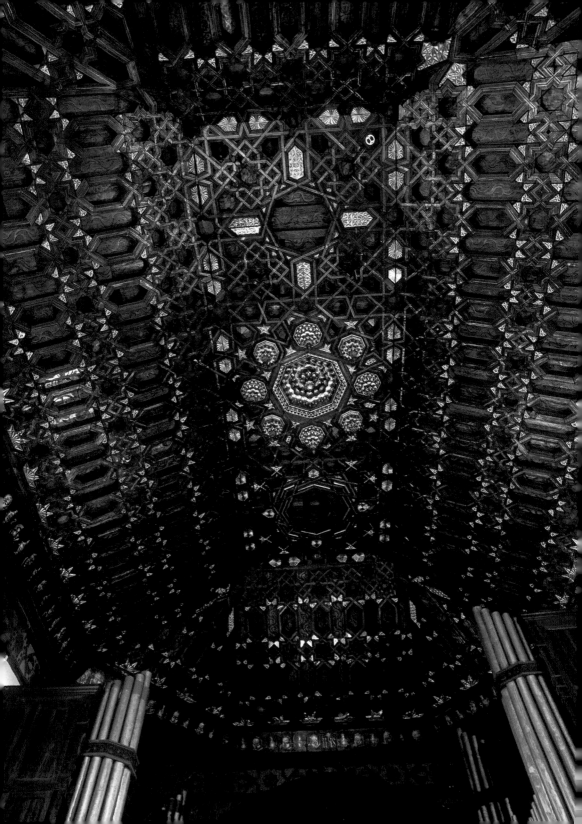

American style had matured since the time of the façade with its homage to Renaissance books. Inside San Francisco the rules of exact symmetry and academic correctness no longer apply. Gilt scrolls ride up the arches of the nave, adorn the pilasters flanking the statues, spread over the ceilings and even accent the horizontal support beams. Golden sunbeams in the ceiling join forces with encrusted mirrors in the altar (a Peruvian tradition) to add to the overall sparkling effect. Twisted columns, garlands, masks, angels and caryatids enliven the pulpit, altar and clerestory, and a golden patina covers the walls, ceiling and altar alike, helping to bring a powerful sense of unity to the interior despite its variety of motifs. Yet this Quiteño taste for visual splendour and ornamentation was already present in the original interior. Above the choir and crossing are two precious remnants of the first roof (165). Made of astonishingly intricate geometrical interlace patterns, these wooden ceilings are an expression of the mudéjar style of Islamic Spain. A delightful marriage of Baroque and mudéjar appears in the nave below, where, in the soffits of the arches dividing the nave from the side aisles, Islamic style arabesques sprout golden Baroque florettes (see 164).

The free-form interior at San Francisco, dramatic in its effect but careless in the details, was only one Latin American approach to the Baroque. Baroque style could also bend the rules in a much more calculated and methodical way, arriving at solutions as sophisticated as those of Rome or Seville, yet unlike anything found in Europe. Two of the most influential churches in Peru demonstrate this other approach and they also emphasize the importance of spectacle during that era. The church of the Compañía in Cuzco and San Francisco in Lima both dominate their urban setting, transforming a city square and a street corner respectively into stages for viewing their façades. The Compañía (166), Cuzco's Jesuit church, was built directly on the most important square in the former Inca capital, the Haukaypata, now called Plaza de Armas. This audacious siting put the church in direct competition with the cathedral, whose somewhat squat façade was on the adjacent side of the same square. An earlier Compañía was destroyed in the 1650 earthquake that flattened most of the colonial buildings in the city (see 109). The present building, finished in 1668 and designed either by the Flemish Jesuit Jean-Baptiste Gilles (1596–1675) or the retablo maker

Martinez de Oviedo (fl.1616–70), introduced a bold new style
that became the model for churches throughout the city during the
post-earthquake rebuilding campaign. San Francisco (167) enjoyed
a similarly influential position in Lima, on a busy street corner only
a block away from the Plaza de Armas and cathedral. It, too, was de-
stroyed in an earthquake (in 1656) and was rebuilt in a style inspired
by the Cuzco Compañía, with a theatrical façade by Manuel de Escobar
facing on to a small square created expressly for the church. Both
churches form the centrepiece of a much more extensive complex
of monastic or college buildings, in San Francisco's case comprising
no fewer than ten courtyards and a separate confraternity chapel facing

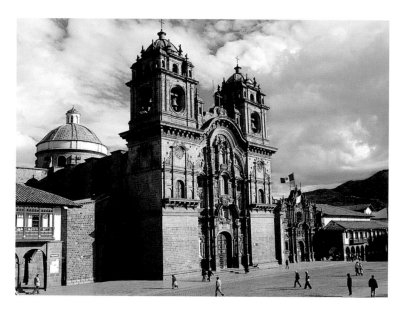

166
Jean-Baptiste
Gilles or
Martinez
de Oviedo,
Church of
La Compañía,
Cuzco, Peru,
completed
1668

167
Manuel de
Escobar,
San Francisco,
Lima, Peru,
1657–74

on to the same square. San Francisco has a basilical plan, while the
Compañía uses a single nave with side chapels, a scheme developed
in sixteenth-century Rome because it allowed greater visibility of
the Eucharist and better acoustics for preaching – two major concerns
of the Counter-Reformation era.

The retablo-façades of both Peruvian churches were meant to grab
the viewer's attention with their lavish ornamentation and unity of
form, and they direct our gaze towards the centre much like a stage
backdrop. This theatrical effect is not coincidental, since plays, musical

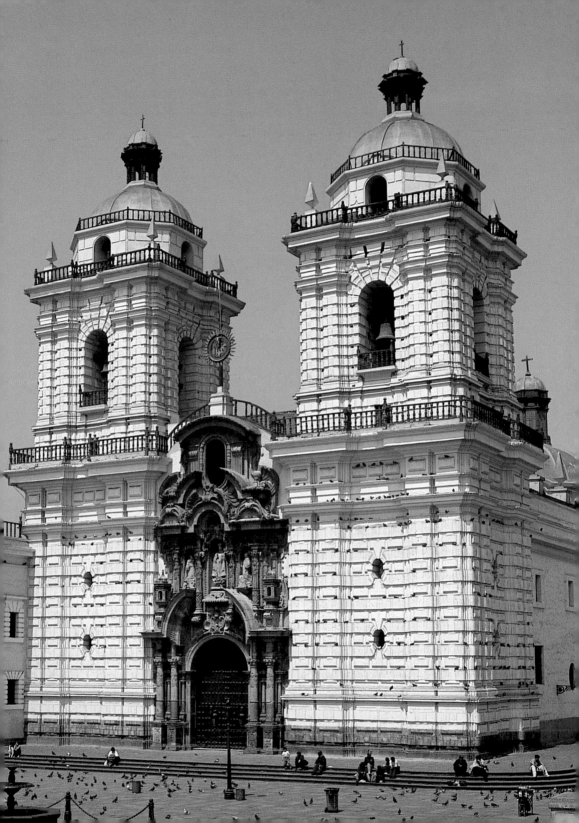

performances, processions and other events took place in front of these very façades. Their design served as a metaphor for the unifying power and splendour of the Church. The central part of the Compañía façade is richly layered and textured, with freestanding Corinthian columns, heavy entablatures, multiple niches, carved foliate decoration and polychrome stone, which contrasts sharply with the plain walls of the tower bases on either side. San Francisco has a similar focus on the centre, where delicately carved grey stone contrasts strikingly with the plainer yellow plaster of the towers, even though they are decorated

with rustication. San Francisco's ornamentation is even denser, with Corinthian columns banded with garlands and diagonal stripes, angel heads and a plethora of scroll and shell motifs.

But this decoration is not as arbitrary as it appears. In both churches, the architect has carefully united the disparate elements through heavy horizontal entablatures. At the Compañía, two parallel entablatures tie the towers to the façade, the top one forming a soaring trilobe curve as it follows the contour of the niche below, unlike anything yet seen

in Europe. The lower one also connects with the façade as it creates the division between the first and second storeys, and its arch-like curve echoes the main doorway below. Even the thinner entablatures of the window frames on the towers – themselves echoing the form of the façade as a whole – link with the choir windows on the second storey. Although San Francisco is not as tightly integrated as the Compañía, a narrow white entablature on the towers joins with that of the second storey of the façade, the paired pilasters on the tower echo the paired columns around the doorway. A delicate wooden balustrade fuses the entire façade together at the roof level. Together with the unification of the elements and focus on the centre, another trademark of Baroque architecture seen in these church façades is the emphasis on upward movement. This effect is achieved in both façades by making the niches and windows above the door expand into the storey above, bending or breaking the entablature and culminating in a curve at the top.

168
Belchior
de Pontes,
Jesuit church
of Nossa
Senhora
do Rosário,
Embu,
São Paulo,
Brazil,
late 17th
century

Although Brazilian civic church architecture had closer ties to Iberia than its Spanish-American counterpart, distinct regional styles began to develop in the eighteenth century, particularly outside the principal cities in places like Cachoeira, São Cristóvão or Minas Gerais, but also in the northeastern cities of Belém, Salvador and Recife. Most of these churches were not built in the Baroque style – despite this being the term usually used to refer to them – but are more accurately described as Rococo, a style that scholars have overlooked in Brazil until very recently. The more decorative Rococo style, inspired by French and German models, dominated much of Brazilian architecture in these regions from the mid-eighteenth century onwards and is characterized by sinuous lines, seen especially in the scrollwork on façades (see 28 and 99). Like Portuguese architecture, Brazilian churches have relatively plain, often whitewashed walls as at the austere Jesuit mission church of Embu, near São Paulo (168). They achieve a two-tone effect by contrasting these walls with details of bare stone or painted wood around the windows and doors, and along the edges of the walls and entablatures. Carved decoration is restrained compared to the churches of Peru or Bolivia, and is usually limited to the main entrance (where a shield-like motif often appears), doorways, windows and the cornice at the top of the façade. These cornices could often

be extremely creative, composed of feathery Rococo scrolls that seem to dance like flames or grow like vines – the best examples are in the northeast, in churches such as the Carmo at Recife (see 99) – giving the whole a lighthearted, almost ephemeral effect. Brazilian churches compensated for this ornamental reticence by featuring lavish interiors and more daring plans than their Spanish-American counterparts, including America's highest concentration of centralized churches, curved walls and round towers. Many of them had octagonal naves, a popular feature in Portugal, which transformed the body of the church into a reception area for the main altar chapel, almost reversing the spatial relationship between nave and high altar seen in Spanish America.

São Francisco (169) in Salvador is one of the largest structures ever built in colonial Brazil and demonstrates the transition from Baroque to Rococo, having the structural solidity and architectural vocabulary of the Baroque but the decorative richness and sinuous lines of the Rococo. Although the church could not be built on the site of a great pre-Conquest temple or palace as in the Andes or Mexico, São Francisco is nevertheless dramatically situated off a public square adjacent to that of the Jesuit church, as befitted an institution that included a college, important library and headquarters of the Franciscan order in Brazil. Replacing an earlier church on the site, São Francisco was built in stone on a Latin cross plan between 1686 and 1737, and was the product of a partnership between Franciscan architects and craftsmen, including Fr Vicente das Chagas and Fr Jerónimo de Graça, and the professional architect Manoel Quaresima. It is a building of contrasts. The façade, in three sections with paired towers like those of Spanish South America, is stately but subdued, with no curving entablatures, no columns in the round and few of the three-dimensional effects of Cuzco (see 166). The most Rococo decoration of its otherwise flat surface appears at the cornice at the top, where an almost plant-like growth of scrolls typical of Bahia frames the central niche and lightens the façade's overall severity. Sky-blue tiles on the towers also add a hint of colour. Inside (170), however, a brilliant vision of gilt wood and stuccoed angels, floral motifs and complex geo-metrical patterns dazzles the eye, the work of the eighteenth-century

169
Manoel Quaresima, Vicente das Chagas, Jerónimo de Graça and others, São Francisco, Salvador, Brazil, 1686–1737

Franciscan sculptor Fr Luís de Jesus. The lavishness of the interior of São Francisco is comparable to that of its namesake in Quito (see 164), only the Brazilian church adheres to a stricter geometry, every section more tightly organized and every architectural element performing a clear structural function despite the heavy stucco decoration that adorns it. The spectacular ceiling, made of star-shaped paintings of angels seen in perspective, reflects a Brazilian Rococo propensity for illusionistic painted ceilings derived from Italian models that is rarely seen in Spanish America. The white and gold of the interior decoration is accented by panels of blue and white tiles, a typical Portuguese feature that was inspired by Asian ceramics and was part of a general increase in colour in eighteenth-century Latin American churches. The panels, depicting biblical scenes, were painted in Lisbon in 1737 by Bartolomeu Antunes de Jesús, who was the leading tile painter of eighteenth-century Lisbon, a reminder of the close links between the Brazilian churches and the architecture of Portugal. The vast, barrel-vaulted main altar chapel, with its side galleries and the nesting arches of its retablo, is one of the most stage-like church interiors in the Americas.

170
Luís de Jesus
and others,
São Francisco,
Salvador,
Brazil,
1686–1737

Nevertheless, the title for the most theatrical church interior must go to a small chapel in the Mexican town of Puebla, a cultural capital not far from Mexico City. The Rosary Chapel (Capilla del Rosario; 171) in the Dominican monastery of Santo Domingo in Puebla (completed in 1690) is one of the most overwhelming Baroque experiences on earth, and was declared upon its inauguration to be the 'Eighth Wonder of the New World'. The interior of the chapel, built to house a miraculous image of the Virgin for whom the Dominicans had a special devotion, is saturated with ornament to a degree that has rarely been equalled. An interweaving, twisting mesh of three-dimensional gold and white stucco strapwork covers the walls and dome of the vestibule and chapel, incorporating foliate decoration, scrolls, birds, grapes, angels and ribbons. This technique of stucco work, using a plaster made of flour, egg white and water under gold leaf, was typical of Puebla and the designs combine traditions from Spain, Italy and Flanders, some of them taken from engraved books. This lace-like ornamental coating takes over the architectural elements, sculptures

171
Rosary Chapel,
Santo
Domingo,
Puebla,
Mexico,
completed
1690

and paintings (the strapwork even spills over the frames of the
paintings of the *Life of the Virgin* on the side walls by the seventeenth-
century painter José Rodríguez Carnero), so that they seem to dissolve
away, a very different effect from the massive and controlled interior at
São Francisco in Salvador. Embedded in the strapwork are allegories of
the Theological Virtues, saints, archangels with the Virgin Mary's titles,
and an *Allegory of the Holy Spirit* in the dome (172), convenient memory
aids for worshippers and preachers alike. The Rosary Chapel's links
to Baroque spectacle are made explicit in a special volume published
to celebrate its dedication, a nine-day event held at the chapel involving
music, preaching and other performances. Fr Diego Gorozpe referred
to the various aspects of the ornamentation directly in his sermon,
emphasizing the other-worldly richness of the chapel, which he
compared to the riches of the mines of Potosí. In an extended
metaphor, he likened the chapel to a musical ensemble, with all of the
architectural units and motifs playing their part. This musical imagery
is echoed in the lunette above the choir, where an angelic orchestra
plays on a myriad of instruments, conducted above by God the Father.

The Rosary Chapel reminds us of the importance of spectacle in the
religious life of the people. In colonial Latin America the liturgical
year was marked by processions, Passion plays, mock battles and other
religious performances, many of them as lavish and richly decorated

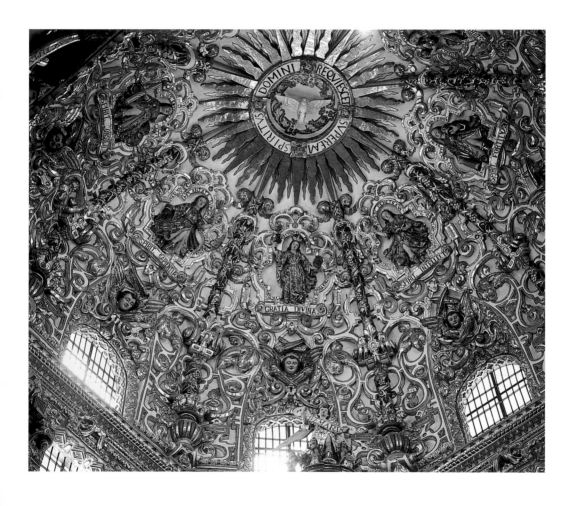

172
*Allegory of the
Holy Spirit,*
Rosary Chapel,
Santo
Domingo,
Puebla,
Mexico,
completed
1690

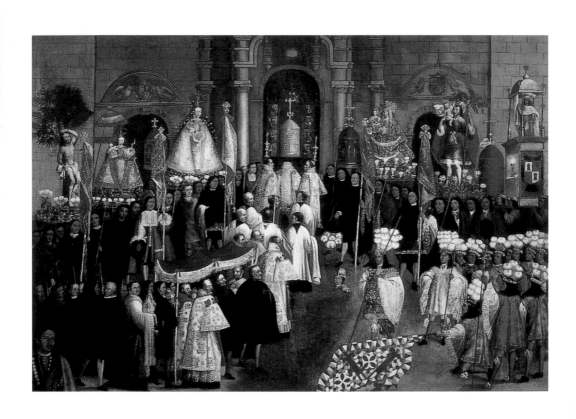

as the viceregal *entradas* discussed in Chapter 3. Like the churches that formed their backdrop, these pageants embraced the whole community. Holy Week celebrations, as illustrated in the depiction of the Viceregal Palace in Lima (see 77), were particularly elaborate. Another key festival was that of Corpus Christi, held in late May or early June, coinciding roughly in Andean countries with the Inca Inti Raymi summer solstice festival and with pre-Hispanic harvest feasts (173). A celebration of the Eucharist and the miracle of transubstantiation, the Corpus Christi procession had a triumphalist spirit similar to that of the *entradas*, with which it shared an origin in Imperial Roman marches. The procession embraced music, dancing, street plays and fireworks. Particularly unique in the Highland Andes was the appearance of Andeans dressed as Inca royalty and Amerindians performing indigenous dances and music played on native instruments.

173
Return to the Cathedral, from the *Procession of Corpus Christi* series, c.1680.
Oil on canvas;
116·8
× 185·4 cm,
46 × 73 in.
Museo de Arte Religioso, Cuzco

Meant to symbolize the pagan world before the arrival of Christianity, these brightly clothed figures took the place of the 'Moors' and 'savages' who appeared in Corpus Christi celebrations in Spain. However, in their American context, they were also a convenient reminder of the conquest of the Incas, an event that the processions served partly to recapitulate. Although Corpus Christi festivals involved a prodigious number of paintings, triumphal arches, canopies, banners, tapestries, garlands, parade floats, altars and other decorations, few depictions of these events have survived, making an anonymous series of paintings (c.1674–80) in the Museo de Arte Religioso, Cuzco, all the more extraordinary.

The Cuzco series was originally composed of eighteen paintings of various sizes, probably painted by indigenous artists and financed by individual neighbourhoods, confraternities and religious orders to celebrate their role in Cuzco's Corpus Christi procession. The series shows the procession passing through crowded streets, with civic and ecclesiastical officials and people of all ethnic backgrounds looking on from the sides and from windows and balconies. Some of them show temporary triumphal arches festooned with mirrors, flowers, feathers, ribbons, candles, banners, relief plaques and statuettes, as well as paintings of still lifes and landscapes (probably with mythological meanings). The most interesting are the depictions of Andean parishes,

which focus on an image of the patron saint on a float surrounded by Indian devotees, and a standard-bearer dressed as an Inca monarch. The floats in these paintings are fictitious, borrowed from engravings of triumphal carts, and were not actually used in Cuzco until 1733, when they replaced the more traditional litters. The 'Inca royalty' wear costumes that combine pre-Hispanic forms such as the *uncu* tunic and the red fringe worn on the forehead to signify royal prestige, with European imports such as the sun medallions on their chests and maskettes on their shoulders (see 31). Given their hybrid nature, it is not surprising that these costumes and the Indian dances have a dual message. On the one hand, the Spanish and *criollo* audience saw them as symbols that the Inca Empire had fallen and that their 'kings' now marched to a different drummer. On the other hand, like the dynastic portraits discussed in Chapter 2, such costumes also underscored the royal prestige of the native communities and reaffirmed their superiority over rival Indian groups. In fact, opposing indigenous groups often used the Corpus Christi as a way to vie for superiority. Recent scholarship has shown that non-Inca groups such as the Cañari and Chachapoya, traditional allies of the Spanish against the Inca, had themselves depicted in the series in a way that emphasized their close ties to the Spanish rulers and their privileged position in colonial society.

Metropolitan cathedrals and churches were not merely works of architecture but the site of incalculable quantities of artworks, reflecting the patronage of figures ranging from the kings and viceroys themselves to civic and ecclesiastical authorities, religious orders, confraternities, neighbourhoods, wealthy families and individuals – Europeans and non-Europeans alike. This patrimony included most colonial Latin American painting and sculpture, works of art that are often seen today in museums or homes, divorced from their original setting. These paintings and sculptures reflected the same stylistic changes as the churches that housed them, beginning in the austerity of the late Renaissance, moving through to the bright colours and emotional expressiveness of the Baroque, Rococo and Ultrabaroque, and ending with the renewed sobriety of the Neoclassical era. Like the churches themselves, these types of artwork quickly developed into a

174
Matteo da Leccio (Mateo Pérez de Alesio), *St Michael and Lucifer Struggle over the Body of Moses*, c.1580. Fresco. Sistine Chapel, Vatican

panoply of regional styles, as different from their Italian, Flemish and Iberian models as those models were from each other. Their creators included many Indians and Africans as well as *mestizos*, *criollos* and Europeans, professionals and amateurs, friars and soldiers.

Cities and towns of colonial Latin America generated an extraordinary variety of painting traditions. Yet those in the Andean Highlands, particularly Cuzco and Potosí, stand out as one of the finest – and most productive. European painting came early to the Andes, beginning with an Italian late Renaissance style that reflected current trends in Rome.

Between the 1570s and 1620 no fewer than four professional Italian painters emigrated to the viceroyalty of Peru, beginning with the Jesuit Bernardo (or Bernardino) Bitti, who arrived in Lima in 1574; he was followed by Matteo da Leccio, Angelino Medoro and Pietro Paolo Moroni, all of whom we have met in Chapter 4. Leccio was the most celebrated of the four as, before coming to Peru in 1590, he contributed to some of the most important commissions of late Renaissance Rome, including the last fresco in the Sistine Chapel (174), directly across from Michelangelo's *Last Judgement*. Leccio's

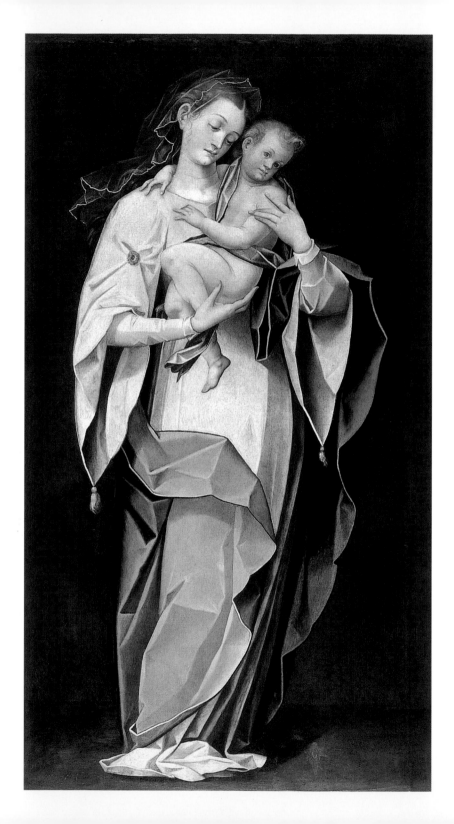

demon figures in the fresco *St Michael and Lucifer Struggle over the Body of Moses* have emphatic musculature and dramatically twisting torsos, paying homage to Michelangelo's style. Bitti had also fulfilled commissions for paintings in Rome before leaving for America, and works like his *Virgin and Child* (175) in Cuzco reflected the styles employed in the leading Roman churches, like the Gesù (see 139) and the Chiesa Nuova. The graceful pose of the Virgin holding the child, and the elongation of the bodies and especially necks and fingers, give the figures a refined elegance that is enhanced by the luminous pinks, reds and blues of the Virgin's gown and the delicate gold braiding on her veil. Bitti's trademark crisp drapery also enhances the Virgin's regal stance. The artist's talents were much appreciated in the young colony, not just on the missions but also in the towns and cities of viceregal Peru, where his Italian origin had a certain snob value.

Nevertheless, the greatest painter of colonial Peru lived in the Baroque era. The Andean painter Diego Quispe Tito was the first to challenge the Italianate style of Bitti's generation. Often mistakenly called the founder of the Cuzco school of painters, Quispe Tito was dead before the heyday of the indigenous Cuzco School workshops, and his personal and introspective style is very different from their more iconic and mass-produced madonnas and saints. Popular legends claim that Quispe Tito served his apprenticeship in Europe, where he travelled through Italy and Spain studying the works of the Renaissance masters. What he owes to European art, however, he gained from a study of engravings. Scholars have been able to identify these models with great precision, including works by the Wierix brothers of Antwerp, Jan Sadeler (1550–1600), Cornelis Galle (1576–1650), and Johannes Stradanus (1523–1605). Quispe Tito borrowed motifs, details and settings from different engravings and distributed them in original ways, adding his trademark luminescent colours and introducing a handful of Andean details. Quispe Tito's landscapes, as seen in his *Christ Calling St Peter and St Andrew with the Sign of Pisces* (1681; 176) from his Zodiac series in Cuzco Cathedral executed at the request of Bishop Mollinedo y Angulo, present the viewer with a rich, detailed panorama, so that the religious figures – Christ, or perhaps the Holy Family – are almost lost in their setting. They include Netherlandish

towns with their pitched roofs and spires, castles on craggy rocks, towering mountains, gnarly trees and shimmering harbours. The paintings are brought to life by their anecdotal details, such as townsfolk gathering at a well, country people selling their produce at a market, fishermen hauling in their catch, shepherds watching over their flocks and beggars on the street. Occasionally some of these figures represent indigenous people, such as Andean women selling produce in a market, and South American birds also appear in the horizon. Quispe Tito's landscapes achieve an idealized, dreamlike mood, especially through the glowing blues of the backgrounds and the warm earth tones of the foregrounds. In each landscape Quispe Tito links Christ's parables with star signs, a devotion that may have owed its popularity in Peru to indigenous traditions of venerating the stars, sun and moon, and relates to the popularity of the archangels with arquebuses series (see 110) and the mural paintings of Andahuaylillas (see 146).

In the generation after Quispe Tito, several distinctive artists emerged in the Andean Highlands. Their leader was Melchor Pérez Holguín, Bolivia's greatest colonial painter, who was active in Potosí and Charcas (Sucre) in the late seventeenth and early eighteenth centuries. Born into a prominent family in Cochabamba between 1660 and 1665, Holguín lived in Potosí from 1678 until about 1724, during which time he specialized in austere portraits of Franciscan saints in which the texture of their cowls is so carefully recreated that they seem to take on a third dimension. Yet one of his most memorable early canvases was for a secular patron: *The Entrance of Viceroy Morcillo into Potosí* (see 57). Like Quispe Tito, Holguín's genius can be found in his landscapes, although his are not so literally extracted from engravings and his figures play a more prominent role. Holguín's *Rest on the Flight to Egypt* (c.1710; see 93) turns an intimate domestic scene into a heavenly vision, not only by the addition of angels who help the Holy Family with the washing and attend the child, but also by the Edenic landscape, with verdant plants, a waterfall splashing in the background and dramatic, chiselled mountains in the distance, which are given an almost ice-like colour by Holguín's characteristic silvery-grey palette. Like Quispe Tito, Holguín also adds an Andean touch, although here it is much more explicit,

as Mary wears the hat and shawl of a Highland country woman and washes her clothes in a traditional wooden washboard, all of which makes the scene more approachable to the picture's Andean viewers. Holguín's art is a unique vision and it is quite distinct from Spanish or Peruvian models.

Andean Baroque painting had its final flourishing in eighteenth-century Cuzco and Potosí, in the indigenous and *mestizo* workshops under painters such as the incomparable Luis Niño (see 47). Although the scale of production of some of these workshops verged on the industrial and many of the paintings executed are lower-quality

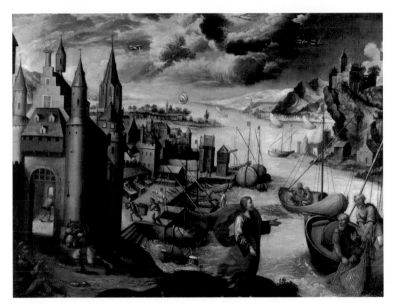

176
Diego Quispe Tito,
Christ Calling St Peter and St Andrew with the Sign of Pisces,
1681.
Oil on canvas;
141 × 185 cm,
55¹⁄₂ × 72⁷⁄₈ in.
Cathedral, Cuzco, Peru

pieces made in haste to meet giant orders, painters such as Niño are also responsible for some of the most exquisite canvases of the colonial era, brought to life through their intricately detailed textile patterns, jewellery, lace, flowers, feathers and especially a delicate highlighting in gold leaf. In their ornamental density and the variety of their bright colours, these paintings recreate on canvas the splendour of the *mestizo*-style architectural ornament of the Highland churches (see 34). Like them, they also include many indigenous features, including native flora and fauna, Inca figures and pre-Conquest ritual items, symbols that the Amerindian patrons

of these canvases used to link their communities with the Inca past, as in the costumes and performances of the Corpus Christi festivals.

For the fullest expression of Rococo optimism in painting we must turn to New Spain, where Mexico City and Puebla rivalled Cuzco and Potosí in their contributions to the medium. The two leaders of Rococo painting were the Afro-Mexican painter Juan Correa and his *criollo* colleague Cristóbal de Villalpando. Both artists are best known for a series

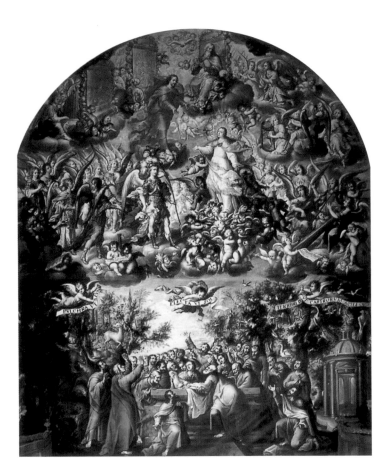

177
Juan Correa,
Assumption of the Virgin,
1685–6.
Oil on canvas.
Sacristy,
Cathedral,
Mexico City

of colossal canvases that decorate the sacristies of Mexico City and Puebla cathedrals. Correa's magnificent *Assumption of the Virgin* (1685–6; 177) in Mexico City Cathedral turns the biblical episode of the Virgin's death and ascension into a great pageant. The Apostles and multitudes stand around the open tomb below, the Virgin ascends heavenwards on the arms of a throng of angels in the centre and Christ steps forward

at the top to receive her with open arms. Correa's impressionistic brushstrokes soften the outlines and allow the figures to blend into each other, creating a dematerialized effect similar to the lace-like interior of the Rosary Chapel at Santo Domingo in Puebla (see 171, 172). Correa enhances the triumphalist mood of the painting through a lighter palette typical of Rococo painting in New Spain, dominated by pastel pinks, blues and greens. These optimistic, dream-like tones, as well as the broken brushwork, were inspired by the colouristic revolution of the Sevillian painter Bartolomé Esteban Murillo (1618–82), many of whose paintings depict visions framed by cloudbursts and showers of golden light.

The same spirit dominates Villalpando's greatest masterpiece, his *Apotheosis of the Eucharist* (1688–9; 178) in the Chapel of the Kings in Puebla Cathedral, the only painted dome interior in New Spain. This tradition of heavenly domes was pioneered in Parma, Italy, by the Renaissance painter Antonio Correggio (c.1489–1534) and was common throughout Baroque Italy, especially in seventeenth-century Rome. Villalpando's work depicts a shimmering empyrean of angels and cherub heads centring on a monstrance held by the Virgin flanked by two angels, the same celebration of the Eucharist seen in the Corpus Christi processions. Villalpando's broken brushstrokes add to the vaporous effect of the scene, blending figures, clouds and angels together, and the entire dome is bathed in a golden light that is backed up by the actual light of the lantern. The immateriality and decorative character of the whole anticipates the flickering surfaces of Estípite-Baroque façades, such as Rodríguez' Sagrario Metropolitano (see 161).

Although much of it is now seen out of context, most of the sculpture commissioned for metropolitan churches and cathedrals was also originally incorporated into larger ensembles such as retablos, pulpits, choir stalls, nativity scenes and Calvary groups. Larger, lightweight monumental sculpture was also designed exclusively for use during Holy Week and for other festivals. We have already looked at some flourishing sculptural traditions in chapters 2 and 4, particularly those of the mission academies. However, the urban sculpture schools were much more important in their day and, like the painters and architects

already considered, they combined a sophistication to rival European schools with a uniqueness and regional diversity that took them far beyond their European models.

The greatest sculptural tradition of all Spanish America was the Quito School, a group of workshops active between about 1660 and 1800 that created elegant Baroque and especially Rococo sculptures, full of expression, painstaking decoration, sensual surface textures and an

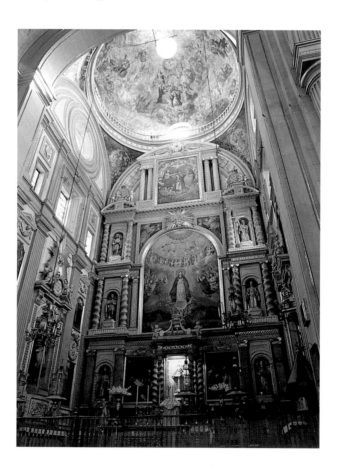

178
Chapel of
the Kings,
Puebla
Cathedral,
Mexico,
showing
the cupola
painting
*Apotheosis of
the Eucharist*
by Cristóbal
de Villalpando,
1688–9

179
**Bernardo de
Legarda**,
*Our Lady of
Carmen*,
second half
18th century.
Polychrome
wood;
h.55·5 cm,
21⅞ in.
Museo
Fray Pedro
Gocial de
San Francisco,
Quito

infectious humanity. Although ultimately inspired by the naturalistic polychrome sculpture of Baroque Seville and the porcelain figurines of France and Central Europe, Quiteño sculptors achieved something unlike anything found in Europe. Through a sophisticated system of labour distribution, artists divided their tasks, specializing in heads, hands or bodies, painting and gilding the textiles and flesh tones, and inserting the glass eyes and human hair that give the pieces such

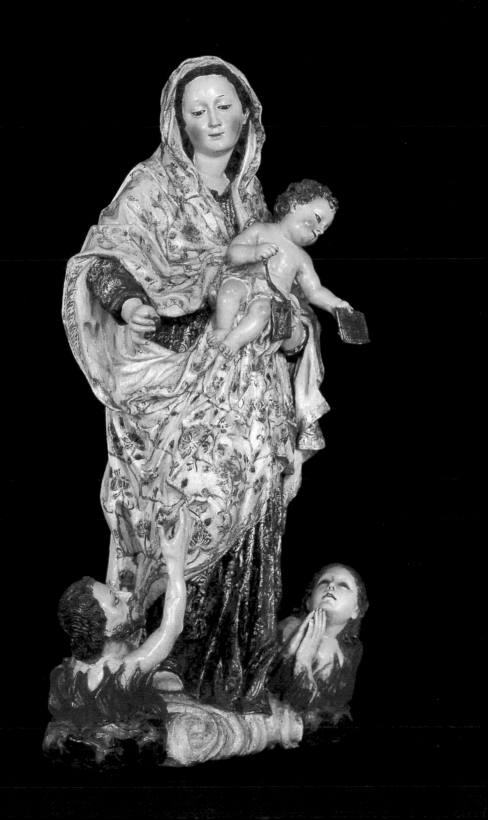

realism. They used an extraordinary range of materials, from woods and metals to vegetal ivory (*tagua*), real ivory from Asia and porcelain. Two features especially stand out: the flesh-like faces, painted on a layer of gesso, sometimes over a silver or lead mask and polished, and the exotic textile patterns, especially a kind of multicoloured floral decoration over silver foil named *chinesca* after the Chinese and other Asian lacquers and fabrics that inspired it. Both of these features distinguish Quiteño sculptures from their Andalusian models. The startling naturalism of the flesh tones (called *encarnación* or 'made into flesh') inspired Quiteño sculptors to explore the partial and full nude, something that was almost unheard of elsewhere in colonial Latin America.

Two of the finest Quiteño sculptors were Bernardo de Legarda (1700–73) and Manuel Chili 'Caspicara' (1720/5–95). Legarda, a *mestizo*, headed a workshop with his brother Juan Manuel that produced not only sculptures in the round but retablos, altars, picture frames, paintings, engravings, and even organs and guns. One of Legarda's masterpieces is *Our Lady of Carmen* (179) in which a lithe young Madonna, her child in tow, reaches down to help two souls burning in Purgatory. The sweet expression of the Virgin, combined with the sweeping movement in her pose and flowing drapery, brings the sculpture alive. The sensuous flesh tones of her face bring a touching humanity to her features, while the brilliant *chinesca* patterns of her textiles remind us of her heavenly status. The *chinesca* decoration on her dress is perhaps the finest in all Quiteño sculpture.

The Amerindian Manuel Chili was Legarda's successor and he enjoyed many commissions from religious orders in Quito and other cities. Although Chili achieved an even greater subtlety in the textile patterns of his drapery, it is in his flesh tones that he made his greatest contribution. One of Caspicara's greatest works is *Our Lady of Sorrows* (180) inspired by the famous Virgin of the Macarena of Seville. This detail of the face allows us to see the subtle variations in hue that show the Virgin has been crying, with gradations of roses and pinks and a burnished, porcelain-like surface, as well as the trademark rosy cheeks of Quiteño sculpture. Another characteristic of sculpture from

late eighteenth-century Quito is an increasing interest in secular subject figures that were inspired partly by a European Rococo craze for porcelain figurines. Many of these small-scale sculptures were made to form part of a crowded crèche scene much like the brightly painted clay shepherds and other folk figures made today in the

180
Manuel Chili,
Our Lady of Sorrows,
18th century.
Polychrome wood;
h. 200 cm,
78¾ in.
Museo de Arte Colonial,
Quito

Via San Gregorio in Naples, intended to adorn elaborate Christmas *presepi* (crèches). Although the setting is superficially sacred, these crèche scenes gave artists and patrons the chance to revel in details of everyday secular life and they included as many ladies and gentlemen, farmers, shepherds and market women as a landscape by Quispe Tito.

Another great centre for colonial sculpture was eighteenth-century Brazil, particularly the mining region of Minas Gerais, where a vigorous, bold style developed that was a world apart from the courtly elegance of Quito. Sculpture was more important than painting in colonial Brazil, with monastic schools leading the way in the seventeenth century and professional lay sculptors in the eighteenth. There are almost as many regional differences in Brazilian sculpture as there are in Spanish America, with independent schools active not only in Minas Gerais but also in Pernambuco, Rio de Janeiro and Maranhão. The explosion of sculpture in the eighteenth century owes much to a new kind of patron, the lay confraternities and 'third orders', who took over after the religious orders lost their dominant position in the second half of the century. Although Bahia was the most productive centre of sculpture, Minas Gerais was the most diverse, because it lacked the capital region's tradition of mass production and it was made up of many isolated towns with little contact with each other or with the ports on the coast. Autonomous schools appeared in the various settlements, and their sculptors often lacked the Portuguese models and the formal training artists enjoyed in Salvador. The sculpture of Minas is much plainer than that of Quito, with less interest in textile patterns, and it has an impressive sense of volume, with deep carving and sometimes an almost Cubist approach to form. The drapery is often illogical, not falling in a natural way but expressing movement or emotion through an ingenious use of geometry, much as in the Guaraní workshops in the Jesuit reductions of Paraguay (see 113).

One of the leading sculptors in Minas Gerais in his day was Francisco Xavier de Brito. Born in Lisbon, he was already working in Rio as a master sculptor in 1735, and then moved to Ouro Prêto in 1741 where he lived until his death in 1751. His *Mary Magdalene* (181) has the twisting torso and swirling drapery so popular in eighteenth-century Portugal, giving the figure a dance-like sense of movement. Although she is carved from a bulky block of wood – and her drapery and tresses are deeply chiselled and painted in only the simplest colours of red, white and blue, dusted with gold highlights – the effect is one of grace, lightness and beauty. Brito devotes particular attention to the face and hands, whose flesh tones are reminiscent of those of the

181
Francisco
Xavier de
Brito,
Mary Magdalene,
18th century.
Polychrome
wood;
h.59 cm,
23⅛ in.
Museo de
Arte Sacra,
São Paulo

Quito School, but her face is more human and less elongated than the Ecuadorian examples and she lacks the hyperrealism of their glass eyes and human hair. These distinctions give this piece a moving empathy that brings it to life, encouraging the viewer to cry with the repentant saint. The other great sculptor of Minas Gerais was the Afro-Brazilian master Aleijadinho – probably the best-known artist of all colonial Latin America – already mentioned in Chapter 5. Aleijadinho received his first independent commission as a master sculptor in 1766, when he executed the façade and interior sculptures of the church of São Francisco de Assis in Ouro Prêto, delicate Rococo ensembles that established a name for him as a church decorator. However, his crowning achievement was the series of life-size wooden Stations of the Cross (fourteen supposed stages in Christ's journey to Calvary, 1796–9; see 183) and twelve soapstone Old Testament prophets (1800–3; 182) at the approach to the pilgrimage church of Bom Jesus de Matosinhos in Congonhas do Campo, about 50 km (30 miles) west of Ouro Prêto along the Royal Road. Scholars have debated which parts of his sculptures can actually be attributed to Aleijadinho himself, but most agree that he only did the faces and hands in the Bom Jesus prophets and the Christ and Apostle figures in the Passion series, a division of labour similar to that found in many Latin American ateliers.

182
Aleijadinho
(Antônio
Francisco
Lisboa),
Prophet Ezechiel,
1800–3.
Soapstone.
Church of
Bom Jesus
do Matosinhos,
Congonhas
do Campo,
Brazil

Aleijadinho's style is immediately recognizable and often imitated. His genius derives from his ability to reduce human figures to a combination of ornamental details – in much the same way that architectural elements are disintegrated in Rococo or Estípite-Baroque façades – yet retain a powerful drama and emotion, inspiring a variety of reactions from empathy to repulsion. Facial features disintegrate into ornamentation, such as the coils of the hair, the flowing moustaches that spring directly from the nostrils, the tightly wound scrolls of the beards, the arched eyebrows that create a continuous line with the nose, the cartouche-like lips and the almond-shaped eyes. Some of these details are inspired by German engravings and they have little to do with Portuguese sculpture (and nothing to do with his African background, as is popularly believed). As with much Minas Gerais sculpture, the drapery is harsh and emotional, often breaking up into faceted planes or diagonal zigzags. In his *Christ Mocked* (183),

183
Aleijadinho
(Antônio
Francisco
Lisboa),
Christ Mocked,
1796–9.
Polychrome
wood.
Church of
Bom Jesus
do Matosinhos
Congonhas
do Campo,
Brazil

the jagged edges of Christ's deeply carved cloak seem full of anger
and reproach and the cloak communicates more of Christ's sadness
than his hands, which seem as ineffective as those of the handicapped
carver himself. In his St George (see 107), Aleijadinho treats the armour
just as Rodríguez would treat a pilaster: by dissolving it into individual
decorative motifs, such as foliate bands, shells and scrolls. In fact,
St George's legs look very much like estípite columns. The Rococo
immateriality of Aleijadinho's art, which has affinities with buildings
like the Rosary Chapel in Puebla and paintings like Correa's Assumption
of the Virgin in Mexico City (see 177), reminds us that although the
Baroque arts enjoyed an essential unity of form, they also embraced an
incredible variety of regional styles. It was this variety, more than any
overarching unity, that made Latin America such a rich centre of artistic
production.

FABRICA DE DOÑA ROSA SOLIS Y MENENEZ, EN MERIDA DE YUCATAN, EN QUATRO DE HENERO DEL AÑO DE MIL SETECIENTOS OCHENTA Y 6

Criollo aristocrats were among the richest people in the world in
the seventeenth and eighteenth centuries, thanks to earnings from
mines, ranches and rents, and their town houses, country estates and
the objects that adorned them bespoke a world of conspicuous luxury
rarely equalled even in Europe. Yet, they had none of the political
influence enjoyed by their counterparts across the ocean and were
completely dominated by the viceregal government and the Church.
In fact, the local gentry were obliged to foot the bill for much of the
splendour surrounding those two institutions and were constantly
struggling to stay out of debt. Dependent upon the Crown for favours
and their all-important titles, the aristocracy were expected to show
support for the king by financing military or economic undertakings
in his name, paying crippling taxes and making generous gestures
of community service in times of crisis. The Crown ordered them
to maintain a lifestyle in keeping with their prestige, emulating the
highest standards of courtly European taste and opulence – a symbolic
expression of European superiority no less conscious than the viceregal
government's use of Renaissance architecture. The Church also
benefited greatly from criollo generosity. Since the demonstration of
piety and pious works was one of their most important duties as peers
of the realm, the nobility were also compelled to found and finance
churches, chapels, altarpieces, confraternities and even missionary
work. Many a fine Baroque retablo or temporary triumphal arch
owed its existence to criollo patronage.

184
Doña Rosa
Solís y
Menéndez,
Bedspread,
1786.
Cotton and silk
thread;
251·5
× 182·9 cm,
99 × 72 in.
Metropolitan
Museum of
Art, New York

Although the dwellings of the aristocracy were modest on the outside –
so as not to compete with the buildings of the Crown or Church – their
ballrooms, dining rooms and reception areas brimmed with luxurious
art objects and furnishings. This was a world in which the so-called
'decorative arts' reigned supreme, whether furniture and silver
or ceramics and textiles. Artisans throughout the Americas rushed
to meet the insatiable demands of the upper classes, producing a vast

array of objects on a grand scale – in some cases entire villages were devoted to making a single item. Although European and Asian decorative arts were readily available in colonial Latin America, thanks to flourishing trade routes across two oceans, the quality and beauty of domestic production was on a par with anything from those regions. Lacking the iconographic rigour of church art or the stern majesty of viceregal trappings, these objects allowed a freer creativity, testifying to the genius of colonial craftsmanship. The material culture of the nobility also demonstrated a cultural diversity that rivalled any branch of Latin American art, embracing objects and styles from India, China, Japan and the Philippines, the Amerindian world, and a panoply of European fashions not seen in the churches, such as English bone china and furniture in the style of English cabinetmaker, Thomas Chippendale (fl.1748–79). Stylistic anarchy was the rule, with Renaissance coexisting alongside Baroque, Rococo juxtaposed with Neoclassical.

Town and country were intimately linked in colonial Latin America, as they were in Europe itself. Not only were the farms and plantations needed to support and feed the cities but also, as in Renaissance Spain or Italy, the urban rich spent part of their lives on country estates. The great families would live in their town house during the 'season', the formal social cycle from autumn to spring, and retire to the country in the summer, for more socializing, riding, card playing and other leisure activities. We cannot fully understand the one world without the other. Most grand homes of the colonial period date from the eighteenth century, a time when the local aristocracy rebuilt their mansions in the towns and expanded their country estates. Some places, like Mexico City and Lima, were transformed into cities of palaces in these prosperous years of the Bourbon dynasty, when the absolutist French court was everyone's model. Forty of them still stand in Mexico City alone. The mansions of the nobility were large enough to house not only the owner's family, but retinues, poor relatives, orphans and clerical employees, as well as notaries, personal chaplains, seamstresses and more than twenty servants, including *mestizos*, Indians, Asians and blacks. The country houses – called haciendas in places like Mexico and Chile, *estancias* in Argentina, and *fazendas* or *quintas* in Brazil – also came into their own in this period. Original sixteenth-century

estates were kept deliberately small by the suspicious Spanish government, who granted plots of about 200 acres to nobility (often conquistadors and their families) and set up legal obstacles to expansion. Nevertheless, expand they did, through purchase or intimidation, swallowing up the smaller estates around them. They also appropriated Amerindian lands, so that the indigenous communities became dependent upon them as indentured workers called *peones*. In the vast Brazilian sugar plantations of the Bahia and Pernambuco hinterland, black slaves were introduced in giant numbers to harvest the crops, many more than were ever brought to the southern United States of America during its slave era. In town and country alike, the extravagant lifestyles of the gentry came at a great cost to the rest of society. Travellers remarked upon the great chasm that existed between the super-rich and the poor, a gap that has only widened today.

The palaces of the marquises, marshals and counts of viceregal America were remarkably similar, from Mexico City to Salvador. Usually limited to two storeys, so that they did not rival churches in height, their façades were simple and flat, with an occasional Rococo window dressing and classical doorway to break the monotony. Sometimes they were decorated with different colours of stone, such as the bronze *tezontle* of Mexico, with polychrome tiles, as in Puebla, or by intricately carved wooden balconies, an old Islamic tradition popular in Lima and Bogotá which added visual splendour to the upper storey of the house while providing privacy. Façades were also dressed up during festivals like the Corpus Christi or viceregal *entradas* with colourful tapestries hung from the windows, sometimes adorned with pieces of silver. Typically, palaces were entered through a grandiose central gateway, high enough for a horse and carriage. The main entrance led directly into the main patio, the main reception and service area, where most of the practical activities relating to the palace's upkeep took place. Some palaces even had shops on the ground floor facing the street, a sensible and lucrative way of obtaining rents to support the building's upkeep. The ground floor also housed the servants' quarters, the kitchens, stables and other rooms that guaranteed the daily functioning of domestic life, often distributed around another patio to the rear. A grand staircase led to the main floor where the family lived. Upstairs

were the private areas: the dressing rooms, bedrooms, lavatories (sometimes including sunken pools) and studies, as well as more public areas like dining rooms (see 190). There were usually two master bedrooms, one each for the man and woman of the house. The most important and showiest rooms of the house were the great reception rooms, usually lit by windows or balconies. The 'dais' room, or ladies' parlour, housed a low platform (*estrado*) strewn with cushions and rugs where women would relax during the evening in an old Islamic tradition, while male guests sat on chairs. The adjacent 'canopy' room (see 191) was the most formal space, serving primarily for evening entertainment and permitted only to titled nobility. The private chapel was also housed upstairs, as were various antechambers.

Haciendas tended to have only one storey, since they had more room for expansion, and they were arranged around multiple patios (see 188). These additional patios served the kitchen, stables, and the peon or slave quarters, depending upon the region. The entrance to the main patio was through an impressive arched gateway as in the town houses, only here the functions of the house were divided vertically rather than horizontally. Two sides of the patio were usually devoted to the living quarters of the owner's family and the third was given over to storage rooms and work areas. Hacienda chapels were often more like a small church, complete with towers, cupola and retablo-façade, giving some country estates the profile of a monastery. Even more than town houses, haciendas were working buildings, heading huge cattle operations, crop farms or mineral processing facilities for the mines, and they were the source of most of the owners' income. The prominent position of vaulted stone stables and storage barns, aqueducts, granaries, settling tanks, textile mills and kiln chimneys testifies to the importance of their practical functions and, together with their kitchen gardens, forges and carpentry shops, they helped make country estates nearly self-sufficient. Haciendas also served as a haven for travellers, including viceroys, as they were often located far from settled areas.

The most fashionable street in eighteenth-century Mexico City was Calle San Francisco, with its seemingly endless row of noble mansions.

Some had battlements and turrets and even had their drainage spouts converted into artificial cannons to add a knightly appearance, recalling the military aspect of the early mission churches. One of the grandest was the palace of the marquises of Jaral, which cost 100,000 pesos when it was created by converting an existing convent into a home for the marquis's daughter and her Sicilian husband. In honour of his son-in-law's hometown, the marquis modelled the mansion on the Royal Palace in Palermo, a Moorish-style castle, which made it stand out from its neighbours. Another spectacular palace was the so-called House of Tiles (Casa del Conde del Valle de Orizba or 'de los Azulejos'; 185), a grand eighteenth-century mansion entirely covered with blue-and-white tiles and rich carved stone details. Lima rivalled Mexico City in the lavishness of its palaces. The most spectacular is the Palacio Torre-Tagle (186), completed in 1735 as the residence of Don José de Tagle y Brancho, who had been made a marquis by Philip V, the first Bourbon king of Spain. The façade is almost as imposing as the nearby church of San Francisco (see 167), with a two-storey retablo-style stone doorway, whose dramatic curving pediments and freestanding columns stand out from the wall, and two flanking wooden balconies on the second floor, richly carved from dark hardwoods in mudéjar geometric patterns and open lattice screens. Inside, the main courtyard has a delicate arcade on the top floor with Islamic-inspired mixtilinear arches on slender columns of cocobolo hardwood and a matching balustrade. Unlike in New Spain, Limeño houses tended to have closed walls surrounding the courtyard on the lower floor.

Brazilian city mansions were not very different from their Spanish-American counterparts, although the façades were sometimes less symmetrically arranged and they usually had the stone-and-whitewash exteriors of the churches. The eighteenth-century Casa dos Contos in Ouro Prêto (187), one of the most elegant domestic structures in all of Brazil, was built between 1782 and 1784 for the tithe collector João Rodrigues de Macedo, who had made his fortune taxing the region's phenomenal gold mines. A grand façade punctuated by exquisitely carved stone door and window frames welcomes the visitor from the narrow street, but the most impressive part of the house is its back

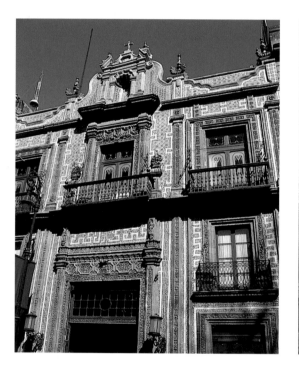

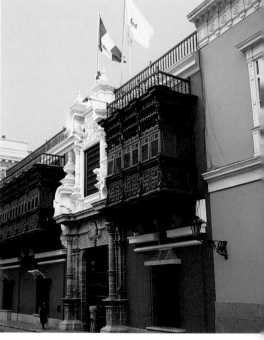

186
Palacio de
Torre-Tagle,
Lima, Peru,
completed
in 1735

185
Casa del Conde
del Valle de
Orizaba
(called 'de
los Azulejos'),
Mexico City,
begun 1737

187
**José Pereira
Arouca**,
Casa dos
Contos,
Ouro Prêto,
Brazil, 1782–4

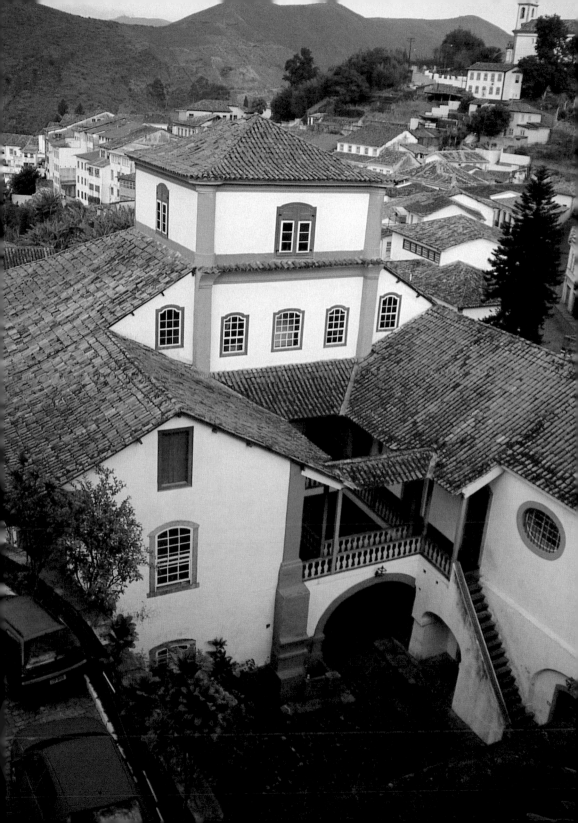

courtyard, which rises not only to the height of the ground floor and two residential storeys but further to accommodate a storage tower with Chinese-inspired eaves which dominates the entire valley. As in Spanish America, the family's living quarters were on the upper floors, reached by rare circular banisters, and its reception room had a fine wood-panelled painted ceiling. The lower floor housed the offices, warehouses and slave quarters.

Latin American country houses could be even more imposing, despite their usual lack of a second floor, because they had a long horizontal profile and were often the only building for miles around. Such is the Hacienda la Herrería (the Foundry; 188) in the lowland rainforest outside Quito. Built in 1750 by Don Miguel Ponce de León, the estate occupied a crucial agricultural zone that produced grain, fruit and vegetables for the city 30 km (18 miles) away. As was often the case in fertile regions, there was a cluster of haciendas here, including not only those of the nobility, but some belonging to religious orders who also sustained their operations through farming and plantations. Don Miguel was the tax collector for the town of Latacunga and upon his death he passed his property on to his brother, the first of a long line of Ponces (including a future president of Ecuador), who still own the estate to this day. Don Miguel had a close relationship with the friars of San Francisco, and he was inspired by the convex-concave staircase of their church (see 162) to build a replica of his own, a high, stone structure which spills down into the entrance courtyard like a cascade, here hidden by a palm tree. The main building is a U-shaped house with an arcade at the front and other arcades around a series of courtyards behind. Like villas in Europe, Latin American country houses have more open and receptive façades than their urban equivalents. The tallest part of the building is the chapel, with its Neoclassical façade of white pilasters and little *espadaña* bell tower. The right half of the portico gives on to the drawing rooms and dining room, and the left half leads to the bedrooms and chapel. A library opens on to the second courtyard and the kitchen is secluded in the third. A working foundry and farm, the hacienda also has granaries, a textile mill, a pottery kiln and servants' quarters.

188
Hacienda la
Herrería,
Quito,
Ecuador,
1750

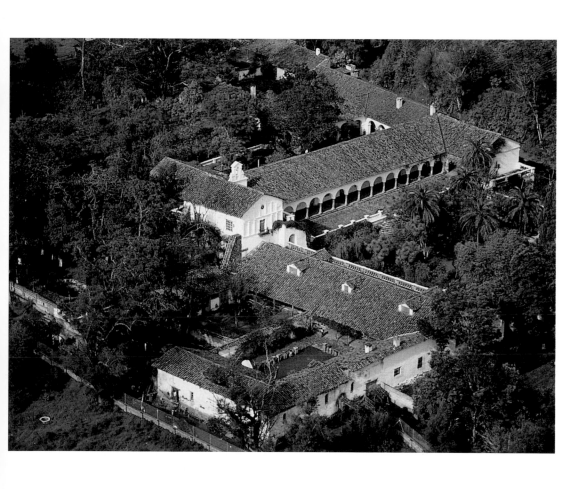

Jutting off the shore in the lower town of Salvador, the Solar do Unhão was also tied to an important agricultural zone (189). A major link in the sugar trade from Bahia, this *quinta* was built at the end of the seventeenth century for Judge Pedro de Unhão Castel Branco, occupying flatlands that had been reclaimed from the sea overlooking the Bay of Todos os Santos. The complex includes a block-like great house, a chapel dedicated to Our Lady of the Immaculate Conception, store houses, a millstone, a distillery, aqueduct and fountain. The exterior of the house, now the Museum of Modern Art, is unrelentingly austere. As in the Casa dos Contos (see 187), the living quarters were on the second floor, the ground floor was the service area and there was a storage area in the attic, although another floor was added in the

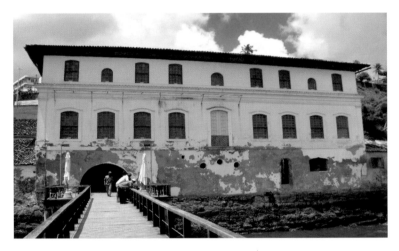

189
Solar do Unhão, Salvador, Brazil, late 17th century and later

190
Reconstructed dining room from colonial New Spain, Museo Franz Mayer, Mexico City

nineteenth century when the building was converted into a snuff factory. Like the Hacienda la Herrería, the *quinta* has a dramatic approach, this time a bridge decorated with Portuguese tiles that descends from the esplanade above, and the main courtyard features an especially handsome sandstone fountain. The chapel (finished 1794) also has an impressive profile, with twin towers and a Neo-classical façade, making the whole complex look like an island city.

The furnishings of even the lowliest rooms of colonial town or country mansions could be splendid, exhibiting the same Baroque taste for spectacle as the churches. Even the lavatories were equipped with silver chamber pots and washbasins. The dining room was a showcase

for fine porcelain from China or England, or high-quality ceramics made locally or at the Talavera Poblana kilns of Puebla. Cut crystal decanters and glasses joined forces with silver cutlery, platters, candlesticks and decorative plaques called *mariolas* or *mayas*, which were placed behind candlesticks to reflect the light, and the room was appointed with the finest wooden sideboards, chairs and serving tables, as well as silver mirrors and tapestries. Even more humble dwellings, such as

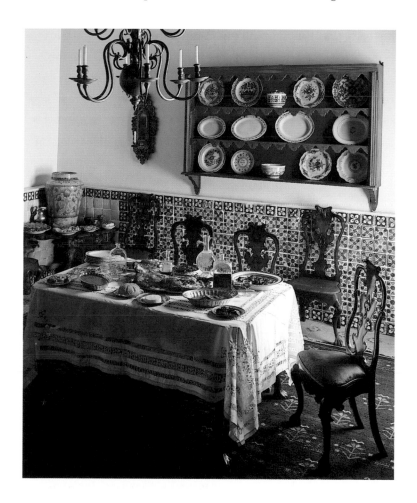

the reconstructed dining room (190) from an exhibition in the 1990s at the Franz Mayer Museum, Mexico City, served as a showcase for imported china and mahogany furniture. The bedrooms had their canopied beds of painted wood, chests of drawers and small portable altarpieces with wooden or ivory images, some of them assembled into dioramas that made them look more like dolls' houses than

shrines. Portable altarpieces folded into easily transportable trunks – or, in Brazil, into a bullet-shaped form – so that families could bring them along as they moved between town and country. In Spanish America, biombos served as room dividers in most of the larger rooms, while in Brazil Chinese screens performed the same function. Reception rooms were the showiest of all, with fashionable English-style chairs, tapestries and carpets, chests of drawers, desks, more silverware and the finest paintings of the house. The dais (estrado) room had little furniture on the platform itself, usually just chests, additional biombos and low writing desks, as well as a kind of low table made expressly for this setting (see 196). Chairs or settees were provided for men on the side of the room opposite the dais. The canopy room (191) required a large decorative canopy, which was placed over the throne(s), and served as a backdrop for the obligatory portraits of the reigning monarchs. The private chapel – a luxury also enjoyed only by the highest nobility – had all of the necessary liturgical accoutrements for the chaplain to celebrate Mass and it was adorned with miniature versions of what we have seen in the churches: retablos, altars with their frontals, a tabernacle, religious imagery and even organs, pulpits and choir stalls.

191
Reconstructed
canopy room
from colonial
New Spain,
Museo
Franz Mayer,
Mexico City

The rooms of the colonial mansions witnessed extravagant entertainments, part of a flourishing social calendar studded with parties and receptions celebrating anything from the arrival of a new bishop to the birth of an heir to the throne. The more important occasions featured multi-course feasts, including in some cases extra-vagances called 'surprise dishes', like large turnovers with live animals or birds inside, or fountains of wine shaped to look like Amerindians worshipping pagan gods. Aristocrats spared no expense when decor-ating the gardens of their country houses for important visitors, including in one case a gold-plated pine tree, and in another a pair of temporary galleries supporting banquet tables and bordered by flower arrangements, false caves enclosing musicians and surprise waterworks of the sort enjoyed in Baroque courts in Europe. In 1640, a marquis visiting the inn of a small town in New Spain slept in a bed-room with a night and day bed and four working fountains, spouting perfumed water, wine, milk and honey, and decorated with flowers and pastries. Carriages and sedan chairs encrusted with gold-plated scrolls

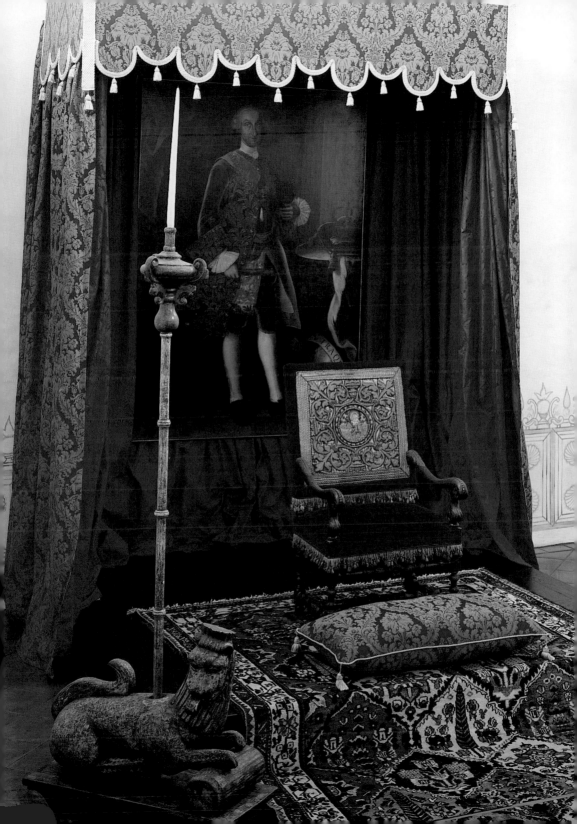

and other carvings also offered the aristocracy a chance for unbridled self-aggrandizement. Wealthy families seized any excuse to form a procession of fine carriages through the streets of Mexico City, Lima or Rio de Janeiro during holidays like Christmas Eve or at society weddings.

Some of the more detailed portraits of the period give us a glimpse inside the houses of the nobility, especially in the eighteenth century, when portraitists turned their attention to a wider spectrum of the aristocracy. Such portraits not only show us some of the objects people had in their houses, but also their costume and they reveal something about the character of the colonial aristocrat. Some of them come straight out of a romantic novel. Doña Mariana Belsunse y Salasar was one of the leading lights of Lima society in the eighteenth century and was immortalized in contemporary literature. In her portrait she stands proudly in a formal reception room next to an ornate wooden table and in front of the standard red curtain (192). A window looks out on to a formal garden in the French style, with a triumphal arch and parallel rows of trees. The first thing the viewer notices is the richness of her magnificent blue silk dress, painstakingly embroidered in silver thread and trimmed with layers of Flemish lace. Doña Mariana's pose also connotes a strong personality, as she does not sit demurely as women often did in portraits, but stands in three-quarters view like a viceroy. She is dripping with jewellery, including pearl earrings, a silver and pearl hair comb, and a black velvet choker adorned with gems and attached to a dangling pendant. In her left hand she holds an expensive watch and in her right hand a Chinese fan, another sign of her sophistication and a compulsory prop in the social games of high society. The table beside her is a fashionable French-style piece in mahogany with sinuous lines, rich Rococo floral decoration, cabriole legs and ball-and-claw feet – precisely the sort of piece that would have been found in the reception rooms of the wealthy in the Bourbon era and is as effusively three-dimensional as a Baroque church façade. The table holds more symbols of her high status, including a pearl brooch, the watch she holds in her hands and a vase with flowers, as well as the book and letters, which demonstrate erudition – but no more than was becoming in a woman of substance (the book is, after all, closed). The scene outside the archway, which also underscores the

French tastes of her era, is likely to have been taken from an engraving, although it is also thought to be a reference to a park which she and her husband founded in Lima.

Doña Mariana comes alive when we learn her story. One of the most famous figures in Lima gossip circles, she was forced against her will to marry an elderly and irredeemably ugly old count for his title and money. Making him wait a year before consummating the marriage, Doña Mariana meanwhile fled to a convent and a huge legal battle ensued as her husband tried to have her removed. The citizens of Lima followed the case closely and took sides. Scandalous poems were composed that questioned the count's virility. Things ended happily for Doña Mariana, as her husband died trying to prove his detractors wrong and she was able to leave the convent with his money and title – and her independence.

A very different side to upper-class life is portrayed by a famous posthumous portrait by Miguel Cabrera of the poet Juana de Asbaje, better known as Sor Juana Inés de la Cruz (1750; 193). The life of an affluent nun in colonial Latin America had little to do with pious abstinence and much to do with elegant society, and Cabrera's subject sits with the ease and authority of a noblewoman, fingering her rosary like a fine necklace. Although few titled ladies joined nunneries, many nuns came from well-to-do families and they led lives of luxury comparable to those of their secular sisters. Entering a convent was as difficult as marrying well, with dowries as high as 5,000 pesos and long waiting lists. The viceregal couple are likely to have sponsored Sor Juana's entry into the convent because her lack of dowry and uncertainty about the identity of her father would have prevented her from marrying into her class. As a nun, she could continue to live the courtly lifestyle she had become accustomed to in the viceregal palace (see Chapter 3) and – more importantly – to pursue her literary and scholarly career without the burdens of child-rearing imposed upon women who marry. Her convent of San Jerónimo was one of the most prestigious of Mexico City's twenty-two female religious houses. Sor Juana's cell was more like a small house, with two floors, a private bathroom, kitchen, sitting room and bedroom, not to mention her

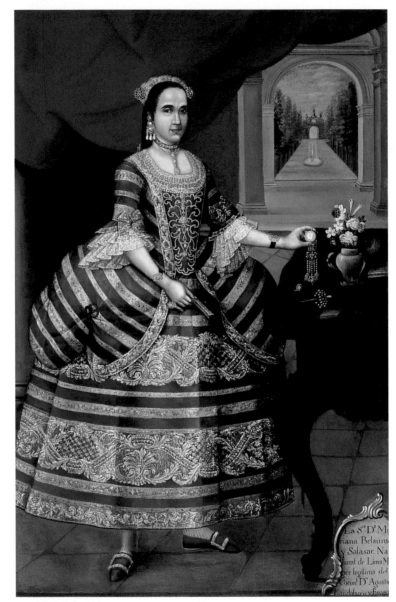

192
Portrait of Doña
Mariana Belsunse
y Salasar,
mid-18th
century.
Oil on canvas;
198·4
× 127 cm,
78⅛ × 50 in.
Brooklyn
Museum
of Art,
New York

193
Miguel
Cabrera,
Portrait of
Sor Juana Inés
de la Cruz,
1750.
Oil on canvas;
207 × 148 cm,
81 × 58 in.
Museo
Nacional
de Historia,
Chapultepec,
Mexico City

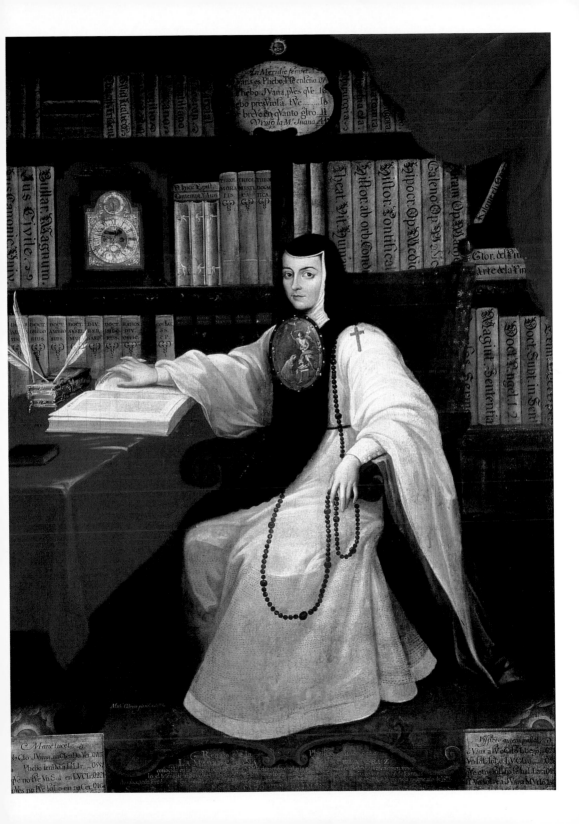

formidable personal library, seen in the background of Cabrera's painting complete with legible spines. The setting of Cabrera's portrait, with its luxurious colours and rich detail, is as ostentatious as that of Doña Mariana. She sits on a massive mahogany armchair with a leather or velvet backrest like those found in the canopy rooms of the nobility (see 191) and it reflects French taste in the scrolling curves of the arms. A similarly Rococo table, covered with a deep red velvet cloth, holds books and an extensively decorated silver inkwell with pens in it. These props on the table – signs of an active literary life – are more typical of

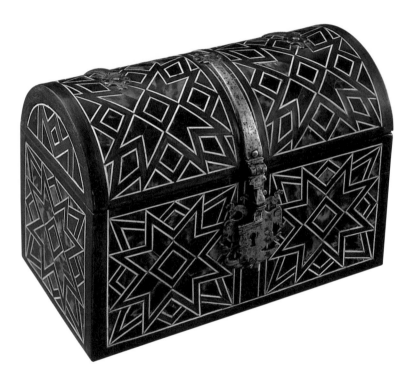

male portraiture and provide a noteworthy contrast with the diminutive, closed book of Doña Mariana. Behind Sor Juana on the bookshelves, under the requisite red curtain, is an elaborate clock with a face showing the signs of the zodiac, another traditionally masculine instrument that refers not only to her wealth but also to her scholarship and interest in the occult. This use of male imagery in a portrait of a woman is a testament to Sor Juana's unusual position in colonial society.

The homes of the wealthy were a showcase for the decorative arts. Although their contents have dispersed through centuries of revolutions and economic crises, much of their furnishings survive in museums and private collections around the world, and they represent a staggering variety of media, styles and ethnic traditions. Furniture was the realm of the *ensambladores* and *carpinteros*, the same men who worked on the retablos, choir stalls and pulpits of the churches. The basic forms of colonial Latin American furniture reflected the functions of the rooms they adorned, including chairs, tables, chests, beds and cabinets. The earlier ones are almost stark in their plainness, with flat surfaces and only a modicum of decoration, and, following an old Islamic tradition brought from Spain, they were usually portable as well. All of this changed in the later seventeenth and eighteenth centuries when waves of Baroque and Rococo fashions reached the Americas, so that their chairs now featured painted and embossed leather on their seats and backs, and grew sinewy, scroll-like arms and – together with the tables and chests – curving legs with ball-and-claw feet. The surfaces of desks, armoires and bookstands exploded with surface ornamentation, from inlaid marquetry patterns to painted lacquer designs with vignettes and floral patterns. Especially intricate were Islamic-inspired *mudéjar* pieces, with painstakingly arranged geometrical patterns of inlaid wood, ivory, tortoiseshell, mother-of-pearl and bone. As in retablo carving, artisans in the Baroque era gave greater emphasis to the third dimension and to the play of light and shadow over surfaces, whether in the bolder, curving shapes of the pieces or the depth of carving of their ornament. Styles changed once again with the arrival of Rococo and Neoclassicism, which brought a taste for the sinewy lines and delicate scrollwork of Thomas Chippendale, and the more sober lines and plain surfaces of French Napoleonic furniture. Furniture was made all over metropolitan Latin America, but certain centres, like Puebla and the Ecuadorian town of Latacunga, were exceptional.

A seventeenth-century chest (194) with a curved lid demonstrates the apex of the *mudéjar* tradition in New Spain. One of the many portable containers that adorned the Latin American home, this piece is impressive both because of the simple lines of its profile (it never had legs and

194
Chest,
17th century.
Tortoiseshell,
wood, ebony,
bone and
ironwork
with traces
of gilding;
h.19 cm, 7½ in.
Museo
Franz Mayer,
Mexico City

was meant to sit directly on the floor) and the extremely complex workmanship of its decoration. The surfaces break out in double eight-pointed stars inscribed within small square panels made of individual pieces of wood, bone, tortoiseshell and ebony. The earthy colours of the woods and mottled tortoiseshell achieve a delicate balance with the white bone. Purely Islamic in design, the chest recalls the *mudéjar* ceilings at San Francisco in Quito (see 165), yet its iron keyhole plate, with the double eagle of the Habsburg dynasty, reminds us of its viceregal origin. On a completely different scale, this splendid wooden cabinet (195) from eighteenth-century Cuzco takes a much more vigorous and textured approach to design. Cuzco was known for highly decorated Baroque cabinets of this sort, with panelled doors, a cornice and four leaf-like feet below. The panels swarm with foliate vines, scrolls and florettes, carved in such high relief that they overlap and cast deep shadows over the front of the piece. Vaguely classical acanthus and egg-and-dart motifs adorn the frames of the doors and cornice. There is a surprise inside, as the shelves, drawers and side panels are painted in bright gold leaf over a black background, echoing the hues of Japanese lacquer boxes.

The heaviness of the Baroque style soon gave way to more delicate forms. A Rococo lightness prevails in this late eighteenth-century Argentine low table (196), sometimes also called a 'mouse table' or 'dwarf table'. Such tables were used on the *estrado*, or dais in the ladies' parlour of an aristocratic home. This table dates from a time when Buenos Aires had just become the capital of a new viceroyalty (1776) and reflects the city's new-found stature as a place of refinement. Derived partly from Chippendale and French furniture and partly from Asian export furniture (itself copying European models), the table compensates for its shortness through the sensuous curves of its sides and ball-and-claw feet. The apron and top have a deeply scalloped profile, and the two drawers on the front, the false ones on the sides and the four legs, are lightly accented by cartouches with crosshatching and shell motifs. Reclining on carpets or cushions, women would eat on these tables or use them during the evening for sipping chocolate or *yerba de mate* (a lightly-stimulating form of herbal tea grown on Jesuit plantations in Paraguay and common throughout South America).

195
Armario or cabinet, 18th century. Cedar; h.208 cm, 82 in. Private collection

196
Low 'mouse table', second half 18th century. Mahogany; h.50 cm, 19⅝ in. Brooklyn Museum of Art, New York

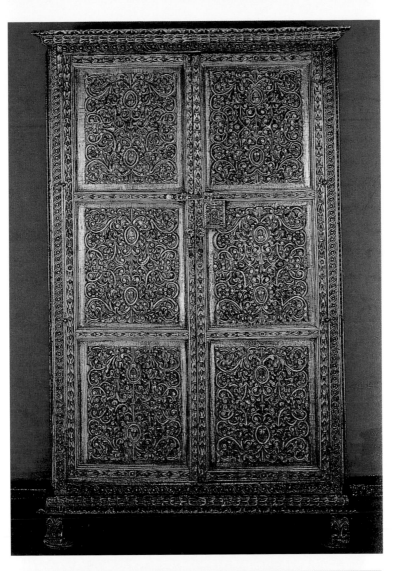

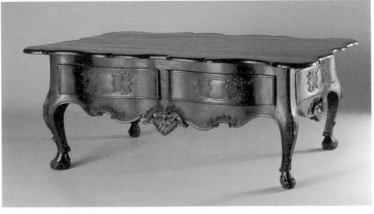

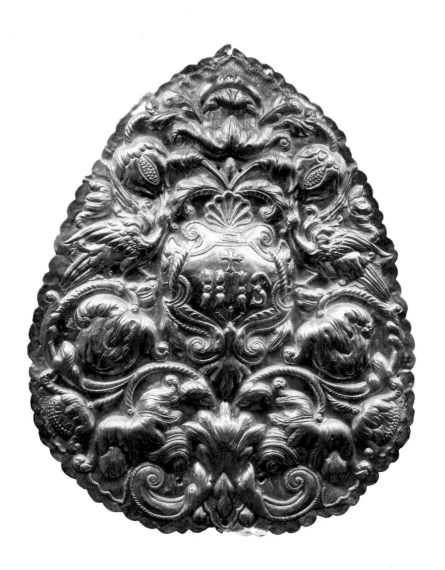

Chocolate was an extremely popular drink in the colonial period, when it was prepared with water, sugar, cinnamon, vanilla and even chili peppers, and it was served on elaborate china or silver services together with pastries.

The *yerba de mate* and chocolate that the women drank at these tables lead us to another leading industry in colonial Latin America: silverware. The art of silverworking was grafted on to pre-Columbian roots, as Amerindians had already mastered the arts of alloying, soldering, casting, repoussé work and moulding as early as 600 BC. Silverware is particularly emblematic of viceregal Latin America, as so much of the colony's fortune depended upon the silver mined at great human cost in Potosí, Guanajuato and the many other silver mines from Bolivia to Mexico. Silver workers belonged to one of the richest and most powerful guilds in the system (see Chapter 4) and their output was staggering, satisfying the needs of church interiors and domestic settings alike. Unfortunately, silver is especially vulnerable to being melted down in hard economic times and the fraction that survives today gives us only a glimpse of its range of forms and styles. The main silver-working centres were in present-day Peru, Bolivia and Colombia, as well as Bahia in Brazil, Guatemala and New Spain. As with furniture, silverware enthusiastically embraced the Baroque and Rococo styles in the seventeenth and eighteenth centuries, incorporating a bewildering range of decorative motifs – many of them taken from northern European engravings – including masks, cornucopia, native flora and fauna (such as the viscacha, a kind of rodent), 'green men' (fanciful human figures that emerge from foliage) and sirens with tails, all executed in densely packed patterns in high relief. The two main techniques were repoussé and filigree. Repoussé creates patterns by hammering and pressing them on to the reverse side and the resulting three-dimensional patterns are then often chased, or engraved, over the top. Filigree work is done by soldering finely drawn wire into decorative forms with lace-like effects. Among the enormous variety of objects manufactured by silver workers, the most common were bowls, cups, platters, cutlery, chocolate pots, stills, flasks called *chifles*, candlesticks and horse tack, as well as pieces of furniture entirely wrapped in silver, such as tables and chests.

197
Maya,
c.1750.
Repoussé
silver.
Museo
Diocesano,
Santa Cruz

Distinctly Latin American forms include this *mariola* or *maya* (197).
The surfaces are repousséd in high relief to achieve a flickering
effect, enhancing the light of the candle that would be placed in front
of them. Made in the silver capital of Potosí in 1750, its surfaces are
covered with a mass of phoenixes, pomegranates, tropical flowers and
an emblem of the name of Christ. The scrolling of these individual
elements is especially masterful, culminating in a floral motif at the
top. Another characteristic type of secular silverware is the domestic
incense burner, meant to perfume the air in stuffy colonial sitting

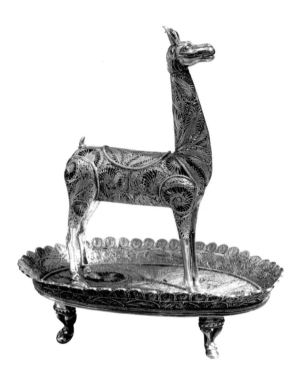

198
Llama incense
burner,
early 19th
century.
Filigreed silver;
h.20·7, 8⅛ in.
Museo Isaac
Fernández
Blanco,
Buenos Aires

rooms. Many of them take the form of animals, as with an early
nineteenth-century llama from Ayacucho, Peru (198), which stands
proudly on a platter with his head raised in the air. His entire body
and that of the platter are made of swirls of filigreed silver, creating
the typical lace-like effect that gave the smoke from the incense the
freedom to waft outside. His head and the legs of the platter are cast
in solid silver. This style of zoomorphic incense burners goes back
to an eleventh-century Islamic tradition, particularly common in
Seljuk Persia and Khorasan. Such is a Persian lion from the eleventh

or twelfth century made of engraved copper alloy and perforated so that the incense could escape, a piece which would have sat on a small table or sideboard (199). As if ready to pounce on his prey, the animal crouches down, and his moustache and curls at the top of his ears lend a whimsical appearance to this otherwise ferocious animal. Islamic art had little in the way of sculpture in the round, owing to its disinclination for graven images, but these delightful small-scale pieces were the exception and their charm guaranteed them a place in post-Islamic Spain and the New World.

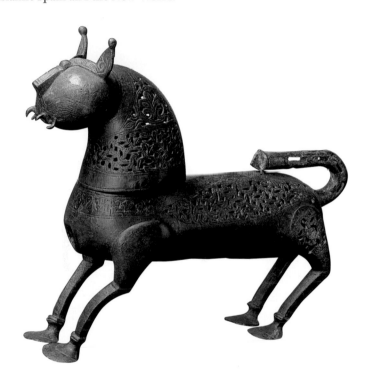

199
Lion incense burner, Persian (Seljuk), 11th–12th century. Engraved copper alloy. Musée du Louvre, Paris

The most luxurious pieces of silver are the silver tables and chests, cited by travellers as a sign of the decadence of Latin American society. This magnificent wooden trunk (200) with a curving lid, made in Lima around 1747, is completely covered with repoussé and chased silver. The piece positively glitters with dense, high-relief decoration, including feathers, scrolls, flowers, clusters of grapes, large floral vases, birds, masks, 'green men', two-headed Habsburg eagles and the arms of the counts of Altamirano. Even the interior is silver-plated, with repetitions of the same decorations.

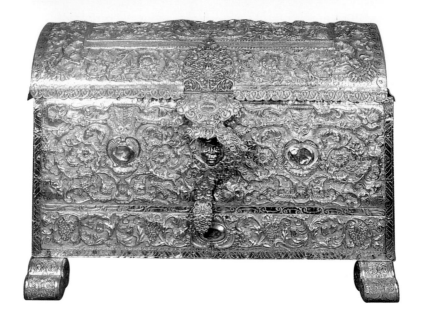

Ceramics were primarily a utilitarian art form in colonial Latin
America, with a few noteworthy exceptions. The art of hand-made
pottery was highly advanced in parts of pre-Hispanic America,
especially the Andean coast and Highlands, and the Spanish imported
new techniques, including wheel-throwing and lead- and tin-glazing.
The Spanish also brought a panoply of new styles, influenced by
Islamic-inspired Hispano-Moresque earthenware with its blue,
white and lustre patterns, Italian maiolica, with figures and more
colour, and eventually blue-and-white Chinese porcelains. The most
prominent and productive ceramic centre in Latin America was Puebla,
home to the Talavera Poblana kilns, named after a ceramics centre near
Madrid. Puebla was blessed with natural resources. Nearby could
be found both of the clay types required for a strong body and perfect
colour, one of them pink and the other black. These clays were blended
in equal portions, ripened, dehydrated, cut into blocks of varying sizes
and then ripened for another year before they could be used. In the next
stage, they were moulded by hand or thrown on the wheel, fired in the
kiln, dipped into the glaze and dried. Artisans then applied decorations
with mineral pigments freehand, or used powdered carbon sketches as
a guide. Finally, the piece was fired again for as much as forty hours to
fuse the pigments into the glaze. The Talavera Poblana kilns made three

200
Trunk,
c.1747.
Wood overlaid
with silver
repoussé;
h.35 cm,
13³⁄₄ in.
Arizona State
Historical
Society,
Tucson

main grades of ceramic: cooking vessels, 'common ware', and 'fine ware' (a later version is 'refined ware', or Chinese-style pieces). The earliest ceramics, from the sixteenth century, copied Hispano-Moresque and Italian models, although never slavishly since they freely integrated motifs from one into the other. Then, after the Manila Galleon trade route was established in 1565, Chinese blue-and-white porcelains flooded the market and by the later seventeenth century Poblano potters started to make Asian-inspired wares using a white to brick-red clay with underglaze blue designs over white slip. These pieces not only included vessels but tiles and soon the walls of the houses and convents, and the domes and façades of the churches of Puebla were covered with blue-and-white and coloured tiles (see 134). Chinese style blue-and-whites dominated the market in the eighteenth century.

Two of the finest surviving pieces of Poblano pottery demonstrate the main stylistic change between the mid-seventeenth and early eighteenth century. This basin (201) from c.1650 combines Islamic and Spanish Renaissance forms. The profile of the piece, a large and deep flat-bottomed basin with steep, slightly flaring walls, is a traditional Islamic form and the cobalt blue colour was also widely used in Islamic ceramics from about the tenth century. However, the interstices of the blue patterns are filled in with filigree-like geometric motifs inspired by a traditional Spanish design known as 'bobbin lace', creating a satisfying balance of colours and a contrast between thick and thin lines. The Chinese-inspired blue-and-whites preserve some of these Islamic shapes, but they replace the tightly co-ordinated geometric patterns with more loosely distributed plant and bird forms, and tiny vignettes with Chinese temples and bridges. One of the finest is this early eighteenth-century basin (202), which was probably used as a washing bowl, and its shape is very typical of the Poblano kilns from about 1650 to 1750, similar to the other basin but with a pie-crust rim made by pinching the clay when wet. It was inspired by a Ming Dynasty dish from the reign of Emperor Wanli (1573–1620), like one with a strikingly similar panel arrangement and figural scenes (203). The centre of the Mexican piece is decorated with a fanciful Chinese landscape, with a river, bridges, and a temple with the Baroque dome and bell tower of a Mexican church. Hunters and birds crisscross

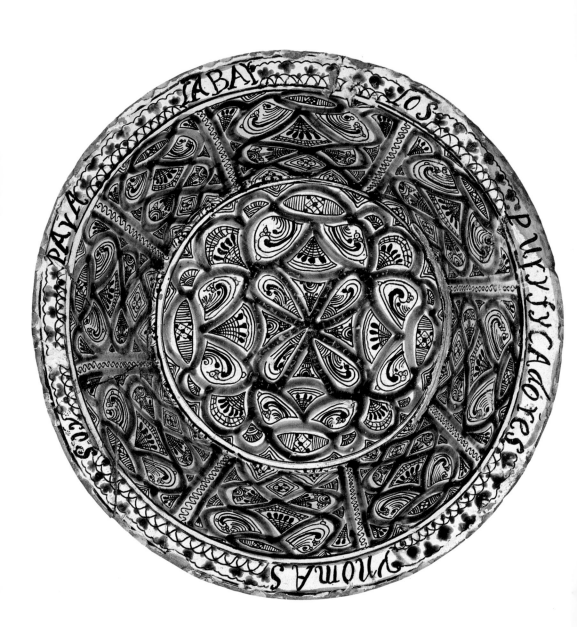

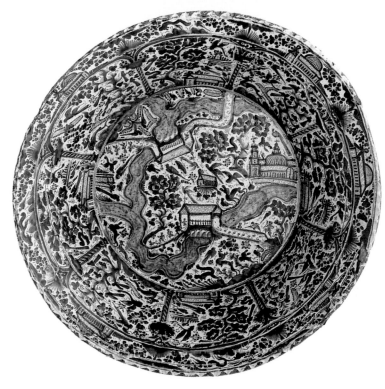

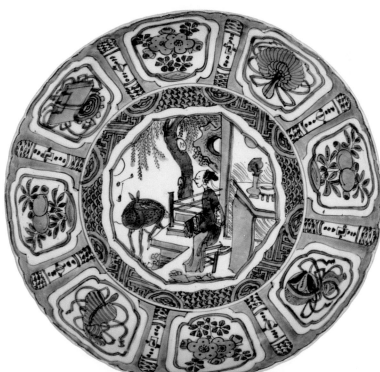

202
Talavera Poblana
basin (*lebrillo*)
with Asian-
inspired
ornament,
early 18th
century.
Glazed
terracotta;
diam. 66 cm,
26 in.
Museo
Franz Maycr,
Mexico City

201
Talavera
Poblana basin
(*lebrillo*),
c.1650.
Glazed
terracotta;
diam.
52·7 cm,
20⅝ in.
Metropolitan
Museum of
Art, New York

203
Dish depicting
a lady with a
deer,
1590–1610.
Porcelain;
diam. 30·2 cm,
11⅞ in.
Private
collection

the fields. The walls are divided into panels by an arcade of twisted Baroque columns, which frame additional bridges and birds, and the rim is adorned with more domed buildings. This Poblano potter was not content just to copy but made a selective collage of motifs, without the strict hierarchy of forms seen in the Chinese original and including motifs taken from his own environment.

A similarly ingenious treatment of Chinese and European subject matter can be seen on Poblano tiles. The Talavera Poblana kilns manufactured tin-glazed earthenware tiles on a giant scale for interior and exterior walls of homes and convents, and façades and domes of churches. Although the patterns and colours of the Poblano tiles look Chinese, the tradition of tile revetments is another Islamic one, already popular in thirteenth-century Persia, where domes, archways and interiors of mosques were covered with brilliant blue and turquoise tiles. As in Persia itself, Poblano potters made two kinds of tile: individual tiles used as accents in brick or plaster walls, and fields of tiles, which pro- duce a single image only when assembled together. Tiles are only glazed and painted on one side, with bevelled edges on the back, so that they can adhere to the wall. The earliest Poblano tiles were done in a colourful Italian style such as those of the interior of the Rosary Chapel in Puebla (see 171), but the Chinese blue-and-white manner domi- nated between 1650 and 1750, also inspired partly by the importation of Dutch Delft tiles. Tiles from the period, showing Asian and European figures in a landscape (204), use different intensities of blue to suggest varieties of colour, a technique pioneered by Chinese potters. The tiles are best seen in situ, such as on the House of Tiles (see 185) in Mexico City or on the façade of the church at Acatepec (see 134).

It is interesting to compare the Talavera kilns with the situation in Brazil, which also had a direct trade link with Asia via Goa. In places like Bahia, Chinese ceramics were so common and inexpensive that there was no need to imitate them – blue-and-white porcelains were plastered on to church steeples as decorative accents, used as chamber pots, and even given to the slaves. The steeple of the eighteenth-century church of Nossa Senhora da Conceição do Monte (205) in Cachoeira is a case in point, liberally coated with broken crockery, including

204
Talavera
Poblana tiles,
c.1650–80.
Glazed
terracotta;
13·3 ×
13·3 cm,
5¼ × 5¼ in
(each).
The Hispanic
Society of
America,
New York

borders of blue-and-white dishes on the edges. There was also no need for a sophisticated local tile kiln, because tiles were ordered directly from Portugal, as we have seen at São Francisco (see 170) in Salvador.

Textiles were one of the most sophisticated of the American arts before the Conquest and a medium in which women played a crucial role. Chapter 2 has already considered the flourishing post-Conquest production of qompi, or 'fine cloth' (see 49), in the Andes, the highest quality textile region in colonial Latin America. All over Latin America, textile workers sought to meet the needs of the colonial market, weaving and embroidering lavish ecclesiastical garments such as chasubles and altar frontals as well as clothing and household items like wall hangings, furniture and floor coverings. Particularly in the eighteenth century, members of the nobility outdid each other in the richness and flashiness of their costume, wearing the finest taffetas, silks, velvets and imported Asian brocades, as we have already seen in the portrait of Doña Mariana (see 192). Portraits of wealthy ladies, such as the Countess of Monteblanco from Lima (206), gave most of their attention to the luxuriousness of the sitter's clothing, here a luminescent pink silk dress made of imported Asian fabric, embroidered with tiny floral and foliate motifs, and trimmed with layers of delicate Flemish lace and pearls. The dress steals the show, overshadowing the Countess's face and her family coat of arms. By the time this portrait was painted, clothing was getting so outrageously showy that colonial governments called for sanctions – all of which were blithely ignored. The Countess represents the epitome of Latin American extravagance. At the time of her death in 1810 she was worth more than a million pesos and owned 1,031 slaves, the largest number ever owned by a single family in Peru.

In New Spain, European and indigenous textile traditions also merged, with European wool and native dyes, and both Spanish large-frame looms and Nahua back-strap looms in use. Silk was cultivated on a large scale here during the sixteenth century, especially in Oaxaca, but the local silk industry was soon drowned in the flood of cheaper Chinese, Filipino and Indian silks after the Manila Galleon was established. Although male embroiderers' guilds dominated the official

205
Steeple encrusted with Chinese dishes, church of Nossa Senhora da Conceição do Monte, Cachoeira, Brazil, 18th century

manufacture of pieces like ecclesiastical vestments, women were also extremely active. Beyond the reach of the guild system, nuns embroidered fine vestments for the Church, including altar frontals, as well as clothing for religious images. Embroidery was taught to most young girls, including aristocratic ones, and noble girls and women would often sit on the *estrado* in the evening and attend to their needlework.

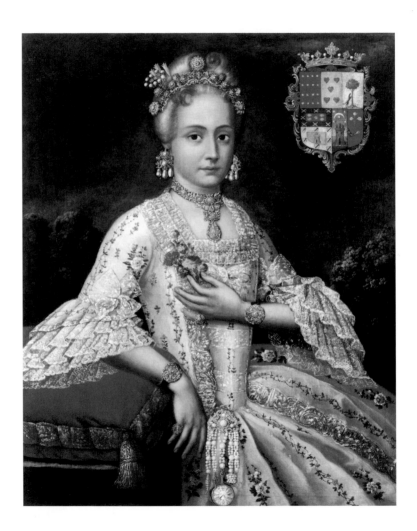

A bedspread from Mérida (see 184), signed by Doña Rosa Solís y Menéndez and dated 1786, is just the sort of piece that a well-off girl would have worked on as part of her wedding trousseau. It shows that skill and creativity were not limited to professional workshops or monastic ateliers. Made of cotton and silk thread, the bedspread

contrasts bright primary colours with an off-white background and it features a courtly man and woman in front of a lively trellis-like pattern, suggesting a walk in the garden. The trellis is created by having floral vines creep up a series of parallel and zig-zag lines, and the flowers are so large that they threaten to swallow up the figures. This pattern of flowers and parallel lines shows the influence of Chinese and Filipino embroideries and Indian painted chintz fabrics, which were widely available in New Spain at the time. An inscription around the border, in alternating colours, reads: 'Made by Doña Rosa Solís y Menéndez in Mérida of Yucatán on the fourth of January of the year 1786.' The couple may be an idealized vision of herself with her bridegroom on her wedding day.

One branch of textiles especially characteristic of colonial Latin America was the convent insignia panel (*escudo*), an oval-shaped image of a saint or biblical scene worn by nuns on their chest, as seen in the portrait of Sor Juana Inés de la Cruz (see 193) and also in this splendid eighteenth-century portrait of a novice nun (207), coincidentally also named Sor Juana de la Cruz, the founder of Sor Juana the poet's San Jerónimo convent in Mexico City. The tradition of wearing such insignia dates from the Middle Ages, when sisters wore patens (saucer-like discs) adorned with pictures of saints to which they had a special devotion. Insignia were usually worn on the chest or the shoulders in New Spain, and they formed a focal point in portraits such as this one. Painted when the young girl was entering the nunnery, she is depicted wearing not only insignia of the *Annunciation* but also a crown, and holding an elaborate bouquet and a dressed-up image of the child Jesus in her hands. The insignia were meant to divert attention away from the nun's face, which could induce vanity, towards the object of her devotion. An eighteenth-century insignia (208) from New Spain, made of silk and silver thread embroidery, depicts the Immaculate Conception crowned by the Holy Trinity and surrounded by other saints and angels floating on clouds. Mary and the saints surrounding her are embroidered with loose silk thread using a stitch called *punto de matiz* or *tendido* that makes a pattern out of broken lines. The entire composition is framed by a durable, padded border covered with galloned silk and silver thread embroidery, designed to withstand daily wear and tear.

206
Attributed to
Cristóbal
Lozano,
*Portrait of Doña
María Salazar
Gabiño, Countess
of Monteblanco and
Montemar*,
last quarter
18th century.
Oil on canvas;
96 × 76 cm,
37¾ × 30 in.
Private
collection

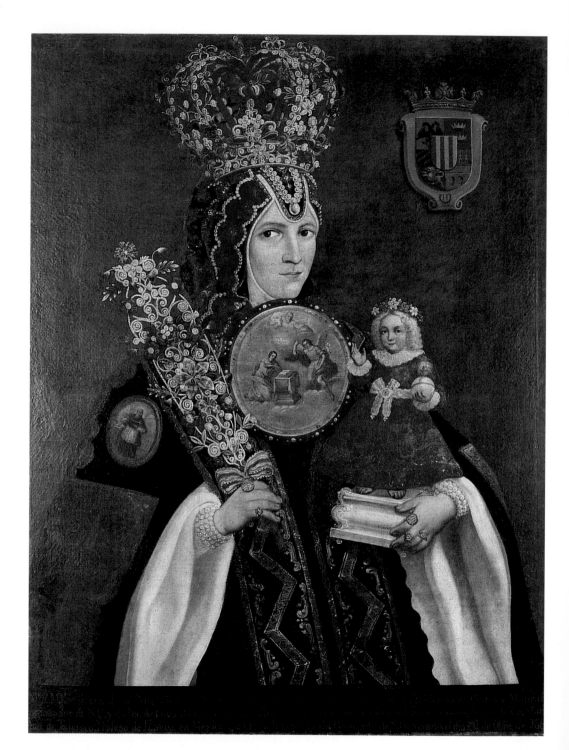

As we have seen time and again, much of the furniture, ceramics
and textiles in seventeenth- and eighteenth-century homes was
either inspired by Asian art or actually came from Asia. Even before
the fashion for *chinoiserie* took Europe by storm, colonial society in New
Spain and South America was captivated by the arts of Japan, China and
India. One of the most celebrated sources of Asian goods was the Parián
market in Mexico City, from which the citizens of the viceroyalty could
purchase luxury items from Manila. The most famous episode in
Asian–Latin American relations took place in 1614, when a trumped-
up embassy of four Japanese Samurai travelled from Acapulco to
Mexico City and Veracruz in the name of the shogun Tokugawa Ieyasu
(r.1598–1616) – in reality a public relations stunt orchestrated by the

207
*Sor Juana de la
Cruz or Portrait
of a Novice Nun*,
18th century.
Oil on canvas.
Museo de
América,
Madrid

208
Nun's insignia
(*escudo de monja*),
18th century.
Silk and silver
thread with
tortoiseshell
frame (later
addition);
diam. 18 cm,
7⅛ in.
Museo
Franz Mayer,
Mexico City

Jesuits who dominated the mission field in Japan. Although a failure
as an embassy (Japan had already started to persecute Christians by
the time they landed in Acapulco), it was a major public spectacle that
made a lasting impression on a colonial society eager for exotica. From
1618, a community of Japanese converts escaping persecution at home
settled outside Puebla, the second-largest city in New Spain, and is
reputed to have produced artworks there for an aristocratic clientele.
As we have already seen, Manila was not Latin America's only link with
Asia. Beginning as early as the 1530s in colonial Brazil, great quantities
of Indian furniture, Christian ivories and Chinese ceramics were
imported to Salvador and Rio de Janeiro from Goa. A second wave

of Asian influence arrived via Europe in the eighteenth century, when Spain and Portugal embraced the fad for *chinoiserie*.

Biombos, pinturas de enconchados, lacquers and blue-and-white ceramics are only a few of the Asian-inspired furnishings that adorned colonial homes. Some of the most overtly Asian objects were chests, lecterns and writing desks done in a varnish technique developed originally in England called 'japanning', whereby the artisans apply several layers of shellac on a black, red or cream-coloured field made of a mixture of whitewash and glue, and then decorate it with Asian-inspired decoration, such as floral motifs, weeping willows, Chinese animals and vignettes of figures set before exotic temples. Three important centres of production were Pátzcuaro in New Spain, the area around Quito in Ecuador, and Bahia in Brazil. The workshop of Manuel de la Cerda, the most prominent Pátzcuaro lacquer worker, made pieces like the exquisite writing desk already discussed in Chapter 2 (see 55), which combines the sinewy lines of the Rococo with Japanese-inspired scenes in gold paint on a black background, including temples, horse-men and weeping willows. Among the most fascinating manifestations of Asian taste in the Americas were high-quality Andean textiles such as an exquisite tapestry (209) from seventeenth- or eighteenth-century Peru, which combines Chinese motifs such as phoenixes, qilins and peonies with South American animals like llamas and viscachas, all in spectacular colours. The red background would have appealed to both cultures, as in China it represented *yang* (that which is auspicious) and in pre-Hispanic Peru the colour was a symbol of luxury as the dye made from cochineal beetle was difficult to work. The model for piece was a so-called 'rank badge', a heraldic device worn at the Chinese court during the Ming Dynasty (1388–1644). Brazilian taste for Asian-style furniture was no less fervent, as demonstrated by this late eighteenth-century oratory (210) from a private home in Salvador. Although its structure is basically classical, with pilasters and an entablature at the top, the piece is painted in Chinese-inspired colours, such as the seal red on the insides of the doors, which are adorned with Chinese pavilions, figures and willows in gold in the frame around the religious images. Even the floral decoration behind the Virgin in the centre, with its bouquets of brightly coloured flowers, recalls the

patterns of Chinese embroidered silks. None of these objects attempts to display an authentic view of China or even an accurate reproduction of a Chinese work of art, but they reveal a taste for exotica and variety that was fuelled by *criollo* society's exposure to increasing numbers of Asian goods.

Colonial Latin America's interest in Asia ran deeper than a mere love for colourful and unusual decoration. It was tied to the heart of *criollo* self-identity. Whether intellectuals or aristocrats, *criollos* believed in a cultural affinity between Asian civilizations and those of America's own pre-Hispanic past and consequently Asian objects played a role in their reclamation of the Aztec and Inca worlds. This connection becomes apparent in the Asian-inspired decorative arts that feature indigenous Americans as their principal subject, sometimes blended into Asian settings, such as *biombo* and *enconchado* paintings, which frequently depict indigenous people, shown dancing or celebrating, or as protagonists in scenes from the conquest of Mexico (see 56). Confusion about the distinction between the East and West Indies dates from Columbus's first landfall in 1492, when he thought he had landed in Japan. The very name 'Indian', now used to refer to indigenous Americans from the Arctic to Tierra del Fuego, was the first of a long line of Orientalist fantasies projected on to the peoples of the Americas by European explorers and settlers. We have already seen how the first Franciscan friars to reach the Americas in the 1520s believed that the indigenous peoples they encountered there belonged to the Lost Tribes of Israel – the Asia of the biblical past. Scholars and writers perpetuated these notions. The sixteenth-century Peruvian Jesuit, José de Acosta, was the first to propose that Amerindian peoples migrated over what became known as the Bering Straits land bridge, and subsequent generations of Latin Americans further explored the connection between the two continents, noting similarities between pre-Hispanic art and that of China or Southeast Asia and especially the apparent affinity between Aztec picture-writing and Chinese script, a link suggested in the 1660s by another Jesuit intellectual, Athanasius Kircher. Bestsellers on American shores, Kircher's works were read avidly by prominent colonial intellectuals such as Sor Juana (his name appears on one of the spines in Cabrera's portrait; see 193)

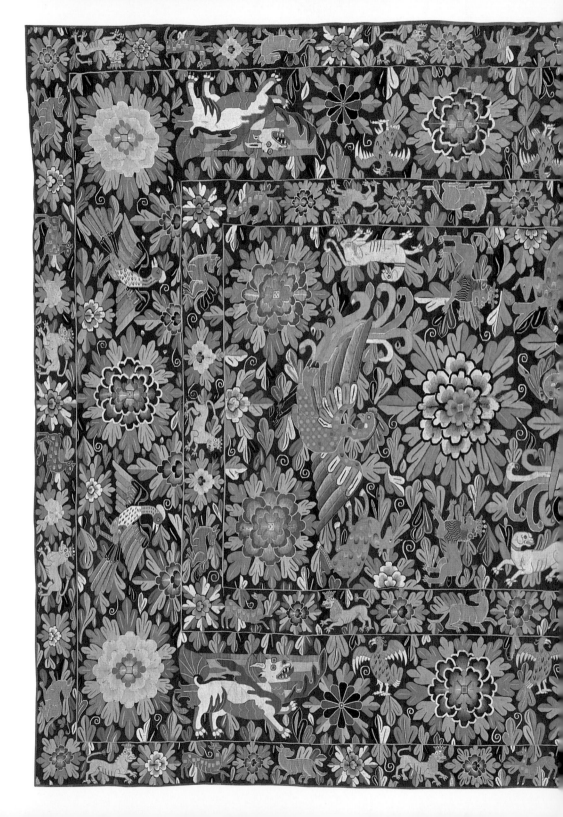

209
Cover with
Chinese
influenced
motifs,
late 17th–early
18th century.
Cotton and
wool;
238·3
× 207·3 cm,
93⅞ × 81⅝ in.
Museum of
Fine Arts,
Boston

210
Private oratory
with Chinese
inspired
decoration,
18th century.
Polychrome
and gilded
wood with
panels of oil
on canvas.
Museu de Arte
de Bahia,
Salvador

and Carlos de Sigüenza y Góngora, as were travel books on the East
such as the voluminous *India Oriental* (1601–7) by Juan de Bry and Juan
Israel, and tomes describing Asian missionary conquests like Daniello
Bartoli's *Missione al Gran Mogor* (1663). As colonial society flourished in
the eighteenth century, so did the popular and intellectual fascination
with Asia, and the conviction that the two worlds were fundamentally
linked. Although their love of Asian and Asian-inspired objects relates
on one level to a general taste for luxury and a European fashion
for *chinoiserie*, the *criollo* élite surrounded themselves with the trappings
of Asia in part because these objects belonged to an ancient civilization
comparable with that of Greece and Rome but related – however
tenuously – to the 'otherness' of America. In the rarified world
of the colonial aristocracy, where people enjoyed an abundance of
wealth but little actual power, such speculations helped compensate
for an otherwise inescapable sense of inferiority to Europe.

Colonial Latin America's link with Asia went beyond trade relations, luxury goods, immigration and the *criollo* identity crisis, and its ties with Africa ran deeper than slavery and the importation of Angolan and Yoruba culture and religion into Peru, Cuba or Brazil. The three regions also shared a common destiny. Throughout the colonial era in Latin America, Spain and Portugal maintained imperial possessions in Asia and, to a lesser degree, in Africa, administering them in very similar ways – in some cases even under the same viceroy. The Portuguese Asian settlements of Goa, Diu, Damão, Bassein, Malacca and Macao, together with their African settlements at Mombasa, Cape Verde, Angola and Mozambique, and Spanish Manila, rivalled Latin American towns in size and splendour. The same categories of colonial arts and architecture were produced there and very similar syntheses arose with indigenous traditions. In some cases, architects from Latin America even worked in Asia or Africa, such as the Brazilian who designed the church of Nossa Senhora da Nazaré (1664; 212) in Luanda, Angola, for his fellow countryman, the governor André Vidal de Negreiros. The church has a typically Brazilian whitewashed façade adorned with simple, rectangular windows, finials and lofty pediment on top (see 168). In fact it would be a mistake to study the churches of colonial Brazil or New Spain without a glance at their counterparts in Goa, Mozambique or Manila, or to consider the development of religious painting in Cuzco without a nod to the Jesuit Seminary of Painters in Japan. The Asian colonies even outlasted their American counterparts. Manila's Spanish overlords were expelled with American help in 1898, Goa was integrated into India in 1960 and Macao returned to China only in 1999 – more than 500 years after the first voyage of Vasco da Gama.

As a parallel case study, Iberian Asia and Africa also have the potential to reveal much about the mechanics of colonial culture in Latin America. But there was one significant difference between these two

211
Pulpit,
17th–18th
century.
Polychrome
wood;
h.260 cm,
102⅛ in.
Fundação
Medeiros
e Almeida,
Lisbon

regions. With the exception of the Philippines, the colonies in Asia
and Africa were relatively small fortified towns, guarded by imposing
forts like the gargantuan Fort Jesus in Mombasa (late sixteenth century;
213) on the coast of present-day Kenya by the Italian engineer
Giovanni Battista Cairato, which we have already seen as a model for
Latin American fortress design. Spanish and Portuguese settlements
in Asia and Africa were surrounded by powerful independent states
such as China, Japan, Mughal India and Ethiopia, cultures that
were never conquered like the Aztecs or Incas. Therefore, the impact
of the non-European cultures was much stronger in the colonial arts
of these regions. Even in the larger colonies, where Europeans were the

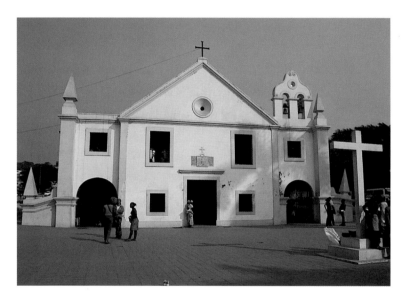

212
Church of
Nossa Senhora
da Nazaré,
Luanda,
Angola,
1664

213
**Giovanni
Battista
Cairato**,
Fort Jesus,
Mombasa,
Kenya,
completed
1593

most numerous, indigenous motifs and styles crept into art and
architecture with great frequency.

Although the churches of sixteenth- and early seventeenth-century
Goa, Damão and Diu (Portuguese India) were built according
to Italian Renaissance principles (as in the Americas, Sebastiano
Serlio was a major influence), often their ornamentation borrowed
liberally from Hindu and Islamic forms native to India. The Jesuit
church at Diu (begun 1601; 214) is a particularly striking example
of the merging of styles. The façade is a rich assemblage of Renais-
sance pilasters, elaborately framed windows and a gabled top with

fan-shaped scrolls. Yet this otherwise Italianate façade is lavished with decoration that combines European heraldic devices and angels with Hindu rosettes and hanging garlands, indigenous vegetation and Islamic geometric arabesques. These motifs, seen also in the choir stalls, church furniture, pulpits and mural paintings, include a variety of floral and arabesque patterns, all rendered in the flowing style of local craftsmen. A carved Goan pulpit (see 211), from the turn of the eighteenth century, is a case in point, with its rich decoration of tropical leaves and its circle of caryatids whose voluptuous nude torsos and jewellery make them look as if they had stepped off a Hindu temple.

Art of Colonial Latin America

214
Jesuit church
of São Paulo,
Diu, India,
begun 1601

An even more dramatic example of cultural convergence is found on the façade of the Jesuit church of Nossa Senhora da Assunção (more popularly known as São Paulo, begun 1601; 215, 216), in the Portuguese enclave of Macao, near Guangzhou (China). With a population of only 900 Europeans by the end of the sixteenth century, Macao was predominantly Asian. With this audience in mind, the church of St Paul made overtures towards Chinese culture. The church was designed by the Italian Jesuits Carlo Spinola and Giovanni Niccolò (1563–1626), and at first (like the one in Diu) it appears to be in the Italian late Renaissance style, with freestanding columns,

215–216
Carlo Spinola and Giovanni Niccolò, Nossa Senhora da Assunção (São Paulo), Macao, China, begun 1601
Below
Sculptural detail by Chinese and perhaps Japanese sculptors

statues in niches and a pediment. But the rich sculptural decoration of the church, carved by Chinese and probably also Japanese sculptors, tells a different story. Chinese temple lions support the obelisks at the very top of the façade, grinning down on the viewer as if from a Buddhist temple. Even the figures of Christ and the Virgin Mary have the bevelled line and windswept drapery of Chinese Buddhist sculpture, and details such as Chinese cloud scrolls and carp are similar

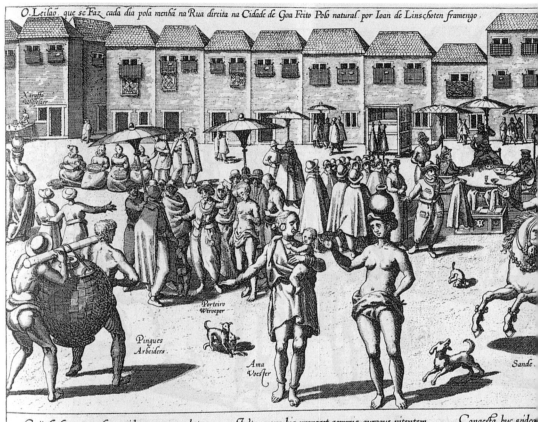

O.Leilão, que se Faz cada dia pola menhã na Rua direita na Cidade de Goa Feito Polo natural por Ioan de Linschoten framengo.

Niruffo wtffeler

Porteiro Wtroeper

Pingues Arbeiders.

Ama Voester

Sande.

Goënsi se quanta foro viden area pandat / Plana frequens tectis splendida dive o um?

Vt mercem hic properet gemmis auroque nitentem / Ille abducta procul vendere mancipia?

Congesta huc videa Insulæ et Eoo

to those found in traditional Chinese painting and other arts. The angels closely resemble a Buddhist flying figure known as an *apsaras*. The façade's Chinese identity is further underscored by explanatory texts in Chinese characters – the first in any Christian building. This richly carved façade recalls the great Buddhist cave temples of Yungang (fifth century) and Luoyang (seventh century).

Colonial cities flourished in Asia and Africa from the earliest years of imperial expansion and were as cosmopolitan as those of Peru or New Spain. Portugal's first Asian cities were well underway before anything comparable existed in Brazil – or even most of Spanish America. Goa, founded south of present-day Bombay in 1510, is the most impressive of these cities even today. Known as the 'Rome of the East', Goa had a population of more than quarter of a million by the early seventeenth

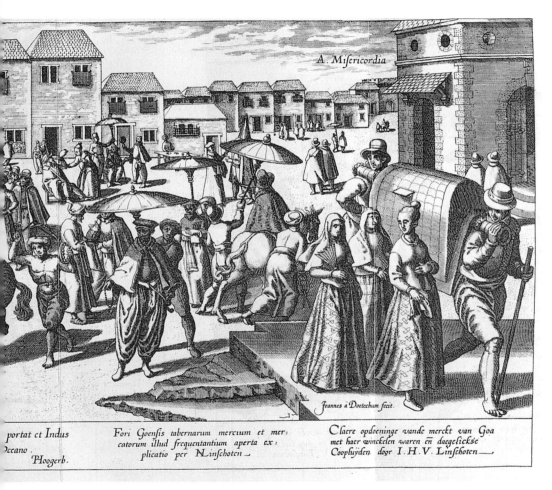

A. Misericordia

Joannes á Doetechum fecit

portat et Indus
Oceano .
Hoogerb.

Fori Goensis tabernarum mercium et mer:
catorum illud frequentantium aperta ex:
plicatio per N.inschoten

Claere opdoeninge vande merckt van Goa
met haer winckelen waren en daegelickse
Cooplyyden door I.H.V. Linschoten

century, larger than Lisbon or London. Its position between the Far East and the Islamic trading routes of the Persian Gulf and Red Sea made Goa the key to Portuguese expansion and it also became the capital of Asian Christianity, with its own bishop in 1538 and archbishop in 1558. The population of the city was extremely heterogeneous, as can be seen from this 1638 engraving (217) of Goa's bustling main square

by the Dutch printmaker Johannes van Deutecum (fl.1554–1600), including Europeans from many countries, Indian-born people of Portuguese descent (here called *castiços*) and as many non-European divisions as in Latin America, with *mestizos* (called *mestiços*), Indians, mulattos and blacks. Slavery was so rampant (a rich woman could have more than 300 slaves), mostly from Africa, that they fetched lower prices than good Arabian horses. Despite the interracial antagonism that existed in Goa, as in Latin America the divisions between the castes were not always watertight and people with non-European blood could rise to positions of influence and authority.

The Spanish Philippines, conquered by Miguel López de Legaspi in his quest for the silk trade in 1565, was the closest situation to that in Latin America, in which vast inland territories were subjugated by colonial powers. The original inhabitants were Tagalog-speaking Malayans, although a Chinese merchant community was already in the vicinity of Manila before the Spanish came. Manila was chosen as the capital in 1571, since it had an excellent natural harbour, and it was built on a Latin American-style grid pattern, with the cathedral and *cabildo* (town hall) on the main square. Massive stone churches like San Agustín (1587–1607; 218), built by the soldier-architect Juan Macias (d.1611) to recall the severe imperial style of Juan de Herrera in Spain, gave the old city a grandeur that was meant to impress. Similar in its solidity and austerity to the early missions of New Spain– in fact, its plan was approved by the royal *audiencia* of New Spain – it is more strictly academic, again inspired directly by Italian Renaissance build-ing manuals, and has a Latin cross plan with transepts, similar to the early cathedrals in New Spain. As a concession to the Chinese in the city, who provided much of the labour and craftsmanship for this church, the atrium is guarded by two Chinese temple lions. In the seventeenth century Manila could boast over 600 houses, many religious houses and churches, as well as schools and hospitals, and its streets, pavements and curbs were paved with granite cobblestones from China.

One of the most productive districts of Manila for the fine arts was the Parián, or Chinatown, outside the walls of Intramuros, where Chinese merchants and craftsmen (known as *sangleyes*) provided a vital service

to the colony, including painting and sculpting most of the religious imagery and carving the stone decoration on the churches. By 1639 the Parián grew to include 30,000 Chinese, a population that dwarfed that of the Spanish colonists in the city. Parián craftsmen excelled in oil painting as well as the exquisite ivory statues of Christ, the Madonna and other Christian figures (*santos*) for which they are famous, and which were exported in great quantities to Latin America. These images were produced in bulk for both the domestic and foreign market, and the neighbourhood still preserved its tradition of carving *santos* into the early twentieth century. Filipino sculptures, such as this ivory of the popular Peruvian saint Rose of Lima from the seventeenth century (219), have an extraordinary delicacy of line and humanity in the faces, which often reflect Chinese physiognomy.

Some of the most astonishing works of art and architecture in the Iberian empires in Asia and Africa are those made on the outer missions, beyond the colonial centres and in the heartlands of the great non-European civilizations. The missions in Japan and China produced some of the most dramatically acculturative art of the entire era, so that in places the Euro-Christian element seems to be lost altogether. As in the outer missions in the Americas, such as the pueblos of New Mexico, missionaries realized quickly that it was imperative to make concessions to local culture and chose to 'go native'. The missionaries primarily responsible for this cultural hybridization were the Jesuits, the world's leading missionary order at the time and one – as we have already seen in places like Paraguay – committed to adapting to indigenous ways.

In 1549, St Francis Xavier established the first Jesuit mission in Japan, a nation torn apart by civil war, and within a few decades the Jesuit enterprise there expanded into a large and flourishing network of missions. Although trade with Portuguese ships was very important to the Japanese, the Portuguese never colonized any part of the islands and never sent troops to subject the people. Thus, the Jesuits were entirely at the mercy of their Japanese warlord patrons and they frequently moved as the political landscape of the country changed. Indeed, the Jesuits were expelled for good in 1614, along with all other

219
St Rose of Lima,
17th century.
Ivory;
h 43 cm,
17 in.
Private
collection

Europeans. The newly unified Japanese government, wary of Iberian interests in Japan (they saw what had happened to the Philippines), felt it was prudent to have nothing more to do with Catholic Europe. But during the sixteenth century, Japan was one of Catholic Europe's greatest success stories.

The Jesuits considered Japan to be the jewel in the crown of their worldwide missions, which was one reason why they founded the largest Catholic art academy in Asia there in 1583. Known as the Seminary of Painters, this giant workshop of up to forty artists

and apprentices was directed by the Neapolitan Jesuit artist Giovanni Niccolò, a master painter and sculptor (and one of the architects of the Macao church; see 215). Nearly all of the artists in the academy were Japanese or Chinese, and their traditions made a profound impact on the art produced there. The Seminary of Painters executed Christian artworks on a grand scale, including oil paintings and watercolours, sculpture, bronze reliefs, and even books and engravings. Although much of their early work was predominantly European in style, such

220
Niccolò
School,
Glorification of
the Eucharist,
late 16th
century.
Oil on copper
panel;
39·5
× 61·5 cm,
15½ × 24¼ in.
Musée Guimet,
Paris

221
Madonna of the
Snows,
Late 16th-early
17th century.
Watercolour;
17 × 12 cm,
6¾ × 4¾ in.
Nagasaki
Martyrs'
Museum

as this late sixteenth-century painting of the *Glorification of the Eucharist* (220) in oil on copper panel encased in an exquisite Japanese inlaid lacquer triptych, others made bold forays into Japanese style.

The finest paintings executed by the Seminary of Painters demonstrate a synthesis between the traditions of Europe and Japan. One is the *Madonna of the Snows* (221), a delicate image in Japanese watercolours on traditional paper, based loosely on an engraving of the Madonna and Child printed in a book entitled *Cruz no monogatari* (*The Story of the Cross*, 1591) by a press the Jesuits had set up in Japan. Despite its clear adherence to a European model, the artist transforms every element of his image into equivalent Japanese style and technique. The brilliant colours on a gold background reflect contemporary trends in traditional Japanese painting, as do the high, arched eyebrows, the narrow eyes, the double chin and the so-called 'bee-sting' lips. The Madonna demonstrates Japanese concepts of beauty: as in typical Japanese portrayals of women, her head is accented by sensuous wisps of hair, and her cheeks and forehead shine with an ivory-like brilliance. The most overtly Japanese element is the manner of framing, the *kakemono* or hanging scroll, framed by textiles such as figured silk or brocade, and attached to a wooden dowel at the bottom.

The church architecture of the Japanese missions was even more acculturative. Jesuit mission churches tended to use materials taken from Buddhist temples or residences. They were built in the Japanese style of post-and-lintel wooden architecture with a hipped-gable roof and they employed Japanese builders. One of the most astonishing of all such structures, as can be seen on this sixteenth-century fan (222), was the Jesuit church of the Assumption in Kyoto (1576), known in Japan as the *Namban-dera* (Southern Barbarian Temple) and built thanks to the generosity of Japanese Christians.

The China mission was also dear to Jesuit hearts and it inherited the tradition of artistic acculturation begun at Niccolò's academy in Japan. In fact, the Seminary of Painters itself moved to Macao in 1614, and invigorated the artistic life of that colonial city. But the more far-flung missions, in places like Nanjing, Nanchang and Beijing, were also the scene of artistic training and it was on these outer missions that the

222
Kano Soshu,
Jesuit church of the Assumption (Namban-dera),
16th century.
Watercolour;
w.19·7 cm,
7¹⁄₄ in.
Kobe Municipal Museum

greatest blending of styles occurred. One of the finest examples is a *Madonna of St Luke* from the late Ming Dynasty (late sixteenth–early seventeenth century; 223), a large silk scroll painted entirely in a flowing, calligraphic, Chinese style in indigenous watercolours. The model is again a European engraving, or more likely a painting, this time of a thirteenth-century miraculous image of the Madonna in the Roman church of Santa Maria Maggiore. The Chinese artist has lengthened the figure from a bust portrait into a full-length image and although the drapery follows its model exactly in the upper part, he has resolved it at the bottom in a typically Chinese manner. Ending in an elegant and dramatic circular sweep, the outer garment encloses the windswept inner robe, above the figure's delicate bare feet. The long Byzantine lines of the original face have been subtly transformed into Chinese style without adding or subtracting a line. The Christ child, here without his halo but still giving the sign of benediction, has under-gone a similar metamorphosis, complete with shaved head and topknot. This Madonna and Child closely resembles traditional images of the *bodhisattva* of mercy, Guanyin, a figure with a very similar intercessory role in Buddhism, and sources tell us that the two images were frequently merged into one. The picture is remarkable because the artist has adhered so carefully to the original yet made it a completely Chinese image, a transformation comparable to the Japanese *Madonna of the Snows*.

In addition to the many other insights that the Iberian experience in Asia and Africa gives us about colonial Latin America, Asian peoples also allow us a glimpse of how Amerindians may have initially reacted to European art since, unlike the Nahua or Quechua, they actually wrote down what they thought about it. Documents in Chinese, Persian and Japanese tell us that people from diverse parts of Asia reacted to European art in similar ways. Although they did not necessarily find European art aesthetically pleasing – this was certainly the case in China where it was held in disdain – they usually found certain things about it curious and remarkable. First, most people were intrigued primarily by the lifelike qualities of European art. Asians from China to India compared European pictures to mirrors and they frequently commented that European figures looked as

223
Madonna of St Luke,
late 16th–early 17th century.
Watercolour on silk.
Field Museum, Chicago

though they were breathing, moving and occupying real space. The features that interested Asian people the most were the anatomical realism of the human body, the naturalism and humanity of gesture, and the effects of *chiaroscuro* (light and shading). Asian viewers also responded to European art's ability to communicate pathos, psychological insight and mood. Some Asian writers considered these artistic innovations to be universal phenomena that went beyond cultural parameters – once they reached Asia they did not belong to Europe any more than any other technology, whether the clock or the musket.

Unfortunately, we do not have sources like this for the indigenous peoples of Latin America and even if we had them, they would have been produced under European domination and could not have expressed their writers' opinions as freely. Also, although Amerindians adapted quickly and skilfully to European art, they did not do it out of choice as many Asian artists did. As scholars have recently pointed out, European realism owes its success in the Americas to the fact that the colonists and missionaries commissioning the art actively discouraged native visual arts traditions. Those early Nahua maps, with their juxtaposition of two alien systems of representation, suggest that realism had little relevance for many indigenous peoples in the Americas. Perhaps scholars will know one day what the Andean nobles or Nahua chieftains thought of Western pictorial realism, but at the moment there is no choice but to rely on conjecture and to use the art itself as evidence.

Epilogue

Epilogue

On a blistering hot Wednesday morning, with the highest dignitaries of the Church and State in attendance, a remarkable spectacle unfolded inside the basilica of the Virgin of Guadalupe near Mexico City. About 22,000 people swarmed the building as crowds more watched outside from trees, balconies and rooftops, many of them wearing traditional hand-woven shawls and straw hats. To the sound of rattles and conch shells, and scriptural readings in both Spanish and Nahuatl, a procession of dancing Amerindians dressed in feathered Aztec costumes and sombre clerics in their embroidered vestments marched down the nave of the church, celebrating the unity of the Euro-Christian and Amerindian worlds. Nevertheless, this unity felt tenuous. The Church dignitary declared that Christianity took up the essential ingredients of indigenous culture yet purified them, giving them the gift of salvation, while angry Amerindians complained that a painting of the Nahua saint he was celebrating looked too European and the saint's submission to the Church made him a traitor to his people. This contentious scene is not an episode from a Viceregal *entrada* some time in the seventeenth century. It took place on 31 July 2002, on the occasion of the canonization of Juan Diego Cuauhtlatoatzin, the sixteenth-century Nahua who is said to have discovered the Virgin's image in his cloak, and its masters of ceremony were Pope John Paul II and Mexican President Vicente Fox. The canonization of the first Amerindian saint took place almost 200 years after the close of the colonial era, yet it revealed just how much the conflicts, ideologies and culture of the colonial past continue to impact the present.

224
Delilah
Montoya,
La Guadalupana,
1998.
Photo mural;
h.4·27 m, 14 ft.
Museum
of Fine Arts,
University of
New Mexico

The colonial era ended in name between 1810 and 1824. It was not rioting Amerindians who finally brought the Spanish and Portuguese empires to their knees – despite some isolated revolts like that of Túpac Amarú in Peru in 1780–1 – but the wealthy *criollo* establishment. In Spanish America, Spaniards and *criollos* had long felt animosity and

mutual contempt for one another, but the rivalry became especially pronounced in the mid-eighteenth century. The *criollo* feeling of superiority over the Spanish had much to do with their relative prosperity. During the seventeenth century, Latin America was one of the richest places on earth at a time when the Spanish economy was in a serious slump and Latin American visitors to Spain were often appalled at the poverty they saw there. Ironically, *criollo* land-owners and entrepreneurs seized upon the indigenous past as a way of asserting their superiority, legitimizing the antiquity of America and turning Amerindian symbols into nationalist ones. Even *The Virgin of Guadalupe* (see 1) became a *criollo* nationalist symbol in the 1690s, an embodiment of the divine grace and bounty of their homeland.

Relations between the colonies and the motherland already began to worsen with a change in the royal family in 1700. Owing to family connections, the Bourbons who then ruled Spain allied themselves with the much more powerful Bourbons of France in 1762, and Spanish – and Spanish American – culture fell under the spell of Paris and Versailles. The wars that allowed the Bourbons' accession had exhausted Spain's already meagre resources and Spain's support of France further emptied its coffers. As a result, the Bourbons increased their exploitation of the Americas, and they tightened their grip over the colonies by curbing the power of the *criollos*. The Crown stripped the viceroys of some of their power, decreed that *criollos* could not participate in government and imposed a greater number of taxes and duties on them. More significantly, they sent the first permanent battalions of troops to the Indies following the disastrous Seven Years War with Britain (1756–63), when Spain lost Florida. Troops of Spanish soldiers like the Regiment of America, which was stationed in New Spain between 1764 and 1765, earned the deep resentment of *criollos*, who gave them the derisive nickname *gringos* – now used all over Spanish America to denote North American or European foreigners – whilst distinguishing themselves as *americanos*. The Bourbons also struck out at the colonial Church, a major blow to Latin America not only because of the Church's role as an educator and patron of the arts but because it was the financial basis for most

of Spanish America's businesses. The Jesuits were expelled in 1767 owing to anti-Jesuit sentiment at the Spanish court and with them went some of the best universities and colleges. After the French Revolution of 1789, the Bourbons seized fifty percent of the Church's holdings in Latin America.

Portugal inspired similar resentment in Brazil by increasing its hold on the colony. With the discovery of the rich gold and diamond mines of Minas Gerais in the 1690s, Portugal sought closer control over its colony, taking its Royal Fifth from the mines and sending some 600,000 Portuguese and millions of African slaves to exploit their riches before the bubble burst around 1760. The Paulistas, or citizens of São Paulo who had lived in Brazil for generations, were the equivalent of the Spanish American *criollos* and they objected so strongly to these European upstarts that civil war briefly broke out over rights to the mines in 1708–9. It was clear to the Paulistas that Brazil's wealth did little to benefit Brazil, as most of it travelled down the Estrada Real (Royal Road) to Rio and was loaded on to ships for Lisbon. Even Portugal had little opportunity to enjoy these riches, aside from a few palaces and Baroque churches, as Portugal's alliance with Britain in the War of the Spanish Succession (1702–13) obliged them to use their money to purchase British goods, financing Britain's Industrial Revolution. Under the dictatorial minister the Marquis of Pombal (r.1750–77) government monopolies were created to regulate the Brazil trade and the colonial church was further undermined by the expulsion of the Jesuits from Portuguese territories in 1758. The Jesuits were forced to abandon their vast mission territories in the Amazon and elsewhere in the Brazilian hinterland, as well as their flourishing colleges in Salvador, Rio and Olinda.

Independence came quickly to Latin America and the two empires vanished like smoke. The Spanish American colonies were inspired to revolt by the defeat of the Spanish fleet at Trafalgar in 1805 and the seizure of the Spanish throne by French Emperor Napoleon's brother Joseph in 1808. Between 1809 and 1821 various *criollo* generals, some of them educated intellectuals who had studied in

Europe, organized armies and struck out against the Spanish, from Mexico to Argentina. Mexico fell in 1821, eleven years after an idealistic priest, Miguel Hidalgo y Costilla, called for independence in the small town of Dolores. The first South American independence movement began in Chuquisaca (Sucre, Bolivia) in 1809, and in the next decade Simón Bolívar liberated Venezuela and Colombia. In 1822, Bolívar sent Major-General Antonio José de Sucre to Ecuador to vanquish the Royalists at the Battle of Pichincha and in 1824 Peru declared independence following victories by Sucre and Bolívar at Junín and Ayacucho. Argentina's revolution began in 1810 under General José de San Martín, who declared independence in Tucumán in 1816, and also conquered Chile, handing over the reins of power there to an Irishman named Bernardo O'Higgins whose father had served as Spain's viceroy to Peru. By the 1820s, all that Spain had left were Puerto Rico, Cuba and the Philippines, which she would keep until they were seized by the United States in 1898. Despite a utopian attempt by Bolívar to unify independent America into a single state on the model of the United States, the four former colonial viceroyalties were transformed into sixteen separate nations by 1839.

The Napoleonic Wars had an equally weakening effect on Portugal, but in this case the heir to the Portuguese throne (later Dom João VI; r.1816–26) chose to move the royal court to Brazil rather than face the wrath of the French general Junot, leaving the British eventually to recapture Portugal on their behalf. Dom João therefore became the first European monarch ever to set foot on American soil, relieving his viceroy of his duties and settling in the spacious Viceregal Palace in Rio de Janeiro. Brazil's independence was declared not by a *criollo* general but an emperor. Dom João was obliged to return to Portugal for political reasons in 1821, leaving his son Dom Pedro I (r.1822–31) in Brazil. Possessing a flair for dramatics, Dom Pedro proclaimed 'Independence or Death' in 1822 and crowned himself Emperor of Brazil. Since Portugal did not have the energy to retaliate (and Britain might have sided with Brazil if they had), imperial Brazil was able to last another sixty-seven years, mostly under Dom Pedro's more enlightened son Dom Pedro II (r.1831–89).

Art of Colonial Latin America

The Republic of Brazil was declared when a military coup sent Dom Pedro II into exile in 1889, the same year that slavery was finally abolished. All that was left of Portugal's great empire was a handful of Asian and African possessions, which lasted until the 1960s and 1990s.

In the late eighteenth and early nineteenth centuries, the absolutist monarchies of Spain and Portugal had imposed their will on the art world through the royal academies, which were staffed by European professors hand-picked by the Crown and which superseded the guild system that had given Latin American artists a collective voice for over two hundred years. Stylistically, the academies were wedded to Neoclassicism as a symbol of authoritarian rule in much the same way that the early viceroys had used the styles of the Italian Renaissance. The megalomaniac tendencies of this movement can be seen in buildings like the Moneda (see 84) in Santiago or the School of Mines (see 112) in Mexico City, two of the largest buildings ever constructed in colonial Latin America. Yet, ironically, the new republics founded after 1821 chose the same style to symbolize independence, seizing upon its connections with late eighteenth-century revolutionary France and the United States under Thomas Jefferson. Neoclassicism persevered after the overthrow of the monarchy because its association with liberal causes had always been as strong as its links with the absolutism of late Bourbon France. Nevertheless, this new brand of Neoclassicism was no more American than the first. As the new republics founded or refounded their own academies, they continued to favour artists and architects from Europe instead of supporting those from their own nations. Aspiring painters, sculptors or architects from the Americas had to prove themselves by travelling to Europe to study in Paris or Rome, where they earned their reputation by showing their work in public exhibitions such as the Paris Universal Exposition.

In the nineteenth century, Latin American artists were obsessed with creating national styles and they sought inspiration in their nations' history, people and geography. Like the colonial-era *criollos*, many of them found this identity in the pre-Hispanic past a uniquely American antiquity comparable to that of Greece or Rome. But they also sought the national soul by studying the traditions of

Santander.

Yglesia ó Capilla del Rosario de Cúcuta donde se reu-
nió el Congreso admirable de Colombia.

contemporary Amerindians, African-Americans and *mestizos*, driven by an Enlightenment interest in scientific enquiry, a romantic enthusiasm for the exotic and a nationalistic interest in the native origins of their homeland. This spirit of enquiry also extended to the mostly colonial-era villages these people inhabited, so that colonial archi-tecture became indelibly associated with this 'primitive' or 'folk' aspect of national culture. Inspired by European scientists and artists like Alexander von Humboldt (1769–1859) or Johann Moritz Rugendas (1802–1858), who travelled in Latin America at the beginning of the century and recorded the appearance and customs of its inhabitants, Latin American artists established painting movements later known as *indigenismo* and *costumbrista* ('relating to local customs'). Such was the Colombian artist Carmelo Fernández, who between 1850 and 1859 took part in a government survey, painting ethnographic watercolours of his nation's traditional peoples and their villages, including this striking image of the colonial-era church of the Rosario in Cúcuta (1850; 225), a monument which was soon destroyed by an earthquake in 1875. However, works like this also romanticized these people and their world as eternal and exotic, untouched by modernity or the changes of time, and they showed little interest in their opinions or concerns.

225
Carmelo Fernández,
Church of the Rosario in Cúcuta, Colombia,
1850.
Watercolour.
Biblioteca Nacional de Colombia, Bogotá

Latin American artists also looked more directly to the colonial era in their search for a national identity. Even though the period was tainted with the memory of Spanish and Portuguese domination, its heroes were still considered symbols of national pride. Inspired by the grand imperial manner of Napoleon's painter Jacques Louis David (1748–1825), Mexican artist Juan Cordero (1824–84) idolized Christopher Columbus in his history painting *Columbus Before the Catholic Monarchs* (1850; 226), the first painting of an American historical event ever seen by the Mexican public. Columbus is shown presenting his discoveries to King Ferdinand and his queen, Isabella. These include Amerindian figures dressed in skins (one of whom, on the far left, is a self-portrait), a heroic treatment of his subject that turns the first episode in imperial domination into a symbol of nationalist pride for independent Mexico. The artist's self-association with both the indigenous people and their conquerors recalls the viceregal

biombos with their sympathetic portrayal of both sides of the Conquest, and the fundamental identity crisis of the colonial *criollos*.

Although Latin American artists laid increasing emphasis on the negative aspects of colonial history by the end of the nineteenth century, they still looked at it through romantic lenses. Fellow Mexican painter Félix Parra (1845–1919) depicted the savagery of Spanish oppression in his *Friar Bartolomé de las Casas* (1875; 227), a stark image set against a fantasy pre-Hispanic temple, its sculpture resembling that

of ancient Egypt as much as that of the Yucatán. A dead Indian warrior lies on the steps below as his widow, dressed modestly in a skirt and shawl, grasps at the feet of the activist friar, whose rigid stance gives him an architectural permanence that the crumbling ruins lack. Although Parra's canvas portrays the colonial era as the brutal destroyer of the Pre-Hispanic world, his romanticized and adulatory view of the Dominican cleric carries a paternalistic message that would have been right at home in the missions of sixteenth-century New Spain.

226
Juan Cordero,
*Columbus Before
the Catholic
Monarchs*,
1850.
Oil on canvas;
173 × 244 cm,
68⅛ × 96 in.
Museo
Nacional de
Arte (INBA),
Mexico City

227
Félix Parra,
*Friar Bartolomé de
las Casas*,
1875.
Oil on canvas;
3·57
× 2·63 m,
11 ft 8½ in
× 8 ft 7½ in.
Museo
Nacional de
Arte (INBA),
Mexico City

By contrast, many artists evoked the colonial Church as a symbol of superstition and backwardness, in keeping with a general anti-clerical sentiment in independence-era Latin America, where priests were imprisoned and churches were used as barracks or stables by republican armies. Mexican painter José María Jara set his dark and brooding painting *The Wake, or Death of an Indian* (1889; 228) inside a colonial chapel – complete with a gold-framed painting of a saint and an Estípite-Baroque retablo – to emphasize the backwardness of his indigenous subjects, sympathizing with their humility but belittling their piety as naive. Jara communicates his subjects' passiveness through their downturned expressions, and by the oppressive shadow cast over them by the church vaults, suggesting a sinister darkness and superstition at the heart of Catholicism. With artists like Jara, colonial art and architecture became more closely associated with *indigenismo* (the celebration of indigenous life and culture), as they were the trappings of traditional folk life, far removed from the industrialized present. Baroque churches and mission retablos evoked a combination of wistful nostalgia and contempt.

228
José María
Jara,
*The Wake, or
Death of an
Indian*,
1889.
Oil on canvas;
178 × 134 cm,
70¹⁄₈× 52¹⁄₄ in.
Museo
Nacional de
Arte (INBA),
Mexico City

Modernist Latin American artists continued the quest for a national artistic identity and, like their late Romantic predecessors, they found one of its sources in colonial art and architecture. A sense of nostalgia for the colonial and early republican era underlay the work of the Uruguayan lawyer-turned-artist Pedro Figarí (1861–1938). In his focus on domestic and small-town life and his cheerful colours, Figarí has often been compared to the French *intimistes* Édouard Vuillard (1868–1940) and Pierre Bonnard (1867–1947), who painted domestic scenes using bright colours and loose brushwork. Figarí shares with them the goal of using colour and composition to achieve a feeling or mood. Nevertheless, Figarí's subjects are quite different from those of his French counterparts. His favourite themes are the colonial towns and interiors of provincial Uruguay, set in a dreamlike and remote era and inhabited by the gauchos, black *candombe* dancers (a Uruguayan derivation of Brazilian Candomblé) and the bourgeoisie of the late nineteenth century. By using warm pastel colours, painting on cardboard and using a broken, smudged brushstroke, Figarí strove for a naïveté that he believed to be at the core of colonial and early

independence-era culture. For Figarí, these fond glimpses of the past were uniquely Latin American and the collapsing of time that resulted when they were seen by twentieth-century viewers was an echo of Uruguayan reality, 'genuinely reflect[ing] our social life', in his own words. In Figarí's *Dulce de Membrillo* (1920s; 229), named after a quince jam popular in the River Plate region, ladies attended by servants enjoy sweets in the patio of a colonial-era mansion that is so lovingly reproduced that it overpowers the figures. The house is a gracious eighteenth-century building of the kind that once stood in the old town of Montevideo or in smaller villages like Maldonado, with a multicoloured tile dado running around the lower part of

229
Pedro Figarí,
Dulce de Membrillo,
1920s.
Oil on
cardboard;
60 × 80 cm,
23⅝ × 31½ in.
Museo Nacional
de Artes
Plásticas,
Montevideo

230
**Tarsila do
Amaral**,
*Central Railway of
Brazil*,
1924.
Oil on canvas;
142
× 126·8 cm,
56 × 50 in.
Museu de Arte
Contemporânea
da Universidade
de São Paulo

the walls, pink whitewash, an elegant arcade, wooden balustrades above and a wall shrine to the Virgin Mary. The painting offers a sense of the resilience of the almost liturgical rituals of domestic life.

The Brazilian painter Tarsila do Amaral (1886–1973), who studied with Fernand Léger (1881–1955) in Paris and was one of the founders of the Modernist movement in Brazil, became fascinated with the dichotomy between primitive and modern in Brazilian culture, juxta-posing colourful tropical landscapes and Afro-Brazilian figures with ordered, machine-like geometric shapes. After a journey in 1924 to the Baroque mining towns of Minas Gerais with her husband Oswald

de Andrade, Tarsila began to incorporate colonial churches (see 28) into her landscapes of Brazilian towns and *favelas* (slums), as in her *Central Railway of Brazil* (1924; 230) or *The Fruit Seller* (1925), where their twin towers and curving pediments lent a picturesque detail to the background. In *Central Railway of Brazil*, she contrasts the rich tropical vegetation and baroque architecture of the traditional Brazilian landscape with the trappings of modern industrial life, such as the railway signals and telegraph poles of the foreground. Tarsila considered these churches to be an inseparable part of the traditional village life she celebrated, linked both to the land itself and to its inhabitants, and they helped her achieve her goal of illustrating a specifically Brazilian reality.

This connection between colonial art and *indigenismo* also informed the work of Mexican painter Frida Kahlo, who evoked colonial painting traditions as a way of exploring a nationalist spirit called *Mexicanidad* (Mexicanness), as well as her own personal affinity with the indigenous people of her country. Kahlo was keenly interested in Mexican folk art, particularly painted tin retablos and ex-votos of the colonial

231
Francisco
Ríos,
*St Veronica of
Juleanis*,
18th century.
Oil on copper;
43·2
× 33·2 cm,
17 × 13 in.
Museo
Nacional del
Virreinato,
Tepotzotlán

232
Frida Kahlo,
*Self Portrait with
Loose Hair*,
1947.
Oil on
masonite;
86·3
× 117 cm,
34 × 46 in.
Private
collection

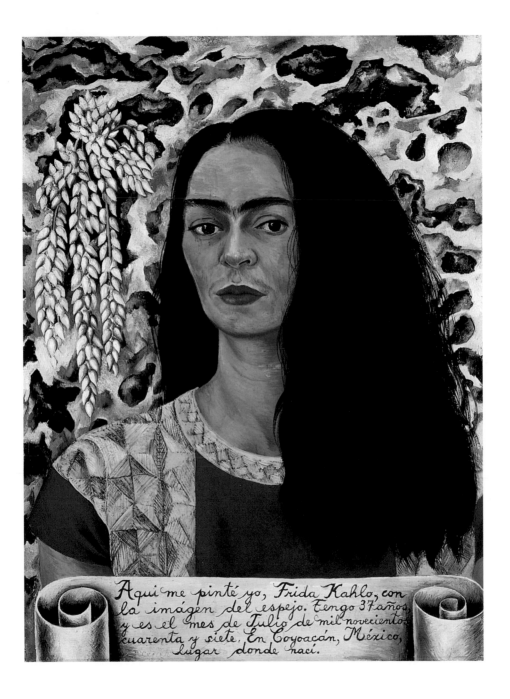

Aqui me pinté yo, Frida Kahlo, con
la imágen del espejo. Tengo 37 años,
y es el mes de Julio de mil novecientos
cuarenta y siete. En Coyoacán, México,
lugar donde nací.

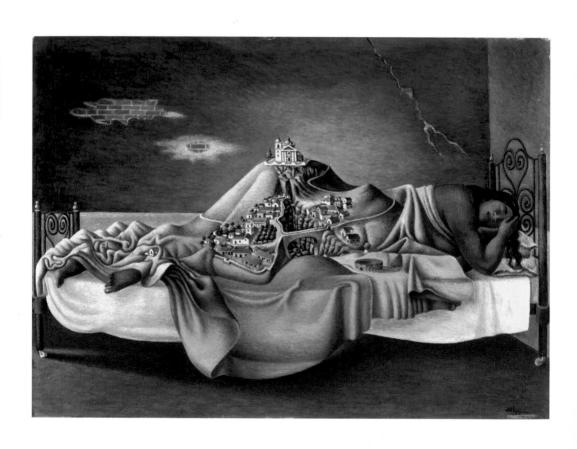

and independence era (231). Retablos usually featured a brightly coloured image of a saint and were kept for private devotion in the home, while ex-votos, narrative scenes showing averted disasters complete with explanatory texts, were left as offerings of thanksgiving in shrines. Kahlo collected both kinds of painting, which she kept in her colonial-style Casa Azul in the Mexico City neighbourhood of Coyoacán. In her *Self-Portrait with Loose Hair* (1947; 232), which was based on a saint's portrait like the eighteenth-century copper painting of *St Veronica of Juleanis* by Francisco Ríos (see 231), she substitutes her own bust portrait for the image of a female saint and records the month and year in which she painted it in a scroll below, using the language and writing style of her colonial-era model to create an almost hagiographic statement of identity. Her peasant costume enhances the painting's ties with the traditional life of Mexico.

233
Antonio Ruiz,
*The Dream of
Malinche,*
1939.
Oil on canvas;
30 × 40 cm,
11 ⅞ × 15¾ in.
Galería de Arte
Mexicano,
Mexico City

Kahlo was not the only Mexican artist of her time to turn to folk retablos for inspiration. The Surrealist painter Antonio Ruiz ('el Corzo'; 1897–1964) also drew from these relics of the colonial past to explore Mexican identity in his paintings. In other works he went further, re-examining the very landscape of the colonial world. Such was the remarkable painting he exhibited at the Mexican Surrealist Exhibition of 1940 called *The Dream of Malinche* (1939; 233). An essay on the *mestizo* nature of Mexican society, it shows the Nahua concubine of the conquistador Cortés asleep on a bed, her body representing the land of Mexico itself as her blanket becomes a hilltop town complete with whitewashed houses with red tile roofs, a leafy plaza and a bullring. The very top of this 'hill' is crowned by a colonial church, whose position and appearance are strongly reminiscent of the church of Nuestra Señora de los Remedios in Cholula (see 117), built, as we have seen, on top of the largest pyramid in the Aztec world. El Corzo's painting is a memorable statement of the *mestizo* essence of Mexican society.

Nevertheless, for most of Kahlo's contemporaries, the colonial era was anathema. Her husband, the painter Diego Rivera (1886–1957) celebrated the pre-Hispanic past and indigenous present in the propagandistic public murals he started painting in the early 1920s

234
Diego Rivera,
Creation,
1922–3.
Mural.
National
Preparatory
School,
Mexico City

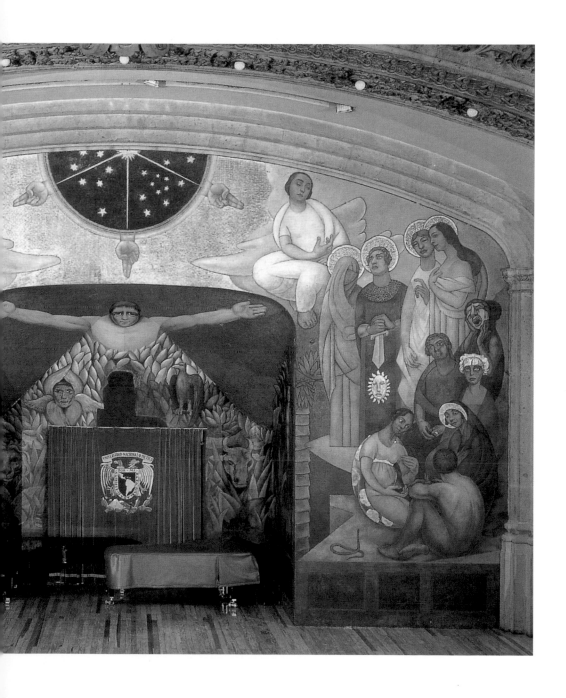

for the Mexican Minister of Education José Vasconcelos, but he depicted the conquistadors and colonial-era clerics as a regime of terror, with exaggerated, cartoon-like features and hunchbacked poses. Nowhere is this approach more apparent than in his *From Conquest to 1930* in the Palacio Nacional (formerly Viceregal Palace), a vast panorama of human misery in which Spanish soldiers hoard money and missionaries beat and torture Amerindians. However, in choosing large-scale mural painting, Rivera turned to a medium that was associated with the goals of the very Catholic Church he so sharply criticized. Rivera even borrowed Catholic imagery for his paintings, such as the haloed angels and Christ-like figure in his *Creation* (1922–3; 234) in the National Preparatory School in Mexico City. Although his paintings owe more to Byzantine icons and Italian Renaissance frescos than they do to actual colonial-era painting traditions, Rivera had the same faith in the didactic potential of public murals as the sixteenth-century friars who commissioned the wall-paintings at Malinalco or Acolman (see 46).

Colonial art resurfaced in a more positive light in the second half of the twentieth century in the work of the Colombian painter and sculptor Fernando Botero (b.1932), who anticipated a European Postmodernist trend of quoting self-consciously from art history. In the 1960s and 1970s, Botero developed a form of figural painting that referred to the Baroque painters Diego Velázquez (1599–1660) and Peter Paul Rubens as well as colonial Latin American painting from Cuzco and Bolivia, featuring figures of an exaggerated plumpness that evoke what the artist refers to as an 'imaginary reality' and an interest in 'formal fullness'. Like Tarsila or Kahlo before him, Botero sees colonial art as a crucial ingredient of national identity. In *Our Lady of Colombia* (1967; 235), the artist fuses sacred and secular in an exploration of the gap between those two worlds in today's society. A rotund Virgin and Child, inspired by the Andean Madonnas of the eighteenth century (see 47), stands in front of an aureole adorned with roses and four Colombian flags. In her right hand she holds the scapular (a badge for a lay confraternity or third order) and in the left she embraces a small infant Christ child, who holds his own Colombian flag in addition to the orb of the Salvador Mundi (Saviour of the World). Down below,

a presidential figure in a bowler hat and a cardinal in his mitre vie for the viewer's attention, suggesting the harmony – or rivalry – of Church and State. Botero also painted colonial-inspired images of Christ, St Rose of Lima and several series of angels paying homage to the archangels in the churches of Highland Peru and Bolivia (see 110).

Botero is one of many Latin American painters of the decades that followed the 1960s who rejected the tenets of Modernism and sought inspiration in the sixteenth- and seventeenth-century Spanish 'Golden Age' artists, such as Velázquez, El Greco, Ribera and Zurbarán.

236
Luis
Caballero,
Untitled,
1989.
Oil on paper;
190 × 130 cm,
74⅛ × 51⅛ in.
Private
collection

237
Alberto
Gironella,
The Black Queen,
1961.
Mixed media
on canvas;
206 × 115 cm,
81 × 45¼ in.
Private
collection

Luis Caballero (1943–96) from Colombia and the Mexican Alberto Gironella (b.1929) replicated the '*mestizo*' character of Latin American society (the word usage is Botero's) by exploring these Spanish Renaissance and Baroque models from a Latin American perspective. Although the models are not, strictly speaking, colonial art, the artists used them to approximate the cultural blending that created it. Caballero's intimate studies of the male nude, which are often frankly erotic essays on homosexuality and are marked by the violence which has torn his country, recall Ribera's anguished poses, dark settings and highly

textured skin tones, while also evoking colonial art. His stark and moving *Untitled* (1989; 236) features a partially nude and bound man lying next to a mysterious figure who can barely be made out in the background, but who seems to be sprinkling holy water or incense over the body according to a religious rite. The tortuous pose of the body and the painting's dark tonality recall at once the art of 'Golden Age' Spain as well as the British painter Francis Bacon (b.1909). It evokes an extreme emotional state that combines agony with ecstasy in a way that would have been familiar to Baroque viewers. If Caballero's work

238
José Gamarra,
*Encounter with
Conquistadors*,
1989–90.
Oil on canvas;
150 × 150 cm,
59 × 59 in.
Private
collection

evokes pathos, Gironella's studies of Velázquez' royal portraits are biting parodies of colonialism and its legacy. Paintings such as *The Black Queen* (1961; 237), a ghoulish paraphrase in negative of Velázquez's *Mariana of Austria* (1652), seems to mock its model, yet it allows the figure to preserve her dignity and aristocratic demeanour. The Mexican writer Octavio Paz has remarked about Gironella's work that 'his critique is indistinguishable from devotion and devotion from vengeful fury'.

Other contemporary Latin American artists quote from colonial art more directly, like Botero, but they rarely do so uncritically. José Gamarra (b.1934) of Uruguay, who has lived in Paris since 1963 but spent some influential years in Brazil, specializes in a kind of panoramic jungle landscape that draws upon the work of Frans Post (1612–80), a Dutch artist who visited Brazil in the seventeenth century when the Netherlands had occupied much of the north and recorded its natural wonders in a series of romanticized landscapes. Gamarra

239
Germán Venegas,
The Grandmother,
1991.
Mixed media
and wood;
180 × 122 cm,
70⅛ × 48 in.
Private
collection

has said that the jungle landscape is the only one that is universally recognized as intrinsically Latin American. For Gamarra, these land-scapes are not meant to be scenes taken from life, but are a matrix that he populates with a symbolic language of figures and other images, sometimes taken from children's toys. In *Encounter with Conquistadors* (1989–90; 238), the Post-like landscape provides a disturbing setting for conquistadors encountering Indians in the jungle, while a toy-like helicopter hovers ominously above. Paintings like this play

with the theme of the meeting of two cultures, and their contrasts recall that contemporary Latin American society was born through the exploitation of the natural and indigenous world.

An intimate and personal encounter with colonial art characterizes the wooden sculpture of the Mexican Germán Venegas (b.1959). In a recent series of work the artist has carved figural images from the wood of an ancient ahuehuete tree given to him by the villagers of his birthplace, La Magdalena Tlatlahuquitepec (Puebla), on the condition that he also carve religious statues for their church from the same tree. The material of the tree is important to Venegas, who feels that his figures have been fossilized in the wood over the centuries and represent different epochs, including the pre-Hispanic, colonial and present, both living and dead. The resulting sculptures, mounted on boards and lightly painted, often evoke the religious statuary of colonial parish churches and processions. His *The Grandmother* (1991; 239), in which ghostly, mummy-like figures seem to emerge from the panel, was inspired by the Holy Week statues made in the Mexico City district of Iztapalapa, which his family helped dress during his youth. The figures have an angularity very reminiscent of traditional colonial Passion figures (see 147) and the human hair of much colonial sculpture.

Central and South Americans were not the only ones to revisit colonial Latin American art and architecture in the nineteenth and twentieth centuries. The United States was itself heir to large tracts of the colonial Latin American world thanks to conquests and treaties, and its colonial history and culture played a powerful role in the American imagination, inspiring a similar combination of loathing and wistful nostalgia. In the earliest years of the republic, Anglo-American commentators promoted a derogatory view of colonial Latin America now known as the 'black legend', which saw Spanish American culture as tainted by absolutism and Catholic superstition, and its people as decadent and lazy – a perfect foil, as it happened, for the liberty, Protestantism and rationalism that were being championed as Anglo-American values. However, at the same time that American historians and politicians were promoting the 'black legend',

nineteenth-century Romantic writers Washington Irving and Henry Wadsworth Longfellow were painting a more sentimental picture of Spanish and Spanish American colonial culture, seeing it less as an embodiment of evil and more as the expression of a picturesque and 'timeless' place inhabited by exotics.

These romantic views helped inspire an interest in Spanish colonial architecture in California and the American southwest in the late nineteenth and early twentieth centuries, focusing on the Franciscan missions built there between 1769 and 1823. Although the first Anglo travellers to California saw these crumbling buildings as relics of oppression and superstition, by the 1860s property developers and railway companies were seizing upon them as reminders of an exotic European past and a Californian equivalent to the English

210
Burrage House,
Redlands,
California,
USA,
1901

colonial architecture of the east coast. All that was needed to bring this sentimental view to life was a story and the New England author Helen Hunt Jackson provided one with the riveting and extraordinarily popular *Ramona* (1884), a romantic novel set against the landscape of the California missions. Her loving and melancholy descriptions of the adobe walls, arcades and bell towers of the missions and colonial haciendas of California immortalized them in the American imagination. Soon people began efforts to preserve California's missions, first in a heavy-handed manner in the 1890s, and then more scientifically in the 1920s and 1930s. To this day the Spanish colonial missions rank among California's most popular tourist destinations and they have become such an important symbol of Californian history that nearly every fourth grader (nine-year-old) in the state studies mission history.

A similar shrine-like status has been granted to the eighteenth-century Franciscan missions near San Antonio, Texas. One in particular has earned a permanent place in the American imagination – although few realize that it was a colonial church. The mission church of San Antonio de Valero (begun 1724), the site of a crucial siege in the 1835–6 Texas Revolution, has been immortalized as the Alamo, a symbol of Texan liberty.

Beginning in the 1890s, American architects began to revive Spanish colonial styles, particularly in California and the southwest. With

names like 'mission', 'Spanish eclectic' or 'Monterrey' these new architectural fashions featured red tiled roofs, quatrefoil windows, elaborately carved doors and mixtilinear parapets. Although their models were almost exclusively religious buildings, architects mostly employed these styles for domestic structures, ranging from simple bungalows to train stations and resort hotels. One of the most extravagant was Burrage House (240) in Redlands, California (1901), a complete mock colonial mission with its twin bell towers

and arcaded wings. Following California's lead, some Latin American countries also introduced neo-colonial architectural styles between the 1910s and the 1940s – most notably Peru, with such extravagant buildings as the lavish Bishop's Palace in Lima (1916) and the reconstructed Plaza de Armas – and 'California'-style houses proliferated throughout Latin America.

American painters were inspired by the romantic nostalgia of Spanish colonial architecture in much the same way as their Latin American counterparts. The most celebrated was Georgia O'Keefe, who became enchanted with the churches and wooden crosses of New Mexico after she began spending summers there in 1929. In works such as *Taos Church, New Mexico* (1929; 241) or *Black Cross, New Mexico* (1929), O'Keefe explored what she felt were these structures' eternal nature and their links with the landscape. Like Tarsila and Kahlo in Brazil and Mexico, O'Keefe saw Latin American colonial art as an inseparable aspect of indigenous identity and she believed that these buildings could represent Amerindian suffering. One noteworthy feature of North American revivals of Spanish colonial arts in general, was that they focused on architecture and non-figurative art (unlike Kahlo's retablos or Botero's Virgins), demonstrating perhaps a Protestant distaste for Catholic iconography.

241
Georgia
O'Keefe,
Taos Church,
New Mexico,
1929.
Oil on canvas;
61·3
× 91·8 cm,
24⅛ × 36⅛ in.
Phillips
Collection,
Washington,
DC

A very different revisiting of Latin American colonial art has been taking place since the 1960s among Americans of Mexican heritage known as Chicanos/Chicanas. Chicano art, which developed out of a labour activist movement and was inspired by the murals of Diego Rivera and his contemporaries, seeks to create a visual identity for Latinos living in the United States and also emphasizes social and political commentary. Although the California mission churches appear here too, Chicano art has focused much more on religious iconography. By far the most prominent image is the Virgin of Guadalupe, who makes regular appearances in the public murals of Los Angeles and San Francisco as a symbol of affinity with the Mexican homeland and of the disjunction between religious and secular life, as seen in this mural by Mario Aguirre Uriarte, *Five Hundred Years of Indigenous Struggle* (1990; 242), at an immigration centre in

Los Angeles. She also appears in works like Delilah Montoya's photo mural *La Guadalupana* (1998; see 224), an altar-like composition featuring a photograph of a shackled prison inmate with a giant tattoo of the Virgin on his back (he was later executed). The inmate is depicted as a captive – perhaps evoking a Catholic penitent – but the image on his back also invites the viewer to genuflect before him, turning the devotee into a martyr-like icon himself. A statement about gang violence and the marginalization of contemporary Latino society in the United States, Montoya's composition also underscores the role

of traditional faith in the Chicano community. Many Chicano artists have explored the home altar and yard shrine format as an expression of personal and cultural memory, power, feminism and identity, focusing on traditional forms such as the offering, retablo and niche.

Latin American colonial art has also resurfaced in American popular culture. In the post-World War II era, following the lead of the romantic writers of California, colonial architecture frequently made an appearance in Western novels and films such as John Sturges'

The Magnificent Seven (1960; 243), a fast-paced action picture featuring Yul Brynner and Steve McQueen and filmed on location in front of an imitation eighteenth-century parish church in Morelos, Mexico. Mission churches, *presidios* (border fortresses) and haciendas frequently lent an exotic flavour to these dramas, often as a decadent or romantic foil for the clapboard farms and schoolhouses of their Anglo Protestant heroes. In the 1980s, the Taco Bell chain of fast food restaurants turned the *espadaña* bell tower into a corporate logo, as familiar in North America today as the golden arches of McDonald's. Rock musicians have also helped give Latin American colonial arts a place in contemporary culture. The Eagles' song 'Hotel California' (1976), set in Baja California (as much a classic today as *Ramona* was a century earlier), begins with a description of a mission bell ringing. In the early 1990s

242
Mario Aguirre
Uriarte,
*Five Hundred Years
of Indigenous
Struggle*,
1990.
Acrylic on
canvas.
One Stop
Immigration
and
Educational
Center,
Los Angeles,
USA

243
Still from
*The Magnificent
Seven*,
1960

pop singer Madonna began collecting Frida Kahlo's paintings, not only helping to turn the Mexican artist into an overnight sensation, but also creating a mania for the retablos and other Latin American religious icons Kahlo herself found fascinating. The fad for iconic refrigerator magnets and do-it-yourself altar kits inspired by Madonna, and later by the 2002 Hollywood film of Frida Kahlo's life starring Salma Hayek, also enjoys a dialectical relationship with Chicano art, which itself thrives on blurring the boundaries between 'high' and 'low' art.

Most recently, colonial Latin American art and architecture – in particular, concepts like 'Baroque' and 'Ultrabaroque' – have provided artists with a theoretical metaphor for Latin American

Modernism and Postmodernism. This process began in Brazil in the heady days of the early 1960s, when Lúcio Costa (1902–1998) and Oscar Niemeyer (b.1907) designed the cathedral (244) and palaces of Brazil's new capital at Brasília (completed 1962), an idealistic city built from scratch in the dusty outback of Goiás on the orders of President Juscelino Kubitschek. Although Brasília was a Modernist urban manifesto, its symmetry and theatrical vistas were inspired by the great Baroque cities of Europe. Together with the art historian Leopoldo Castedo, who wrote a book in 1964 called *The Baroque Prevalence in Brazilian Art*, Brasília's architects and planners believed that the Baroque lay at the heart of Brazilian Modernism, part of a collective national predisposition towards sensuality, the curve, hybridity, drama and untutored expressive freedom that derived from its colonial heritage. The soaring buttresses of Brasília's cathedral pay homage to Baroque architecture not only through their curves, but also through their emphasis on the ornamental potential of structural elements. These notions continue to inspire artists and art theorists in Brazil today. The 2001–2 *Brazil: Body and Soul* exhibition at the Guggenheim was based on the premise that Baroque arts are at the 'deepest roots of Brazil's nationalist artistic identity' and the catalogue goes to great pains to draw links between colonial, Baroque culture and the artistic world of the late twentieth and early twenty-first centuries.

The affinity between the Baroque and Postmodernism inspired an exhibition organized in 2000–3 by the Museum of Contemporary Art in San Diego, which travelled to various locations in the United States of America and Canada. Entitled *Ultrabaroque: Aspects of Post-Latin American Art*, the show featured the work of fifteen contemporary Latin American artists from six different countries who explored the Baroque as a source of cultural identity and an analogy for their own work. The artists featured in *Ultrabaroque* revive the idea of the Baroque in negative and positive ways. Although some artists make deliberate references to colonial art, like the Brazilian painter Adriana Varejão (b.1964), whose juxtapositions of Portuguese blue-and-white tiles and human entrails such as *Carpet-style Tilework in Live Flesh* (1999; 245) send a quite literally visceral message about the cruelty and hypocrisy

**244
Oscar
Niemeyer**,
Cathedral,
Brasília,
completed
1962

of the colonial regime, most of the artists use the Baroque as an overarching cultural metaphor. They acknowledge that the Latin American Baroque was the product of a civilization very similar to ours today, with the same tangled web of cultural traditions. They feel an affinity with its willingness to unite different art forms into a whole, and its ability to merge aspects of the sacred and secular, as well as 'high' and 'low' art – features which resonate especially strongly in the early twenty-first century. However, in the final analysis, it is Baroque's expressive exuberance that appeals the most, an intuitive creativity reflecting the aspirations of generations of Latin American artists and architects and giving their culture a uniqueness that is once again being explored and celebrated in all its cross-currents and contradictions.

245
Adriana Varejão, *Carpet-style Tilework in Live Flesh*, 1999. Oil, foam, aluminum, wood and canvas; 150 × 191 × 25 cm, 59 × 75¹⁄₄ × 9⁷⁄₈ in. Museum of Contemporary Art, San Diego

Glossary

Amanteca Feather painters from New Spain. The **Nahua** name *amanteca* derives from the neighbourhood of Amantla in Tenochtitlán where most of them lived under the Aztecs.

Atrium Cross A prominent stone cross elevated on a stepped platform placed at the centre of the atrium in front of mission churches in New Spain. Instead of depicting the full *Crucifixion*, with the body of Christ on the cross, atrium crosses are usually adorned with a series of glyph-like symbols of the Passion, sometimes with Christ's face appearing in the centre, and they are occasionally carved to resemble tree branches. The effect of having Christ appear to be inside the cross may relate to pre-Hispanic belief in the World Tree, a tree that served as a place of origin for humanity and as a link with the underworld.

Audiencia A royal tribunal in the Spanish empire that held authority independently of the Viceroy. They combined the role of a court of appeals and a cabinet council, and were given many political and administrative powers. An *audiencia* also refers to a geographical sub-division of a viceroyalty under the authority of these tribunals, which their leaders sometimes ruled as governor or even captain-general. In the late sixteenth century, in addition to the two viceroyalties of New Spain and Peru, there were three *audiencias*: Guatemala, Santo Domingo and Santa Fé de Bogotá.

Aymara Amerindian people of the south central Andes. Possibly descended from the Tiahuanaco civilization, the Aymara were conquered by the Incas and incorporated into their empire. The Aymara language is still commonly spoken in the provinces of Arequipa and Puno in Peru and La Paz in Bolivia.

Backstrap Loom The primary traditional loom used in the Andes and elsewhere in the Americas, made of a series of loom bars. The uppermost bar is attached to a fixed object such as a tree using a cord and the lowest bar is attached to a belt worn by the weaver. The weight of the weaver and her backwards pressure against the loom pulls the warp threads taut.

Baroque A European and Latin American historical period and artistic style which is generally dated from c.1590 until c.1750. Its origins are associated with the resurgence of Catholic culture following the crisis of the Protestant Reformation and the Counter Reformation. The style placed particular importance on theatricality, visual allure and its ability to elicit an emotional response from the viewer. It originated in Rome with painters such as Caravaggio (1571–1610) and Annibale

Carracci (1560–1609), and gained greater confidence in the mid-seventeenth-century with the work of painters such as Pietro da Cortona (1596–1669) and sculptor/architects such as Gianlorenzo Bernini (1598–1680). By the first decade of the 1600s, the style was already international, spreading to Spain, France, Holland and elsewhere. Baroque reached Latin America in the mid-seventeenth century. In architecture, Baroque differs from **Renaissance** style through an increased interaction of structural forms and by a greater love for ornament and fanciful shapes – especially **mixtilinear** forms. Baroque architectural ornament is also more three-dimensional and stands out more dramatically in profile than Renaissance precursors.

Basilica Plan A church plan of Early Christian derivation featuring a long rectangular nave and three or five aisles. In Latin America, many of the first generation of churches used the basilica plan because it was reasonably simple to build and also because it served as a symbol of the Early Christian period, considered a golden age by Catholics.

Batea A polychrome lacquered wooden tray made predominantly in Michoacán (New Spain), in the towns of Pátzcuaro, Uruapan and Periban. *Bateas* were greatly esteemed as decorative accents in the homes of the wealthy during the colonial period.

Biombo Large painted folding screens adorned with landscape and urban scenes and sometimes inlaid with mother-of-pearl, ivory and gold. They derived from a Japanese screen called a *byobu*. *Biombos* were either done in oil on canvas or as **enconchado** paintings executed on a wooden panel with mother-of-pearl inlay. Although primarily Mexican in origin, painted *biombos* were also made in Central America and Spanish South America.

Cabildo The municipal council in the viceregal capital, presided over by the viceroy. The term also refers to the building in which the council met. Every sizeable town in Spanish America also had a *cabildo*, equivalent to a town hall.

Candomblé In Brazil the term refers to a syncretic religion of African origin introduced by slaves from the Yoruba, Nago, Jeje and other West African peoples. The faith preserves traditional African rites behind a veneer of Catholicism. The Yoruba word Candomblé denotes a dance in honour of the gods. The faith is characterized by ceremonies featuring dancing and chanting. According to Candomblé, every believer is protected by a personal *orixá*, or god. Candomblé is most

prevalent in Bahia, but versions exist under other names in other parts of Brazil (in Pernambuco it is called Xangô).

Captaincy General The name of a subdivision of a Viceroyalty in Spanish America presided over by an official called a captain-general. By the end of the colonial period there were two captaincy-generals in South America: Venezuela (1773) and Chile (1778).

Cacique A term of Caribbean origin used generally throughout the colonial period to refer to an indigenous leader. On missions, *caciques* were elected by the missionaries to serve as temporal administrators to the mission communities.

Calmecac A type of Aztec university. Located near the main temple in each district, the *calmecac* would instruct the sons of the ruling and religious élite in history, astrology and religion, as well as the art of picture writing.

Casta Paintings A kind of painting in vogue in eighteenth-century New Spain, but which also existed in Spanish South America. Usually produced in sets of sixteen, they categorized the ethnic subdivisions of colonial society with zoological precision. Typically, each *casta* painting depicts a man and a woman of different races with one or more of their offspring. The scene is accompanied by a label identifying the resulting racial mixture.

Catafalque A temporary monumental funerary structure erected inside churches to commemorate the death of a monarch or other important figure. Typically, they combined Classical architectural features such as columns and pediments with paintings and plaster sculptures depicting allegories of the royal person.

Classical orders The components of Greco-Roman temple architecture, revived in the Italian **Renaissance** and from there disseminated throughout Spain, Portugal and Latin America in the sixteenth century. There were originally three orders and later five, including the Tuscan, Doric, Ionic, Corinthian and Composite. The orders can be identified by differences in the capitals (the crowns) of the columns and in the entablatures (the horizontal element above them). The structural elements of a Classical order also included columns, pilasters (flat, rectangular column-like structures embedded in the wall), and pediments (the triangular or semicircular cap to a façade, derived from Greek temples). The classical orders were not only used in Renaissance architecture, but were the basis of **Baroque** and **Neoclassical** architecture as well.

Confraternity A lay religious organization. Of medieval origin, confraternities were founded to provide support for their members, par ticularly by providing funeral rites. They also provided financial support for death, sickness and natural calamities, fellowship through social gatherings such as meals and communal prayer, and helped resolve disputes among their members. They helped the poor through almsgiving, and mounted parades during their saint's day. Confraternities were often trade-related, so that there were confraternities of artists and architects, and they also gave a collective voice to non-European peoples such as Amerindians and blacks. Women's confraternities, known in Latin America as *sodalidades* (sodalities) provided one of the only collective organizations for women outside the convent. The confraternity was also one of the leading arts patrons in colonial society.

Convergence When two different cultures make use of a single symbol while allowing it to maintain its dual meaning.

Corpus Christi, Feast of The festival celebrating the institution and gift of the Holy Eucharist, held on the Thursday after Trinity Sunday (following Easter). As the celebration tended to fall in May or early June, its timing in Andean countries roughly coincided with the Inca Inti Raymi summer solstice festival and with pre-Hispanic harvest feasts. The event was particularly developed in later seventeenth-century Cuzco, where it was marked by elaborate processions involving indigenous groups dressed in traditional costume, and these groups used it as a way of reconstructing their identity as rightful heirs to the Inca past.

Criollo (pronounced 'cree-o-yo') A person born in America of European ancestry. It is *not* equivalent to the English term 'creole', which can refer to a person of mixed European and African parentage.

Encarnadura The creation of flesh tones on wood sculpture and sometimes painting. Specialist artisans called *encarnadores* sanded the surface of the head and hands of sculptures and applied a plaster and glue mixture. Once dried, this was painted with a coat of oil paint over white lead in lifelike tones and varnished for brilliancy. In the sculpture workshops of Quito, sometimes a lead or silver mask was applied to the face first, before painting, to enhance the lustrous shine.

Encomienda The infamous forced labour system introduced by Christopher Columbus in Hispaniola in 1499, and later applied throughout Spanish America. In a procedure similar to feudalism, Spanish colonists were given tracts of land called *encomiendas*, which included the people already living on them. Where the indigenous people were nomadic, they were forcibly settled into towns, a policy made official in the Laws of Burgos (1512–13). The indigenous community was assigned to this colonist as labourers for the long term in return for spiritual guidance, protection and a small wage. The system was largely phased out by the end of the seventeenth century.

Enconchado A type of painting on wooden panel popular in seventeenth- and eighteenth-century New Spain that is accented with shell and mother-of-pearl inlay. *Enconchado* paintings were done in imitation of the inlaid boxes and furnishings of seventeenth-century Japan,

although their subject matter tended to depict Mexican or biblical themes.

Entrada In Spanish America, the term refers to the official entrance of a new viceroy to his new post. Replete with allegories about the colony's ties with Spain, the conquistadors and the indigenous communities, *entradas* combined processions, musical and theatrical performances, liturgical celebrations, bullfights and speeches. In general, they tried to follow the route taken by the first conquistadors in an attempt to underscore the Spanish authority. They were also very frequent, as viceroys served for multiple terms of three years.

Espadaña A church bell tower formed of a single wall, usually with a curved profile, with one or more pierced openings. It is usually attached to the front or side of the church, but sometimes it forms part of a wall surrounding the church compound.

Estípite-Baroque An elaborate variety of late **Baroque** or **Ultrabaroque**, it is an architectural style prevalent in New Spain and Central America in the last three-quarters of the eighteenth century. It is mostly apparent on façades, doorways and **retablos**. Its main component is the *estípite* column, a pilaster that tapers towards the base like an upside-down pyramid. In general, the style is characterized by a breakdown and multiplication of the structural elements, so that they appear no longer to be functional but merely decorative. They give the overall composition a less focused and weightless appearance. The style is also accompanied by an increased use of colour, particularly in New Spain.

Estofado The creation of textile patterns on the costume of wooden sculpture. Once the work of the carver is done, and after the statue is covered with a coat of plaster, the costume areas are covered in gold leaf, which is then burnished to a brilliant shine. Next, the painter covers the gilt areas with paint of different colours and patterns, and uses a sharp stylus to carve decorations into it, allowing the gold to re-emerge from underneath. The effect is of richly embroidered gold brocade fabric.

Gothic An international medieval style originating in France whose architecture was characterized by pointed rib vaults and delicate tracery windows, and whose wooden sculpture and painting achieved a startling realism using bright polychrome colouring. The earliest buildings, sculptures and paintings in the Americas (early to mid-sixteenth century) were executed in the Gothic manner, sometimes blending with forms taken from **Renaissance** or **Plateresque** style. Flanders was one of the cultural capitals of the late Gothic, and it had a particularly powerful influence over Spain and Portugal.

Guaraní A semi-nomadic Amerindian people from Paraguay. The **Jesuits** resettled the Guaraní on to **reductions** between 1609 and 1767, where they developed a syncretic form of life, blending European Catholic traditions with indigenous ones. The Guaraní were extremely skilled sculptors and masons. They left a substantial legacy of religious imagery, itself echoing the sacred world of Guaraní religion.

Hacienda The Spanish term for ranch, prevalent in Mexico, Peru, Chile and elsewhere. In Argentina they are usually called *estancias* ('estates'). In Brazil, the two most common terms used for a ranch are *fazenda* and *quinta*.

Huaca Quechua term for a sacred place or thing. Andean worship focused on natural phenomena like thunder and rainbows as well as terrestrial forms called *huacas*, which could be rocks, hills, springs or caves, as well as built structures such as shrines or fountains. Under the Inca, *huaca* came to refer more generally to sacred icons.

Inquisition The investigative office of the Catholic Church concerned with the detection and punishment of heresy. In Spain it took on a new form in 1478, when the monarchy was permitted to set up a new Inquisition under royal authority to administer to their territories. Portugal also had its own Inquisition, under royal jurisdiction. The Inquisition was first established in the Americas in Lima (1569), followed by Mexico City (1571) and Cartagena (1610). It was briefly abolished between 1808 and 1814, and disappeared entirely with Independence in the 1820s. Although the Inquisition was never formally established in Brazil, the Portuguese Inquisition regularly sent commissaries there from 1591 onwards. Contrary to popular belief, the institution had no jurisdiction over non-converted Amerindians and even indigenous and African Christians were punished less frequently and more leniently than their Spanish, *criollo* and *mestizo* counterparts. The main focus of the Inquisition was people of European descent, particularly those accused of Protestantism, Freemasonry, and converted Jews and Muslims. These people were tried and often tortured and publicly burned at the stake for deviation from Catholic norms. Often the trials were trumped up to gain more wealth for the inquisitors.

Jesuits A religious order of priests and brothers founded by Ignatius of Loyola in Rome in 1540. The Jesuits differed from other orders in that they were not obliged to meet regularly as a community to chant the Office, giving them greater independence to engage in practical activities. The Jesuits quickly became the leading education and missionary order of the Catholic Church, founding universities and colleges around the world and establishing missions in more remote regions than any of their predecessors. They were especially known for adapting to indigenous ways, a methodology that they borrowed from the Franciscans, and it helped them gain access to remote areas. The first Jesuits reached the Americas in Brazil in 1549 and they reached Spanish America in Peru in 1567.

Kiva A religious and community structure used by the Puebloan and proto-Puebloan peoples of New Mexico. A kiva is usually a flat-roofed masonry structure built in a circle or D-shape,

half submerged in the ground. Inside, the kiva houses fire pits, benches and a symbolic navel of the earth called the *sipapu*. In Puebloan tradition, the kiva is the location of rituals involving kachinas, or ancestral spirits who help people communicate with the under-world. They also serve as community centres.

Kero A wooden, beaker-shaped drinking vessel used by the Incas and colonial Andean peoples. *Keros* were traditionally produced in pairs and used to drink *chicha* (maize beer) in ritual drinking ceremonies with important sacred associations. Before the arrival of the Spanish, *keros* were adorned primarily with incised geometrical symbols. After the Conquest, however, *keros* were painted with figural and other representational ornament, including portraits of Incas.

Lliclla A traditional female garment from the Andes. The Quechua term refers to a woman's mantle of camelid fibre or wool, usually rectangular in shape. It is worn across the back and draped over the shoulders, held in place with a pin. *Llicllas* are commonly worn to this day in Bolivia and Peru.

Manila Galleon A generic term to refer to the seaborne trade between New Spain and the Philippines (and, by extension, the rest of Asia). For 250 years, between 1565 and 1815, galleons travelled regularly between Manila and Acapulco. To the Philippines they carried silver coin and ingots, as well as cochineal for dying textiles. From Manila to Acapulco came goods and handicrafts from every corner of Asia: spices, silk, pearls and precious metals, carved ivory, porcelains, lacquers and furniture. The galleons also carried people, so that Mexicans lived in the Philippines and Asians emigrated to New Spain, Peru and beyond.

Mariola or Maya A silver decorative plaque, usually mounted on a base, which was placed behind a candlestick in a church or private home to reflect the light.

Mendicant A religious order whose members were forbidden to own property in common – literally a 'begging' order. While other orders had such a vow, the orders traditionally classified as 'mendicant' included the Franciscans, Dominicans, Augustinians and Mercedarians.

Mestizo Spanish term denoting a person of mixed parentage, usually Spanish and Amerindian. The term is also applied to a style of architectural decoration that proliferated in the late seventeenth and eighteenth centuries in southern Highland Peru from Arequipa to La Paz and Potosí in Bolivia. *Mestizo*-style architecture combines European **Baroque** forms with images of local flora and fauna, as well as Andean sacred symbolism.

Mita A system of migrant rotational Amerindian labour derived from pre-Hispanic traditions in the Andes and exploited by the Spanish Crown in the mines and other public works projects. Under this system, indigenous communities were called upon in turn to provide labour for a fixed period and a fixed salary, after which labourers would return to their communities.

Mixtilinear The juxtaposition of straight and curved lines or concave and convex forms.

Mudéjar A style of Islamic art current in Spain before 1492, when large parts of the country were under Islamic rule. It was produced by craftsmen both in the Muslim-controlled territories to the south and in the Christian territories to the North, who emulated the lifestyle of the Islamic courts. *Mudéjar* is characterized by complex geometrical patterns, usually executed in inlaid wood and mother-of-pearl. Carpenters and furniture makers in early colonial New Spain excelled in *mudéjar* furnishings and ceilings, as did the carpenters of Quito.

Nahua A central Mexican people who were the ruling ethnic group of the Aztec Empire.

Nahuatl The language of the Aztec Empire and of **Nahua** people in colonial New Spain. In the colonial period, a written version of Nahuatl using Latin letters was devised by Spanish friars and their Nahua associates. Nahuatl is still spoken by millions of people in central Mexico.

Neoclassicism A severe and regulated version of Classicism, Neoclassicism dominated Europe and Anglo-America from the mid-eighteenth century to c.1830, and was prevalent in Latin America from the 1780s until well into the Independence era. It was the architectural language of the art academies, such as Mexico City's Real Academia de San Carlos (founded 1785), and it reflected the idealism of the Enlightenment. In Spanish America, Neo-classicism was also tied with the Bourbon monarchy's attempt to fortify its weakening hold on its colonies. Neoclassicism is based on an almost cultish return to the sobriety, logic and morality of Greek antiquity and **Renaissance** architects such as Palladio (1508–80).

Open Chapel Also known as an 'Indian chapel', the open chapel is an apse-like enclosure open on one side that was usually placed next to the main façade of the mission churches of early colonial New Spain. They varied considerably in size and design, some plain while others had elaborate vaulting and carved decorations. Some of them were even built in the form of a mosque or three-aisled **basilica**. Open chapels served the practical goal of accommodating large crowds, but they also were meant to echo the outdoor worship of the Aztecs in an attempt to make Christianity more palatable to mission communities.

Pachamama Andean mother earth, worshipped by pre-Inca, Inca and early colonial Andeans. Some scholars maintain that the Cuzco School and Potosí painters of the eighteenth century fused images of the Virgin Mary with that of Pachamama, who usually takes the form of a mountain.

Papel de Amate An indigenous Mesoamerican paper made from fig bark. Used in the early

colonial period as a backing for paintings, particularly by the **Nahua** artist **Juan Gerson**.

Parián The Chinese neighbourhood of Manila and the Asian crafts market of Mexico City. The Parián in Mexico City, located in the southeast corner of the Plaza Mayor and given its own building in the late seventeenth century, was where wealthy Mexicans went to purchase porcelains, screens ivories, and other luxury goods from the Philippines, China, Japan and India. It was given the name 'Parián' in 1703, in honour of the original in Manila.

Plateresque Literally meaning 'silversmith-like', it is a style of flat architectural ornament that developed in Spain in the first half of the sixteenth century and is formed of clusters of elaborate, intricate, often floral decoration applied to basically simple structures.

Posa Chapel A form of **open chapel** used on the missions of early colonial New Spain and, to a lesser degree, in the Andes. *Posa* chapels are smaller, kiosk-like buildings with domed or pyramidal roofs, which are positioned on two or four of the corners of the atrium. *Posas* were used as stopping points during processions such as the **Corpus Christi** and Holy Week processions. The counter-clockwise direction of the processions may derive from Aztec practice and the *posa* chapels' connection with different sectors of the mission community may relate to a kind of pre-Hispanic kinship group known as a *calpolli*. As they had less relevance to pre-Hispanic Andean traditions, they appear less often in South America.

Purépecha The indigenous people of Michoacán, more frequently (and less correctly) known by the **Nahua**-derived name 'Tarascans'. The Purépecha were one of the few peoples of ancient Mesoamerica able to repel the Aztecs and maintain independence. Their language has more in common with the indigenous languages of Ecuador than with **Nahuatl**. After the Spanish conquest, the Purépecha rapidly demonstrated an extraordinary artistic ability, a skill that was actively fostered by the Franciscan and Augustinian missions in Michoacán under the patronage of Bishop **Vasco de Quiroga**.

Qompi Quechua for 'fine cloth', denoting high-quality élite textiles made for the Inca and his nobility, as opposed to ordinary, or *abasca* cloth. Generally *qompi* were done in the highland tapestry-weave tradition, in a such a sophisticated way that none of the ends of the multiple weft yarns were visible or loose on either the front or back of the cloth. An **uncu** is an example of a type of garment that used *qompi*. These traditions of élite textiles survived into the colonial period, incorporating Spanish and Asian styles, materials and techniques. *Qompi* were made by men and women who had been chosen for religious service and who learnt their traditions in a secretive and rarified atmosphere.

Quechua The language of the Inca Empire, and the lingua franca of the entire Andean region.

As with **Nahuatl**, a written form of Quechua was developed in early colonial times in Latin letters. Quechua is still the second-most spoken language in Peru, with an estimated two or three million Quechua speakers who know no Spanish at all. It is also common in Ecuador, Bolivia and Colombia.

Quincha An indigenous Andean building technique made of mud and rushes. After almost a century of earthquakes, churches built in coastal Peru in the seventeenth century began substituting *quincha* for stone in their vaulting. This lightweight material, similar to that used in Medieval England and referred to as 'wattle-and-daub', made the church vaults much less prone to collapsing on their congregations.

Quilombo A community of runaway slaves in colonial Brazil. These settlements were common throughout the colonial period, hidden throughout the forests of the interior. Some were small groups known as *mocambos*, but others were made up of hundreds of inhabitants, who sustained themselves with agriculture and periodically raided plantations for new members. The most famous *quilombo* was at Palmares (Pernambuco), which had a population of 20,000 at its height and lasted through most of the seventeenth century, its last ruler Zumbí (r. 1678–95) finally falling to the Portuguese only in 1695.

Quipu Knotted strings used by the Incas to preserve information such as censuses, tax records and astronomical data. Information was recorded through differentiations in knot type and position, as well as cord colour and placement. During the colonial period, converted Andeans knotted pre-empted answers onto *quipus*, so that when under pressure in a confessional they could deliver the response that would lead to the lightest punishment.

Reduction One of many Spanish terms for a mission. It literally means a 'resettlement' of formerly nomadic peoples and is equivalent to the English term 'reservation'. The best-known missions referred to as 'reductions' are the **Guaraní** reductions of Paraguay (1609–1767), although the term was used elsewhere, particularly in the Lake Titicaca district.

Renaissance A cultural and artistic movement that began in Italy around 1400 and reached its height a century later. It then spread to Flanders, Spain and Portugal, and to the Americas. In Europe, the Renaissance meant a new interest in empirical knowledge and also a return to antiquity and the intellectual and literary movement known as humanism. This fascination with antiquity also signalled a desire to evoke the purity and glory of a classical Golden Age. Renaissance painters strove towards idealized pictorial realism. They were especially concerned with anatomical accuracy in depicting human figures, and painters were preoccupied with recreating the third dimension through perspective and shading. Painters, sculptors and architects alike sought a return to ancient models, and the architecture of the period was made up of

components taken from Greek and Roman temples based on the **Classical Orders**. In Latin America, Renaissance-style paintings, sculpture and architecture were still common as late as the mid-seventeenth century.

Repartimiento A forced labour system that replaced the *encomienda* in New Spain in the second half of the sixteenth century. The Mexican equivalent to the Peruvian *mita*, the *repartimiento* was a marginally more humanitarian system based on rotating corvée labour. Every Amerindian village had to send a fixed proportion of its male population to work on public works projects for a fixed number of weeks at a fixed wage, on a rotational basis throughout the year. Although less feudal than the *encomienda* system, *repartimientos* had a deleterious effect on indigenous communities, sending their able-bodied men to unfamiliar surroundings sometimes hundreds of miles from home for months and seriously hampering the agricultural life of their home villages.

Retablo An altarpiece, sometimes translated into English as 'retable'. Elaborate affairs combining architecture with sculpture and painting in a profusion of ornament, they frequently occupy the entire wall behind the altar and are the most decorated part of a church interior. These complex structures were not the work of one man, but involved careful planning between designers, sculptors, painters, joiners and woodworkers. The artisans who assembled retablos were called *ensambladores*.

Rococo A late **Baroque** style particularly associated with Louis XV of France (r.1715–74) and also very popular in Germanic countries. Rococo is characterized by a more decorative, lighthearted and fanciful approach to ornamentation. In architecture, structure gave way to embellishment, and in painting, forms lost their solidity through ever-looser brushwork and lighter, pastel colours. Rococo was extremely prevalent in Brazil in the eighteenth and early nineteenth centuries, thanks to the influence of Germanic architects at the Portuguese court. The Spanish American version of the style is more popularly known as **Ultrabaroque** or **Estípite-Baroque**.

Solomonic Column A twisted column based on ancient columns excavated at St Peter's in Rome and believed to have formed part of the original Temple of Solomon in Jerusalem. Popularized by the Italian **Baroque** architect Gianlorenzo Bernini, solomonic columns were soon in vogue throughout Spain, Portugal and the Americas. In South America they were used more often than the *estípite* characteristic of New Spain and Central America. They are common both in Baroque and **Ultrabaroque** architecture and **retablos**.

Syncretism When two different cultures make use of a single symbol, giving it a new meaning in the process.

Talavera poblana The most important ceramics manufacturing centre in colonial Latin America. Named after the city of Talavera de la Reina in central Spain sometime in the 1680s, the Talavera kilns of the Mexican city of Puebla became important enough to have their own guild by the mid-seventeenth century and acquired viceregal *ordenanzas* to standardize almost every aspect of the industry. The potters of Puebla had the advantage of two kinds of local clay that could be combined to form an extraordinary plasticity and consistency and rivalled the best clays of Europe. Styles produced at the Puebla kilns ranged from maiolicas inspired by Italy and the Islamic world to imitation Chinese blue-and-white porcelains.

Tequitqui A **Nahuatl** term for 'vassal' used by art historians to denote a style of architectural carving in early colonial New Spain that retains aspects of Aztec symbolism, glyphs and style. The style of carving is very flat, with deep, bevelled carving, and different decorative elements tend to be placed next to each other rather than made to interconnect. *Tequitqui* can also refer to a similar phenomenon in wall and manuscript painting.

Testerian Catechism A kind of picture book used on the missions in early colonial New Spain that attempted to spell out prayers such as the Our Father in rebuses inspired by Aztec and Mixtec glyphs. The idea was that the Catholic catechism would be more appealing to the congregation if written in a form made up of ideographic pictures and symbols recalling those of pre-Hispanic manuscripts. This technique remained popular into the nineteenth century, and was probably devised as much by the **Nahua** communities as by the missionaries. They are named after Fr Jacobo de Testera, the sixteenth-century Franciscan missionary who is credited with inventing them.

Tlacuiloque Aztec picture writers. An élite skill taught in the *calmecac*, picture writing combined writing with painting, based on a written language of ideographic glyphs. Aspects of Aztec picture writing survive into the earliest colonial-period manuscripts in New Spain.

Ultrabaroque An extremely decorative variant of late **Baroque** style, primarily in architecture, which in Spain is popularly called *Churrigueresque*. The term Ultrabaroque is used throughout Spanish America to refer to **Rococo** style and **Estípite-Baroque**. Ultrabaroque style dates from the last three-quarters of the eighteenth century. It is characterized by a dissolving of structure and form and profuse ornament, so that the structural elements such as columns or entablatures look more decorative than functional. In the past decade contemporary Latin American artists have adopted the term 'Ultrabaroque' as a metaphor for Postmodernism.

Uncu An Inca male tunic of interlocked tapestry with intricate, chessboard-like patterns that recorded the rank and familial ties of the wearer. The *uncu* is an example of *qompi*.

Brief Biographies

Aleijadinho (Antônio Francisco Lisboa; 1730–1814) Afro-Brazilian late-**Baroque** sculptor and architect. He was born in Minas Gerais to a Portuguese architect and a freed West African slave. At the age of thirty-nine he contracted leprosy or syphilis and lost his fingers and toes. Nevertheless, Aleijadinho was able to continue working, strapping his tools to his arms and assisted by slaves. It was during these later years of his life that he executed his most important sculpture. His best-known carvings are the façade of the church of São Francisco de Assis (1766) in Ouro Prêto; the Church of São Francisco de Assis (1774) in São João del Rei; and the soapstone statues of the Twelve Prophets (1800–5) on the steps and terraces leading to the pilgrimage church of Bom Jesus do Matosinhos in Congonhas do Campo.

Claudio de Arciniega (c.1527–93) Spanish architect active in New Spain. Arcienega was probably born in Burgos and worked in both Madrid and Guadalajara before emigrating to New Spain around the 1550s. In the new colony he was made chief architect of New Spain in 1578. Arciniega designed the first plan of the new Mexico City Cathedral (c.1569) and in 1570 served as chief architect of that building. He may also have contributed to Santo Domingo and San Agustín in Mexico City, as well as Puebla Cathedral.

Jerónimo de Balbás (fl.1706–50) Spanish **retablo** maker active in New Spain. One of the leading retablo makers of Spain, where his most important works were the High Altar (now destroyed) at the Seville Sagrario (1706–9) and the choir stalls at San Juan, Marchena (1714), Balbás championed the most decorative late-**Baroque** style. He helped introduce the so-called **Estípite-Baroque** into New Spain through his extremely influential Altar of the Kings in Mexico City Cathedral (1718–37).

Charles Belleville (1656–1730) French **Jesuit** painter active in China and Brazil. Born in Rouen, Father Charles Belleville was a miniaturist, sculptor and architect by trade, and had served the Jesuits in China for about ten years beginning in 1698. In China, Belleville designed the Jesuit church at Guangzhou (Canton) and in the capital, Beijing. Under the Chinese name Weijialou, Belleville also served Emperor K'ang-hsi directly as one of a group of European specialists the ruler maintained at court to introduce him to Western technology and arts. Belleville's connection with Brazil dates from his return trip to Europe, in 1708 or 1709, when the artist's ship sank off the coast of Bahia and he decided to remain in Brazil for the rest of his life. In Brazil, Belleville worked primarily as a painter, where he specialized in chapel ceilings and other architectural details painted in the Chinese style. His most notable work is the sacristy ceiling of the church of Belém de Cachoeira.

Bernardino Bitti (1548–1610) Italian **Jesuit** painter active in Peru. A professional artist from Camerino (Marches), Bitti joined the Jesuit order as a young man and may have painted frescos at the Jesuit Novitiate of S Andrea al Quirinale in Rome before emigrating to Lima in 1574. Bitti specialized in large-scale canvas altarpieces featuring full-length figures of Christ, the Virgin Mary and the saints. He travelled extensively during his career in Peru, to Cuzco, Arequipa, the Lake Titicaca area and into present-day Bolivia.

Francisco Xavier de Brito (d.1751) Portuguese sculptor active in Brazil. Born in Lisbon, Brito had already emigrated to Rio de Janeiro by 1735, where he signed a contract for a wood carving in the Igreja da Penitência with the title of 'Master Sculptor'. He was active in Ouro Prêto from 1741, where his most important works are the wood carving in the high altar chapel of the Matriz de Nossa Senhora do Pilar. This work inspired the younger **Aleijadinho** to carve a similar interior in São Francisco.

Miguel Cabrera (1695–1768) Zapotec painter from New Spain. Born in Oaxaca, Cabrera had already moved to Mexico City in 1737, where he married Ana María Solano y Herrera in 1740. He may have studied with José de Ibarra (1685–1756), and was one of a group of artists who studied the original canvas of the Virgin of Guadalupe in 1751. Cabrera was a man of letters, publishing an account of the Virgin of Guadalupe with the Colegio de San Ildefonso press (1756), and he attempted to found an art academy in 1753. Cabrera is known for a voluminous output, including large-scale wall paintings and **retablo** panels, as well as his portraits and *casta* **paintings**.

Doña Leonor Carreto, Marquise of Mancera (d.1674) Vicereine of New Spain. She had been lady-in-waiting to Queen Mariana of Austria, and her Germanic background ensured her a high position in the Habsburg court. She married the Marquis de Mancera and it was probably her aristocratic lineage that gained her husband the coveted post of Viceroy of New Spain in 1664. An extremely intelligent and cultured woman, she was a great patron of the arts and her greatest legacy to world literature was her encouragement of the literary skills of her fifteen-year-old lady-in-waiting, the brilliant **Juana Inés de la Cruz**.

Bartolomé de las Casas (1474–1566) Spanish missionary and historian active in the Caribbean, Venezuela and Guatemala. Born in Seville, Las Casas studied law at Salamanca University. The Spanish governor of the Antilles brought him to Hispaniola in 1502. Although he began as a plantation owner, Las Casas took holy orders in 1512/13, probably the first ordination in the New World. From 1514 he began to fight against Amerindian slavery and travelled to Spain in 1515 to argue his point with King Ferdinand. He was unsuccessful in founding a utopian Amerindian colony at Cumaná (Venezuela) in 1520–2, although he did succeed in gaining passage of laws to protect Amerindian rights in 1542. Las Casas joined the Dominican order in 1522 and was Bishop of Chiapas in 1544–7. He took part in the famous debate over the legality of Amerindian slavery at Valladolid in 1550–1, and is author of *A Brief Relation of the Destruction of the Indies* (1552) and *History of the Indies* (only published in 1875).

José Manuel de la Cerda (active c.1764) Purépecha lacquer worker from New Spain. De la Cerda's workshop was based in Pátzcuaro, Michoacán, where his brother Luis was also employed. Their products ranged from **bateas** to larger pieces of furniture and are most remarkable for their use of gold-leaf decoration. Many of them closely resemble Asian models, especially gold filigree work on a black or red background inspired by Japanese lacquers. The Cerda workshop evidently felt an affinity between the Asian lacquer technique and the indigenous lacquer traditions of Michoacán.

Chico-Rei (Galanga; before 1700–74) African king and confraternity leader active in Brazil. A king in Africa, Chico-Rei was kidnapped with his tribe by the Portuguese in the early eighteenth century and sold to a mine operator in Ouro Prêto. Chico-Rei worked there as a foreman and eventually purchased not only his own freedom but also that of his entire people. After buying his own gold mine, Chico-Rei and his son Osmar set up court as a royal family, financing lavish festivals on African holidays and helping build the church of Santa Ifigênia dos Pretos, for which he hired the sculptor **Francisco Xavier de Brito**.

Manuel Chili 'Caspicara' (active last half of eighteenth century) **Quechua** sculptor from New Granada (Ecuador). Caspicara was one of the two of the finest sculptors of the Quito School and he enjoyed many commissions from religious orders in Quito and other cities. A student of **Bernardo de Legarda**, Caspicara was especially renowned for the delicacy, elegance and humanity that he gave to human figures, as well as his attention to anatomical detail and naturalistic flesh tones. His best work in Quito, none of which is dated, includes the *Four Virtues* and the *Holy Shroud* in the Cathedral, *St Francis of Assisi*, the *Apostles* series and the *Assumption of the Virgin* in San Francisco, and the *Virgin of the Carmen*, *St Joseph* and the *Coronation of the Virgin* now in the Franciscan Museum.

Isabel de Cisneros (Isabel de Santiago; active late seventeenth–early eighteenth century) *Criolla* painter from New Granada (Ecuador). The daughter of the celebrated Quito painter Miguel de Santiago (1633–1706), Isabel trained to be an artist, a rare opportunity for women of her time. After apprenticing in her father's workshop, she enjoyed a flourishing career as an artist in her own right, painting canvases for the churches of Quito, signing her name with an anagram. She married another painter, Don Antonio Egas Vanegas de Córdova (c.1635–c.1705), which undoubtedly helped her continue her practice after marriage. She is known for an extreme delicacy of line and attention to detail, especially in the depiction of costume and textiles. Her known works include an *Annunciation*, *Visitation* and *St Isidore* at the Museo Jacinto Jijón y Caamaño and the paintings in the **retablo** of San Pedro de Alcántara in the sanctuary of Guápulo.

Diego Colón (1479/80–1526) Admiral of the Indies and Governor of Hispaniola. Diego was the son of Christopher Columbus and became Governor of Hispaniola in 1508. Together with his noble wife, María de Toledo (the niece of the Spanish King and kinswoman of the Dukes of Alba), he ushered in the kind of aristocratic lifestyle that would become typical of the Spanish governors and viceroys in later centuries. They were patrons of architecture and the arts and held court in their Alcázar palace in Santo Domingo, an early imitation of an Italian villa. The Colóns aspired to the ideals of the Italian nobility, who fostered a tradition of contemplative leisure at their villas.

Juan Correa (1646–1716) Afro-Mexican painter. Born in Mexico City, Correa became one of the two most prominent artists in New Spain during his lifetime, along with **Cristóbal de Villalpando**. He was the son of a mulatto doctor from Cádiz with the same name and a free black woman named Pascuala de Santoyo, and he likely studied under the celebrated painter Antonio Rodríguez (1636–91). Correa's family became an artists' guild unto itself, with his brothers, sons and cousins all participating. Correa's workshop was not only one of the most celebrated in the Americas but also one of the most active, producing devotional paintings on an impressive scale for a varied clientele, as well as for the export market. After 1680, Correa's style became much more dynamic, with an emphasis on movement, a looser brushstroke and a triumphalist use of bright colours. His most celebrated works are his canvases in the Sacristy of Mexico City Cathedral: the *Assumption of the Virgin* (1689) and the *Entry of Christ into Jerusalem* (1691). He also painted several versions of the Virgin of Guadalupe and is responsible for introducing black and brown-skinned angels and other dark-complexioned figures into colonial painting.

Sor Juana Inés de la Cruz (1651–95) *Criolla* poet and nun from New Spain. An early prodigy, Sor Juana captured the attention of the Vicereine **Doña Leonor Carreto** who took her on as a lady-in-waiting and encouraged her talents. She entered the convent of San Jerónimo in Mexico City in 1669, where she lived the life of a scholar, studying the sciences and humanities.

She became the favourite of the next vicereine, María Luisa Manrique de Lara y Gonzaga and enjoyed her generous patronage. Nevertheless, in 1693 she renounced her scholarly and poetical activities and sold her sizeable private library. She is the author of many celebrated lyric poems, published in *Inundación castálida* (1689), *Segundo volumen de las obras de Sor Juana Inés de la Cruz* (1692) and *Fama y obras pósthumas de Fénix de México y Décima Musa* (1700). Sor Juana also prepared librettos and programmes for temporary triumphal arches and other ephemeral decorations associated with viceregal *entradas*.

Juan Cuiris (fl. 1550–80) **Purépecha** feather painter from New Spain. The feather paintings of this Michoacán artist brilliantly fused a pre-Hispanic technique with European subject matter to create intricate and luminous portraits of the saints that were the toast of **Renaissance** princely courts. Cuiris was active in the Augustinian art school at Tiripetío (Michoacán) and his finest works are the paintings of the *Virgin Mary* and of the *Christ Child Lost in the Temple* now in the Kunsthistorisches Museum in Vienna. The feather paintings of Cuiris are characterized by luminous colour and masterful shading effects.

Pedro de Gante (Peeter van der Moere of Ghent; 1486–1572) Flemish Franciscan lay brother and founder of an Amerindian school and art academy. One of the most remarkable missionaries in the history of the Americas, Pedro de Gante was a relative of Emperor Charles V (r. 1519–58) and a friend of Pope Adrian VI (r. 1522–3). He founded the school of San José de Belén de los Naturales ('of the Natives') adjacent to the monastery of San Francisco in Mexico City in 1529. The most famous trade school of colonial America, it offered instruction in a variety of arts and crafts, including painting, to **Nahua**-Indian pupils. One of his students was **Diego de Valadés**, who became the first *mestizo* to be ordained in 1549. Many of the painters trained at this school travelled throughout New Spain to execute mural paintings in the various mission churches and cloisters.

Juan Gerson (active c. 1562) **Nahua** painter from New Spain. Gerson, named after a French theologian, was one of the most important of the indigenous painters who decorated the mission churches of early colonial Mexico. His only known work is the vault at the church at Tecamachalco, in Puebla, a brightly coloured painting of the Old Testament and Apocalypse painted on the indigenous material of *papel de amate*. His rich colours take the paintings to a chromatic level rarely achieved by indigenous muralists at the time and his scenes, taken from European engravings, incorporate stylistic features from Aztec picture writing. Some scholars believe that he chose the Apocalypse as a subject because it resonated with pre-Hispanic traditions.

Franz Grueber (1715–after 1767) Bavarian **Jesuit** architect active in Chile. Brother Franz Grueber, a carpenter and church builder who

had lived in Naples, was part of the second migration of Germanic Jesuits to Chile in 1747, most of them craftsmen and artists to staff the Jesuit art workshops at the Calera de Tango and at the Colegio Máximo. After 1748, Grueber became chief architect of the new Bavarian **Baroque** church of San Miguel (1766), the principal Jesuit church in Chile and the most important colonial structure in Santiago. Grueber built a church at Valparaíso which was one of the only round churches ever built in Spanish South America. It might have been inspired by one of the architectural manuals of Sebastiano Serlio (1475–1555). Grueber was deported from Chile when all Jesuits were expelled from Spanish territories in 1767.

Joaquín Gutiérrez (c. 1720s–c. 1800s) **Criollo** painter from New Granada (Colombia). Known as 'The Painter of the Viceroys', Gutiérrez specialized in portraits of the local aristocracy and became the leading society painter of eighteenth-century Bogotá. Gutiérrez studied with Nicolás Banderas, a pupil of the celebrated Bogotá painter Vásquez Ceballos, but his main influence was the painting of **Rococo** France, which reached Latin America via the Bourbon court in Madrid. In his portraits, Gutiérrez achieved an extraordinary fineness in his drawing and precision in his use of line, and he also had a talent for anatomical accuracy and a keen eye for detail in costume and setting. Although his subjects were presented with grace and sobriety, they were much enlivened by Gutiérrez' rich colours.

Melchor Pérez Holguín (c. 1660–1742) **Mestizo** painter from Alto Peru (Bolivia). Born in Cochabamba, Holguín spent most of his career in Potosí, the largest and richest city in the Spanish Empire at the time. His work can be divided into three periods. During the first (1687–1706) he specialized in half-length portraits of Franciscan saints done in silvery-grey tones against a dark background, with particular care paid to the naturalism of the fabrics. In the second (1706–10) he painted larger canvases and during the third (1710–32) he moved away from the darker tonality of his early work towards a brighter palette. Holguín is especially renowned for his expansive landscape paintings, in which the human element is overwhelmed by its natural setting, and he is also known for the characteristically gaunt faces of his figures.

Diego de Alvarado Huanitzin (active second quarter sixteenth century) **Nahua** patron of the arts from New Spain. The son of the Aztec noble Tezozomoczin, Huanitzin came from a family which continued to enjoy influence in the colonial era. He was first appointed colonial governor of the town of Ehecatepec and then, in 1539, Viceroy Antonio de Mendoza made him Governor of Tenochtitlan/Mexico City. Huanitzin is associated with the most celebrated of the early colonial feather paintings, *The Miraculous Mass of St Gregory* (1539), which was made as a gift for Pope Paul III (r. 1534–49). Although it is not certain whether Huanitzin made the piece or simply commissioned it, Nahua nobles were frequently trained in the

fine arts, particularly feather painting, which was an élite craft under the Aztecs.

Juan Rodríguez Juárez (1676–1728/32) *Criollo* painter from New Spain. Rodríguez was born in Mexico City, where he grew up with · his brother Nicolás Rodríguez Juárez (1666–1731), also a celebrated painter. He was one of the main exponents of the Mexican **Baroque**, and painted religious imagery, portraits, and *casta* **paintings**. Among his most celebrated works are the portraits of Archbishop José de Lanciego and Viceroy Fernando de Alencastre, Duke of Linares, as well as his canvases of the *Adoration of the Kings* and the *Assumption* in **Jerónimo de Balbás'** Altar of the Kings in Mexico City Cathedral. In his early works, he worked in the style typical of the later seventeenth century in New Spain, with precise drawing (particularly in the details of fabrics), solid figures and deep shading. Later he acquired a taste for the lighter palette, looser brushwork and dynamism of the Spanish Baroque painter Bartolomé Esteban Murillo (1618–82).

Antonio Giuseppe Landi (1713–91) Italian architect active in Brazil. From Bologna, Landi studied in Italy with Giuseppe Galli Bibiena (1696–1756), the principal set designer and architect to the Viennese court of Charles VI (r.1711–40) and one of the most important exponents of perspective design of the **Baroque** era. After emigrating to Brazil in 1753, he became the most prominent architect in Belém, in the Amazon region. One of his most important works in the city is the church of Sant'Ana and he also designed the Cathedral, the Carmélite church and a number of other churches and chapels in the city. However, Landi's crowning achievement was the Governor's Palace, the largest public structure ever built in colonial Brazil (now the Palácio Lauro Sodré, 1762–71), a building which adroitly combined quotations from Italian **Renaissance** villa architecture with **Rococo**. In addition to his contributions as an architect, Landi also helped record the flora and fauna of the Rio Negro region on behalf of the Portuguese government.

Georg Lanz (1720–71) Bavarian sculptor and architect active in Chile. Lanz was born to German parents in Leiden, in the Spanish Netherlands. Although Lanz began as a **Jesuit** brother, reaching Chile on the same ship as **Franz Greuber** in 1747, he left the Order in 1751 and became a prominent civic planner and sculptor. He was elected chief city planner of Santiago in 1758 and then chief sculptor in 1770. His best-known work is the pulpit in the church of La Merced in Santiago (c.1760).

Matteo da Leccio (1547–1616) Italian painter active in Peru. A prominent artist in late **Renaissance** Rome, Leccio contributed to the frescos in the Sistine Chapel and the Oratorio del Gonfalone, and he was also active in Malta and Seville. Together with his young apprentice Pedro Pablo Morón (c.1570–1616), he emigrated to Peru in the 1580s. In Peru, where he was known as Mateo Pérez de Alesio, he quickly rose to prominence as the 'Painter of

his Honour the Viceroy', and painted for aristocratic clients and religious orders, including a series of thirty-six canvases of the *Life of St Dominic* created for the Convento de Santo Domingo in Lima. His only securely attributable work to survive is a small painting on copper of the *Virgin of the Milk*, now in a private collection in Lima.

Bernardo de Legarda (late seventeenth century–1773) *Mestizo* sculptor and painter from New Granada (Ecuador). A pupil of José Olmos, he founded a workshop with his brother Juan Manuel (fl.1730–70) across the square from the Quito church and monastery of San Francisco, his principal patron. Legarda is best known for his sculpture, but he was also a painter, gold- and silversmith, gunsmith, organ-maker and engraver. Legarda's most famous work is the *Virgin of Quito* (1734) at San Francisco, a winged Virgin of the Apocalypse that is now the symbol of the city of Quito. Her dancing pose and outstretched arms and wings give the piece a **Baroque** theatricality and mysticism that became typical of the Quito school of sculpture. Legarda is also responsible for the **retablos** of the church of La Merced, the churches of the Carmen Moderno and Cantuña, and other churches in the city. In 1745 he gilded the high altar of the Compañía and decorated the dome of the Sagrario Metropolitano. Favourite themes in his paintings include the *Nativity*, the *Adoration*, the *Virgin of Sorrows* and the *Massacre of the Innocents*.

Francisco Juan Metl (active c.1560s) **Nahua** architect and sculptor from New Spain. He was most likely a Nahua (the name 'Metl' is **Nahuatl** for 'maguey plant') and not a **Purépecha**, even though he worked in Michoacan. Metl was an extraordinarily skilled architect who specialized in a delicate and creative **Plateresque** style and probably travelled with teams of masons to build churches around the Basin of Mexico. He was sufficiently important to allow him to sign his name in an elaborate plaque that still adorns the façade of the sixteenth-century Augustinian church at Cuitzeo in Michoacán ('Fr. Io. Metl Me Fecit', literally 'Franciscus Iohannes Metl made me').

Manuel de Mollinedo y Angulo (r.1673–99) Spanish bishop and arts patron active in Peru. Mollinedo was born of a noble family in Madrid, where he became curate to the parish of Nuestra Señora de Almudena (Santa María la Mayor). After becoming Bishop of Cuzco in 1673, he ushered in a two-decade long period of lavish patronage in the city and its surroundings, almost single-handedly allowing a distinctive metropolitan style of architecture to develop there. During his tenure no fewer than fifty churches were built and furnished, many financed by himself. He is also remembered for promoting the tradition of **Corpus Christi** processions in the city, expanding the ceremony to closely resemble the version he had known in Madrid. Among the artists he championed were the Andean painters **Diego Quispe Tito** and **Basilio de Santa Cruz Pumaqallo** and the Andean architect **Juan Tomás Tuyrú Túpac**.

'Motolinía' (Toribio de Benavente; late fifteenth century–1568) Spanish friar active in New Spain. One of the first twelve Franciscans to reach Mexico with Fr Martín de Valencia in 1524, Toribio became known by the **Nahuatl** word 'Motolinía' ('he who inflicts suffering upon himself') by the **Nahua** Indians he administered. His self-conscious poverty and asceticism made him attractive to his congregations, because his manner of living reminded them of the priests of the Aztec religion. Motolinía travelled to Guatemala and Nicaragua, and then served in Texcoco and Tlaxcala. He was chosen to be part of the commission to found the city of Puebla, in which he first said Mass in 1530. Although he was revered as a saint by the Nahua people, who tried to cut his robe up for relics when he was buried in Mexico City, he was a harsh opponent of the theories of **Bartolomé de las Casas**.

Juan de Palafox y Mendoza (1600–59) Spanish bishop, poet and arts patron active in New Spain. As Bishop of Puebla (from 1639), Palafox was one of the most generous and enlightened promoters of the fine arts and architecture of his time. Palafox was also involved in the civil government, having held the positions of fiscal of the Consejo de Guerro, fiscal of the Consejo de Indias and viceroy of New Spain, among other offices. His greatest architectural legacies in Puebla are the completion of the cathedral (1649) and the foundation of the convent of Santa Inés, as well as several schools. His magnificent library, testament to his scholarly ambitions, is still standing in Puebla. His administrative reforms led to conflicts with the **Jesuits**, culminating in a legal battle between 1647 and 1655. After returning to Spain in 1649, Palafox became Bishop of Osma in 1655.

Simón Pereyns (c.1530–89) Flemish painter active in New Spain. Born into a Lutheran family in Antwerp, Pereyns lived in Lisbon for several years, where he studied painting with a Portuguese master. He then moved to Toledo and Madrid, where he worked with the court painters of Philip II (r.1556–98), before emigrating to New Spain with Viceroy Gastón de Peralta in 1566. Although Pereyns fell foul of the **Inquisition** in 1568 (one of the charges brought against him was that he preferred to paint portraits to religious pictures), he quickly grew to become the most prominent professional artist in early colonial New Spain. His most celebrated work in his day was the *Virgin of Mercy* (destroyed 1967), which the Inquisition made him paint free of charge as a punishment. Today he is best known for his **retablos**, especially the one at Huejotzingo (1588), as well as a handful of other paintings on panel that use the shimmering colours and elongated figures of Flemish painting at the time.

Felipe Guaman Poma de Ayala (1534–1615) **Quechua** writer and illustrator from Peru. Born into a noble Andean family shortly after the Spanish invasion, Guaman Poma's experience spanned two worlds. Converted to Christianity as a child, he became fluent in Spanish and wrote in both Spanish and Quechua. He was hired as an informant and translator in the protracted negotiations that took place between colonial officials and indigenous communities. Although he took part in a Spanish effort to crush an indigenous revolt, he soon became an activist for Andean causes himself, particularly in his campaign for Andean literacy. His most famous work is his *Nueva Corónica y Buen Gobierno* (1612–15), a voluminous illustrated history and letter of protest to the Spanish king about the treatment of indigenous people in the colony.

Giovanni Battista Primoli (1673–1747) Italian **Jesuit** architect active in Paraguay and Argentina. Born in Milan, Primoli was a professional architect in Italy before joining the Society of Jesus and emigrating to the Paraguay **Reductions** in 1717. In the early 1730s, Primoli worked on three of the grandest stone churches of the Reductions: San Miguel, Trinidad and Concepción, and he also worked on projects in Buenos Aires after 1735.

Don Vasco de Quiroga (c.1470–1565) Spanish bishop and social reformer active in New Spain. A jurist, Quiroga served as judge of the second *Audiencia* before taking Holy Orders and being elected bishop of Michoacán. While in Michoacán he made Thomas More's *Utopia* the literal model for a series of Indian towns he founded in his diocese, including Uruapan, Pátzcuaro and Tzintztuntzan, each of them centred on a church and community hospice. Quiroga founded the College of San Nicolás in Pátzcuaro (after 1580 in Valladolid) for both Spanish and **Purépecha** students. He also promoted craft production among the villages of Michoacán, to such an extent that the region is still one of the leading producers of handicrafts in Mexico.

Diego Quispe Tito (1611–81) **Quechua** painter from Peru. From a noble family, Quispe Tito lived in the neighbourhood of San Sebastián in Cuzco. Quispe Tito trained many Andean pupils and his noble status allowed him to work as a master and arrange his own contracts. Quispe Tito is most celebrated for his ethereal landscapes that combine shimmering colours with occasional Inca symbolism, and their style shows the influence of Flemish paintings and engravings. His first signed painting is an *Immaculate Conception* from 1627, but his best-known work is the series of the *Life of St John the Baptist* at San Sebastián (1663), after engravings by Johannes Stradanus (1523–1605) and Cornelis Galle (1615–78), and his *Signs of the Zodiac* series in Cuzco Cathedral (1681), adaptations of engravings by Jan Sadeler I (1550–1600) and Adrian Collaert (1560–1618). The *Zodiac* series related the signs of the zodiac to one of the parables of Christ and they were intended to capitalize upon indigenous Andean veneration of the sun, the moon and the stars.

Jodoco Ricke de Marselaer (1494–1578) Flemish friar and educator active in New Granada (Ecuador and Colombia). Born in Ghent, Ricke was ordained in Spain between

1524 and 1526, joining the Franciscan Order. He reached Ecuador with the first Franciscans in 1535 and stayed there until 1569 when he was transferred to Popayan (Colombia). He is best remembered as the founder of the Colegio de San Andrés in Quito (1555), a school for **Quechua** and **Aymara** students. The college taught liberal arts such as grammar and music (including plain chant and organ music), as well as canvas and miniature painting, sculpture and carpentry, silver and gold working, watchmaking, ironworking, carpentry, weaving, shoemaking, hatmaking and clothes design. The college trained a generation of indigenous artists, who went on to train their own pupils and found the distinctive schools of painting and sculpture that gave Quito its renown.

Lorenzo Rodríguez (c.1704–74) Spanish architect active in New Spain. Born in Andalusia, Rodríguez was the son and apprentice of the chief architect of the diocese of Guadix. After moving to Cádiz, he became master mason at the cathedral and then moved to New Spain in 1731 as a carpenter at the Mint. Nine years later he acquired the title of master architect and went on to become one of the most influential architects of the Mexican **Estípite-Baroque**. His masterpiece is the Sagrario Metropolitana (1749–67) next to the cathedral in Mexico City, a work that introduced the style of **Jerónimo de Balbás**'s Altar of the Kings to architecture.

Bernardino de Sahagún (c.1500–90) Spanish friar and educator active in New Spain. Born in Sahagún de Campos in the province of León, Sahagún studied at the University of Salamanca. He went to New Spain in 1529, where he lived in the missions of Tlalmanalco, Tlatelolco, Xochimilco, Huejotzingo and Cholula. At Tlatelolco he taught Latin, science and music at the Colegio de Santa Cruz, and he became proficient in **Nahuatl**. His superior ordered him to compile a compendium of the history and customs of New Spain, for which he gathered together seven leading **Nahua** elders of the region (including four of his own students) and spent seven years collaborating on this twelve-volume illustrated encyclopedia, which he entitled *Historia general de las cosas de la Nueva España*. Written in Spanish and Nahuatl, it remains one of the most important chronicles of the lost world of the Aztecs in existence.

Basilio de Santa Cruz Pumaqallo (fl.1661–99) **Quechua** painter from Peru. Together with **Quispe Tito**, Santa Cruz Pumaqallo was one of the leading indigenous painters of his day in Cuzco. His prodigious output and the inconsistent quality of his paintings suggest that he operated a large workshop with many apprentices. As a master, he signed his name to some of his work. He was a favourite of Bishop **Mollinedo**, who commissioned a series of monumental canvases for the cathedral. Santa Cruz Pumaqallo also painted important series (murals and canvases) in the monastery of San Francisco and the church of La Merced. His many pupils included the Quechua painter Juan Zapata Inca (fl.1668–84), with whom he

collaborated on the fifty-four canvases of the Life of Saint Francis in San Francisco church in Santiago, Chile (1668–84).

Esteban Sampzon (fl.1773–after 1800) Filipino sculptor active in Argentina. Nothing is known of his youth in the Philippines, or whether he received his artistic training there, but he probably reached Spanish America via the **Manila Galleon** or Brazil. He was already making sculpture in Buenos Aires in 1773, when he was recorded as living at the monastery of Santo Domingo. Specializing in extremely naturalistic sculptures of saints, characterized by a powerful sense of emotion, Sampzon became one of the leading sculptors of the new Viceroyalty of the Río de la Plata. Although his only documented work is a *Penitent Saint Dominic*, several other pieces are attributed to him, including a *Christ of Humility and Patience* in the church of La Merced and various others in Buenos Aires and Cordova, where he lived in the first decade of the 1800s.

Andrés (or Adrián) Sánchez Galque (active c.1599) **Quechua** painter from Nueva Granada (Ecuador). Sánchez Galque studied at **Jodoco Ricke**'s Colegio de San Andrés in Quito, probably with the painting instructor Pedro Gosseal, and he also had contact with the Dominican painter Pedro Bedón (fl.1586–94) at the nearby monastery of Santo Domingo. In spite of his indigenous background, Sánchez Galque was commissioned by Juan de Barrio, the principal judge in the *Audiencia* of Quito, to paint a portrait of three Afro-Ecuadorian potentates for King Philip III (r.1598–1621) as part of a report he wrote on the pacification of the Pacific coast of present-day Ecuador. Signed by the artist and dated 1599, the *Mulattos of Esmeraldas* was one of the most important commissions of its day and remains the oldest dated painting of colonial South America.

Catarina de San Juan (1606–88) Mughal Indian mystic active in New Spain. Born in northern India into a Muslim family reputedly related to the Mughal emperors, Catarina converted to Christianity and ended up at the slave market in Manila, where she was purchased by Captain Miguel de Sosa of Puebla. She reached New Spain via the **Manila Galleon** in 1621 and spent the rest of her life in Puebla, first as a slave and finally as an anchorite. She rapidly became famous for her extravagant religious visions, as full of figures, angels and sunbursts as the **Baroque** paintings of her era. Based in her small cell near the **Jesuit** church, she was visited by the wealthy and influential of the city and foretold several deaths, including those of the Viceroy and Bishop of Puebla. One of her two biographies was the longest book ever published in New Spain. She is popularly believed to be the prototype of the *China Poblana*, a popular folkloric figure of nineteenth-century Mexico.

Joaquín Toesca y Ricchi (c.1745–99) Italian architect active in Chile. Toesca came from Rome, where he studied with Francesco Sabatini (1721–97), pupil of the famed **Baroque** architect Luigi Vanvitelli (1700–73).

When Sabatini was named architect to the Spanish court, Toesca moved there as well and eventually obtained important commissions, including the tomb of Ferdinand VI (r.1746–59) and additions to the Royal Palace in Madrid. Toesca came to Chile in 1780 to build the new cathedral in Santiago and he was quickly put in charge of designing the new Royal Mint (La Moneda; 1795–after 1799), a gargantuan project that would take up the rest of his life. As the leading proponent of **Neoclassicism** in Chile, Toesca y Ricchi made a profound impact on architectural taste in the whole Southern Cone of South America.

Manuel Tolsá (c.1750–1810) Spanish architect and sculptor active in New Spain. After studying at the Academy of San Carlos in Madrid and joining the Academy of fine arts of San Fernando, Tolsá emigrated to New Spain as the Crown architect. Tolsá championed the **Neoclassical** style in New Spain, designing some of the most important structures in Mexico City, including the towers of the cathedral and the School of Mines (1797–1813), as well as the famed bronze equestrian statue of Charles IV (1802). He was made director of the Academy of San Carlos in Mexico City in 1798.

Francisco de Toledo (c.1520–83) Viceroy of Peru. From a noble family, Toledo was appointed fifth Viceroy of Peru in 1569 and was soon known for his social reforms. He decreed that Amerindian communities should be governed by chiefs of their own people and he fixed the tribute that they were obliged to pay, making all men under eighteen and over fifty exempt. He also reformed the **mita** system of rotating labour. Toledo founded the first **Jesuit reductions**, in the Lake Titicaca region. Although he began his rule by hunting down and executing Tupac Amaru, the heir to the Inca throne, he gained the support of the indigenous communities through his deft administrative skills. After returning to Spain in 1581 he was arrested for misuse of public funds and died a prisoner.

Juan Tomás Tuyrú Túpac (d.c.1718) **Quechua** architect and sculptor from Peru. Tuyrú Túpac descended from Inca nobility, giving him an advantage in the competitive arts world of mid-seventeenth-century Cuzco. Trained in the guilds of his city, Tuyrú Túpac showed extraordinary skill as a **retablo**-maker and gilder, as well as an engineer and architect. After gaining the status of master architect he set up his workshop on the Plaza de Armas. In the years after the 1650 earthquake, Cuzco was rebuilt from the ground up and Tuyrú Túpac became one of the key figures in this reconstruction. His buildings include the church of San Pedro (1688), the tower of the Recoleta and the Belén church. He is also responsible for a large number of sculptures in the city, including the *Virgen de la Almudena* (1686) in the Almudena church, a retablo in Cuzco Cathedral and the figures and gilding of a retablo at Santa Ana.

Diego de Valadés (1533–82) *Mestizo* friar, painter and writer from New Spain. Born in Tlaxcala to a Spanish father and a Tlaxcalteca mother, Valadés became the first *mestizo* friar in 1549, paving the way for their acceptance into religious orders. A pupil of **Pedro de Gante**, he was a skilled painter and engraver as well as an accomplished Latinist, and he taught at the Colegio de Santa Cruz. In 1570 he became Superior of the mission of San Francisco de Tlaxcala. A brilliant literary talent, Valadés published an influential treatise on Christian life in Mexico called *Rhetorica Christiana* (Perugia, 1579), the first book ever published by an American-born author, which treated theology, philosophy, history and education, and contained a famous image of an ideal Franciscan mission in New Spain.

Cristóbal de Villalpando (c.1644–1714) *Criollo* painter from New Spain. Together with **Juan Correa**, Villalpando ushered in the late **Baroque** style of eighteenth-century New Spain, with its lighter palette, sense of bombast and movement, and broken brushwork. One of his earliest works is the altarpiece of the church of Santa Rosa de Lima (Huaquechula, Puebla; 1675). He is best known for the series of monumental canvases he painted for the sacristy of Mexico City Cathedral, including the *Apotheosis of St Michael*, the *Woman of the Apocalypse*, the *Church Militant and Triumphant* and *Triumph of the Eucharist*. In 1686 he worked on the temporary triumphal arch built in honour of the Conde de la Monclova, Melchor Portocarrero and Lasso de la Vega. In Puebla Cathedral he executed the *Apotheosis of the Eucharist* in the Cúpola de los Reyes, the only painted dome in the history of Mexican colonial architecture.

Marcos Zapata (Sapaca Inka; c.1710/20–c.1773) **Quechua** painter from Peru. One of the leading members of the Cuzco School of painters in the eighteenth century, Zapata was typical of their prodigious output. He alone is believed to be responsible for over 200 paintings. As a young man he trained in the guild system, rising to the rank of master. He soon put his new skills to work, creating an original approach to series of images of the saints' lives, as well as difficult themes such as the Apocalypse. His most famous work is the *Marriage of Don Martín de Loyola to Ñusta Doña Beatriz Qoya* in the **Jesuit** Compañía church in Cuzco.

Juan de Zumárraga (1468–1548) Spanish friar and bishop active in New Spain. The first bishop of Mexico (1528–48), the Franciscan friar Zumárraga was responsible for founding many of the cornerstones of early colonial society. These included the Colegio de Santa Cruz at Tlatelolco in 1536, to teach **Nahua** boys Latin and the liberal arts (including painting and music), a school for Nahua girls and the first college library and printing press in the Americas. He also founded hospitals in Mexico City and Veracruz, and promoted agriculture, industry and handicrafts. Although he is perhaps most famous for burning collections of Aztec manuscripts as heretical books, an incalculable loss for posterity, he also championed the rights of indigenous people. He was elevated to Archbishop of Mexico in 1547.

Key Dates

Numbers in square brackets refer to illustrations

Art of Colonial Latin America
(Country names are modern and used only for convenience)

A Context of Events

c.1200–600 BC Olmec civilization in eastern coastal Mexico; mammoth basalt heads carved at Olmec site of La Venta [3]

448–432 BC Construction of the Parthenon in Athens

c.900–200 BC Chavín civilization in Highland Peru [6]

1–150 AD Construction of the great Pyramid of the Sun, Teotihuacan (Mexico)

1–600 AD Moche civilization in north coastal Peru [10]

1–700 AD Nazca civilization in south coastal Peru [9]

72–80 AD The Roman Colosseum constructed

711 Islamic rule in Spain and Portugal begins

731 Temple of the Giant Jaguar built on the Mayan site of Tikal (Guatemala) [7]

900–1000 Toltecs carve the atlantean guardian figures at Tula (Mexico) [11]
c.900–1125 Construction of Pueblo Bonito in Chaco Canyon (USA) by the Proto-Puebloan civilization, largest pre-Hispanic building in North America

c.1000 Lief Ericson, first European to reach the Americas, founds settlement in Newfoundland (Canada)

1140–4 Abbey church of St Denis in Paris gives birth to the Gothic style

1375 Aztecs found city of Tenochtitlán (Mexico) [12]

1419 Brunelleschi begins the Spedale degli Innocenti in Florence [67]

1427 Foundation of the Inca state (Peru)

1492 Christopher Columbus makes landfall in the Bahamas. Martin Beheim designs the first globe of the world. The Nasrids of Granada, the last Islamic kingdom in Spain, are expelled

1494 Treaty of Tordesillas divides the spheres of conquest of Spain and Portugal

1495–8 Leonardo da Vinci paints his *Last Supper* at Santa Maria delle Grazie, Milan

Art of Colonial Latin America	A Context of Events
	1496 Foundation of Santo Domingo, first permanent European city in the Americas (Dominican Republic)
	1498 Portuguese explorer Vasco da Gama becomes first European to reach India via the Cape of Good Hope
	1499 Columbus introduces the *encomienda* system in Hispaniola (Dominican Republic/Haiti) **1499–1502** Florentine Amerigo Vespucci explores north Brazilian coast
	1500 Portuguese Pedro Alvares Cabral lands for the first time in Brazil **c.1500** Incas build Machu Picchu (Peru) [15] **Early 1500s** Spanish painters Fernando Yáñez and Fernando Llanos train and work in Italy, ushering Italian Renaissance style into Spain
	1501–4 Michelangelo carves his *David*, Florence
	1505–15 Viceroys Almeida and Albuquerque establish Portuguese mercantile empire in Asia
	1507 German scholar Martin Waldseemüller christens the new continents 'America' in honour of Amerigo Vespucci
	1508–12 Michelangelo paints the Sistine Ceiling for Pope Julius II
1510 Construction of Alcázar, Santo Domingo (Dominican Republic) [65]	**1510** Dominican friar Antonio de Montesinos begins struggle against Amerindian slavery **1510–11** First African slaves are brought to America
1512 Construction of Santo Domingo Cathedral [2]	**1512–13** Spanish Laws of Burgos forcibly settles nomadic indigenous people into towns
	1516 English statesman Thomas More writes his *Utopia*, describing communal ownership of land, religious tolerance and equality between the sexes **1516–56** Reign of the Habsburg emperor Charles V of Spain
	1517 Martin Luther begins the Protestant Reformation by posting ninety-five theses at the castle church at Wittenberg
	1519 Spanish officer Hernán Cortés lands in the Yucatán and first encounters Aztec Empire (Mexico)
1520s Diego Díaz de Lisboa constructs the House of Cortés in Cuernavaca (Mexico) [68]	
	1521 Cortés conquers the Aztec Empire, taking the city of Tenochtitlán. Tenochtitlán is renamed Mexico City and the Aztec territories are renamed New Spain
1523 Pedro de Gante founds the first college of the New World, in Texcoco (Mexico) **1523–4** Plan of Mexico City laid out [77]	**1523** The first three Catholic missionaries reach New Spain
1524 Cortés founds the Hospital de la Concepción (Jesús Nazareno) in Mexico City, possibly by Pedro Vásquez and Diego Díaz de Lisboa [70] **1524–32** Construction of the Iglesia Mayor, the first church in Mexico City	**1524** Spaniard Bartolomé Ruiz encounters an Inca trading ship south of Panamá. The first official contingent of Franciscans arrives in New Spain

Art of Colonial Latin America	A Context of Events
	1526–34 Giulio Romano builds the Palazzo del Te in Mantua [83]
	1527 Charles V sacks the city of Rome
1529–70 Construction of Franciscan mission church at Huejotzingo (Mexico) [21]	
1530 Foundation of the guild of gold- and silversmiths in Antigua (Guatemala)	**1530** Six nuns arrive in Mexico City as teachers, the first in the Americas
1531 Virgin of Guadalupe appears in the cloak of Juan Diego Cuauhtlatoatzin in Mexico [1]	**1531** The conquest of Peru under Francisco Pizarro begins. Portugal establishes the first feudal captaincies in Brazil. Bishop Vasco de Quiroga founds first utopian hospice at Santa Fé
1533 Foundation of San Francisco in Quito (Ecuador), the first monastery in South America [162–165]	**1533** Spanish execute Inca Emperor Atawallpa on trumped-up charges in Cajamarca (Peru)
1533–52 Foundation of Hospital of San Nicolás in Santo Domingo [69]	
c.1535–c.1585 Golden age of mural painting in New Spain [21, 39, 45 and 46]	**1535** Foundation of the Viceroyalty of New Spain, the first in the Americas. Foundation of the city of Lima (Peru)
1536 Foundation of the Colegio de Santa Cruz at Tlatelolco (Mexico) to teach Nahua boys Latin and the liberal arts, including painting and music	
	1537 Sebastiano Serlio publishes the first instalment of his architectural manual *Regole generali di architettura* in Venice [61]
c.1538–c.1565 Main era for production of corn-pith statuary in Michoacán (Mexico) [51]	
1539 Diego de Alvarado Huanitzin commissions or paints *The Miraculous Mass of St Gregory*, the earliest dated feather painting [52]	
1540 Foundation of Augustinian college at Tiripetio (Mexico) to teach Purépecha youths, including painting classes taught by Spanish artists from Mexico City	**1540** Pope Paul III approves the foundation of the Society of Jesus (or Jesuits) **1540s** Portuguese painters Francisco de Holanda and António Campelo train in Italy, ushering the Renaissance style into Portugal. Nahua rebel leader Martín Ocelotl attempts to overthrow European rule in New Spain
	1542 Amerindian slavery abolished by New Laws of the Indies. Viceroyalty of Peru founded
	1544 First session of the *Audiencia* of Lima
	1545–63 Council of Trent and beginnings of Catholic reform in the face of Protestantism (also known as the 'Counter Reformation')
	1546 First silver mines developed at Potosí (Bolivia)
1549 First formal carpenter's guild founded in Lima (Peru)	**1549** Jesuits land in Salvador (Brazil), the first Jesuits in America. Salvador acquires its first governor. St Francis Xavier founds the first Jesuit mission in Japan
1550–80 Career of Purépecha feather painter Juan Cuiris, an alumnus of Tiripetío	**1550–1** Public debate about Amerindian slavery between Bartolomé de las Casas and Juan Ginés de Sepúlveda at Valladolid (Spain)
1551 Construction of the House of the Tower of Garcia d'Ávila (Brazil) [80]. Jodoco Ricke founds what becomes known as the Colegio de San Andrés in Quito, to train Quechua and Aymara youths in arts and trades	**1551** Foundation of the Royal and Pontifical University of New Spain in Mexico City, the first university in the Americas

	Art of Colonial Latin America	A Context of Events
		1556–98 Reign of Philip II, son of Charles V and champion of Renaissance style in Spain
1557	First guild of painters and gilders founded in New Spain	
1560	Foundation of the Confraternity of St Joseph for carpenters and bricklayers in Lima. Completion of Acolman mission church façade (Mexico) [124]	**1560s** Taqui Onqoy (Dance of Disease) rebellion in Peru seeks to overthrow European rule
1562	Purchase of palace of Martín Cortés, on the site of Moctezuma's palace in Mexico City, for the Viceregal Palace of New Spain [74]. Construction of the cathedral at Mérida (Mexico) by Juan Miguel de Agüera and others [160]. Juan Gerson paints the vault at Tecamachalco (Mexico) [45]	
1563	Foundation of new cathedral at Mexico City, by Claudio de Arciniega [158]	**1563** Vasco de Quiroga decrees that every town in Michoacán (Mexico) with a church should also have a hospice. Foundation of the Accademia del Disegno in Florence, the first art academy in Europe **1563–82** Philip II commissions El Escorial Palace from the royal architects Juan Bautista de Toledo and Juan de Herrera [78]
1564	Andrés de la Concha finishes the retablo at San Juan Bautista Coixtlahuaca (Mexico) [125]	
		1565 Spanish take the Philippines. The Manila Galleon begins its trade between Manila (Philippines) and Acapulco (Mexico)
		1568 Construction begins of the church of the Gesù in Rome, the Jesuit headquarters and proto-type for many churches around the world [139]
		1569 The Inquisition is founded in Lima. Francisco de Toledo is appointed the fifth Viceroy of Peru
1570	Spanish law restricts the art of gilding to masters (therefore whites), although the law is ignored. Mural of Augustinian church fathers painted at Actopan (Mexico) [145]	
1570s	Painting of the Paradise Garden murals at the Augustinian monastery of Malinalco (Mexico) [46]. Professional teams of retablo makers begin travelling throughout New Spain	
		1571 The Inquisition is founded in Mexico City
before 1572	Incas build their last urban stronghold at Espíritu Pampa (Peru) combining Inca masonry traditions with imitation Spanish roof tiles	
1572	Viceroy Francisco Toledo commissions series of Inca portraits for Philip II	
1573	The Laws of the Indies establish grid plan as standard throughout Spanish America	**c.1573–c.1583** Mendicant missions in New Spain are handed over to parish priests
1574	Jesuit Bernardino Bitti arrives in Lima, first European painter in South America	
1575	Foundation of the Convento de Santa Catalina in Arequipa (Peru) [26].	
		1576 Construction of the Jesuit church of the Assumption in Kyoto, the largest Catholic church in Japan
		1578 Sir Walter Raleigh and Sir Humphrey Gilbert begin expedition against the Spanish in the Caribbean for Elizabeth I of England
		1579 Birth of San Martín de Porres in Lima, America's first black saint. Diego de Valadés, first

Art of Colonial Latin America	A Context of Events
	mestizo friar in America, publishes his *Rhetorica Christiana* in Italy, the first book published by an American-born author [115]
1580s Italian painter Matteo da Leccio, one of the last artists to paint the Sistine Chapel, emigrates to Lima	**1580–1640** Spain and Portugal are united under one crown, although they operate as distinct powers
1581 Philip II commissioned military engineer Battista Antonelli to inspect and repair the Caribbean forts. San Francisco in Quito completed by Benito de Morales or Alonso de Aguilar [162–165]	**1581** Final conquest of Inca territory secure. Protestant Netherlands breaks free from Spanish control
	1583 Foundation of the Seminary of Painters, a Jesuit art academy in Japan
1584–6 Construction of the retablo at Huejotzingo by Simón Pereyns and Pedro de Requena [21]	
	1585 Construction begins of the Cathedral at Valladolid (Spain) by Juan de Herrera [155]
	1587–1607 Construction of the church of San Agustín in Manila [218]
	1588 Destruction of the Spanish Armada by English navy under Elizabeth I
	1591 Commissaries from the Portuguese Inquisition begin periodic visits to Brazil
1598 Construction begins at the Forte dos Reis Magos in Natal (Brazil) [81]	**1598** Florentine painter Bartolommeo Carducci becomes a court painter in Spain. Spanish colony of New Mexico founded (USA)
1599 Andrés Sánchez Galque paints the *Portrait of the Mulattos of Esmeraldas*, the oldest dated painting in South America [90]	**1599–1602** Caravaggio paints three canvases in the Contarelli Chapel, Rome, helping to usher in the early Baroque style and secure his reputation
	1601–3 Jesuits ordain Japanese priests, the first non-European priests in the Catholic church **1601** Jesuit church at Diu constructed (India) [214]. Construction begins of Jesuit church of Nossa Senhora da Assunção in Macao (China) [215]
1603 Completion of the Viceregal Palace in Lima [77]	**1603** Samuel de Champlain becomes first governor of Canada, founds New France
	1607 Foundation of Jamestown in Virginia (USA), the first permanent English settlement in North America
	1608 Foundation of city of Québec (Canada)
1609 Foundation of the Jesuit Reductions of Paraguay (Paraguay, Argentina, Brazil)	
1610–80 First Franciscan missions among the Puebloans (USA)	
1613–15 Guaman Poma de Ayala writes his *Nueva Corónica* [22 and 102]	
	1614 Jesuits orchestrate a false embassy of four Japanese Samurai to New Spain and Europe. The Jesuits are expelled from Japan
1618 Japanese and other Asian communities settle outside Puebla and Guadalajara (Mexico)	**1618–48** Thirty Years War in Europe, which begins as a war between Protestants and Catholics and ends up as a European power struggle. Spain participates in the war
	1620 Crossing of the Mayflower with the Pilgrim Fathers to Massachusetts (USA)

Art of Colonial Latin America	A Context of Events
1621 Foundation of a guild of black silversmiths in Bahia (Brazil)	**1621** The Dutch establish the West India Company
	1624–54 Dutch conquest of northern Brazil
	1625 Jesuits start missions to Amerindians in Canada
1629–44 Construction of Franciscan mission of San Esteban Rey at Ácoma, (USA) [141]	
1630–57 Fort of San Felipe de Barajas (Colombia) commissioned by Pedro Zapata de Mendoza [63]	**1630** Foundation of the city of Boston (USA)
1639–59 Tenure of Bishop Juan de Palafox y Mendoza, Puebla's greatest arts patron	
1641–58 Francisco Zurbarán paints his series of the *Lives of the Saints* for the monastery of St Camillus de Lellis in Lima and his *Apostles* series for the monastery of Santo Domingo in Antigua [96]	
1650 Cuzco destroyed in the great earthquake (Peru)	
	1651 Birth of the poet Sor Juana Inés de la Cruz in Mexico City
1653 Viceroy of New Spain issues ordinances in favour of the new guild of ceramicists in Puebla, establishing the Talavera Poblana workshop	
	1655–95 Reign of Zumbí, the ruler of the *quilombo* of Palmares (Brazil)
1657–74 Construction of the new church of San Francisco in Lima, following an earthquake [162]	
	1664 *Entrada* of Viceroy Don Antonio Sebastián de Toledo, Marquis of Mancera, and Vicereine Doña Leonor Carreto. Contruction of the church of Nossa Senhora da Nazaré in Luanda (Angola) [212]
1668 Completion of the Compañía in Cuzco, the most important new structure following the 1650 earthquake, by Jean-Baptiste Gilles or Martinez de Oviedo [166]	
1670 *St Rose of Lima*, important sculptural group by Italian Baroque master Melchiorre Cafà shipped from Rome to Santo Domingo in Lima [97]	
1673–99 Tenure of Bishop Manuel de Mollinedo y Angulo, Cuzco's greatest arts patron	
c.1674–c.1680 Execution of the *Corpus Christi* series of canvases now at the Museo de Arte Religioso in Cuzco [173]	
	c.1675–82 Height of the career of Spanish painter Bartolomé Esteban Murillo
	1680 The Pueblo Revolt expels the Spanish from New Mexico
1681 Diego Quispe Tito executes his *Zodiac* series in Cuzco Cathedral [176]	
1684–1709 New shrine constructed at Guadalupe (Mexico) by José Durán y Diego de los Santos and Pedro Arrieta [58]	
1685–6 Juan Correa paints his *Assumption of the Virgin* in Mexico City Cathedral [177]	
1686–1737 Construction of São Francisco in Salvador by Fr Vicente das Chagas, Fr Jerónimo de Graça and Manoel Quaresima [170]	

Art of Colonial Latin America	A Context of Events
1687–8 Andean painters accuse Spanish masters of mistreatment and declare intention to form their own guilds, paving the way for the Cuzco School of Painting	
1688–9 Juan Tomás Tuyrú Túpac builds the church of San Pedro in Cuzco [103]. Cristóbal de Villalpando paints his *Apotheosis of the Eucharist* in the Chapel of the Kings in Puebla Cathedral, the only painted dome in New Spain [178]	
1690 Completion of the Rosary Chapel in the monastery of Santo Domingo in Puebla [172]	**1690** French Canada has a population of 10,000. The English colonies to the south have a population of 200,000, the largest European settlement north of New Spain
	1693 Foundation of the gold mines at Minas Gerais (Brazil)
	1694 Viceroyalty of Brazil founded
	1700 Bourbon monarchy takes over in Spain. African king Chico-Rei is taken to Brazil with his tribe as slaves
	1701 Architect Johannes Friedrich Ludwig establishes Germanic Rococo style at the Portuguese court, from where it soon spreads to Brazil
	1703 Foundation of the Parián (or Chinatown) district in Mexico City
1708/9 French painter Charles Belleville reaches Salvador (Brazil)	**1708–9** Paulistas fight civil war in Brazil over mine ownership
	1715–74 Reign of Louis XV of France, champion of Rococo culture
1716 Melchor Pérez Holguín paints *The Entry of Viceroy Archbishop Morcillo into Potosí* [57]	
1718–37 Jerónimo de Balbás builds the Altar of the Kings in Mexico City Cathedral, ushering in the Estípite-Baroque style [154]	**1718** Viceroyalty of New Granada (Colombia, Ecuador, Venezuela and Panama) founded
1720s First Germanic Jesuit artists and artisans arrive in Santiago and the Calera de Tango (Chile)	**1720** Gold mines at Matto Grosso established (Brazil). A Portuguese government decree limits the freedom of women of European background to leave Brazil
	1725 Construction begins of Chiswick House, Kent, by Lord Burlington and William Kent, ushering Neoclassicism into England
1727 Construction of the reduction church of San Ignacio Miní (Argentina) [44]	
c.1730 Construction of the parish church of Acatepéc (Mexico) [134]	
1731–47 Construction of reduction church of São Miguel (Brazil) by Giovanni Battista Primoli [138]	
1733 Black confraternity under Chico-Rei commissions church of Santa Ifigênia dos Pretos in Ouro Prêto which is finished in 1780 (Brazil) [28]	
before 1734 Construction of mission church of Santa María at Achao, Chiloé (Chile) [143, 144]	
1735 Palace of the Torre-Tagle (Peru) completed [186]	

Art of Colonial Latin America	A Context of Events
1741 Quito's first guild of painters and *encarnadores* founded. Francisco Xavier de Brito moves to Ouro Prêto	
1749–68 Lorenzo Rodríguez rebuilds Sagrario Metropolitano in Mexico City, an important prototype of Estípite-Baroque style [161]	
1750 Hacienda La Herrería built by Don Miguel Ponce de León (Ecuador) [188]. Miguel Cabrera paints posthumous portrait of the poet Sor Juana Inés de la Cruz [193]	
	1752 Royal Academy Madrid, founded
	1756–63 Miguel Cabrera publishes account of the Virgin of Guadalupe at the Colegio de San Ildefonso Press. First permanent battalions of Spanish troops arrive in the Americas following the Seven Years War with Britain, when Spain lost Florida
	1757–92 Jacques-Germain Soufflot builds the Panthéon in Paris, ushering Neoclassical style into France
	1758 The Jesuits are expelled from Portugal, and Brazil and Portugal's Asian territories
	1759 The British take Québec and annex New France
c.1760 Georg Lanz carves the pulpit in the church of La Merced in Santiago [150–153]. Purépecha lacquer artist Manuel de la Cerda creates his finest work [55]	
1762–1771 Construction of the Governor's Palace at Belém do Pará (Brazil), the largest public structure in Portuguese America [82]	
	1763 Rio de Janeiro, closer to the mines of Minas Gerais, succeeds Salvador as capital of Brazil
	1767 Jesuits are expelled from Spain, Spanish America and the Philippines
1768–82 Franciscan mission church of San José y San Miguel de Aguayo constructed (USA) [136, 137]	
	1770 Construction begins of Thomas Jefferson's home, Monticello, in Virginia, ushering Neoclassicism into Anglo America
1773 Filipino sculptor Esteban Sampzon recorded as living in Buenos Aires (Argentina)	**1773** Society of Jesus suppressed worldwide
	1776 Viceroyalty of Río de la Plata (Argentina, Paraguay, Uruguay and Bolivia) founded. American Revolution and the foundation of the United States of America
1778 Free Trade Edict of the Bourbon kings permits direct trade with Spain. It an has enormous impact on the sculpture workshops at Quito and the painting workshops in Cuzco	
1780 Junta de Policía formed in Mexico City to monitor all architectural activity	**1780–1** Tupac Amaru II uprising against Spanish (Peru)
1785 Foundation of Mexico City's Real Academia de San Carlos	
	1789 French Revolution
1793 All guilds are abolished in Quito	**1793** Jacques-Louis David paints *The Death of Marat*

	Art of Colonial Latin America	A Context of Events
1795–after 1799	The Royal Mint in Santiago (Chile) is constructed, the most important Neoclassical monument in South America [84]	
1797–1813	Construction of the School of Mines in Mexico City, the most important Neoclassical monument in New Spain [112]	
1800–3	Aleijadinho carves his *Prophets* series at the pilgrimage church of Bom Jesus de Matosinhos in Cangonhas do Campo (Brazil) [182]	
		1804 Haitian independence. Napoleon declared emperor of France
		1805 Spanish fleet defeated by the British at Trafalgar
		1807–21 Portuguese royal family lives in Brazil to escape Napoleon
		1808 The French invade Spain and Napoleon's brother Joseph seizes Spanish throne
		1809 First South American independence movement begins in Chuquisaca (Bolivia)
		1811 Paraguayan Independence
		1812 Wellington enters Madrid; liberal constitution imposed on Spain
		1816 Argentine Independence
1817	Final touches put on Mexico City Cathedral by Manuel Tolsá [158]	
		1818 Chilean Independence
1820	Academy of Fine Arts founded in Rio de Janeiro (Brazil)	
		1821 Mexican Independence. Guatemalan Independence
		1822 Dom Pedro I proclaims Brazilian Independence and crowns himself Emperor. Ecuadorian Independence
		1824 Peruvian Independence
		1828 Uruguayan Independence from Brazil
		1848 United States invades Mexico and conquers New Mexico, Arizona and Texas
		1861–5 Civil War between the Confederate States and United States of America. Slavery abolished in the United States
		1867 Canadian Confederation makes nation independent of England
		1889 Brazilian Emperor toppled in a coup and republic declared. Slavery abolished in Brazil
		1898 Spain loses Puerto Rico (Cuba) and the Philippines to the United States of America

THE UNITED STATES OF AMERICA

Los Angeles
Tucson
Acoma
Abó
San Antonio

Atlantic Ocean

Monterrey
MEXICO

THE BAHAMAS

Havana
CUBA
Mérida
Morelia
Huejotzingo
Patzcuaro
Veracruz
Mexico City
Cuernavaca Puebla
Acapulco Oaxaca GUATEMALA
Antigua

DOMINICAN
REPUBLIC
JAMAICA HAITI
BELIZE
Santo Domingo

COSTA RICA
Cartagena
Caracas
TRINIDAD &
TOBAGO
PANAMA
Medellín
Cúcuta
VENEZUELA

Bogotá
COLOMBIA
Quito
ECUADOR

Belém do Pará

Paita
PERU
Cajamarca

Natal
Recife

BRAZIL

Lima
Cuzco BOLIVIA
Andahuaylillas Lampa
Arequipa
Ayo Ayo La Paz
Sica-Sica
Sucre
Potosí Manquiri
PARAGUAY

Praia do Forte
Cachoeira Salvador
Brasília

Concepción
Santa Cruz
Congonhas
do Campo Ouro Prêto
Rio de Janeiro

São Paulo

Pacific Ocean

Trinidad

CHILE
San Ignacio Miní

Cordova
Santa Fé URUGUAY
Santiago
Buenos Aires Montevideo
La Plata

ARGENTINA

CHILOE
Achao

0 2000 miles

0 2000 kilometres

TIERRA DEL FUEGO

Borders shown are those at the beginning of the 21st century

Further Reading

The literature in Spanish and Portuguese (as well as French and German) is vast and, as this book is aimed at an English-speaking audience, I have included only the most important texts. For an extensive bibliography on colonial Spanish America in all languages, see *Los Siglos de Oro*. For an extensive bibliography on colonial Brazil, see Sullivan (2001).

General Works

Listed below are cultural histories as well as specifically art-historical texts that deal with larger regions of colonial Latin America. Few studies consider both Spanish America and Brazil, and there are not many that treat Spanish North and South America under one cover.

Luisa Elena Alcalá, *Fundaciones Jesuíticas en Iberoamérica* (Madrid, 2002)

Diego Angulo-Iñiguez, et al., *Historia del Arte Hispano-Americano*, 3 vols (Barcelona, 1945–56)

Gauvin Alexander Bailey, *Art on the Jesuit Missions in Asia and Latin America, 1540–1773* (Toronto and Buffalo, 1999)

Arnold J Bauer, *Goods, Power, History. Latin America's Material Culture* (Cambridge, 2001)

D Bayón and M Marx, *History of South American Colonial Art and Architecture* (New York, 1992)

Elizabeth Hill Boone and Tom Cummins (eds), *Native Traditions in the Postconquest World* (Washington, DC, 1998)

Sara Bomchil and Virginia Carreño, *El mueble colonial de las Américas y su circunstancia historica* (Buenos Aires, 1987)

Yves Bottineau, *Iberian-American Baroque* (New York, 1970)

Anita Brenner, *Idols Behind Altars* (New York, 1929)

Mario J Buschiazzo, *Arquitectura colonial* (Buenos Aires, 1944)

François Cali, *The Spanish Arts of Latin America* (New York, 1961)

Leopoldo Castedo, *A History of Latin American Art and Architecture* (New York and Washington, DC, 1969)

Diana Fane (ed.), *Converging Cultures: Art & Identity in Spanish America* (exh. cat., Brooklyn Museum of Art, 1996)

Claire Farago (ed.), *Reframing the Renaissance* (New Haven and London, 1995)

Ángel Guido, *Redescubrimiento de América en el Arte* (Rosario, 1940)

Ramón Gutiérrez, *L'arte cristiana del nuovo mondo: il barocco dalle Ande alle Pampas* (Milan, 1997)

—, *Pintura, escultura y artes útiles en iberoamérica, 1500–1825* (Madrid, 1995)

Isabella Stewart Gardner Museum, *The Word Made Image: Religion, Art, and Architecture in Spain and Spanish America, 1500–1600* (Boston, 1998)

Richard L Kagan, *Urban Images of the Hispanic World, 1493–1793* (New Haven and London, 2000)

Pál Kelemen, *Baroque and Rococo in Latin America* (New York, 1951)

Carmela Padilla (ed.), *Conexiones: Connections in Spanish Colonial Art* (Santa Fe, 2002)

Gabrielle Palmer and Donna Pierce, *Cambios: The Spirit of Transformation in Spanish Colonial Art* (exh. cat., Santa Barbara Museum of Art, 1992)

Santiago Sebastián, *El barrocco iberoamericano* (Madrid, 1990)

John F Scott, *Latin American Art: Ancient to Modern* (Gainsville, 1999)

Los Siglos de Oro en los Virreinatos de América, 1550–1700 (exh. cat., Museo de América, Madrid, 1999)

Francisco Stastny, *El manierismo en la pintura colonial latinoamericana* (Lima, 1981)

Eddy Stols and Rudi Bleys, *Flandre et Amérique latine* (Antwerp, 1993)

Edward J Sullivan, *Latin American Art in the Twentieth Century* (London, 1996)

Rubén Vargas Ugarte, *Ensayo de un diccionario de artífices coloniales de la America Meridional* (Lima, 1947)

Monographs on Specific Regions or Artists

Rolena Adorno, *Guaman Poma: Writing and Resistance in Colonial Peru* (Austin, 1986)

Americas Society, *Guaman Poma de Ayala: The Colonial Art of an Andean Author* (New York, 1992)

—, *Paradise Lost: The Jesuits and the Guaraní South American Missions* (New York, 1989)

Americas Society Art Gallery, *Potosí: Colonial Treasures and the Bolivian City of Silver* (New York, 1997)

—, *Southern Splendor: Masterworks of Colonial Silver from the Museo Isaac Fernandez Blanco, Buenos Aires* (New York, 1987)

Verle Lincoln Annis, *The Architecture of Antigua Guatemala, 1543–1773* (repr. Guatemala City, 2001)

Associação Brasil 500 Anos Artes Visuales, *Mostra do Redescobrimento: Arte Barroca* (São Paulo, 2000)

Kurt Baer, *Architecture of the California Missions* (Berkeley, 1958)

Gauvin Alexander Bailey, '"Just Like the Gesù": Sebastiano Serlio, Giacomo Vignola,

and Jesuit Architecture in South America', in *Archivum Historicum Societatis Iesu LXX*, 140 (July–December, 2001), pp.233–64

—, 'The Jesuits and the Non-Spanish Contribution to South American Colonial Architecture', in H M Pabel and K M Comerford (eds), *Early Modern Catholicism: Essays in Honour of John O'Malley* (Toronto, 2001), pp.211–40

Joseph A Baird, *The Churches of Mexico, 1530–1810* (Berkeley, 1962)

Banco de Crédito del Perú, *Colección arte y tesoros del Perú: Escultura en el Perú* (Lima, 1999)

—, *Colección arte y tesoros del Perú: Pintura en el Virreinato del Perú*, (Lima, 2001)

—, *Colección arte y tesoros del Perú: Pintura mural en el sur andino* (Lima, 1993)

—, *Colección arte y tesoros del Perú: Pintura virreynal* (Lima,1973)

D A Brading, *Mexican Phoenix: Our Lady of Guadalupe, Image and Tradition across Five Centuries* (Cambridge, 2001)

Bainbridge Bunting, *Early Architecture in New Mexico* (Albuquerque, 1976)

Germain Bazin, *L'architecture religieuse baroque au Brésil*, 2 vols (Paris, 1956)

Teofilo Benavente Velarde, *Historia del arte cusqueño: pintores cusqueños de la colonia* (repr. Cuzco, 1995)

Marcus Burke, *Treasures of Mexican Colonial Painting: The Davenport Museum of Art Collection* (Santa Fe, 1998)

—, *Pintura y escultura en Nueva España* (Mexico City, 1992)

Louise Burkhart, *The Slippery Earth: Nahua-Christian Moral Dialogue in Sixteenth-Century Mexico* (Tucson, 1989)

Rafael Carrillo Azpeitia, *Juan Gerson. Pintor indígena del siglo XVI* (Mexico City, 1972)

Abelardo Carrillo y Gariel, *El pintor Miguel de Cabrera* (Mexico City, 1966)

Leopoldo Castedo, *The Baroque Prevalence in Brazilian Art* (New York, 1964)

—, *The Cuzco Circle* (New York, 1976)

Teresa Castelló Yturbide, *The Art of Featherwork in Mexico* (Mexico City, 1993)

Ruth Corcuera, *Herencia textil andina* (Buenos Aires, 1995)

Thomas B F Cummins, *Toasts With the Inca: Andean Abstraction and Colonial Images on Quero Vessels* (Ann Arbor, 2002)

Carol Damian, *The Virgin of the Andes: Art and Ritual in Colonial Cuzco* (Miami Beach, 1995)

Carolyn Dean, *Inka Bodies and the Body of Christ: Corpus Christi in Colonial Cuzco, Peru* (Durham, NC, 1999)

Christian Duverger, *Agua y fuego: arte sacro indígena de México en el siglo XVI* (Mexico City, 2002)

James Early, *The Colonial Architecture of Mexico* (Albuquerque, 1994)

Samuel Y Edgerton, *Theaters of Conversion: Religious Architecture and Indian Artisans in Colonial Mexico* (Albuquerque, 2001)

Ticio Escobar, *Una interpretación de las Artes Visuales en el Paraguay*, 2 vols (Asunción, 1980)

Valerie Fraser, *The Architecture of Conquest* (Cambridge, 1990)

Gillermo Furlong, *Arte en el Río de la Plata, 1530–1810* (repr. Buenos Aires, 1993)

Charles Gibson, *The Aztecs under Spanish Rule* (Stanford, 1964)

Teresa Gisbert, *Iconografía y mitos indígenas en el arte* (La Paz, 1980)

—, *El paraíso de los pájaros parlantes: la imagen del otro en la cultura andina* (2nd edn, La Paz, 2001)

Teresa Gisbert and José de Mesa, *Arquitectura andina: historia y análisis* (La Paz,1985)

—, *Holguín y la pintura virreinal en Bolivia* (La Paz, 1977)

Gloria in Excelsis: The Virgin and Angels in Viceregal Painting of Peru and Bolivia (exh. cat., Center for Inter-American Relations, New York, 1986)

Ricardo González, *Imagenes de dos mundos: la imaginería cristiana en la Puna de Jujuy* (Buenos Aires, 2003)

Mary Grizzard, *Spanish Colonial Art and Architecture of Mexico and the US Southwest* (Lanham, MD, 1986)

Serge Gruzinski, *The Conquest of Mexico* (repr. Cambridge, 1996)

—, *Painting the Conquest: The Mexican Indians and the European Renaissance* (Paris, 1992)

Ramón Gutiérrez, *Arquitectura del altiplano peruano* (Buenos Aires, 1986)

—, *The Jesuit Guaraní Missions* (Rio de Janeiro, 1987)

Detlef Heikamp, *Mexico and the Medici* (Florence, 1972)

Ilona Katzew, *Casta Painting* (New Haven and London, 2004)

—, *New World Orders: Casta Painting and Colonial Latin America* (New York, 1996)

Benjamin Keen, *The Aztec Image in Western Thought* (repr. Rutgers, 1990)

Alexandra Kennedy (ed.), *Arte de la Real Audiencia de Quito, siglos XVII-XIX* (Quito, 2002)

George Kubler, *Mexican Architecture of the Sixteenth Century* (New Haven, 1948)

—, 'Mexican Urbanism in the Sixteenth Century', *Art Bulletin*, 24:2 (June, 1942), pp.160–71

—, 'On the Colonial Extinction of the Motifs of Pre-Columbian Art', in Thomas F Reese (ed.), *Studies in Ancient American and European Art* (New Haven and London, 1985), pp.66–80

—, *The Religious Architecture of New Mexico in the Colonial Period and Since the American Occupation* (Colorado Springs, 1940)

George Kubler and Martín Soría, *Art and Architecture in Spain and Portugal and their American Dominions 1500–1800* (Baltimore, 1959)

George Kuwayama, *Chinese Ceramics in Colonial Mexico* (Los Angeles, 1997)

James Lockhart, *The Nahuas After the Conquest* (Stanford, 1992)

John McAndrew, The Open-Air Churches of Sixteenth-Century Mexico: Atrios, Posas, Open Chapels, and Other Studies (Cambridge, MA, 1965)

Sabine MacCormack, 'From the Sun of the Incas to the Virgin of Copacabana', Representations, 8 (1984), pp.30–60

—, 'Pachacuti: Miracles, Punishments, and Last Judgment', American Historical Review, 93 (December, 1988), pp.960–1006

—, Religion in the Andes (Princeton, 1991)

C J McNaspy and J M Blanch, Lost Cities of Paraguay (Chicago, 1982)

Margaret Connors McQuade, Talavera Poblana: Four Centuries of a Mexican Ceramic Tradition (New York, 1999)

Hans Mann and Graciela Mann, The 12 Prophets of Aleijadinho (Austin and London, 1967)

Manrique Zago Ediciones, Las misiones jesuíticas del Guayrá (Buenos Aires, 1995)

Sidney David Markman, Architecture and Urbanism of Colonial Central America (Tempe, 1993–5)

—, Architecture and Urbanization in Colonial Chiapas Mexico (Philadelphia, 1984)

—, Colonial Architecture of Antigua, Guatemala (Philadelphia, 1966)

Mexico: Splendors of Thirty Centuries (New York, 1990)

Ramón Mujica Pinilla, Ángeles apócrifos en la América virreinal (repr. Mexico City, 1996)

Robert J Mullen, Architecture and its sculpture in Viceregal Mexico (Austin, 1997)

—, The Architecture and Sculpture of Oaxaca (Tempe, 1995)

Museo de Arte de Lima, Art in Peru: Works from the Collection of the Museo de Arte de Lima (Lima, 2001)

Museo Poblano de Arte Virreinal, El retrato novohispano en el siglo XVIII (Puebla, 1999)

Museu Nacional de Belas Artes, Rio de Janeiro. Antônio Francisco Lisboa o 'Aleijadinho': o que vemos e o que sabemos (Rio de Janeiro, 2000)

José Gabriel Navarro, El arte en la provincia de Quito (Mexico City, 1960)

Anthony Pagden, The Fall of Natural Man (Cambridge, 1982)

Erwin Walter Palm, Los monumentos arquitectónicos de la Española (repr. Santo Domingo, 2002)

Gabrielle G Palmer, Sculpture in the Kingdom of Quito (Albuquerque, 1987)

J H Parry, The Spanish Seaborne Empire (repr. Berkeley, 1990)

Octavio Paz, Sor Juana, or the Traps of Faith, trans. by Margaret Sayers Peden (Cambridge, MA, 1988)

Eugenio Pereira Salas, Historia del arte en el reino de Chile (Santiago, 1965)

Jeannete Favrot Peterson, The Paradise Garden Murals of Malinalco (Austin, 1993)

—, 'The Virgin of Guadalupe: Symbol of Conquest or Liberation?' Art Journal (Winter 1992), pp.39–47

Donna Pierce et al., Painting a New World: Mexican Art and Life, 1521–1821 (Denver, 2004)

Pedro Querejazu, Las misiones jesuíticas de Chiquitos (La Paz, 1995)

Myriam Andrade Ribeiro de Oliveira, O rococó religioso no Brasil e seus antecedentes europeus (São Paulo, 2003)

Adolfo Luis Ribera and Hector Schenone, El arte de la imaginería en el Río de la Plata (Buenos Aires, 1948)

Robert Ricard, The Spiritual Conquest of Mexico (Berkeley, 1966)

Héctor Rivero Borrell et al., The Grandeur of Viceregal Mexico: Treasures from the Franz Mayer (Mexico City and Houston, 2002)

Donald Robertson, Mexican Manuscript Painting of the Early Colonial Period: The Metropolitan Schools (New Haven, 1959)

Paul M Roca, Spanish Jesuit Churches in Mexico's Tarahumara (Tucson, 1979)

Mardith Schuetz-Miller, Building and Builders in Hispanic California, 1769–1850 (Tucson, 1994)

Augusto Carlos da Silva Telles, Atlas dos monumentos históricos e artísticos do Brasil (Rio de Janeiro, 1980)

Robert Chester Smith with Elizabeth Wilder, A Guide to the Art of Latin America (Washington, 1948)

Francisco Stastny, Pérez de Alesio y la Pintura del Siglo XVI (Buenos Aires, 1970)

Rebecca Stone-Miller, To Weave for the Sun: Ancient Andean Textiles (Boston, 1992)

Edward J Sullivan, Brazil Body & Soul (exh. cat., Guggenheim Museum, New York and Bilbao, 2001)

Bozidar D Sustersic, Templos Jesuítico-Guaranies (Buenos Aires, 1999)

Percival Tirapeli and Wolfgang Pfeiffer, As mais belas igrejas do Brasil (São Paulo, 2001)

Manuel Toussaint, La catedral de México (repr. Mexico City, 1992)

—, Colonial Art in Mexico, trans. by Elizabeth Wilder Weismann (Austin, 1967)

—, La pintura en México durante el siglo XVI (Mexico City, 1936)

Guillermo Tovar de Teresa, Pintura y escultura en Nueva España (1557–1640) (Mexico City, 1992)

Marc Treib, Sanctuaries of Spanish New Mexico (Berkeley and Los Angeles, 1993)

Richard C Trexler, 'Aztec Priests for Christian Altars', in Richard C Trexler (ed.) Church and Community (Rome, 1987), pp.469–92

Unión Latina, El retorno de los angeles: barroco de las cumbres en Bolivia (La Paz, 1996)

Gary Urton, Signs of the Inka Khipu (Austin, 2003)

Elizabeth Wilder Weismann, Art and Time in Mexico (New York, 1985)

—, Mexico in Sculpture, 1521–1821 (Cambridge, MA, 1950)

Harold E Wethey, Colonial Architecture and Sculpture in Peru (Cambridge, MA, 1949)

Index

Numbers in **bold** refer to illustrations

Acknowledgements

This book would not have been possible without the generous assistance of many people throughout Latin America, North America and Europe. Above all, I would like to acknowledge the crucial assistance of Peta Gillyatt, who helped me conceive the original idea of this book and came up with many of the themes for the chapters. She also travelled exhaustively with me to visit sites and art works in Mexico and South and Central America. Space compels me to list the rest of these generous individuals in alphabetical order: Luisa Elena Alcalá, Marysabel Alvarez Plata, Roberto Paulo Cezar de Andrade, Henry Aparicio S J, Eduardo Julio Arteaga, Cecilia E Assunção Corallo, Fernando O Assunção, Sylvia Maria Menezes de Athayde, Rafael Ayerza Achával, Ian and Sherry Ballantyne, Gustavo Barros, Clara Bargellini, Alberto Bellucci, Maria Bonta de la Pezuela, Gabriela Braccio, David Brading, Jonathan Brown, Soledad and Claudia Bruzzone, Ximena Carcelen, Charlotte de Castelnau-L'Estoile, Susanna Cavellini, Jorge Cometti, Constance Cortez, Tom Cummins, Oscar Centurion Frontanilla, Pedro Corrêa do Lago, Ana María Chumacero de Thames, Jorge Cometti, Ines Coutinho, Carolyn Dean, Eduardo Diaz Hermelo, Rosa Dopazo Durán, Barbara Duncan, Samuel Y Edgerton, Consuelo Esguerra, Raúl Espinosa Villanueva, Susana A Fabrici, Jeaninne Falino, Juan Carlos Fernández-Catalán, Alicia Fraschina, Walter Fuentes, Agustín García-Real de los Ríos, María Concepción García Sáiz, Ana García Sanz, Abelardo García Viera, Guy Gillyatt, Teresa Gisbert, Martha Gomez Gama, Patricia Groves, Serge Gruzinski, Walter Hanisch Espíndola, Johanna Hecht, Mauro Herlitzka, Roberta and Dick Huber, José María Jaramillo Breilh, Emilio and Mauricio Lluis, Miguel Jauregui Rojas, Richard Kagan, Ángel Kalenberg, Alexandra Kennedy, T Frank Kennedy S J, David Kowal, Erendira de la Lama, Andrea Lepage, Norberto Levinton, John and James Li, Natalia Majluf, Luis C López Morton, Mónica López Velarde, Marta Loredo, Enrique J Luco, Sabine MacCormack, Elida M Masson, Lisle Francis McNair, Margaret Connors McQuade, Jorge Melo, María del Pilar Miño, Oscar Manosalvas, Magnus Mörner, Mireya Muñoz, Marysol Nieves, João Sérgio Marinho Nunes, Marion Oettinger, Pamela A Parmal, Tony Pasinski, Ricardo A Pérez Alvarez, Gabriel Perez-Barreiro, Alberto Gabriel Piñeiro, Kathryn Puffett, Leo W Hillar Puxeddu, Myriam Andrade Ribeiro de Oliveira, John W O'Malley S J, Héctor Rivero Borrell, Rodrigo Rivera Lake, Paul Russell and Robert Jeffrey, Diego Santander, Anne-Louise Schaffer, Hector H Schenone, Francisco Soares Senna, Alex Seowtewa, Francisco Stastny, Bozidar D Sustersic, Anita Suárez de Terceros, Edward Sullivan, Osvaldo Svanascini, Celia M Terán, Vera L Bottrel Tostes, Gustavo Tudisco, Nuno Vassallo e Silva, Oswaldo Viteri, Lúcio Wagner Lima Valente, Lauren D Whitley, Carlos Yánez and Catherine Wilkinson Zerner. I am especially grateful to the students in my seminar 'Tropical Baroque' at Clark University for helping me fine-tune the ideas and language in this book, particularly Teresa Sarroco, Erica Cook, Tiffany Racco and Anita Hayashi, who helped me with various photography and editing issues. I would also like to acknowledge the encouragement, assistance and patience of staff at Phaidon, Pat Barylski and especially Julia MacKenzie, Beulah Davies and Joanne Beardwell, who saw this project through to its completion. I would like to acknowledge the support of the Higgins School of the Humanities at Clark University, the Jesuit Institute at Boston College and the National Endowment for the Humanities for the research travel which made this book possible. Three chapters of this book were written while a fellow at the Harvard University Center for Italian Renaissance Studies at Villa I Tatti in Florence and I am grateful to that institution for its support.

Photographic Credits

A K Smiley Library, Redlands: 240; Academia Nacional de Belles Artes, Buenos Aires: 29; AKG: 232, photo Gilles Mermet 39, 145; Ancient Art & Architecture Collection: photo B Norman 136; Archivo Criollo: Museo Nacional de Arte Colonial 105; Archivo General de Indias, Seville: 64, 75; Arizona State Historical Society, Tucson: 200; The Art Archive: 35, 45, 83, 124, 134, Museo de Arqueología e Historia del Estado de México, Toluca 38, Museo Nacional de Arqueología, Antropología e Historia del Perú, Lima 10, Pinacoteca San Diego, Mexico 91; Art Directors & Trip Photo Library: 7, 162, photo Martin Barlow 171, photo T Bognar 215, photo A Deutsch 26, photo Judy Drew 28, photo Efrin Knight 68, photo K McLaren 72, photo J Sweeney 169; The Art Institute of Chicago: photo Robert Hashimoto 41; Artothek: Alte Pinakothek, Munich 88, photo Blauel/Gnamm 101; Gauvin Alexander Bailey: 15, 23, 34, 36, 42–4, 65, 70, 73, 79, 80, 99, 103, 108, 123, 126–31, 133, 135, 137, 142–3, 149–153, 161, 163, 168, 182–3, 187, 205, 216, 218, 221; Banamex Collection, Mexico City: 25; Benson Latin American Collection, University of Texas at Austin: 33; Biblioteca Nacional, Madrid: 32, 59, 114; Biblioteca Nacional de Colombia, Bogotá: 225; Biblioteca Nazionale Centrale di Firenze: 62; Bibliothèque Nationale, Paris: 14, 17; Bibliothèque Royale de Belgique, Brussels: 98; Bridgeman Art Library: 19, 61, 66, 87, 203, photo Paul Freeman 203, photo Paul Maeyaert 109, 176, Banco Mexicano de Imagenes: photo Arturo Osorno 112, Brooklyn Museum of Art, New York 50, 92, 192, 196, Museu de Arte Contemporânea da Universidade de São Paulo 230; Casa Nacional de Moneda, Potosí: 48; Convento de Madres Dominicas de Clausura, Tudela: photo Jesús Alava Sesma 106; Corbis: 69, 170, 213, photo Julio Donoso 144, photo Michael Freeman 141, photo Jeremy Horner 2, photo Charles and Josette Lenars 6, photo Nick Wheeler 117; Denver Art Museum: 47; Dumbarton Oaks Research Library and Collections, Washington, DC: 8; Robin J Dunitz: 242; Victor Engelbert: 63, 119, 166–7; Field Museum, Chicago: 223; Adrian Forty: 244; Robert Frerck: 20; Fundação Medeiros e Almeida, Lisbon: 211; Galería de Arte Mexicano, Mexico City: photo Jesús Sánchez Uribe 233; Galerie Albert Loeb: 238; Daniel Giannoni: 97; Alberto Gironella: 237; The Hispanic Society of America, New York: 55, 204; Angelo Hornak: 67, 125, 172; Christoph Hirtz: 165, 180; The Image Pro Shop: 81; Kobe Municipal Museum: 222; Det Kongelige Bibliotek, Denmark: 22, 102; Kunstbibliothek, Staatliche Museen Preussischer Kulturbesitz, Berlin: 139; Lonely Planet Images: 157; Metropolitan Museum of Art, New York: 184, 201; Delilah Montoya: 224; Mountain High Maps © 1995 Digital Wisdom Inc: p.434; Musée d'Auch: 52; Musée Royaux des Beaux-Arts, Brussels: 95; Musei Vaticano: photo A Brachetti and P Zigrossi 174; Museo de América, Madrid: frontispiece, 4, 16, 30, 54, 56, 57, 76, 207; Museo de Antioquia, Medellín: 235; Museo de Arte Colonial, Morelia: 51; Museo de Franz Mayer, Mexico City: 60, 71, 89, photo Jorge Vértiz 194, 202, 208; Museo Inka, Cuzco: 31; Museo Nacional de Arte, Mexico City (INBA): 226–8; Museo Nacional de Artes Plásticas, Montevideo: 229; Museo Nacional de Historia (INAH), Mexico City: 193, photo Alberto Milán 86; Museu de Arte de Bahia, Salvador: 210; Museum of Fine Arts, Boston: 9, 19, 209; Museum voor Schone Kunsten, Ghent: 94; Österreichische Nationalbibliothek, Vienna: 5, Jorge Pérez de Lara: 21, 24, 46, 118, 120, 160; Phillips Collection, Washington, DC: 241; Germán Ramirez: 236; Lydia Sada de Gonzalez: 219; N Saunders: 121; South American Pictures: photo Robert Francis 3, 84, photo Tony Morrison 12, 111, 122, 154, 158, 164, 178, 186, 189, photo Chris Sharp 11, 74, 156, 185, Museo Diocesano, Santa Cruz 197, Museo Isaac Fernandez Blanco, Buenos Aires 198; Museum of Contemporary Art, San Diego: 245; Santa Maria Museum, Paraguay: 113; Teresa Sarroca: 212; N Saunders: 121; RMN, Paris: Musée du Louvre: photo Hervé Lewandowski 199, Musée Guimet 220; Roberta and Richard Huber Collection: 206; Germán Venegas: 239; Werner Forman Archive: Museo Nacional de Antropología y Historia, Mexico City 13; Michel Zabé: 40, 190–1

Phaidon Press Limited
Regent's Wharf
All Saints Street
London N1 9PA

Phaidon Press Inc.
180 Varick Street
New York, NY 10014

www.phaidon.com

First published 2005
Reprinted 2006
© 2005 Phaidon Press Limited

ISBN 0 7148 4157 9

A CIP catalogue record for this book is available
from the British Library.

Text typeset in Joanna,
chapter numbers in Gill Sans

Printed in Singapore

Cover illustration Detail from Luis Niño,
Our Lady of the Victory of Malaga, c.1735 (see p.95)